KEY WRITERS ON ART:
FROM ANTIQUITY TO THE
NINETEENTH CENTURY

This magnificent survey is a great introduction to the history of
aesthetics. Anyone interested in reliable information about what the
leading thinkers from Plato to Riegl have said about art will find
this an essential reference.

David Carrier, Champeney Family Professor, Case Western
Reserve University/Cleveland Institute of Art

Key Writers on Art: From Antiquity to the Nineteenth Century is a unique
and authoritative guide to theories of art, from the development of
aesthetics in Ancient Greece to the emergence of both modernism and
the discipline of art history at the end of the nineteenth century.
Written by international experts, the 49 entries present the ideas of
key figures from a wide range of disciplines and approaches, including:

- Plato
- Aquinas
- Alberti
- Vasari
- Winckelmann

- Kant
- Ruskin
- Baudelaire
- Tolstoy
- Nietzsche

Written in an accessible style and arranged chronologically to
establish a broad historical framework, the essays provide an analysis of
each writer's ideas and influence, as well as a brief biography, a list of
their key texts, and a helpful guide to further reading.

Together with its companion volume, *Key Writers on Art: The
Twentieth Century*, this book provides an invaluable resource for all
those interested in aesthetics, art history or visual culture.

Chris Murray is a freelance editor and writer. He is the editor of *Key
Writers on Art: The Twentieth Century*, also available from Routledge.
He is currently compiling an encyclopedia of the history, concepts and
methodologies of art history.

ROUTLEDGE KEY GUIDES

Routledge Key Guides are accessible, informative and lucid handbooks, which define and discuss the central concepts, thinkers and debates in a broad range of academic disciplines. All are written by noted experts in their respective subjects. Clear, concise exposition of complex and stimulating issues and ideas makes *Routledge Key Guides* the ultimate reference resources for students, teachers, researchers and the interested lay person.

KEY WRITERS ON ART: FROM ANTIQUITY TO THE NINETEENTH CENTURY

Edited by Chris Murray

Routledge
Taylor & Francis Group

LONDON AND NEW YORK

First published 2003
by Routledge
2 Park Square, Milton Park, Abingdon, Oxon, OX14 4RN

Simultaneously published in the USA and Canada
by Routledge
270 Madison Avenue, New York, NY 10016

Reprinted 2005

Routledge is an imprint of the Taylor & Francis Group

Typeset in Bembo by Taylor & Francis Books Ltd
Printed and bound in Great Britain by Biddles Ltd
King's Lynn, Norfolk

British Library Cataloguing in Publication Data
A catalogue record for this book is available from the British Library

Library of Congress Cataloging in Publication Data
A catalog record for this book has been requested

ISBN 0–415–24301–7 (hbk)
ISBN 0–415–24302–5 (pbk)

100473S24X

CHRONOLOGICAL LIST
OF CONTENTS

ALPHABETICAL LIST
OF CONTENTS

CONTRIBUTORS

A. Owen Aldridge, Professor Emeritus of the University of Illinois, has published a range of articles on Shaftesbury, in addition to 'Shaftesbury and the Deist Manifesto' (1951), and is an advisory editor of the Standard Edition. His books also include biographies of Benjamin Franklin, Thomas Paine, Voltaire, and Jonathan Edwards. His most recent book is *The Dragon and the Eagle: the Presence of China in the American Enlightenment* (1993).

Ruben Berrios is Visiting Fellow in Philosophy at University College Dublin. His research interests include aesthetics, Nietzsche, and the philosophy of value.

Laurel Brake is Reader in Literature and Print Culture at Birkbeck College, University of London. Her books include *Walter Pater* (1994), *Subjugated Knowledges* (1994) and *Print in Transition* (2001). She co-edited with Ian Small *Pater in the 1990s* (1991) and, with Carolyn Williams and Lesley Higgins, *New Pater Studies: Transparencies of Desire* (2002). Her research interests include nineteenth-century print culture, and she is currently working on a biography of the Pater.

Hugh Bredin teaches philosophy at Queen's University, Belfast. He has written articles on figurative language, translated books by Umberto Eco, and co-authored (with Liberato Santoro-Brienza) a recent introduction to aesthetics, *Philosophies of Art and Beauty* (2000). He is currently working on topics in medieval aesthetics.

Ronna Burger is a professor of philosophy at Tulane University, where she teaches courses on Plato and Aristotle. She received her Ph.D. in philosophy from the New School for Social Research in 1975. She is the author of *Plato's Phaedrus: A Defense of a Philosophic Art of Writing* (1980)

and *The Phaedo: A Platonic Labyrinth* (1984; 1999). She is currently completing a book on Aristotle's *Ethics*.

Erin J. Campbell teaches Renaissance Art at the University of Toronto. Her writings on the issues of artistic identity, old age, and the problem of obsolescence appear in *Word & Image, Sixteenth Century Journal*, and *Art History*. At present she is working on a book about late self-portraits.

Abigail Chantler is a lecturer in the School of Music at Trinity College Dublin. Her research interests focus on early-Romantic aesthetics and hermeneutics and she is currently researching a monograph on E.T.A. Hoffmann's musical aesthetics. Her Ph.D. dissertation, completed in 1999, is on 'The Confluence of Aesthetics and Hermeneutics in the Writings of E.T.A. Hoffmann, Wackenroder, and Schleiermacher'.

David E. Cooper is Professor of Philosophy at the University of Durham. He has written in many fields, including aesthetics, philosophy of language and modern European philosophy. His books include *Existentialism: A Reconstruction* (1990; 2000) and *World Philosophies: An Historical Introduction* (1996; 2002). He edited *A Companion to Aesthetics* (1992) and *Aesthetics: The Classic Readings* (1997). His latest book is *The Measure of Things: Humanism, Humility and Mystery* (2002).

Matthew Craske is currently a lecturer at Oxford Brookes University. He has been a fellow of the Warburg Institute, Churchill College, Cambridge, The Henry Moore Foundation, and the Leverhulme Trust in Association with the National Portrait Gallery.

Robert Crouse is Professor Emeritus of Classics at Dalhousie University and the University of King's College, in Halifax, Nova Scotia, and serves regularly as Visiting Professor of Patrology at the Augustinian Patristic Institute, in Rome. Most recent among his many publications on Augustine and medieval Augustinians is the essay 'Augustine's Platonism', in Dodaro and Lawless, *Augustine and His Critics* (2000).

Richard Drake teaches modern European history at the University of Montana. He specializes in modern Italian history and in modern cultural and intellectual history. His published work includes *Byzantium for Rome: The Politics of Nostalgia in Umbertian Italy, 1878–1900* (1980), *The Revolutionary Mystique and Terrorism in Contemporary Italy* (1989), and *The Aldo Moro Murder Case* (1995). He currently is writing a book on the Marxist revolutionary tradition in Italy.

Sharon Gregory teaches art history at the University of the South in Sewanee, Tennessee. She received her Ph.D. from the Courtauld Institute of Art, London, in 1999, with a dissertation on 'Vasari, Prints and Printmaking'. She is the author of several articles on Vasari and his circle, and is currently researching the theory and practice of imitation in sixteenth-century Florentine art.

James Hall is an art critic and historian. He is the author of *The World as Sculpture: The Changing Status of Sculpture from the Renaissance to the Present Day* (1999). He is currently writing a book on Michelangelo.

Margaret Iversen is Professor of Art History and Theory at the University of Essex. She is author of *Alois Riegl: Art History and Theory* (1993) and of a study of artist Mary Kelly (with Douglas Crimp and Homi Bhabha, 1997). She edited a special issue of *Art History* called 'Psychoanalysis in Art History' (1994) and (with Dana Arnold) edited a collection of essays called *Art and Thought*, on the interface of the history of art and philosophy (forthcoming). She is soon to publish a book called *Art Beyond the Pleasure Principle* on psychoanalytic art theory and twentieth-century art.

W. Gareth Jones was previously Professor of Russian at University of Wales, Bangor. His main interests are the Enlightenment in eighteenth-century Russia and the nineteenth-century Russian novel. His publications include *Nikolay Novikov: Enlightener of Russia* (1984); *I Cannot Be Silent: Writings on Politics, Art and Religion by Leo Tolstoy* (1989); and *Tolstoi and Britain* (1995).

Linda A. Julian teaches Victorian literature at Furman University. Her main interests are William Morris, Charles Dickens, and the Pre-Raphaelites, subjects of published essays and lectures. Publications also include essays that incorporate some major, often primary research on such Victorian women poets and fiction writers as Harriet Hamilton King, Caroline Clive, and Mary Anne Hearne. She is working on a long-term project about Dickens and the use of the doppelganger.

Mark Ledbury is a lecturer in Art History at the University of Manchester. His research focuses on the relationships between drama and visual art in eighteenth-century France. He is the author of *Sedaine, Greuze, and the Boundaries of Genre* (2000), and, with David Charlton, *Michel-Jean Sedaine, 1719–1797* (2000). He has also published articles on

Jacques-Louis David, and is currently researching a new book, *Melodrama and History Painting in France, 1770–1815*.

Andrew Robert Leng lectures in the University Scholars Programme, at the National University of Singapore. His chief research interest is Ruskin's role as critic-patron of Victorian artists. Recent publications include: 'The Critic as Patron: Ruskin's Production of Britain's "Modern Painters"', in *Nineteenth-Century Contexts* (1999), and 'Letters to Workmen?', in *Fors Clavigera, Whistler v. Ruskin* and 'Sage Criticism in Crisis', in *Prose Studies* (2002).

Peter Lewis teaches philosophy at the University of Edinburgh. His main interests are aesthetics and the philosophies of Wittgenstein, Schopenhauer, and Collingwood. He has contributed articles to periodicals such as *British Journal of Aesthetics, Philosophical Investigations, Collingwood Studies*. At present he is editing a volume of essays on Wittgenstein and aesthetics.

Rosemary Lloyd teaches at Indiana University, where she is Rudy Professor of French. Her latest books are *Mallarmé: The Poet and His Circle* (1999), and *Baudelaire's World* (2002).

Walter S. Melion, Professor of the History of Art at The Johns Hopkins University, is the author of numerous articles on print culture in the sixteenth- and seventeenth-century Netherlands. His book on Karel van Mander, *Shaping the Netherlandish Canon*, was published in 1991, and he has just completed *The Meditative Art: Prints and Prayer in the Netherlands, 1550–1625*.

Harry Mount teaches art history at Oxford Brookes University, his main interest being British eighteenth-century art and art theory. He recently published an edition of Joshua Reynolds's *Journey to Flanders and Holland* (1996), and is currently working on a study of attitudes to minuteness in eighteenth-century Britain.

Hilary Nias is a linguist and cultural historian, and author of *The Artificial Self: The Psychology of Hippolyte Taine* (1999). She is currently editing Taine's unpublished notebooks of 1853–80 and preparing a translation of the philosophical essays of Théodore Jouffroy (1796–1842).

Claire Pace is Honorary Senior Research Fellow (formerly Senior Lecturer) in the Department of History of Art, Glasgow University. Her research interests focus chiefly on seventeenth-century French and Italian

painting and critical writings, and on the relationship between visual and literary modes. Recent publications include articles on Poussin and Bellori.

George Pattison teaches in the theology faculty of Aarhus University (Denmark), specializing in Christianity and modern thought and with particular interests in existentialism and the visual arts. He edited *Kierkegaard on Art and Communication* (1992), and has written *Art, Modernity and Faith: Towards a Theology of Art* (1998), *Kierkegaard: The Aesthetic and the Religious* (1999), *The Routledge Guide Book to the Later Heidegger* (2000), and *Kierkegaard, Religion and the Nineteenth Century Crisis of Culture* (2002).

Alex Potts is Professor of the History of Art at the University of Michigan at Ann Arbor and an editor of *History Workshop Journal*. His interests include the historiography of art history and the theory and history of modern sculpture. He is the author of *Flesh and the Ideal: Wincklemann and the Origins of Art History* (1994) and *The Sculptural Imagination: Figurative, Modernist, Minimalist* (2000).

Thomas Puttfarken is Professor of the History and Theory of Art at the University of Essex. He has published extensively on Italian and French theories of art, and on iconography, in particular of the classical tradition. His latest book is *The Discovery of Pictorial Composition: Theories of Order in European Painting from 1400–1800* (2000).

Gary Shapiro, Tucker Boatwright Professor in the Humanities and Professor of Philosophy at the University of Richmond, Virginia, is the author of two books on Nietzsche and of *Earthwards: Robert Smithson and Art After Babel* (1995); his next book, *Archaeologies of Vision: Foucault and Nietzsche on Seeing and Saying*, will be published in 2003. He is currently working on geophilosophy and ecoaesthetics.

Kaylee Spencer-Ahrens is presently a Ph.D. candidate in the department of art history at the University of Texas at Austin. Publications include 'Political Rhetoric and the Unification of Natural Geography, Cosmic Space, and Gender Spheres' (with Linnea Wren and Krysta Hochstetler) in *Landscape and Power in Ancient Mesoamerica* (2001); and 'Religion, Astronomy and the Calendar' and 'Religion, Cosmology, and Art' (with Linnea Wren) in *Handbook to Life in the Ancient Maya World* (2002).

Suzanne Stern-Gillet is Professor of Philosophy at the Bolton Institute, having previously taught in universities in continental Europe and the USA. She holds degrees in philosophy and in classics from the Universities of Liège (Belgium) and Manchester. She is the author of *Aristotle's Philosophy of Friendship* (1995) and of numerous articles on ancient philosophy, aesthetics, and ethics. She is currently working on a history of ancient philosophy, *From Thales to Iamblichus*.

Roger Tarr teaches Art History at Edinburgh University. His main areas of interest are in the period *c.* 1250–*c.* 1500 in Italy, particularly Florence and Siena. He has published articles on the painting and sculpture of this period, most recently a study of the iconography of Duccio's *Maestà* in *Viator* (2000). He is also interested in the theory of art and architecture, and is currently working on a study of the theory of painting and sculpture in Florence in the early fifteenth century.

Pamela Warner is presently working on a dissertation on word and image issues in the art criticism of the Goncourt brothers at the University of Delaware. Her essay 'The Poetry of Laszlo Moholy-Nagy: Catalyst for an Artistic Identity' appeared in the exhibition catalogue *Laszlo Moholy-Nagy: From Budapest to Berlin, 1914–1923*. She is co-author with Ellen A. Plummer of *The Romance of Transportation: Vehicle and Voyage in North American Art* (1993).

Nick Webb is an arts staff tutor in the Open University. His cultural-historical interests include some study of the relationship between philosophy and arts during the Italian Renaissance.

Barbara Wright is Professor of French Literature at Trinity College, Dublin. Her main interest is in the interface between word and image in nineteenth-century France. Her works include *La Vie et l'oeuvre de Fromentin* (with James Thompson) (1987), *Correspondance d'Eugène Fromentin* (1995), and *Eugène Fromentin: A Life in Art and Letters* (2000). She is co-ordinator of a graduate course in Textual and Visual Studies, operated conjointly by Trinity College, Dublin, Université Paris 7, and Université Paris X.

PREFACE

The aim of the two volumes of *Key Writers on Art* is to provide, both for students and the general reader, a stimulating and wide-ranging introduction to the many writers and thinkers – across disciplines – whose ideas play an important role in our understanding of the visual arts. Over the past few decades, the study of art has become increasingly complex and many-sided, with the concepts and methodologies of a range of disciplines being used to explore the relationships between the artist, the work, the viewer, and society. To the more traditional concerns with technique, style, artists' lives, cultural and historical contexts, iconography and so on, has been added a keen interest in the tools of analysis provided by, for example, the psychology of perception, psychoanalytical theory (orthodox and reformed), sociology, political thought (above all Marxism in its many forms), structuralism, semiotics, feminism, cultural theory and deconstruction.

It is this very diversity of approaches, traditional and modern, that the two volumes of *Key Writers on Art* aim to illustrate. So there are entries not only on aestheticians and art theorists (though they are well represented), but also on art critics and art historians, religious thinkers, poets, artists, social and political scientists, cultural theorists, connoisseurs, anthropologists, psychologists, and semioticians.

The entries in the first volume, which covers the period from classical antiquity to the end of the nineteenth century, are arranged chronologically to reflect broad historical changes. The entries in the second volume, which covers the twentieth century, are arranged alphabetically. For ease of reference, there are chronological and alphabetical listings in both volumes, and both have a general index. Cross-references have been indicated in bold throughout. Each entry ends with a paragraph of biographical data and, for those interested in finding out more, a further reading section that lists both primary and secondary texts.

Key Writers on Art: From Antiquity to the Nineteenth Century brings together the writers of the classic texts of art history and aesthetics, as well as a number of less familiar, but historically significant figures. Covering the period that stretches from classical antiquity to the Middles Ages, and from the Renaissance to the end of the nineteenth century, it includes entries on (among others) Aristotle, Alberti, Vasari, Diderot, Winckelmann, Hegel, Ruskin, Tolstoy and Nietzsche. There is no suggestion that taken together the entries in this volume represent a single, continuous development in our understanding of art. It is the profound differences between these thinkers and writers over what they take to be the nature, purpose and values of art that are often more significant than their similarities.

Key Writers on Art: The Twentieth Century contains entries on twentieth-century thinkers from many disciplines; some have written specifically about the visual arts, either as historians or aestheticians; others have developed ideas (in sociology, political philosophy, psychoanalytical theory and so on) that can be applied to the study of art. They include: Adorno, Baudrillard, Benjamin, Danto, Derrida, Arnold Hauser, Julia Kristeva, Panofsky, Wittgenstein and Richard Wollheim.

Given this broad scope, the task of creating a balanced, representative selection of entries was often a difficult one; beyond a certain point, every important addition meant the loss of someone whose claims for inclusion were just as strong. As a main concern was to illustrate a broad range of approaches and styles, four overlapping – and sometimes conflicting – principles were used in making the selection. Candidates had to fall into at least one of the following groups:

- those who are widely studied in art history, art theory or visual culture (Plato, Vasari, Kant, Hegel, Winckelmann, Wölfflin, Benjamin, Gombrich)
- those who represent an important period, concept, focus or methodology (Plotinus, Bellori, De Piles, Locke, Lévi-Strauss, Pollock)
- those whose relevance to the analysis of art has yet to be fully explored (Kierkegaard, Lyotard)
- those who are generally neglected by current interests and courses of study (Read, Stokes, Simmel).

While it cannot claim exhaustive coverage of all figures who have influenced this field, the result, I hope, will provide those interested in the visual arts with an invaluable guide not only to its essential (and often daunting) texts, but also to a number of important but far less familiar works. Readers may notice that writers on photography and

on architecture and design are not included, and that only a few artists, those whose ideas are historically significant, have been selected. These groups will I hope be covered in future projects.

I'd like to thank all the contributors for their commitment and hard work; having only 2,000 words to introduce a subject about whom there is so much to say is an exacting and sometimes thankless task. I'd also like to thank Roger Thorp for commissioning the project, and Elisa Tack, Milon Nagi and Barbara Duke at Routledge for their efficiency, patience and good humour in seeing the two books through to completion.

KEY WRITERS ON ART:
FROM ANTIQUITY TO THE
NINETEENTH CENTURY

PLATO (427–347 BC)

GREEK PHILOSOPHER

The dialogues of Plato contain the first extant discussions of art by a western philosopher. Like his treatment of many topics in other areas of philosophy, these discussions have been of abiding influence. This is despite, or in some cases even because of, long-standing misunderstandings of Plato's views on art. It is despite the fact, too, that neither he nor the Greeks generally possessed a concept equivalent to the one now expressed by the term 'art'. Although music, painting and other artforms were described as *technai*, so were mathematics, horsetraining, medicine and many other skilled disciplines. (In the early dialogue *Ion*, Plato in fact questions the status of some poetry as *techne*, arguing that it is a divine 'inspiration' or 'madness', not a skill, that the poet's works manifest.) If *techne* is translated as 'art', it is in that broad sense in which we may speak, for example, of the art of healing or teaching – a sense having no special connection with what artists do or with things of aesthetic interest.

That the Greeks had no term equivalent to 'art' in its aesthetic sense reflects the fact that artistic activity was not regarded by them as 'autonomous', as something pursued 'for its own sake'. Music and sculpture, for example, typically had religious, ceremonial or civic functions, while poetry and drama played central roles both in the education of youth and in the dissemination of information. It is essential to bear in mind such communal roles of the arts in order to understand certain aspects of Plato's notorious hostility towards the arts – literature in particular. For example, one reason why epics, like those of Homer, are to be 'banished' from the society envisaged in *Republic* is that 'impersonation' by Athenian boys of immoral or unsavoury heroes and gods should have no place in an education whose proper aim is the training of character.

It is important to bear in mind, too, that while Plato's main discussion of visual art – also in *Republic* (Book 10) – is of independent interest; it serves, for him, primarily as a prelude to some criticisms of literature. There are, he argues, certain truths about artists and their works that we are apt to forget in the case of literature and of which a preliminary focus on painting can serve to remind us. It is, for example, obvious that the painter of battles, say, does not require, and typically lacks, any expert military knowledge. Analogously, therefore, we should not, as we are wont to do, suppose that the poet is any kind of expert or authority on what he writes about.

Plato also employs his discussion of painting to illustrate something that, in his view, is a distinctive feature of what we, if not the Greeks, would call 'the arts' – *mimesis* (a concept that would also be central to **Aristotle**'s approach to the arts). It has since become commonplace to refer to Plato's 'mimetic theory' of art. Writers who use that label often attribute the following three views to Plato:

- art is to be defined as *mimesis*,
- *mimesis* is a 'copying' or 'imitation' of things, events and so on, and
- precisely because art *is* mere 'imitation', it is something that, if not to be entirely 'banished', should at any rate not be credited with a serious function in human life.

While these claims are not without a grain of truth, each of them is, however, mistaken or misleading. To begin with, Plato nowhere *defines* 'art', not least because, as noted earlier, he employs no term translatable as 'art'. The most one can say is that, in his view, it is true of each artform – but not perhaps *only* of artforms – that it is mimetic in character. Second, it is crucial to note that Plato uses the term '*mimesis*' in two significantly different ways, so that any characterization of art as *mimesis* would be equivocal. In Books 2–3 of *Republic*, *mimesis* refers specifically to someone's 'impersonating' or 'representing' a character – Achilles, say – when acting the part of Achilles in a tragedy or reciting Achilles's lines from an epic. (Notice that, in this sense, one could not intelligibly regard the artist's – here Homer's – account of Achilles as mimetic.) In Book 10, however, *mimesis* is understood as the artist's practice of producing representations or, in a very broad sense, 'images' *of* things, people or whatever.

In neither of these senses is *mimesis* happily translated as 'copying' or 'imitation'. An actor playing the part of Achilles is hardly imitating him, not at any rate in the way that an imposter or some admirer for whom Achilles is a 'role-model' might. Nor, despite an analogy he briefly draws between painting something and holding up a mirror to it, does Plato suggest that a painting is, or should be, a slavish, 'photographic' reproduction of an object. Indeed, for reasons that will soon emerge, he thinks it impossible for paintings accurately to represent. The most that can be said is that *mimesis*, in the second sense, involves adapting or exploiting certain features of a subject in order to create something that produces effects similar, in some respects, to those produced by the original subject. As such, Turner's impressionistic paintings of Venice are no less 'mimetic' than Canaletto's 'realistic' ones. There is nothing in Plato's account to

support the view of writers like **Alberti** – inspired, ironically by Renaissance Neoplatonism – that paintings of bodies should be 'just like those bodies' to the point of virtual indistinguishability. The element of truth in claim 3 is that Plato did not regard the making of representations or images as high in the hierarchy of human pursuits. It contributes nothing to our rational understanding of things, nor, since it affords relatively trivial pleasures, to the political and moral welfare of the Republic. Indeed, it is a distraction from both of these. By attending to the 'appearances' of things rather than to their real natures, artworks operate at the level where our beliefs and understanding are most confused, and by appealing to our emotions, they distract from the cool, rational examination of events that is essential to proper moral judgement. There is an 'ancient quarrel' between poetry – or artforms more generally – and philosophy, and Plato is clear in whose favour it should be resolved.

Claim 3 is mistaken, however, in crediting Plato with the view that art is dangerous or lacking in seriousness *because* it merely represents or 'imitates'. Almost the reverse is true: artists purport faithfully to represent, but they do not, and cannot, do this. For a start, they cannot represent what is most truly real – namely the Forms, those ideal, abstract entities of which objects in the empirical world of 'appearances' are, according to Plato's metaphysics, pale and confused 'copies'. Only the rational discourse of philosophy and mathematics can achieve this. Second, artists cannot even represent an empirical object as it is, but at best only their own subjective 'takes' on it, from a particular visual perspective, say. This is why, as Plato puts it, what we see when looking at a painting is 'two generations away from reality': it represents a subjective 'take' on something that itself is a pale representation of what is fully real. The final reason that the artist does not faithfully represent the real is that, in order to produce his 'semblances', he must resort to various 'illusory' devices or 'trickery' – such as linear perspective and shadowing – that have no correspondence to anything in the world.

Much of the history of the visual arts may be understood in terms of the ways that artists and theorists of art have responded to Plato's views about representation indicated in the previous paragraph. One kind of response has been almost total agreement with those views, but accompanied by an attempt to turn into a virtue what Plato regarded as a vice. Some champions of Impressionism, for example, agreed that paintings could not faithfully represent objects or events: but they argued that, for this very reason, the artist's proper aim was to record fleeting, subjective impressions of things. Again, writers like Ernst

Gombrich and Nelson Goodman have agreed that paintings do not reproduce anything furnished by a supposedly 'innocent eye', but go on to locate the genius of painting in the intriguing 'conventions' and 'devices' that succeeding generations of artists adopt for 'making' depictions of the world. A different kind of response has been agreement with Plato's conception of what it is to represent reality, but accompanied by a rejection of the limitations he attributes to art. Thus, for some Renaissance theorists, as later for **Schopenhauer**, artworks *can* represent, or at least intimate, the essential Forms of things, and in a way, perhaps, that linguistic articulation cannot. This was Degas's point, possibly, when he remarked that he did not paint women, he painted Woman.

Plato's submission of the arts to moral demands has had, in modern western societies, a more uniform and negative reception. Four considerations, however, might serve to mitigate this hostile verdict. First, like many of the proposals in *Republic*, the insistence on Draconian censorship or outright 'banishment' of artists was probably intended, not as a realistic policy, but as a dramatic device for making a certain point – in this case, that our overarching concern must be with the morally good. (In other dialogues, such as *Laws*, Plato's proposals were markedly less Draconian.) Second, Plato should not be accused, alongside **Tolstoy** and some Marxist art critics, of judging artistic value by moral standards. He was fully aware of and sensitive to, for example, the greatness of Homer's epics: indeed, it was to this very greatness that their seductive and dangerous power owed. Third, in order to avoid anachronism when appraising Plato's position, we need to recall the roles, in education and as mass entertainment, that artworks played in the Athenian *polis*. His concern about the effects of the epics, for instance, should be compared to contemporary worries about the influence on young minds, not of 'highbrow' art, but of violent or racist TV programmes and pop songs. (One wonders, in connection with Plato's strictures against 'impersonating' immoral heroes or gods, how many modern parents would want their children to play the part of, say, Heinrich Himmler or a heroin addict in the school play.) Finally, Plato's willingness to police artistic activities attests to his appreciation that, while the arts cannot be 'serious' in the manner of philosophy and other rational disciplines, works of art may possess enormous beauty and emotional charge. Many of Plato's critics, especially among artists, share that appreciation. In that case, they need to ask themselves whether it is realistic to suppose that this power of art is always something to welcome and whether it is

legitimate, therefore, to deny that, as Plato put it, art must also have a 'terrifying capacity for deforming even good people'.

Biography

Plato, originally named Aristocles but later called *Platon* ('broad') because of his impressive shoulders and forehead, was born in Athens in 427 BC into an aristocratic family. He was a friend and pupil of Socrates, whose execution in 399 prompted Plato to flee Athens and live in various Greek cities around the Mediterranean for 12 years, visiting Egypt, Sicily, Magna Graecia and Cyrene. After his return to Athens in 387 BC, he founded and directed a religious, philosophical community – the Academy – whose pupils included Aristotle. After an unsuccessful visit to Syracuse in 367 BC as royal tutor and political adviser, he spent the remainder of his life teaching and writing in Athens. He died in 347 in Athens.

Bibliography

Main texts

The Collected Dialogues of Plato, E. Hamilton and H. Cairns (eds), various translators, Princeton, NJ, Princeton University Press, 1963.

Secondary literature

Annas, Julia, *An Introduction to Plato's Republic*, Oxford, Clarendon Press, 1981.
Halliwell, Stephen, *Plato Republic 10: with translation and commentary*, Warminster, Aris & Phillips, 1988.
Janaway, Christopher, *Images of Excellence: Plato's Critique of the Arts*, Oxford, Clarendon Press, 1995.
Kelly, Michael (ed.), *Encyclopedia of Aesthetics*, Oxford, Oxford University Press, (1998), vol. 3, pp. 518–32.
Murdoch, Iris, *The Fire and the Sun: Why Plato Banished the Artists*, Oxford, Oxford University Press, 1977.
Nehamas, Alexander, 'Plato and the Mass Media', *Monist* 71 (1988), pp. 214–33.

DAVID E. COOPER

ARISTOTLE (384–322 BC)

GREEK PHILOSOPHER

Aristotle's *Poetics* is a treatise, not on the philosophy of art or aesthetics, but rather, on the art of poetry, or more specifically, at least in the text

that has come down to us, on tragic drama; yet it has come to have a profound effect on the development of our understanding of art. Actually, though the *Poetics* was available to western thinkers from the thirteenth century, it had little immediate impact. For several centuries it was Aristotle's works on metaphysics and psychology that influenced medieval thinkers such as **Aquinas** and Renaissance writers on art such as **Lomazzo**, before the *Poetics* became an important text in the tradition.

The *Poetics* begins by situating tragedy, along with other forms of poetry and music, as instances of *mimesis* – imitation or representation – although without defining this apparently comprehensive notion, which played a key role in **Plato**'s thought and came to be a central concept in theories of art and beauty. Aristotle offers an indication of the complex meaning it will bear in the *Poetics* when he first proposes that the art of poetry has its roots in the nature of human beings as 'the most mimetic' of all animals (ch.4). Our inclination to *mimesis* shows up in two rather different forms. On the one hand, *mimesis* is the imitation or mimicry of others by which we learn 'the first things', like our native language or our dispositions of character. On the other hand, *mimesis* is a work of representation, which we find a natural enjoyment in contemplating. Even, or especially, something painful to see in itself – like 'the most dishonorable beasts', Aristotle suggests, or corpses – can produce a strange pleasure when we contemplate a precisely made image of them; and the source of this pleasure is what we learn when we recognize in the image, 'This is that' (1448b17). While our inclination to *mimesis* as imitation attests to our natural attachment to others, that is, our political nature, the pleasure we take in *mimesis* as representation is a sign of our natural possession of reason.

It is the claim about the transforming image of a repulsive animal that the *Poetics* sets out to translate into its account of tragedy. In doing so it raises a number of provocative questions: of what exactly is the drama a *mimesis*? What do we recognize through the mimetic representation that transforms what would otherwise be ugly and painful to see in itself? Aristotle offers a key in the *Parts of Animals* (645a6–24), when he appeals, once again, to the visual image: it is not just the most divine things in the heavens that should attract the student of nature, but even 'the more dishonorable animals'; for however repulsive it might be to look at their insides, it would furnish immense pleasure to one who is able to 'recognize the causes', who is 'by nature philosophical'. If we appreciate the image of such a creature, Aristotle reasons, which manifests the skill of the artist, we

should take all the more pleasure in contemplating the organism itself, where nature displays the fittingness of parts to whole and the absence of chance.

The visual image, in its capacity to disclose an otherwise hidden design, seems to provide the model for the mimetic work as such. Drawing, painting, or sculpture, we might have thought, would be the paradigm case of mimetic art. Yet when the *Poetics* opens with a set of arts that make up the class of *mimesis*, it includes only poetry and music, with no visual art to be found among them. The generic class is differentiated into species on the basis of three principles: the means, the object, and the manner of the *mimesis*. Different genres of music and poetry employ, in various combinations, the means of rhythm, harmony, and language – just as colours and figures are used, Aristotle explains, to represent and produce likenesses (ch.1). Drawing and painting seem, then, after all to be forms of *mimesis*, yet they are brought up only to clarify the apparently more obscure case of rhythm, harmony, and language. In dramatic poetry all these means are employed and one must look to the object of imitation for further differentiation: it is the kind of character portrayed, either better than us or worse, that accounts for the distinction between tragedy and comedy – just as one portrait painter, Aristotle goes on, makes likenesses of those better and another of those worse (ch.2). The term 'likeness', which is applied as before only to the visual image, might be thought to exemplify, perfectly, the object of *mimesis*; yet the sketch or painting is offered, once again, only as an analogy. The task of the *Poetics*, it seems, is to extend the understanding of *mimesis* we have from the visual arts, where it seems as if it could be taken for granted, to poetry, where it apparently belongs most of all, however difficult it is to fathom its meaning.

In the context of differentiating tragedy from comedy as a species of mimetic art, the object of *mimesis* is said to be character. That account is radically altered when tragedy is defined in its own right and we discover that it is in essence the '*mimesis* of [an] action', and only for that reason represents those acting (ch.6). The action in question is that of the drama as a whole, and it is precisely because of this object, Aristotle argues, that the representation can be unitary and complete. The vehicle of *mimesis* responsible for this unity and completeness is 'the arrangement of the incidents' or plot (*muthos*). Plot is the end (*telos*) of the drama because it is 'the soul, as it were' of it, like the life principle of a living animal (1450a24, 39). Character, therefore, must be as subordinate to plot as colour is to figure in a visual image, if a drama is to realize its true nature as mimetic.

The way plot constructs its representation makes it clear that *mimesis* cannot be understood as a passive 'mirror of nature'. The limits that must be set by the plot – a beginning that does not follow from anything else and an end from which nothing else follows – constitute a frame imposed by art which no sequence of incidents in life would seem capable of supplying. Plot determines, at the same time, the fitting magnitude of the work: while events in life are liable to be like the very small animal, of which our view is confused; or one so gigantic we cannot take in the whole. Plot establishes a size that makes manifest the relation of parts to the whole. Most importantly, plot binds together the sequence of incidents it represents by the logic of probability and necessity: while portraying how certain sorts of persons would act in certain sorts of situations, it must display an internal order where each part has such a necessary place that none could be transposed or removed without destroying the whole. It is by these standards that the contingency of life is transformed into the perfectly designed whole of the mimetic work. This transformation makes poetry the *mimesis* of that which could, or would, happen and in this respect 'more philosophic' than history, whose proper object is that which has happened (ch.9).

Plot orders and designs the work as a self-contained whole. The visual image that provided the basis for this understanding of plot was introduced, however, in order to explain an effect on us – the peculiar pleasure we experience in contemplating it. The poetic equivalent to that effect makes a startling appearance when the formal definition of tragedy, which was culled from the whole preceding analysis, suddenly ends with something unprepared for and rather mysterious: the aim of tragedy is to accomplish 'through pity and fear' the purification (*katharsis*) of such passions (ch.6). This is what gives tragedy its 'psychagogic' function – its power to lead souls. No further explication of *katharsis* is offered, at least in our extant text. (See the last book of the *Politics* (1340b38–41), where Aristotle refers to the cathartic effects of music on the emotions with the assurance that it is spoken of more clearly in the *Poetics*.) However, if *katharsis* as a function of tragedy is finally to be understood, it must arise, Aristotle argues, from the arrangement of incidents in itself, which has been designated the *telos* and 'soul, as it were' of the drama.

Plot must be a *mimesis*, then, not just of complete action, but of one that is fearful and pitiable. That requires a sequence of incidents arranged one as the consequence of another, but at the same time contrary to expectation. The representation of such a sequence is the particular strength of a privileged plot structure, which Aristotle calls

'complex': its distinctive features are a 'reversal' – a moment in the drama that leads to precisely the opposite outcome from what was intended by the character involved – and 'discovery' – when the logic of events that brought about the unintended result comes to be recognized by that character (chs 10–11). It is our perspective in contemplating such a plot that allows us, at the same time, to identify with the tragic character enough to fear, while standing back to pity what we think of as his undeserved suffering, whereas in real life pity is a luxury that the state of fear precludes (*Rhetoric* II.8).

If the tragic character, in his discovery, comes to recognize his unintended deed as belonging to some design of the gods or fate, what the spectator recognizes in his contemplation of the drama is not that, it would seem, or not only that, but the design of the plot as the product of the mimetic art of the poet. Such recognition was illustrated, originally, by the case of contemplating the precise image of a 'dishonorable' animal and coming to understand, 'This is that': in what might have looked like a repulsive creature, mind discovers with pleasure a previously undisclosed order. The visual image seems to furnish such an appropriate analogy for the mimetic role of plot that we are led back to the question why the work of visual art should not be the paradigm case of *mimesis*.

One suggestion emerges in the discussion of the third principle Aristotle called upon – the 'manner' of *mimesis* – to differentiate one mimetic art from another (ch.3): the poet either 'imitates the one acting' (as in tragic or comic drama) or he 'remains himself' (in narrative poetry) or he mixes these (in epic). The author of a drama, this would mean, assimilates himself to the fictional characters in whose voice he speaks. This principle has no obvious equivalent in the visual arts. It is the notion Socrates has in mind when, in the third book of Plato's *Republic* (393c–401d), he defines *mimesis* in the strict sense as a matter of likening oneself to another in voice or figure. (The two discussions of poetry in *Republic* III and X seem to split between them the two senses of mimesis articulated in the *Poetics*.) *Mimesis* as imitation, is a process, Socrates argues, by which we establish habits in body, voice, and thought; and what makes rhythm and harmony such powerful means is the way they penetrate to the soul on the most primitive level. Aristotle confirms this suggestion in the last book of the *Politics*, when he observes that, while the visual image uses colour and figure to represent corporeal things and can only provide a sign of character, rhythm and harmony are in themselves mimetic of character states; and what it means for them to be mimetic is indicated by the

'sympathetic' effects our souls undergo when listening to music in different modes or rhythms (1340a34–b19).

Mimesis in the form of likening oneself to another is at work, according to the *Poetics*' opening analysis of the mimetic arts, in the dramatic poet's relation to the character through whom he speaks; it is involved, as the analysis of pity and fear suggests, in the natural response of the audience to the suffering that character undergoes in the drama. Since the visual image is not the vehicle for this mimetic process of imitation or assimilation to another, it is perhaps for that reason excluded as the paradigm case of *mimesis*. But the whole argument of the *Poetics* aims, one might say, at an analysis of tragedy that harnesses *mimesis* as imitation in the service of *mimesis* as representation, in the form of plot. And it was the visual image that provided the analogy for our contemplation of the order and design constructed by plot, which is at once the source of the pleasure of learning and the 'psychagogic' effect, which it is the distinctive function of tragedy to produce.

Biography

Aristotle was born in 384 BC in Stagira, northern Greece, the son of a physician. From 367–347 he studied under Plato at the Academy in Athens. From *c.*344–342 BC he taught in Mytilene. Invited by Philip of Macedon, he directed the education of Alexander *c.*342–*c.*339. He returned to Athens in 335 BC where he founded his school, the Lyceum, which ran until 323. With Alexander's death in 323 BC, anti-Macedonian sentiments made Aristotle's situation in Athens precarious, and when a charge of impiety was brought against him, he is said to have fled to Chalcis on the island of Euboea, where he died in 322 BC.

Bibliography

Main texts

Aristotle: On Poetics, trans. Seth Benardete and Michael Davis, Notre Dame, St Augustine's Press, 2002.

Aristotle: Poetics, trans. Gerald F. Else, Ann Arbor, University of Michigan Press, 1967.

The Poetics of Aristotle: Translation and Commentary, Stephen Halliwell, Chapel Hill, University of North Carolina Press, 1987.

The Politics, by Aristotle, trans. Carnes Lord, Chicago, University of Chicago Press, 1984.

Secondary literature

Benardete, Seth, 'On Greek Tragedy', in *Current Developments in the Arts and Sciences: The Great Ideas Today*, Chicago, Encyclopedia Britannica, 1980.

Belfiore, Elizabeth, *Tragic Pleasures: Aristotle on Plot and Emotion*, Princeton, Princeton University Press, 1992.

Butcher, S.H., *Aristotle's Theory of Poetry and Fine Art*, New York, Macmillan, 1898; repr. Dover Publications, 1951.

Davis, Michael, *Aristotle's Poetics: The Poetry of Philosophy*, Lanham, Maryland, Rowman & Littlefield, 1992.

Else, Gerald, *Aristotle's Poetics: The Argument*, Cambridge, MA, Harvard University Press, 1957.

Goldstein, H.D., 'Mimesis and Catharsis Reexamined', *Journal of Aesthetics and Art Criticism* XXIV (1966), pp. 567–77.

Halliwell, Stephen, *Aristotle's Poetics*, Chapel Hill, University of North Carolina Press, 1986.

Rorty, Amelie Oksenberg (ed.), *Essays on Aristotle's Poetics*, Princeton, Princeton University Press, 1992.

RONNA BURGER

PLOTINUS (204/5–70 AD)

LATE GREEK PHILOSOPHER

Plotinus, the founder of Neoplatonism and the author of the *Enneads*, is a major figure in the history of western philosophy. His school flourished in late antiquity during the third and fourth centuries AD and comprised both pagan and Christian thinkers. Although Neoplatonists, as they have been called since the eighteenth century, saw themselves as engaged in the study of **Plato**'s philosophy, most were in fact, original thinkers whose theories often departed significantly from the master's. Plotinus's own metaphysics, like that of Plato, privileges intelligible realities over phenomena; unlike it, it provides a comprehensive account of the generation of the world of sense. Plotinus's concept of beauty, although close to Plato's, differs from it in important respects. To be understood, it must first be placed in its doctrinal context.

Plotinus's metaphysics is monistic. Assuming that reality, like unity, admits of degrees, he holds that everything in this world, and out of it, has being and intelligibility to the extent that it participates in unity. All of reality, metaphysical and physical, he maintains, can be accounted for in terms of three principles of decreasing unity: the One, the Intellect, and the Soul. The terms of this hierarchy, he claims

further, are related by a timeless and necessary process of emanation: the One emanates Intellect, which emanates Soul, which, in turn, produces and in-forms matter. Each principle is the ontological parent and the model for, as well as the destination of, the reality (or hypostasis) that is emanated from it. Emanation does not alter any of the three principles.

The One (or Good), principle and source of all things, is beyond being, determinacy and thought. It transcends all else in so far as it cannot be counted as one more entity added to the intelligible and the sensible beings that derive from it. As the ultimate unity, it is the object of the striving of Intellect and Soul. In so far as it is entirely self-sufficient, the One is beyond thinking, even self-thinking. In so far as it is without properties, it cannot be spoken.

The One overflows eternally, and its superabundance makes something other than itself. Like a ray of light, its source, the product of the One, differs from its source while reflecting it. Only by turning back towards its source does the product know itself in its otherness. Knowing itself, it yearns for the perfect simplicity of its source. In this act of self-knowledge the product of the One constitutes itself as a separate metaphysical principle or hypostasis, which Plotinus calls Intellect and which he describes as possessing being, life and beauty. Thinking itself, Intellect thinks the forms. Plotinian forms, which constitute one nature with Intellect, are organically linked to one another, each reflecting the whole of Intellect while apprehending it in timeless contemplation. Although composite, Intellect, therefore, possesses a measure of unity second only to the unity of the One.

In the second stage of emanation, Intellect gives rise to Soul, the third and last principle in the Plotinian intelligible universe. An 'expressed thought' or 'image' of Intellect, Soul, too, turns towards its source. In this process, it contemplates the forms and gains awareness of itself while generating the great multiplicity of the world of sense. More diverse than its source, this hypostasis enfolds within itself different manifestations, or kinds, of soul, to which correspond the stages of its descent into body. While the World-Soul, as a discarnate entity, remains in the Intelligible realm, the souls of heavenly bodies, the soul called nature because it gives and sustains life, as well as the individual souls of organic beings and things, are stages in the descent of Soul into body. They are the manifestations of its progressive estrangement from its ontological source. At each level Soul projects onto lower instantiations of itself such reflections of the Forms as it succeeds in apprehending. As Soul gets more engrossed in body, these simulacra get more insubstantial. At the ultimate point of its fall, Soul

produces matter, indefinite and lifeless, which Plotinus equates with non-being, evil, and ugliness. As he conceives it, the world of sense is eternally caused to exist by the interaction of the being of Soul and the non-being of matter.

Plotinus's metaphysics has implications for ethics. Human beings, who are one of the products of Soul's descent into matter, can choose to surrender to the world of sense and to minister to the needs of their body. But if they so do, it is at the cost of alienating their soul, which is the higher part of their being and their true self. The moral life, as Plotinus conceives it, consists in resisting the lure of phenomena, tending one's soul and enabling it to (re)turn to the Intelligible Principle, whence it came. In so transcending themselves as compounds, human beings become their true self. In a famous passage, Plotinus describes the return of the soul to its source as an 'awakening' and the reality that it apprehends in the Intelligible Principle as 'beauty wondrous beyond all other' (IV.8.1.3).

The concept of beauty plays an important role in Plotinus's philosophy: it has an ethical as well as an aesthetic dimension, and serves to characterize both the sensible and the intelligible worlds. Unsurprisingly, therefore, the whole of the *Enneads* is permeated with aesthetic concepts and metaphors. In addition, two tractates (I.6 and V.8) are devoted to the discussion of issues pertaining directly to beauty in all its aspects.

The most basic judgements of taste originate in the delight that human beings take in sights and sounds, be it in nature or in art. Plotinus, who rejects the Gnostic view that this world is the work of an evil force, does not disparage the love of beautiful sights and sounds. But he would wish it to be understood that it is but a stage towards a more exact apprehension of a purer beauty. Sensible beauty, in his view, is but an enfeebled reflection of the intelligible beauty of the forms. The sensible particulars of our world, he explains, are the outcome of the meeting of lower manifestations of Soul with the incapacity of matter. The further Soul alienates itself from Intellect, the weaker its capacity for contemplation becomes, and the more closely it engages with matter. As a result, Soul at this point does not hold steadily within itself the intelligible objects that it would contemplate, and transmits only blurred reflections of the Forms to indeterminate matter. The delight that we take in sensible beauty, therefore, is a response to the modest measure of shape or unity that the sensible world owes to the demiurgic action of the lower manifestations of Soul.

To the phantasm of beauty, which rests on the world of sense, Plotinus contrasts the true beauty of the intelligible realm. The

contemplation of such radiance requires of individual souls that they engage in an ethical process of purification from the body, and that they turn inwards and reach out to the Forms in Intellect, by which all other things are beautiful. Then, and only then, will they realize that the world of sense, in which they had previously taken delight, *has* only an inferior beauty in so far and to the extent that it participates in Intellect. By contrast, Intellect and the Forms *are* beauty and their beauty is to be apprehended in a single, all-embracing act of intellectual vision in which beholder and beheld become identical.

Such a metaphysical concept of beauty carries consequences for aesthetics, and Plotinus explicitly drew some of them. Against the Stoic view that beauty consists in good proportions and harmony, he claimed that the single and the simple, too, could have beauty (I.6.1). From his view that discarnate Forms are more beautiful than their reflections in the world of sense, he inferred that the Form in the artist's mind is aesthetically superior to the empirical artwork: being 'divided by the external mass of matter', (I.6.3) the latter cannot achieve the purity and the unity of the former. In locating the work of art proper in the mind of the artist, who can directly apprehend the Forms, (V.8.1) Plotinus prefigured the theories of idealist aestheticians such as Croce and Collingwood, though there is no concrete evidence of Plotinus's direct influence upon either philosopher. Lastly, the ontological gap that Plotinus posited between art and *sensibilia* led him to reject such crudely mimetic view of art as is offered in book X of Plato's *Republic*: 'the arts', Plotinus claimed, 'do not simply imitate what they see, but they run back to the forming principles from which nature derives; ... they do a great deal by themselves, and, since they possess beauty, they make up what is defective in things' (V.8.1.35–8; Armstrong). Thus the sculptor's vision need not be restricted by the imperfections of the sensible world, and Phidias, for instance, 'did not make his Zeus from any model perceived by the senses, but understood what Zeus would look like if he wanted to make himself visible' (V.8.1.38–40; Armstrong).

His defence of the arts notwithstanding, Plotinus cannot be said to have an aesthetics in the modern sense of the term. To begin with, he had no concept by which to distinguish artworks from other manufactured objects: ' ... hand-made objects (*techneta*), have bronze or wood or stone, and they are not brought to completion from these until each craft makes one a statue, another a bed, and another a house by putting the form which it has in them' (V.9.3.11–14; Armstrong, modified). By thus making form the necessary and sufficient condition of beauty, Plotinus so widened the extension of the concept of beauty

as to render it practically unfit for the exercise of the judgement of taste. Indeed, since everything in the sublunary world reflects, to a greater or lesser degree, the Forms in Intellect, Plotinus would have needed to provide an extra criterion in order to demarcate those objects which do possess aesthetic properties, as traditionally defined, from those which do not possess such properties. From the evidence of the *Enneads*, he never evolved one. The reason is likely to come from the emphasis that he placed on detachment from the world of sense. This, in turn, led him to distinguish between outer and inner beauty. While the former, as he saw it, is but the 'surface bloom' of bodies and other material things, the latter, which characterizes the soul within and the realities imaged in the sense world, is inseparable from the moral life. Thus, holding moral and aesthetic values to be inseparable, he was left without the theoretical resources to evolve an autonomous concept of aesthetic value.

Paradoxically, this did not prevent Plotinus' system from exerting an enduring, if mostly indirect, influence upon the arts. Byzantine paintings and mosaics, Christian iconography of the High Middle Ages and, especially, Italian painting and sculpture of the *cinquecento* and *seicento* can all plausibly be claimed to have roots in some aspects of Neoplatonist philosophy.

Biography

Plotinus was reticent to divulge what he considered to be irrelevant biographical details. For whatever knowledge we have of the circumstances of his life, we are mostly indebted to the short treatise written by his disciple Porphyry to serve as an introduction to his edition of Plotinus' writings. He was probably born in 205 AD in Egypt. From 232–43 he studied philosophy in Alexandria under the Platonist Ammonius Saccas. After an unsuccessful attempt to gain direct acquaintance with the philosophies professed by the sages of Persia and India, Plotinus settled in Rome, where he opened a school in 246. The 54 treatises that form the *Enneads* were written from 254–70. He died in 270.

Bibliography

Main texts

Plotinus' writings were edited by Porphyry, who divided them into six sets of nine tractates (hence the name *Enneads*) according to subject matter, and gave them the titles under which we know them. For a critical edition of the Greek text, see P.

Henry and H.-R. Schwyzer, *Plotini Opera*, 3 vols: Vol 1 (*Enneades* I–III), Brussels, Edition Universelle, 1951; Vol 2 (*Enneades* IV–V), Brussels, Edition Universelle, and Paris, Desclée de Brouwer, 1959; Vol 3 (*Enneas* VI), Paris, Desclée de Brouwer, and Leiden, E.J. Brill, 1973.

For a generally faithful rendering into English, see A.H. Armstrong, *Plotinus* (7 volumes), Loeb Classical Library, Cambridge, MA, Harvard University Press, 1966–88.

Secondary literature

Anton, J.P., 'Plotinus' conception of the function of the artist', *The Journal of Aesthetics and Art Criticism* 26 (1967–8), pp. 91–101.

Gerson, L.P., *Plotinus*, London and New York, Routledge, 1994.

Hadot, P., *Plotin ou la Simplicité du Regard*, 1963, trans. M. Chase, *Plotinus or the Simplicity of Vision*, Chicago, University of Chicago Press, 1987.

Keyser, E. de, *La signification de l'art dans les Ennéades de Plotin*, Louvain, Université de Louvain, Travaux d'Histoire et de Philologie, 1953.

O'Meara, D., *Plotinus: An Introduction to the Enneads*, Oxford, Clarendon Press, 1995.

Panofsky, E., *'Idea': ein Beitrag zur Begriffsgeschichte der alteren Kunsttheorie*, 1924, trans. J.J.S. Peake, *Idea: A Concept in Art Theory*, New York, Harper & Row, 1968.

Stern-Gillet, S., 'Le principe du beau chez Plotin: réflexions sur *Enneas* VI.7.32 et 33', *Phronesis* vol. XLV, no 1 (2000), pp. 38–64.

Wallis, R.T., *Neoplatonism,* London, Duckworth, 1972.

SUZANNE STERN-GILLET

AUGUSTINE (354–430)

EARLY CHRISTIAN BISHOP AND THEOLOGIAN

> What is beautiful? And what is beauty? What is it that attracts us and delights us in the things we love? Unless there were grace and beauty in them they could not draw us to themselves.
>
> (*Confessions*, IV, 13, 20)

Among the many works of Augustine, none is devoted specifically to aesthetic theory, except for his earliest work, on beauty (*De pulchro et apto*, which was almost immediately lost: see *Confessions*, IV, 13, 20), and another earlier treatise (perhaps about 387) on music. Many of his works, however, from earliest to latest, include passages in which he considers the significance of beauty in nature and in art, and those works were powerfully influential in shaping the thought and imagination of western Christendom, through the medieval centuries and beyond.

In its basic character, Augustine's aesthetic theory is Platonic (or Neoplatonic), but with important modifications deriving from his Christian transformations of Platonic theology. Thus, the notion of

beauty as consisting in measure and symmetry – already clearly defined in the dialogues of **Plato**, and the common property of the whole Platonic tradition – forms the basis of Augustine's doctrine of beauty as harmony; and the Platonic theory of beauty as that which elicits human aspiration (*eros*) is at the heart of the theory of love (*amor*) in Augustine, according to whom human love finds its fulfilment in the ultimate beauty, which is God. Thus, he exclaims: 'Late have I loved thee, beauty so ancient and so new! Late have I loved thee' (*Confessions*, X, 27, 38).

For Augustine, as for the Platonic tradition generally, a certain ambiguity attaches to sensible beauty, whether in nature or in human arts. Nature imitates the ideal, transcendent forms, while the work of art imitates nature, and is thus, according to Plato (*Republic*, IX) 'at third remove from the throne of truth'. In that perspective, sensible beauty may be seen as seducing and entrapping the soul, holding it in a realm of darkness and alienation, deprived of the wings by which it should soar to its true homeland, submerging it, as **Plotinus** remarks (*Enneads*, I, vi, 13, 12–15), in the darkness of Hades. Augustine sometimes speaks in a similar way about the dangerous lure of earthly beauties, imprisoning the soul in an alien realm, far from its true *patria* (homeland). Thus, for instance, in *Confessions*, X, 18, 15 (in that passage which would, centuries later, so profoundly move Petrarch), he expresses his misgivings about those who admire natural beauties, but ignore their own souls, where a higher beauty is to be sought.

For Augustine, however (as, indeed, for Plato and other Platonists), the suspicion pertaining to sensible beauties, and the consequent ascetical negation of images, constitutes only one side of the consideration. As one sees in Plato's famous allegories of the Line and the Cave (*Republic*, VI and VII), the sensible images of images must also be the starting point of the soul's ascent to the Good; they must serve as signs to remind the soul of the reality of which they are images. Just so, for Augustine, the soul's ascent must have its beginning in the external and temporal realm of the sensible. In the vision at Ostia (*Confessions*, IX, 10, 24), Augustine and his mother rise to a mystical vision of the true and eternal Wisdom; but they must do so by passing through a consideration of material things in their various degrees, and then through a consideration of their own souls. There is at once negation and affirmation of the images. The temporal image reflects the eternal archetype; the contemplation of earthly beauty leads to a contemplation of the uncreated beauty (*Epistle 138*, 5). Thus, for Augustine, as for the whole Platonic tradition, art must have essentially an anagogical character: the image is not for its own sake,

but has the function of revealing its archetype, thereby leading the soul to contemplate the beauty which is eternal, 'the beauty of all beauties' (*Confessions*, III, 6, 10).

Augustine shares all of these basic conceptions with the Platonic tradition generally, whether in its pagan or its Christian forms. For the subsequent history of art, it was vastly important, of course, that he gave such concepts an explicitly Christian reference to a greater extent than any before him had done, and that he did so in writings, which were immensely influential through all the centuries of western Christendom. His contribution was not, however, simply a matter of translating traditional Platonic conceptions into a Christian context. His work involved a fundamental transformation of Platonic theology in the light of biblical revelation and the central tenets of Christian doctrines about God, Creation, Incarnation, Resurrection, and the nature and destiny of the human soul: a transformation which would imply a changed evaluation of sensible images and material representations, and, therefore, a changed perspective in regard to art.

From the standpoint of ancient Platonism, there was nothing strange in thinking of the cosmos as a work of art, and of God as the supreme artist; indeed, the ordered motion of the heavenly bodies was seen as the visible manifestation of the divine harmony which is the very essence of beauty. Thus, there would be nothing strange about Augustine's frequent assertions that the beauty of created things is their voice, 'confessing the God who made them' (*On Psalm 148*, 15). Platonic theology finds profound difficulties, however, in understanding precisely the relation of image to archetype. The image imitates, or participates in the transcendent form; but what is it that divides between the form and its image? Is there (as Plato's creation myth in the *Timaeus* would seem to suggest) some irrational aspect or element in things, contrary to divine reason? And how does the multiplicity of forms relate to the transcendent divine unity? Must the forms, or ideas, belong to some secondary, derivative level of divinity, below the absolute One, as in Plotinus's doctrine of subordinate divine hypostases?

These questions Augustine resolves in his explication of the Christian doctrine of creation from nothing (especially in *Confessions*, XI–XIII, *City of God*, XI, XII, and his several lengthy commentaries on Genesis). Arguing particularly against the Manichees, he rejects any dualistic theory which would see matter as a contrary principle: creation is from nothing, by the word and will of God. The forms, the ideas, are eternally established in the mind of God, the eternal Word, who is not a secondary level of divinity (as in Neoplatonic and Arian theology), but absolutely God, equal to the Father and the Spirit.

Thus, in terms of the doctrines of Trinity and Creation, the theological basis of the theory of images is transformed, and the foundations are laid for a new theology of art. Still other Christian doctrines serve to enhance the dignity of created images. Against all Gnostic and Arian misgivings, Augustine insists upon the reality of the Incarnation; that is to say, he insists that Christ who is enfleshed in human nature is at the same time absolutely God. Against Porphyry and other Platonists, he insists upon the doctrine of the resurrection of the body (*City of God*, XXII, 25–30), so that 'the saints will see God with their bodily senses', and in heaven there will rise 'a great hymn of praise to the supreme Artist who has fashioned us, within and without, in every fiber, and who, by this and every other element of a magnificent and marvelous order, will ravish our minds with spiritual beauty'.

In such a view, love of sensible beauty may be seen as the starting point of a continuous line of ascent to the vision of God. For Augustine, love (*amor*) is the principle of spiritual motion: 'My love is my weight, whithersoever I am drawn, I am drawn there by love' (*Confessions*, XIII, 9, 10). The way of ascent is the way of the purification and unification of loves. Thus, his position would underline the anagogical significance of art, as not only instructive, but as inspirational. Its role is profoundly sacred.

In the vast body of his writings, Augustine has little to say directly about art and artists. Yet, he establishes the theological foundations on which the aesthetic traditions of Latin Christendom will be built. Perhaps it is only in the High Middle Ages that the aesthetic principles of Augustine become fully manifest in practice. Perhaps the finest image of his theology of *amor* is Dante's Beatrice, where the continuity of earthly and heavenly beauty is so perfectly affirmed. And also in that gothic age, Augustine is present, not only as theologian of art, but himself the subject of marvellous representations, such as Benozzo Gozzoli's great fresco cycle in the choir of St Augustine's Church in San Gimignano, and the magnificent Arca di S. Agostino, which contains the saint's tomb in the Church of S. Pietro in Ciel d'Oro, in Pavia, one of the greatest monuments of gothic sculpture.

Biography

Aurelius Augustinus was born in 354 in Thagaste, Numidia, North Africa, the son of Patricius and Monnica. He was educated at Madaura and Carthage, and became a teacher of rhetoric, first in Carthage, then in Rome (*c.* 383), and finally Milan, where he came under the

influence of Ambrose, the Christian bishop, and was baptized Easter 387. Soon thereafter, he returned to Africa, to establish a monastic community at Thagaste. Ordained in 391, he became bishop of Hippo in 395/96. He died in 430 at Hippo.

Bibliography

Main texts

Augustine left a vast body of writings, including about 300 letters and 400 sermons, as well as many philosophical and theological treatises. He provided an account of his childhood, youth, and conversion in his *Confessions*, and there is a biography of him by his contemporary, Possidius.

A useful table, with up-to-date information on editions and translations, is provided in Fitzgerald, A. (ed.), *Augustine Through the Ages*, Grand Rapids and Cambridge, William B. Eerdmans, 1999, pp. xxv–il.

Secondary literature

Balthasar, Hans Urs von, *The Glory of the Lord*, vol. II, trans. A. Louth *et al.*, Edinburgh, T. and T. Clark (1984), pp. 95–143.

Beierwaltes, W., '*Aequalitas numerosa*. Zu Augustins Begriff des Schönen', *Wissenschaft und Weisheit* 38 (1975), pp. 140–57. Italian translation by G. Girgenti, in Beierwaltes, *Agostino e il neoplatonismo christiano*, Milan, Vita e Pensiero (1995), pp. 159–86.

Bonner, G., *St. Augustine of Hippo, Life and Controversies*, London, SPCK, 1963.

Dodaro, R. and Lawless, G. (eds), *Augustine and his Critics*, London and New York, Routledge, 2000.

Harrison, C., *Beauty and Revelation in the Thought of St. Augustine*, Oxford, Clarendon Press, 1992.

O'Connell, R.J., *Art and the Christian Intelligence in St. Augustine*, Cambridge, MA, Harvard University Press, 1978.

Starnes, C., *Augustine's Confessions*, Waterloo, Ontario, Wilfred Laurier University Press, 1990.

Stump, Eleonore, and Kretzmann, Norman (eds), *The Cambridge Companion to Augustine,* Cambridge, Cambridge University Press, 1999.

ROBERT CROUSE

ALCUIN (*c.* 735–804) and THEODULF OF ORLÉANS (died 821)

ANGLO-LATIN POET, EDUCATOR AND CLERIC

SPANISH-BORN POET AND THEOLOGIAN

Iconoclasm, the breaking or destruction of religious images, has on two occasions influenced the development of European art: first, at the time of the Carolingian Renaissance (eighth and ninth centuries), and

again at the Reformation. The word is particularly associated, however, with the earlier period, when there occurred what Church historians refer to as the Iconoclastic movement.

This movement began in Byzantium in the early eighth century, and came to an end in the middle of the ninth century. Iconoclasm was never very strong in the Latin west, but it did lead to the appearance of an important work known as the *Libri Carolini* (The Caroline Books), so-called because it was written at the instigation of the Emperor Charlemagne. Authorship of the *Libri Carolini* is disputed. Its contents were almost certainly the fruit of discussions amongst the intellectuals whom Charlemagne had gathered to his court in an effort to revive and sustain the tradition of learning in the west. But the actual text has traditionally been ascribed to Alcuin, who was the leading light among Charlemagne's intellectuals and one of his most trusted advisers. More recent scholarship, however, suggests that it may have been the work of Alcuin's contemporary, Theodulf of Orléans. The jury is still out on this question, which may never be settled satisfactorily.

The Byzantine Empire in the eighth century was a Christian superpower. But many Moslems lived within its territories, just as many Christians lived within the Mohammedan Caliphate in North Africa and the Near East. Mohammedanism forbade the production of religious images, and this may have been one factor in the decision by Emperor Leo III to issue an order, in or around 726, for the removal or destruction of the Christian icons and crucifixes which had been, up to then, objects of veneration throughout the Empire.

The order caused immediate controversy. It was opposed by a number of senior churchmen and civil servants, and also by the monasteries, not to mention ordinary worshippers who were devoted to the icons that adorned their churches. John of Damascene, spokesman for the Patriarch of Jerusalem, wrote no less than three defences of sacred images, and Popes Gregory II and III protested to the Emperor as well.

The Imperial case against religious images can be summed up in three propositions, two theological and one pastoral:

- Representations of Christ are false and misleading, because they are images of His human nature alone. Thus, they artificially separate His divine and human natures, and impose a physical limit upon someone who, as second person of the Trinity, is without limit.
- Representations of saints are false and misleading because saints are now in heaven and so freed from the limitations of the body.
- Veneration of religious images is idolatrous.

As the movement spread it produced a serious ideological split in the Empire between iconophobes, supported by the Imperial side, and iconophiles, supported by churchmen and the monasteries. In the Latin west the Papacy, though not directly affected by the issue, took the side of the iconophiles, and Iconoclasm was condemned by Roman synods in 731 and 769. The controversy turned for a while into a rather unpleasant war against the monasteries, but towards the end of the century it seemed to run out of steam, and at the Second Council of Nicaea (AD 787) the veneration of images was declared to be legitimate provided that it did not become idolatrous. The Council's language was very moderate, and was to provide thereafter the standard defence of religious images: 'The honour given to an image passes over to its subject, and whoever adores an image adores the being depicted by it'.

In the following century Iconoclasm revived for a time under a series of iconophobic Emperors, but it finally ended with a synod held in Constantinople in 843 which declared once and for all in favour of the Council of Nicaea's earlier decision.

The Papacy, it has been said already, came out against Iconoclasm from the beginning. In part, no doubt, this was due to its wish to oppose the Imperial power. But in part, also, pastoral worries about idolatry never had the same force, or perhaps the same necessity, in the Latin west as they had in the east.

None the less, the social and religious disruptions caused by Iconoclasm in the Byzantine Empire were a cause of concern in the west. The great power in the west at that time was the Frankish Kingdom. Under the political and military genius of Charlemagne this expanded over a vast territory, to the point where Charlemagne identified it with the western empire of ancient Rome, and had himself crowned Emperor in 800.

Charlemagne was not in the business of deferring to either Popes or Councils, and he was not disposed to become an iconophile just because the Pope and the Council of Nicaea said so. In fact, after receiving from Rome a very faulty translation (from Greek to Latin) of the relevant Nicene Council documents he became disposed to iconophobia, and he called upon his circle of theologians and scholars to compose a work setting out objections to the veneration of images. The result was the *Libri Carolini*, composed in the period 790–3.

Overall the work is a point by point refutation of the Council of Nicaea's views on the use of images in the Church. Although intellectually astute and well-argued, it is not always comfortable with the sophistication of Greek argument, and it sometimes displays a sort

of naïve ignorance (for instance, it says of the illustrious Gregory of Nyssa that 'his life and preachings are unknown to us'). When the *Libri Carolini* was rediscovered in the sixteenth century it was often used by the Reformers as a justification for their own iconoclasm, and it was, as a consequence, put on the Catholic *Index* of prohibited books for some centuries.

Its overall conclusion, however, was in fact quite a moderate one which avoided the excesses of both iconophilia and iconophobia. Its attitude to religious art was that of Pope Gregory the Great (reigned 590–604), who is referred to in the last paragraph of the work, and who had pointed out that pictures are an instrument of learning for people who cannot read. Pictures, Gregory had said, should not be worshipped, but they could and should be employed for the purposes of instruction. Implicit in this, and explicit in the *Libri Carolini*, is the view that writing is superior to pictures. The superiority, however, hinges on the fact that the fullest knowledge of the truths of the faith must be acquired from Scripture. To put it in contemporary language: the propositional content of Scripture cannot be articulated completely in pictorial form. Pictures can represent Biblical people and events, but not, for instance, the commandments or the beatitudes. They can *illustrate* them, but cannot *state* them; only language can do that.

Pictures, none the less, were recognized to be important elements in human culture and experience. The Carolingian intellectuals noted that pictures could express either truth or falsehood. Used rightly, they could record events such as the life of Christ or the lives of the saints, and so communicate some knowledge of these events to persons who could not or did not read.

They found it ludicrous, however, that anyone should think of worshipping a picture. They constructed what is now called a thought experiment, in which they imagined an iconophile being shown two pictures of women, and told that one is a picture of God's mother and the other a picture of the goddess Venus:

> He turned to the painter and asked him which was the picture of Mary and which of Venus — for they were alike in every way. The painter gave to one picture the title *Mary,* and to the other he gave the title *Venus. Mary* was elevated, honoured and kissed, but *Venus* was maligned, insulted and execrated. Yet both pictures were alike in shape, colour and material. The only difference was the title.

The point is well made: venerating a picture rests upon a confusion about how pictures represent their objects. To adopt Monroe Beardsley's terminology, a picture may *depict* a woman and *portray* Mary the mother of Jesus; or it may *depict* a woman (the very same woman) and *portray* the goddess Venus. But if we want to verify whether or not the portrayal is 'true' – is an actual likeness of the original – we can do so only by comparing it with the person, and this is not possible either in the case of the divine mother or the Roman goddess. Without such verification, all we have is a title, which can be bestowed at the artist's whim, or indeed at anyone's whim. And even if *per impossibile* we could verify that it was a 'true' portrayal of Mary it could very well be identical with a picture of Venus in both its depictive character and its material properties.

There is a difficult question here about the nature of representation. For there is a fundamental difference between the truth conditions for depictions and those for portrayals. One kind of verification is required to show that a picture by Holbein is a picture of a man, and quite a different kind of verification to show that it is a picture of Henry VIII. The *Libri Carolini* did not, of course, pursue this line of inquiry, but it is quite clear that its author(s) were aware of the problem, and aware of its implications for religious worship.

The *Libri Carolini* also considered the aesthetic value of pictures. Some pictures, it noted, are more beautiful than others, and are therefore valued more highly than others. But if people should venerate the more beautiful rather than the less beautiful they are guilty of mistaking aesthetic for religious fervour. And if they venerate the less beautiful this is somehow 'unjust' (*injustum est*). This argument is not without difficulty, but the main point is that pictures should not be 'adored'. Their value lies partly in their beauty, which is appropriate for the adornment of churches, and partly in their commemorative and educational role in recording the events of Scripture. Religious images should not, therefore, be broken or destroyed.

The Carolingian view of religious pictorial art can be summed up as follows:

- Pictures are inferior to language as a method of articulating and communicating the truths of religion, but they are valuable for the instruction of the unlettered.
- Pictures are also useful as a way of illustrating and commemorating significant events in Scripture and the lives of the saints.
- Pictures adorn and beautify the House of God.
- Pictures should not be adored, but they are honourable and

acceptable because they help in calling to mind the truths of religion. Therefore they should not be destroyed.

Europe, both east and west, was strongly influenced in many ways over many centuries by a highly sophisticated Arab culture; and, if Mohammedanism had not forbidden religious images, it is intriguing to speculate how differently European visual art, inspired by Moslem examples, might have developed. And if Iconoclasm had taken permanent hold either in the whole of Europe or even in the east alone, European art would have developed very differently also. In Byzantium, it should be remembered, only religious images were forbidden: the Emperor Constantine V encouraged artists to paint secular images, presumably in the hope that this might induce people to forget about the religious icons to which they were so devoted. If he had succeeded, the pictorial genius of Byzantium would certainly have altered course, and so altered in turn the course followed by pictorial genius in the west.

As it was, the western Church was to remain the principal patron of the visual arts until the Reformation, and it was therefore an art that was not only deeply religious in theme, style and iconology, but also an art that developed for the most part independently of eastern Europe and the Moslem world. We can therefore see in retrospect that the *Libri Carolini* helped to define the role and character of art in western Europe for almost eight centuries.

Biography

Alcuin was born *c.* 735 in Northumbria, of Saxon stock (his Saxon name was Ealhwine), and educated in York. He met Charlemagne in Parma, and was invited to join the circle of scholars, educators and theologians which, Charlemagne hoped, would inspire a revival of classical order and learning in the west. Thereafter Alcuin became one of its leading figures, and wrote books on grammar, rhetoric, dialectic and even orthography. He also wrote commentaries on the Bible and helped to reform the Liturgy. He retired to the Abbey of St Martin at Tours in 796. He died in 804 at Tours.

Theodulf of Orléans was born in Spain (date unknown) and educated there. As his name suggests he was of Visigothic parentage. He joined Charlemagne's circle of scholars and intellectuals and became Archbishop of Orléans in 800. A distinguished poet and connoisseur of art, and knowledgeable about classical literature, he has

also been credited with writing the text of the *Libri Carolini* and producing a revised version of the Vulgate text of the Bible, both of which are attributed by other scholars to Alcuin. He died in 821.

Bibliography

Main texts

Libri Carolini, in J.-P. Migne (ed.), *Patrologiae Cursus Completus. Series Latina*, 222 vols, Paris, 1844–90 (vol. 98, cols 941–1248).

Libri Carolini sive Caroli Magni Capitulare de Imaginibus, Hubert Bastgen (ed.), *Monumenta Germaniae Historica, Legum Sectio III, Concilia Tomi II Supplementum*, Hanover and Leipzig, 1924.

Secondary literature

De Bruyne, Edgar, *Études d'esthétique médiévale*, 3 vols, Bruges, De Tempel (1946), vol. I, pp. 261–74.

—— *The Aesthetics of the Middle Ages* (*L'esthétique du moyen age*), trans. Eileen B. Hennessy, New York, Frederick Ungar, 1969.

Eco, Umberto, *Art and Beauty in the Middle Ages* (*Sviluppo dell'estetica medievale*), trans. Hugh Bredin, New Haven and London, Yale University Press, 1986.

Freeman, Ann, 'Theodulf of Orléans and the Libri Carolini', *Speculum* 32 (1957), pp. 663–705.

Tatarkiewicz, Wladyslaw, *History of Aesthetics*, 3 vols, The Hague and Paris, Mouton (1970–4), vol. II, pp. 91–106.

HUGH BREDIN

SUGER (1081–1151) and BERNARD OF CLAIRVAUX (1090–1153)

FRENCH PRELATE AND STATESMAN

FRENCH CHURCHMAN

Historians of ideas talk of two 'Renaissances' during the medieval period: a Carolingian Renaissance (eighth to ninth centuries) and a twelfth-century Renaissance. The latter was, in fact, an immensely creative period in western Europe: it witnessed a flourishing of the Schools that were shortly to develop into universities; a speeding up in the recovery and translation of classical texts; the beginnings of a division between philosophy and theology, and a powerful impetus towards the systematization of all knowledge.

However, European culture had not been static during the previous two centuries. In AD 910 a Benedictine monastery was founded at

Cluny, in Burgundy, which had far-reaching effects upon the development of learning and the arts. Under a series of remarkable Abbots its ideals spread across western Europe, even as far as Poland and Scotland, in a loose confederation of monastic houses – over a thousand at its peak – constituting a so-called 'Cluniac order' (*ordo cluniacensis*).

One important consequence of the Cluniac movement was the large-scale building of new churches, in the Romanesque style, all over Europe. It also encouraged the practice of adorning churches with sculptures, stained glass, elaborate chalices, vestments, crucifixes, woodwork and stonework. Churches – the main public buildings in early medieval Europe – were also centres for the display of its artistic genius.

The effects of the Cluniac movement were felt throughout the tenth and particularly the eleventh centuries. But so far as art theory and aesthetics are concerned, it was the twelfth century that produced the most interesting developments. In the history of aesthetics it is customary to mention three important twelfth-century schools: the Victorines, the School of Chartres, and the Cistercians.

Details of the aesthetic theories associated with these three schools do not concern us here. However, they flourished at the same time as a dramatic new development in the visual arts: the appearance of what is now called 'Gothic' architecture. The Cathedral of Chartres was one of the earliest of the great Gothic structures, and the Cistercians were responsible for spreading the Gothic aesthetic across the face of Europe.

One of the most obvious differences between Romanesque and Gothic is the use in Gothic of external buttresses to support the immense weight of the walls and roof. In Romanesque churches this weight is supported by heavy internal masonry. In Gothic churches buttressing allowed the internal masonry to become tall and thin, with large spaces in between which were filled with stained glass. Gothic interiors were therefore awash with light and colour. Artworks within Gothic churches developed to take advantage of the light, for instance by working in ivory and gold, and using naturalistic lines in sculpture and ornament that could now be seen clearly.

The twelfth century was therefore a period of great architectural and artistic innovation. But not everyone was pleased with this, and voices were raised against, in particular, the rich and elaborate adornment of churches. Peter Cantor (d. 1197), a professor at the Cathedral School at Paris, was even opposed to large churches. Their builders, he wrote, 'resemble those giants who built the tower of

Babel, rearing themselves up against the Lord'. This sentiment was quite at odds with common sentiment at the time, for whole populations would devote themselves over decades or even centuries to the building of a church, an enterprise that involved both religious devotion and civic pride.

However, building a church was one thing and adorning its interior was another. The original Cistercian aesthetic was based upon an unadorned purity of line, figure, and volume, with a limited use even of stained glass. The aesthetic did not survive for long the overwhelming medieval desire for rich and elaborate ornamentation, but it did have a formidable spokesman in St Bernard of Clairvaux.

Bernard, one of the most able and influential churchmen of the century, was austere both in his spiritual life and his aesthetic sensitivities. He was passionately opposed to the Cluniac love of elaborate church decoration, and expounded his views in his celebrated *Apologia ad Guillelmum*, a letter to William, Bishop of St Thierry, written about 1125.

The *Apologia* commences with a criticism of monks who are too fond of food, drink and luxury. But it soon passes on to church art and architecture, and it is here that he writes most vividly and forcefully:

> I say naught of the vast height of your churches, their immoderate length, their superfluous breadth, the costly polishings, the curious carvings and paintings which attract the worshipper's gaze and hinder his attention.

One of Bernard's objections to rich and costly ornament was his suspicion that it was intended to attract donations to the church. 'At the sight of these costly yet marvellous vanities', he writes, 'men are more kindled to offer gifts than to pray'. Later in the *Apologia* he concedes, somewhat grudgingly, that people whom he calls 'simple and devout' may benefit from their desire to beautify the House of God. But what need have monks, he asks, for such vanities within their private cloisters.

> What profit is there in those ridiculous monsters, in that marvellous and deformed comeliness, that comely deformity? To what purpose are those unclean apes, those fierce lions, those monstrous centaurs, those half-men, those striped tigers, those fighting knights, those hunters winding their horns? Many bodies are there seen under one head, or again, many heads to a single body. Here is a four-footed beast with a

serpent's tail; there, a fish with a beast's head. Here again the forepart of a horse trails half a goat behind it, or a horned beast bears the hinder quarters of a horse. In short, so many and so marvellous are the varieties of divers shapes on every hand, that we are more tempted to read in the marble than in our books, and to spend the whole day wondering at these things rather than in meditating the law of God. For God's sake, if men are not ashamed of these follies, why at least do they not shrink from the expense?

If we examine Bernard's views with some care we can abstract the following points:

- Lavish ornamentation in churches distracts the faithful from prayer.
- It is also inappropriate for monks who should lead austere and simple lives.
- In addition, it is extremely costly, and the money should be spent instead upon the poor: 'The church is resplendent in her walls', he writes, 'beggarly in her poor; she clothes her stones in gold, and leaves her sons naked'.

To these we may add:

- Bernard's personal aesthetic sensibility favoured clear and simple artefacts with a minimum of representation.

Bernard's aesthetic, and the Cistercian aesthetic in general, stood at one pole of the twelfth-century aesthetic sensibility. The other pole was spectacularly represented by another twelfth-century figure: Suger, Abbot of Saint-Denis.

The Abbey of Saint-Denis, on the outskirts of Paris, had at that time a special relationship with the French monarchy – several Frankish kings were buried there – and has the distinction of being the first foundation to possess a Gothic church. It was actually an older church, which was enlarged and remodelled along Gothic lines by Suger, Abbot from 1122 until his death in 1151.

Suger, himself a very able and influential churchman, embarked upon the rebuilding programme in 1135. Unusually for a medieval patron of the arts, he also wrote a detailed account of the rebuilding and of the artworks commissioned for the church interior. In fact he

wrote two accounts, *De rebus in administratione sua gestis* and *Libellus alter de consecratione ecclesiae sancti dionysii*. Together they provide a remarkable insight into an aspect of twelfth-century aesthetic taste quite different from that of St Bernard. Both have been brought to a modern readership by Erwin Panofsky, who edited the texts and translated them into English.

There is a considerable overlap in content between the two works, so if we take them together we can abstract Suger's artistic credo as follows.

First, Suger was conscious that art changes and develops, and is subject to cross-cultural influences. He remarked that a mosaic was positioned in a manner that was 'contrary to modern custom', and he said of a panel distinguished by its sumptuousness that '[its] barbarian artists are even more lavish than ours' (in this case 'barbarian' meant non-French). Second, Suger referred more than once to the necessity of reconciling the old (Romanesque) structure with the new. The aesthetic value of harmony – a value inherited from the ancient world and also ratified by Scripture – was deeply embedded in medieval culture.

Suger was typically medieval in another way. For it was important, in his view, that his remodelled church, and the artworks that embellished it, should incorporate and communicate the truths of faith. The windows told stories from Scripture. The precious materials brought to life a passage from *Ezekiel*: ('Every precious stone was thy covering, the sardius, the topaz, and the jasper, the chrysolite, and the onyx, and the beryl, the sapphire, and the carbuncle, and the emerald.') The number of columns in the church represented the twelve apostles. The church and its contents, in short, were intended to be a kind of visual and spatial analogue of the spiritual church.

He was concerned in particular to defend the use of rich materials. This was, in any case, something that appealed to the medieval aesthetic sensibility. But Suger also justified it, partly by reference to passages in Scripture such as *Ezekiel*, and partly by asserting that it was appropriate for the worship of God. 'To me ... one thing has always seemed pre-eminently fitting', he wrote, 'that every costlier or costliest thing should serve, first and foremost, for the administration of the Holy Eucharist'. He also stressed that the craftsmanship used in fashioning the rich materials was itself a pointer to the Divine. The nobility of the work shone out, as it were, in a way that brightened the mind and so led it to the true Light of Christ. In the same way, the light that poured through the windows pervaded the interior beauty of the church and reminded us of the Light of the World.

This association between the experience of art and the experience of the Divine was characteristic of the twelfth century. It was connected with the philosophical thesis that reason is both human and divine, and unites man and God in a 'single, delightful concordance of one superior, well-tempered harmony'. There was no leap of faith across an otherwise unbridgeable gulf, but a smooth progression from the material and corporeal to the immaterial and spiritual.

This is what underlies one of the most famous passages in Suger, in which he describes how the experience of art conducts him to a state of mystical ecstasy:

> Thus when – out of my delight in the beauty of the house of God – the loveliness of the many-coloured gems has called me away from external cares, and worthy meditation has induced me to reflect, transferring that which is material to that which is immaterial, on the diversity of the sacred virtues: then it seems to me that I see myself dwelling, as it were, in some strange region of the universe which neither exists entirely in the slime of the earth nor entirely in the purity of heaven; and that, by the grace of God, I can be transported from this inferior to that higher world in an anagogical manner.

The contrast between Bernard of Clairvaux's puritanical aesthetic and the rococo exuberance of Suger carries with it many cultural echoes: iconophobe and iconophile, Renaissance and Baroque, classical and romantic. Suger was more representative than Bernard of the taste of the common man, and his Gothic restructuring of the church at Saint-Denis pointed to the future. On the level of art theory, however, it was a sort of last hurrah. For in the following century the great Scholastic philosophers, such as **Aquinas** and Bonaventure, concentrated almost entirely on the metaphysics of beauty, and reflection upon art became, for a time, comparatively impoverished.

Biographies

Suger was born in 1081 in Argenteuil, France. As Abbot of Saint-Denis he was a friend and adviser of Louis VI and Louis VII; Regent of France from 1147–9 while Louis VII was away on the Second Crusade. He was a notable statesman, administrator, and patron of the arts, who introduced Gothic art and architecture to western Europe. He died in 1151 in Saint-Denis.

Bernard of Clairvaux was born in 1090 in Dijon, France. He founded a Cistercian community at Clairvaux, which, because of Bernard's eminence, became an important source of Cistercian influence. Despite the austerity and simplicity of his personal life he became the most influential churchman of the century: a leading theologian, an adviser to popes, a preacher for the Second Crusade and an opponent of the philosopher Abelard. By all accounts he had great personal charm but was strong and forthright in his opinions. He died in 1153 at Clairvaux.

Bibliography

Main texts

Bernard of Clairvaux, *Apologia ad Guillelmum*, in J.-P. Migne (ed.), *Patrologiae Cursus Completus, Series Latina*, 222 vols, Paris, 1844–90 (vol. 182, cols 895–918). Partial English translation in G.G. Coulton, *Life in the Middle Ages*, 4 vols, Cambridge, Cambridge University Press, 1929–30 (vol. IV, pp. 169–74).
Panofsky, Erwin, *Abbot Suger on the Abbey Church of St.-Denis and its Art Treasures*, Princeton, Princeton University Press, 1946 (Latin text with an English translation of Suger's writings).

Secondary literature

De Bruyne, Edgar, *Études d'esthétique médiévale*, 3 vols, Bruges, De Tempel (1946), vol. II, pp.135–45.
—— *The Aesthetics of the Middle Ages* (*L'esthétique du Moyen Age*), trans. Eileen B. Hennessy, New York, Frederick Ungar, 1969.
Eco, Umberto, *Art and Beauty in the Middle Ages* (*Sviluppo dell'estetica Medievale*), trans. Hugh Bredin, New Haven and London, Yale University Press, 1986.
Simson, O. von, *The Gothic Cathedral*, New York, Pantheon, 1962.
Tatarkiewicz, Wladyslaw, *History of Aesthetics*, 3 vols, The Hague and Paris, Mouton (1970–4), vol. II, pp. 144–51 and 183–90.

HUGH BREDIN

THOMAS AQUINAS (1225–74)

ITALIAN THEOLOGIAN AND PHILOSOPHER

Scholastic philosophy flourished in the thirteenth and fourteenth centuries. It has undergone revivals since then, notably in the sixteenth and seventeenth centuries, and again in the late nineteenth and twentieth centuries. But it originated in the high medieval period, and is so called because it emerged in the 'Schools' that were by then well

established in the major political and administrative centres of the time. By the twelfth century these Schools had advanced far beyond the provision of basic education to become the intellectual power-houses of the age. They were, in fact, the first universities, and many of the great European universities – Paris, Oxford, Bologna – were founded in medieval times.

Scholastic philosophy attempted, for the first time since the demise of the classical world, to construct a complete and systematic account of God, man, and nature (not wholly unlike the theoretical physicist's quest for a unified theory of everything). In pursuit of this, and in order to clarify its own foundations, it distinguished clearly between philosophy (founded on reason) and theology (founded on faith) – thus bringing about the survival of philosophy as a distinctive intellectual discipline that is taught in universities to this day.

Scholastic philosophy was also influenced by **Aristotle**. Hitherto, Platonism in its various forms had provided the intellectual framework for advanced thought in western Europe. Now, as a result of contacts with the Arab world, Aristotle joined the canon, and many of his works were translated for the first time into reliable Latin versions by William of Moerbeke. Thomas Aquinas referred to Aristotle simply as *philosophus* – 'the philosopher'.

Unfortunately, the Scholastic philosophy of art produced little or nothing that was original. One cannot help wondering how different it might have been if the Scholastics had read and assimilated Aristotle's *Poetics*. It is hard to say why they did not. An abridged version of the *Poetics* was available for most of the thirteenth century, and William of Moerbeke produced a complete translation in 1278. Yet the work was ignored, not only by Scholastic thinkers, but also by people such as Dante and Boccaccio, and continued to be ignored right through the *quattrocento*.

Perhaps the biggest obstacle to a distinctive Scholastic theory of art was that its main interest in aesthetic problems concerned the nature of beauty, not of art. One of the best known passages in Aquinas – best known not only to scholars, but also because it was exploited by James Joyce in his *Portrait of the Artist as a Young Man* – states that three conditions are necessary for beauty: integrity, proportion, and clarity (*Summa Theologiae*, I, 39, 8c). A full exposition of these terms would require a lengthy exploration of Aquinas's metaphysics. But we can say at least that 'integrity' refers to the degree of ontological completeness or perfection of a thing; 'proportion' refers to the structural relations within a thing which produce and sustain that ontological complete-ness; and 'clarity' refers to the knowability of a thing, its resonance

with the structure and capabilities of the human mind, so that its integrity and proportion are accessible to human perception and understanding.

Ultimately all three conditions enable the beauty of things to be *knowable*. Beauty for Aquinas was an objective attribute of the created world, and was experienced by means of the cognitive powers of the human mind. Beauty was, in particular, the object of 'apprehension' (*apprehensio*), meaning the initial grasp of natures or essences by the mind when it confronts and assimilates the world around it. If my mind grasps a nature or essence that is complete (integrity), properly structured (proportion) and clearly evident (clarity), then I experience pleasure because my mind has achieved cognitive possession of something whole and well formed and vividly present.

The cognitive character of the aesthetic is also apparent in Aquinas's remarks about the arts. He defined art as *recta ratio factibilium* – that is, a correct understanding of making things. 'Art' for Aquinas, as for all of the medievals, was manifested just as much in ploughing and sowing a field as in painting a picture. They made no distinctions among skills, crafts, arts, or manufacturing. They did not have, and indeed had no need or desire to have, a concept of fine art.

This is why Aquinas was content to repeat the view that art imitates nature in its way of working (*ars imitatur naturam in sua operatione*). The 'imitation' referred to in this sentence has nothing to do with representation. It indicates rather that human art is directed by human intelligence and purposes, just as the workings of nature are directed by God's intelligence and purposes. Throughout the whole of the medieval period (roughly 800 to 1400) the first and best artist was God, creator of the richness and beauty of the earth and skies. Human artists were engaged in work analogous to that of God, and used their reason in their work just as God used His. Of course, the works of man were inferior to the works of God – art was inferior to nature. But human artificers were, none the less, engaged in work that was consonant with the divine origin and divine character of the universe in general.

Aquinas was also aware, to some extent, of a special relationship between beauty and art. He wrote, for instance, 'An image is called beautiful if it perfectly represents something, even something ugly' (*Summa Theologiae*, I, 39, 8c). In this passage beauty (integrity, proportion, clarity) is achieved by the representational skill of a painter or sculptor, and it is interesting that Aquinas should take his illustration from the visual arts, rather than the natural world. It should be noted, however, that he more often cited the human body as an example of

material beauty; for in the last analysis God's work was more perfect, more beautiful than the works of humankind.

A less obvious connection between Aquinas's philosophy and the art of his own time arose from his theory of transcendentals. This complex metaphysical doctrine, Aristotelian in its origin, states that everything that exists shares certain attributes with everything else – principally the attributes of unity, truth, goodness, and beauty. These are attributes of being itself, in all of its manifestations, and thus 'transcendental' attributes of being.

The importance of this theory for our purposes here is that it provided a theoretical foundation for a significant aspect of the medieval aesthetic sensibility – namely, a belief in the universal analogy of all things. This sensibility had existed for centuries before Aquinas, and it survived for centuries after him, but the theory of transcendentals gave it a new type of philosophical legitimation for the deep analogies of being rooted in the transcendentals justified the medieval instinct for taking any object as a symbol, icon or emblem of anything else.

In such a perspective, there is nothing strange in finding or asserting an analogy between a plant and a virtue, a bird and a saint, a colour and an emotion. Hence, there arose throughout the medieval period an extensive repertoire of visual symbols in its painting, sculpture, manuscript illuminations and stained glass. The dove stood for Noah, for peace, for the Holy Ghost, and for the Purification. The lamb stood for Christ, and for St Agnes. The thistle stood for earthly sorrow, the vine for the Church. St Peter was represented holding keys or a fish; St Paul with a sword or a scroll of his epistles. It was a very extensive iconography indeed, which gave symbolic meanings to every kind of creature, to earth and sky (clouds symbolized the unseen God), to artifacts, colours, letters, numbers, modes of dress, shapes, and just about anything that could be represented visually.

We do not know whether Aquinas himself would have considered his theory of transcendentals to be closely connected with the visual arts. But with hindsight, we can see that the visual semantic and the philosophical theory were entirely complementary with one another, that they were rooted in a common sensibility and culture. It is here, not in his explicit remarks about art that we find Aquinas to be most closely implicated with the artistic semiotics of his time.

It is also a useful reminder that this visual iconology – which survived in much of the Christian art of the Renaissance also – cannot be discounted or ignored. If we try to experience medieval art without knowing its language, we miss one of its essential features, and

fail to make complete imaginative contact with the culture that produced it.

Biography

Thomas Aquinas was born in 1225 in Roccasecca, Italy. He was educated at Monte Cassino, Naples, Paris and Cologne. In 1244 he joined the Dominican Order. He lectured in the University of Paris from 1252–6, and was then appointed to a Chair of Theology, which he held from 1256–9. Returning to Italy, he taught for almost a decade at various Dominican houses of study. During this period he wrote his *Summa Contra Gentiles* and began the *Summa Theologiae*. His second Paris professorship was from 1269–72, where he was involved in controversies concerning Aristotle and Averroes. He returned to Naples in 1272 and died in 1274 at Fossanuova.

Bibliography

Main texts

Thomas Aquinas, *Summa Theologiae,* Blackfriars edition and translation, 60 vols, London, Eyre & Spottiswoode and New York, McGraw-Hill, 1964–76.

Secondary literature

Bredin, Hugh and Santoro-Brienza, Liberato, *Philosophies of Art and Beauty,* Edinburgh, Edinburgh University Press, 2000.
De Bruyne, Edgar, *Études d'esthétique médiévale,* 3 vols, Bruges, De Tempel, 1946 (vol. III, pp. 278–346).
Eco, Umberto, *The Aesthetics of Thomas Aquinas* (*Il problema estetico in Tommaso d'Aquino*), trans. Hugh Bredin, Cambridge, MA, Harvard University Press, 1988.
Ferguson, George, *Signs and Symbols in Christian Art,* New York, Galaxy Books, 1966.
Grabar, André, *Christian Iconography,* London, Routledge & Kegan Paul, 1969.
Tatarkiewicz, Wladyslaw, *History of Aesthetics,* 3 vols, The Hague and Paris, Mouton, 1970–4 (vol II, pp. 245–63).

HUGH BREDIN

CENNINO CENNINI (c. 1360 – before 1427)

ITALIAN ARTIST AND WRITER

Cennino Cennini's father, Andrea, probably a local painter in the small hill town of Colle di Val d'Elsa, inspired in Cennino a feeling

for the materials of his craft. However, the early formative influence on him was Agnolo Gaddi, in whose Florentine workshop he enrolled. Agnolo was the leading heir, through his father Taddeo, to the tradition of Giotto. Cennino remained there for twelve years. In 1388 he took an independent commission in his native Tuscany, but, by around 1391, he was in Padua, becoming, in 1398, the painter and 'familiaris' to the then ruler of Padua, Francesco Novello da Carrara. Attempts have been made to ascribe works for him, but none, securely documented, exist. What does, however, is a book, known in Italian as the *Libro dell'arte* (Book of the Art) – that is, painting – though life-casting as an aid to drawing is mentioned. It exists in very few manuscripts, none autograph. The earliest is dated 1437.

This brief résumé of Cennino's career provides an idea of the experiences which shaped the *Libro*. From this background he became aware, on the one hand, of the physical aspects of painting – the preparation of pigments, the application of paint etc., in other words the stock-in-trade of the painter's workshop – and, on the other, of the theoretical side to the art, for, in Florence, Giotto's achievement had been compared favourably with that of men of letters – whose art, rhetoric in particular, was considered to be based, not on practice alone, but on intellectual principles and rules. This view was given further encouragement in Padua at the Carrara court. In the *Libro* he attempts to bring these two attitudes together so that the apprentice, to whom the book is ostensibly addressed, might combine, as he says, 'skill of hand' with 'theory' (*scienzia*) in producing his works. Though limited when looked at in the light of later, more sophisticated, contributions, the *Libro dell'arte* stands as the first surviving attempt to do this. It also stands at a seminal period in attitudes to the status of painting, which was gradually consolidating the higher intellectual-standing it had achieved through Giotto, to be counted among the Liberal rather than the Mechanical Arts.

The practical advice and instruction should be taken first. This is particularly important for both the historian and the conservator, for it is the clearest and, from practical demonstration, the most accurate, account we have of such methods as the preparation of grounds, the techniques of silverpoint, pen and charcoal drawing, for fresco painting from the initial drawing (*sinopia*) on the rough plaster (*arriccio*) to the drawing on the finished plaster (*intonaco*), to the final painting, and for tempera painting on a meticulously prepared panel. This instruction, reflecting best workshop practice, is developmental, proceeding from stage to stage, culminating in the painting of panels,

which Cennino says, foreshadowing Leonardo later, is a 'gentleman's job, for you may do anything you want to do with velvets on your back'. These procedures are augmented by practical guidance on making individual colours from the basic pigments, and by instruction on applying and punching gold-leaf – an important embellishment to painting at the time. Cennino enlivens his instruction with disarming tips, such as, that the making of ultramarine from *lapis lazuli* 'is an occupation for pretty girls rather than for men; for they are always at home, and reliable, and they have more dainty hands'. He also shows knowledge of non-Italian practice, particularly when describing the use of oil as a mordant for colours, on both panels and walls, to which, he says, the '*tedeschi*' (probably northerners in general) are much given. This statement, made many years before Jan van Eyck, suggests that he knew the *De diversis artibus* (Of divers arts) of the twelfth-century German monk, Theophilus – a practical manual to which the *Libro* has affinities in both conception and form.

Apart from such practical information, Cennino also describes procedural methods which fluctuate between practice and theory, such as his advice on creating space in pictures, which, though basically rule-of-thumb, anticipates the more thorough-going explorations of 'pictorial perspective' pursued by later theorists and practitioners, such as **Alberti** and **Leonardo da Vinci**. Similarly, with proportion, Cennino attached great importance to consistency, say, in the relationship of buildings to figures so that the painter should compose his pictures to look as natural as possible. Here two assumptions combine: first, that painting should be tested against the judgement of the eye, and, second, that the painter should carefully compose his picture against its effect on the onlooker. It is difficult to say exactly where Cennino found such ideas. His Giottesque training may have been sufficient as these were admired aspects of Giotto's work. However, it is possible, that he also knew a written tradition. His proportions of the human figure suggest this for, on the one hand, he seems to be following medieval Byzantine practice, whereas, on the other, he seems to reflect Vitruvius, particularly when he says, 'a man is as long as his arms crosswise'. Certainly Giotto in his crucifixes provided a practical example, but the fact that Cennino elsewhere advocates the use of a module to control the relationships within the picture does suggest knowledge, either direct or indirect, of a particularly Vitruvian precept.

Further to these quasi-theoretical views, Cennino also demonstrates a knowledge, if somewhat schematic, of more sophisticated

ideas of painting's status vis-à-vis the Liberal Arts. At the opening of the *Libro* he says:

> justly it [painting] deserves to be enthroned next to theory, and to be crowned with poetry. The rationale lies in this: that the poet, with his theory ... is free to compose and bind together, or not, as he pleases, according to his will [*voluntà*]. In the same way the painter is given freedom to compose a figure, standing, seated, half-man, half-horse as he pleases according to his imagination [*fantasia*].

The basic source for this idea, signalled by the phrase 'half-man, half-horse', is the *Ars poetica* of the Roman writer, Horace (first century BC), whose axiom *ut pictura poesis* ('as in painting, so in poetry') became a touchstone for subsequent discussions of the arts in Renaissance literature. However, for Horace, such hybrid figments of the imagination are to be ridiculed rather than approved. Cennino, who, so far as we know, had no literary training, probably did not read Horace, but the idea that poetry and painting stemmed from a common creative impulse, namely, the imagination (*fantasia*) was long established by his time. Interestingly, Cennino modifies this view making the poet's will (*voluntà*) the significant creative factor as against the *fantasia*, which he reserves for the painter. This change may reflect the distinction made by Filippo Villani, writing in Florence in the early 1380s, when commenting on Giotto, that the masters of the Liberal Arts, 'learn by means of study [i.e. reading] and instruction rules of their arts, while painters derive such rules as they find in their art from a profound natural talent and a tenacious memory'. Memory was one of the main faculties of the mind in medieval epistemology. It was fed in particular by the *fantasia*, where visual images were received and retained. Thus, *fantasia* and memory allow the artist to create, from the manifold images he has learned to record, new ones proper to his visual discipline.

In the preceding passage Cennino had said that painting 'calls for imagination [*fantasia*] and skill of hand, in order to discover things not seen, hiding themselves under the shadow of natural objects, and to fix them with the hand, presenting to plain sight what does not actually exist'. Cennino amplifies this idea of *fantasia*, as the creative guiding force behind the painter's hand later on, when explaining the best method of learning to draw. The apprentice should select the best master to follow and then copy his work, day by day, so that,

it will be against nature if you do not get some grasp of his style [*maniera*] and his spirit [*aria*] ... Then you will find, if nature has granted you any *fantasia* at all, that you will eventually acquire a style individual to yourself, and it cannot help being good; because your hand and your mind, being always accustomed to gather flowers, would ill know how to pluck thorns.

The apprentice should not follow different masters, as this would dissipate his *fantasia*, which is the innate quality he must possess if his hand and mind (*intelletto*) are to work together in a single creative process. Although Cennino identifies both drawing (*disegno*) and the application of colours (*colorire*) as the principle parts of painting, it is drawing that engages the intellect at the deepest level, for once the apprentice has gained some feeling for drawing as described, the true test is the natural world which, he says, is the 'most perfect steersman ... and best helm' in all his endeavours for it guides the power to see and act through 'the light of the sun, the light of your eye, and your own hand'. This symbiotic relationship is revealed by the way light falls on objects, so that the correct distribution of light and shade (*chiaro e scuro*), is the true demonstration of mastery and judgement, for, without it, a drawing or a painting would seem but a simple thing lacking the dimension (*rilievo*) of the natural world. The painter who achieves such mastery is no longer confined to precedent and formulae, but free to imagine new forms of things, to demonstrate his own vision both as a craftsman and as an intelligent being – his personal spirit, or *aria* – so as to present 'to plain sight what does not actually exist'. How far Cennino understood by this statement anything more than the illusion of three dimensions on a two-dimensional surface is open to question. But he would have known that Giotto's mastery of this had earned him the reputation as the first of the moderns to appeal to the intellect rather than to the eye alone and, brought up in this tradition, he probably accepted this as the painter's ultimate goal.

Why did Cennino write his book and where and when did he write it? He is conscious that painting is an evolving process. Giotto 'transformed the art of painting from Greek [Byzantine] into Latin [Italian] and made it modern [*moderno*]'. Agnolo Gaddi, his own master, improved on this to paint in a more engaging and fresh manner. Although deprecating of his own talent, he saw himself as

heir to a tradition and yet looking to the future. The book has an air of mature reflection about it, which would hardly sort well with his early Florentine years, so it is more likely to have been written in Padua. After all, Giotto's works could be seen there, and his tradition had been carried on by Giusto de'Menabuoi, a Florentine, who had been painter at the Carrarese court prior to Cennino's arrival. The indigenous Paduan tradition, though owing something to Giotto, tended towards elaboration and ornament. Perhaps, Cennino, as an incoming Florentine, was asked – even challenged – to explain what it was about Giotto's legacy, as witnessed, say, by Petrarch, who had strong connections with Padua, that set it apart. Cennino's emphasis on the good practice he had learnt might suggest this, so the book might have been of interest – perhaps of practical use – to local painters. However, a more ambitious purpose has been argued: that it was written for the Paduan court itself in emulation of humanist tracts written to secure preferment. The echoes of classical authors, and the similarity which has been noted between Cennino's idea of imitating the best master's drawing style and classical theories of imitation in rhetoric and poetry, certainly alive in Paduan at the time, might suggest this. Otherwise, the use of Paduan dialect in the text and the dedication, in part, to St Anthony of Padua, further argues its Paduan origin, and, therefore, a date around 1400 when we know Cennino was there.

Cennino Cennini's writing on art is significant for it comes at the end of the medieval tradition of books on technique and presages the systematic development of a 'poetics' for painting, particularly in Florence, which culminates in the sixteenth century. The term *disegno*, and the emphasis placed on drawing, finds its definitive statement 150 years later in **Vasari**. Other terms, however elusive, give evidence of a developing vocabulary for art in both workshop and literary culture. Such terms as, *maniera*, *aria*, *rilievo* – particularly in the form of *chiaroscuro* – and *sfumare* – for the smoky blending of shading. However, the most significant concept is that of artistic *fantasia*, which, in Cennino's usage, embraces more than superficial imagination. It signifies an inner intellectual commitment which informs and can be discerned in the individual painter's work. It is more than the painter's hand and derives from his whole person, his moral as well as his artistic demeanour. By the sixteenth century, via Leonardo, the idea that every painter paints himself became a commonplace in artistic theory. This idea can be found in embryonic form in Cennino's book. However, as so few manuscripts exist, its direct use by later writers is hard to establish for certain.

Biography

Cennino di Andrea Cennini was born *c.* 1360 at Colle di Val d'Elsa, near Siena, the son of Andrea Cennini, probably a local painter. He entered Agnolo Gaddi's workshop in Florence *c.* 1372, where he remained for 12 years. In 1388 he gained an independent commission in Poggibonsi, between Siena and Florence. He moved to Padua *c.* 1391. In August 1398 he is documented as painter and *familiaris* in the court of Francesco Novello da Carrara, Lord of Padua. A signed fresco, now lost, is recorded in 1403 in Colle di Val d'Elsa, where he died before 1427.

Bibliography

Main texts

Modern Italian edition:
Il Libro dell'arte, Serchi, M. (ed.), Florence, Felice le Monnier, 1991.
Translation:
The Craftsman's Handbook: The Italian 'Il libro dell'arte', trans. Daniel V. Thompson, Jr., New York, Dover Publications, 1960.

Secondary literature

Barasch, M., *Light and Colour in the Italian Renaissance Theory of Art*, New York, New York University Press, 1978.

Bolland, A., 'Art and Humanism in early Renaissance Padua: Cennini, Vergerio and Petrarch on Imitation', *Renaissance Quarterly*, vol. 49 (1996), pp. 469–87.

Bomford, D. *et al.*, *Art in the Making: Italian Painting before 1400*, London, National Gallery, 1989.

Boskovitz, M., 'Cennino Cennini: pittore nonconformista', *Mitteilungen des Kunsthistorischen Institutes in Florenz*, XVII (1973), pp. 29–50.

Chastel, A., 'Le "sì come gli piace" de Cennino Cennini', *Scritti di storia dell'arte in onore di Ugo Procacci*, Milan, Electra, 1977.

Kemp, M., *Behind the Picture: Art and Evidence in the Italian Renaissance*, New Haven and London, Yale University Press, 1997.

Schlosser, J., *La Letteratura Artistica*, Florence, La Nuova Italia, 1977.

Skaug, E., 'Cenniniana: notes on Cennino Cennini and his treatise', *Arte Cristiana*, 81 (1993), pp. 15–22.

Summers, D., *Michelangelo and the Language of Art*, Princeton, Princeton University Press, 1979.

Venturi, L., 'La critica d'arte alla fine del Trecento: F. Villani e Cennino Cennini', *L'Arte* 28 (1925), pp. 233–44.

ROGER TARR

LORENZO GHIBERTI (1378–1455)

ITALIAN ARTIST AND WRITER

Lorenzo Ghiberti was the leading goldsmith and bronze sculptor in Florence in the first half of the fifteenth century. He is best known for the two sets of bronze doors he made for the Florentine Baptistery, the second of which are known, after a remark by **Michelangelo**, as the 'Gates of Paradise'. He was trained as both a goldsmith and a painter. His workshop was the foremost of his time, training both painters and sculptors including, for example, Uccello and Donatello. Ghiberti's early training as a painter is significant for it underpins his view as to the common basis of both arts in drawing (*disegno*), which, as he says repeatedly in his *Commentarii* (Commentaries), 'is the head and front of both painting and sculpture'.

These *Commentarii*, written in Italian, are his main contribution to the writing on art. The autograph manuscript is now lost. The only surviving copy, known to **Vasari** in the mid-sixteenth century, who used it for his *Lives of the Artists*, has inaccuracies of transcription, and breaks off prematurely. Although the original may have been complete, the third book, which is mainly an amalgam of quotations from various sources, sometimes repeated, suggests revision was needed. The fact that, at the end of the second book, Ghiberti describes the completed Paradise Doors, suggests that he wrote this part after 1447. However, there is some evidence that he had begun working on the whole project as early as 1430. The *Commentarii* are conveniently divided into three books by modern commentators.

The first book is, ostensibly, a history of ancient art taken from the Elder Pliny's *Natural History* (first century AD). This text was known throughout the middle ages, but, nearest to Ghiberti's time, it was used by the Florentine chronicler, Filippo Villani, around 1380, to establish the excellence of the ancient Greek artists, particularly in representing the visible world, an achievement which had then been revived and emulated, even surpassed, by Giotto. Ghiberti reinforces this view over his first two books; in the first adopting from Pliny information about ancient artists and their works. However, his selection of passages suggests that he discerned, behind their achievements, the presence of some kind of theory. To make sense of this, Ghiberti called on another ancient writer, the Roman architect Vitruvius (first century BC), who, in his *De architectura* (On architecture), had recommended to the architect other arts, such as philosophy and geometry, to give an intellectual basis for his practice. Ghiberti paraphrases Vitruvius, to

explain that the science (*scienza*) of painting and sculpture, demands, of all the Liberal Arts, the greatest inventive skill (*invenzione*) – his own addition – for it 'is made with a certain reflection, which is made up of practice and theory [*materia e ragionamenti*]', in equal measure, for, whilst unlettered artists lack authority for what they do, those with letters and theory alone possess 'the shadow but not the substance'. The practice of sculpture combines the signified, that is, what is proposed, with that which it signifies, that is, its meaning, demonstrated though reason and learning. The practitioner must bring together natural talent (*ingegno*) and instruction (*disciplina*) to achieve this. The two arts specifically needed, beyond those of Vitruvius, are: theory of drawing (*teorica disegno*) and perspective (*prospettiva*). These are the bases for both painting and sculpture, the former for practice, the latter for theory. 'Perspective' may correspond to Vitruvius's 'optics' (*optica*), for, in Ghiberti's time, through medieval natural science, this would have been the accepted meaning. Ghiberti links it directly to the visual arts. This is demonstrated by his re-interpretation of a story from Pliny, where Apelles and Protogenes, Greek painters, competed in drawing the finest of lines. This competition, demonstrating refined skill of hand, is challenged by Ghiberti as a feeble test of expertise, failing, as he says, to show any depth of artistic theory. Ghiberti gives his own version, changing the 'finest of lines' to a 'problem in perspective, proper to the art of painting', for it demanded practice and theory to demonstrate how perception of the three-dimensional world could be recreated in two. Vitruvius says that in Greece this had been done in theatrical scene-painting (*scenographia*), and, furthermore, commentaries had been written about it. From this Ghiberti takes his lead in writing his own.

Having established, through Pliny and Vitruvius, that ancient art was predicated on three things – the individuality of the artist; the development of art towards naturalism, albeit idealized; and the intellectual basis of art in theory, particularly 'perspective' – in the second book Ghiberti applies these criteria to his own era, taking Giotto as his starting point, who, he says, 'left the crudeness of the Greeks [i.e. Byzantines]' to bring in 'the new art [*l'arte nuova*]' based on a refined and proportionate naturalism. To the received Florentine canon, Ghiberti adds fourteenth-century Sienese artists. Curiously – perhaps significantly – of his contemporaries, only the northern European bronze sculptor, Gusmin, now unknown, is mentioned. This book has proved the most useful for later historians, such as Vasari, even to the present day, for it provides fairly accurate attributions of works otherwise undocumented. Ghiberti's comments

on particular artists and the works he saw, made with the eye of a practising artist, are perceptive and original, such as his characterization of Taddeo Gaddi, as 'a man of admirable natural ingenuity', who was also 'most learned [*dottissimo*]'. Taddeo's understanding of light and space, in a word, 'perspective', is still admired. As might be expected, Ghiberti's persistent accolade is 'learned' (*dotte*), and he prefers artists accordingly. Of the Sienese artist, Simone Martini, he says: 'the Sienese masters think him their best, but it seems to me that Ambrogio Lorenzetti was much better and altogether more learned than all the others'. Having begged to differ, Ghiberti then feels obliged to justify himself. Therefore, he describes a painting he has seen to show that he particularly admired Ambrogio's ability to make the scene appear real, through controlled composition and expressive narrative, something, of course, that concerned Ghiberti in his own work. His history of painters and sculptors culminates in his autobiography – the first of an artist surviving from any era. Here he explains how combining practice and theory – here clearly that of visual perception – informed his own work:

> I have always sought the first principles, seeking to investigate how nature works, so that I might approximate to her, how images come to the eye and how the faculty of sight functions and how visual [things] come about, and in what way the theory of the art of statuary [*statuaria*] and painting might be established.

This ambition is echoed when he says of the Paradise Doors:

> I strove to observe every measurement in them, seeking to imitate nature at far as I possibly could ... [the narratives (*istorie*)] were all in compartments so ordered that the eye measures them in such a way that, standing back, they appear in three dimensions [*rilevati*]. The relief [itself] is very low and on the planes the figures can be seen so that those near to appear larger than those farther off, just as is shown in reality.

Ghiberti's approach to recreating the natural world, perhaps reflecting the three dimensions of sculpture, is fluid and guided by a sense of the elusiveness of visual perception. His terminology – images (*species*), the visual faculty (*virtu visiva*) – indicates his knowledge of medieval optics and its experimental and empirical approach to the subject. Indeed, the third book consists of a patchwork of quotations

taken from the Arab, Alhazen's *Optics* (*De aspectibus*) of around 1000 AD (a late-fourteenth-century Italian translation of which was used by Ghiberti), Roger Bacon's *Perspectiva*, Witelo's *Perspectiva*, and John Pecham's *Perspectiva Communis*, all of the later thirteenth century. Though somewhat awkwardly assembled and at times repetitive, these quotations were certainly not chosen at random. Their choice exhibits Ghiberti's keen response to both the anomalies of vision and its underlying rationale. He selects passages of particular interest to the visual arts, like the judgement of distances, such as clouds over a flat landscape, but also, following Alhazen, he explains the process of vision from the eye's passive reception of images, through the imagination (*fantasia*), where they are retained, to the memory and the intellect, where certainty is distinguished from approximation. He worries the problems of bifocal vision at a time when the paradigm for 'perspective' in painting was monocular. He also follows his sources into the labyrinths of catoptrics – the study of the properties of mirrors – something of particular interest in painting at the time, especially in northern Europe. His intention is to give painting and sculpture a scientific basis equal, say, to geometry (and optics) and arithmetic. He is aware of the literary concept, 'invention', as a key requirement in art, but, unlike others at the time, he denies the classical analogy of painting and poetry. In describing the Paradise Doors he focuses on the story telling and the formal disposition of the various events rather than any deeper rhetorical meaning. The artistic expertise lies in disposing the sequential narratives in space so that the eye reads them as though real, rather than in the interpretation of content. After establishing the scientific axioms of vision, Ghiberti returns to Vitruvius's description of the practice of spatial representation developed by the ancient Greeks for it seemed to correspond to what he had learnt about the actual working of the eye. Unfortunately, the text we have ends just at the point where he is on the verge of concluding exactly how practice and theory should come together, both in 'perspective' and in the proportions, both categorical and empirical, of figure sculpture. Fortunately, we do have his works as a visual demonstration of his ideas. His *Commentarii* are important as the first extant text where one artist's theoretical ideas, albeit unresolved, can be measured against what he actually produced.

Why did Ghiberti write these *Commentarii* and for whom? The overall argument concerns visual perception, both natural and scientific, and naturalism in art. Ghiberti is the first to use 'perspective' to link the two – a usage which became common later, particularly with Leonardo. Alberti's *Della pittura* of 1436 dealt with the same

problem (though he never uses the term 'perspective'), and, perhaps, in the light of Florentine artistic practice at the time, Ghiberti was challenging Alberti's authority. Indeed, a certain defensiveness of tone suggests he felt the need to justify his own procedures and claim his rightful position in the van of contemporary art. Perhaps, with his knowledge of Latin and his association with contemporary humanists, he felt in a singular position to make the ideas of classical and medieval authors, probably circulating at the time in Florentine workshops, available to the ordinary practitioner. However, it is hard to say how far the *Commentarii* were known outside his immediate circle. Nevertheless, apart from 'perspective', he does help to establish terms redolent of workshop ideas which resonate in later writing on art: *disegno*, as more than simply 'drawing', for example, used earlier by Cennino **Cennini**, and defined later by **Vasari**; *ingegno*, as 'natural talent', which can be developed through practice; *aria*, as 'individual touch', which could not be taught. From Pliny's *statua*, he developed the term *statua virile*, intending a living presence in the bronze or marble figure.

The *Commentarii*, as we have them, are not polished, nor is Ghiberti an elegant writer. The sutures between the quotations which make up books one and three are not smoothly negotiated. Nevertheless, Ghiberti's additions to his sources, and his remarks on his immediate artistic predecessors show a unique sensibility to both painting and sculpture born from long experience of practice and reflection. They also reveal something of the man and their strength lies precisely in their honesty and lack of literary pretension. In the long, somewhat breathless, description of the martyrdom of the Franciscans by Ambrogio Lorenzetti, we share his excitement at reading what is going on and his enthusiasm at identifying where the extraordinary skill of the artist lay. Even looking back over the years, he can vividly recall the immediacy of the emotion he felt before the works he has seen. This is best shown in his descriptions of ancient statuary.

The third book begins with the simple statement: 'nothing is seen without light.' Following **Aristotle**, he acknowledges the supremacy of the eye in our experience of the world. He then turns to the medievals to explain the scientific theory. However, what interests him is what he sees and his own experience of the fall of light on objects: the way a chalcedony carved with figures must be viewed against a strong light to perceive its full beauty; the way temperate light reveals the subtleties of carved marble. Although, even then, sometimes, the eye itself is lacking – as he says of an ancient sculpture of a Hermaphrodite he saw in Rome: 'There were many subtleties in it, imperceptible to the eye

alone and revealed only to the hand'. Visual perception fails without the hand to guide it, much as the artist's hand fails without an understanding of visual perception to give it guidance and authority.

Biography

Lorenzo (di Cione) Ghiberti was born in 1378 in Florence, his natural father a notary, his step-father a goldsmith. He trained as a goldsmith and painter. In 1401 he won the competition for the second bronze doors of the Florentine Baptistery (1403–24). In 1425 he was commissioned for a second set of doors (known as the Gates of Paradise). These were finished in 1452. Other commissions included three bronze statues for the church of Or san Michele in Florence and the bronze tomb of St Zenobius for Florence Cathedral. He worked in Siena on the Baptistery Font. He also worked as an architect, being appointed, along with Brunelleschi, to supervise the building of the dome of the Cathedral, and as a designer of stained glass. He died on 1 December 1455 in Florence.

Bibliography

Main texts

Modern Italian edition:
I Commentarii, Bartoli, L. (ed.), Florence, 1998.
No full English translation exists. Translations of Book 2 are:
Ghiberti's Second Commentary, trans. C. Fengler Knapp, Madison, University of Wisconsin, Bryn Mawr, Bryn Mawr College, 1974.
Lorenzo Ghiberti's Treatise on Sculpture: The Second Commentary, trans. J. H. Hurd, Bryn Mawr College, 1978.

Secondary literature

Federici Vescovini, G., 'Il Problema delle fonti ottiche medievali del "Commentario II" di Lorenzo Ghiberti', in *'Arti' e Filosofia nel secolo XIV,* Florence, Nuovedizioni E. Vallecchi, 1983.
Gombrich, E.H., 'The Renaissance conception of artistic progress', in *Norm and Form*, London, Phaidon Press, 1966.
Lorenzo Ghiberti 'materia e ragionamenti', exhibition catalogue, Florence, 1978.
Lorenzo Ghiberti nel suo tempo, National Institute of Renaissance Studies, *Acts of the International Study Congress, Florence, 1978*, Florence, 1980.
Krautheimer, R. and T. Krautheimer-Hess, *Lorenzo Ghiberti*, Princeton, Princeton University Press, 1956.
Parronchi, A., 'Le "misure dell'occhio" secondo il Ghiberti', *Paragone*, XII (1961), pp. 18–48 (reprinted in A. Parronchi, *Studi su la dolce prospettiva*, Milan, 1964).

Schlosser Magnino, J., *La letteratura artistica*, Florence, La Nuova Italia, 1964.

ROGER TARR

LEON BATTISTA ALBERTI (1404–72)

ITALIAN ARCHITECT AND WRITER

Not long after Alberti's death in 1472, the scholar and philosopher, Cristoforo Landino, placed him 'among the natural scientists [*physici*]', for 'he was born solely to investigate the secrets of nature', through his mastery of those Liberal Arts – geometry, arithmetic, astrology and music – which made up the mathematical curriculum. However, Alberti was also trained, first in Padua and then at university in Bologna, in the other Liberal Arts – grammar, rhetoric and dialectic – which made up the curriculum of the humanities. All his writings – from the *Ludi matematici* (Mathematical games), on surveying, to the *Della famiglia* (On the family), on family ethics – display a coherence of analysis and expression stemming from this background. The *De pictura* (On painting) and the *De statua* (On sculpture), are no exception, for in them either art is given its own scientific and expressive rationale. Whereas for architecture – on which he wrote the influential book *De re aedificatoria* (On building) – he had a classical model in Vitruvius's *De architectura* (On architecture) (1st century BC), for painting and sculpture he had no extant precedents to follow. Unlike his contemporaries who wrote on art, Cennino **Cennini** and Lorenzo **Ghiberti**, both practising artists, Alberti worked mainly as a papal secretary. Nevertheless, he did engage in both arts, although nothing, except a self-portrait medal with the emblem of a winged eye, can be fairly attributed to him. In its imagery Alberti encapsulates his beliefs and aspirations and the sources from whence they came. Portrayed in stern profile, classically clad, his hair cut after the Roman manner, Alberti declares himself heir to the great Republican past. The medal revives an antique type, and, in durable bronze, reflects an antique consciousness of posthumous fame. Landino added one further 'art' to Alberti's achievements, namely, 'perspective' – the term used, in the Latin Middle Ages, for the natural science of optics, which analysed perception and visual experience. Alberti's 'eye' surely alludes to this, but it is also winged to signify the timelessness of speculative thought.

The medal is usually dated around 1434–55, when, newly arrived in Florence with the papal curia, Alberti wrote *De pictura*, which he

then abridged and translated into Italian (*Della pittura*) in 1436, dedicating it to those in the van of Florentine art at that time – Brunelleschi principally, but also, Donatello, Ghiberti, Masaccio, and Luca della Robbia. *De pictura* epitomizes his method, for, on the one hand, it is a geometric text based on Euclid and the experimental axioms of medieval optics and, on the other, it is a pedagogical tract based on Quintilian's 1st century AD *Institutio oratoria* (Instruction in oratory) for the education of rhetoricians. The tone is didactic, encouraging an intellectual approach to painting both in the underlying natural science of its practice and the overt moral significance of its purpose. As Alberti explains in his dedicatory preface to the Italian version, the book is in three parts:

> The first, which is entirely mathematical, shows how this noble and beautiful art arises from roots within nature herself. The second puts the art into the hands of the artist, distinguishes its parts and explains them all. The third instructs the artist how he may and should attain complete mastery and understanding of the art of painting.

This tripartite form echoes classical poetics: first, the grammar; second, the poem itself; third, the character of the poet. Thus Alberti sets up for painting: the basic rules; their application; finally, the artist's standing vis-à-vis his subject matter. But Alberti is also conscious of the novelty of his approach, as he says himself: 'we are not writing a history of painting like Pliny [the Elder], but treating of the art in an entirely new way'. Nor is he writing a practical manual on making colours etc. like earlier medieval treatises. However, he continually says he writes as a painter and, although for him practice is inextricably bound up with theory, in the Italian version for artists (as against the Latin version for Gianfrancesco Gonzaga at Mantua), he plays down the literary for the more scientific basis of the art.

This is particularly apparent in Book 1 where, relying on classical and medieval optics, he establishes the underlying geometrical principles governing vision, so that the painter, when simulating the three-dimensional world on a two-dimensional surface, will be on the same visual wavelength as the viewer. After criticizing current workshop practice as too approximate, he presents a procedure for creating space in painting, reflecting, in its fictive visual rationale, the demonstrable visual rationale that informs appearances. This is based on the principle that the surface of any painting is but the intersection

of the pyramid of rays taking the apex at the eye to what is seen, standing at a certain distance away, delimited by the shape of the projected painting so as to appear as though seen through a window. Alberti has replaced the abstract geometry of the natural scientist for the material geometry of the painter to explain what we see. Based on the classical axiom of 'man as the measure of all things', Alberti shows that, by taking the proportions of a man notionally standing on the picture plane, the painter can create a spatial arena for both figures and buildings which, in its logical continuity, reflects common experience whatever size his picture. For coherence the procedure demanded a fixed viewpoint common to both painter and viewer. Centred round a single axis called the 'centric ray', which carried the most accurate information from the object and projected the most concentrated focus of the eye, this served to bring the eye and mind of both the painter and the viewer together in a single 'point of view', both visually and conceptually. Although Alberti never uses the term 'perspective', its dual modern sense of a pictorial technique and a way of looking at things is endemic in his system. The pictorial technique may reflect earlier demonstrations, again based on optical geometry, made by Brunelleschi in Florence to show buildings in space, but, in these, Brunelleschi was not concerned with content. Alberti is concerned with creating a focused *mise-en-scène* for the action – reflecting classical descriptions of scene-painting (*scenographia*) – precisely in order to concentrate the meaning.

The second book shows how such a 'stage' might be animated with figures in order to do this. Here, the painter must master the three parts of his art: circumscription (*circumscriptio*), composition (*compositio*), and the reception of light (*luminum receptio*). These divisions follow classical principles of recognition. Thus, 'circumscription' registers the outline to establish volumetric form in space. This was particularly admired among ancient painters, and Alberti says that 'by itself is often most pleasing'. It is of paramount importance for the spatial organization of the picture and Alberti describes a loom-like 'veil' of thin thread he has invented to facilitate its accuracy. 'Composition' registers the distribution of the planes and surfaces within a form which reveal its physical three-dimensional structure. The 'reception of light' animates such a form with light and shade to create the illusion of relief and refines its surface so that we recognize exactly what we are seeing. Together, these three parts of painting make up what contemporary workshops would call 'drawing' (*disegno*) (a term not used by Alberti) – the intellectual foundation of painting – on to which, as with Alberti, colours were applied. But Alberti takes

the argument further, for the parts also correspond to those familiar from classical rhetoric: 'circumscription' (the initial idea) to 'invention'; 'composition' (the putting together of the argument) to 'disposition'; 'reception of light' (the way the argument is presented) to 'elocution'. 'Composition' plays the central role. It refines the initial idea and controls how it is expressed. It is here, Alberti says, that 'all the skill and merit [*ingenium*] of the painter lies', not only in creating individual figures, but also in governing their disposition and interaction in the overall drama. This compositional coherence, each part inextricably, but economically, linked to another, recalling Vitruvius on architecture, constitutes the essential requirement for the *historia* (Italian *istoria*), which is, according to Alberti, the ultimate purpose of painting and the ultimate goal of the painter.

Usually the term *istoria* meant a 'story', traditionally presented and interpreted. Alberti invests it with a new creative resonance. His *historia*, like an oration, demands original synthesis and interpretation. Therefore, the painter, like the orator, should possess, beyond his craft, learning and personal rectitude to give his point of view depth and authority. He recommends knowledge of all the Liberal Arts, but also that the painter, when composing his *historia*, consult with others perhaps more skilled than he. However, in the end, the responsibility is his own, and abstract learning should be distilled through experience and guided by reason. To demonstrate this he cites the Greek painter, Apelles, who, in representing Calumny, or Slander, disposed its various aspects − deceit, envy, truth etc. − in such a way that the idea and the experience − for Apelles was in fact defending himself − became visible, striking the mind through the eye more forcibly than in words. Thus, as the painter gives material substance to abstract geometry, so he gives shape and form to abstractions, and, as a speaker puts letters, syllables and words together to explain his invention − what he has formulated in his mind − so the painter puts outline, surface and members together to display his. The eventual *historia* succeeds according to the strength of its 'invention' (*inventione*) initiated through the artist's *ingenium* (Italian *ingegno*) − his 'innate creative talent' − the drive he must possess to create something from nothing.

Alberti says he prefers the painter's *ingenium* because it sets itself a more difficult task, nevertheless, he grants that sculpture is nurtured by the same underlying impulse. The Latin *De statua* deals with this. Unlike for *De pictura*, Alberti made no Italian translation. The first dedication we have is in the 1460s, but its tone and content suggest that Alberti was working out what was new in civic statuary, particularly that of his friend, Donatello, in Florence in the 1430s. The

De statua seems, at first, merely a technical manual, for, in it, Alberti describes two complementary mechanisms for creating a standing figure from a given block of marble. The first consists of two instruments: the *exempeda* and the 'movable squares'. The *exempeda* is a simple ruler, calibrated from the foot to give the overall height. The height is designated six 'feet', which, like the proportions of a man in *De pictura*, can be scaled to size. For the 'colossus', which, for Alberti, is the sculptor's highest aim, this proportional system enables scaling-up from working drawings rather like those the painter would use when inventing his *historia*. The 'movable squares', similarly calibrated, like modern callipers, measure the width. Used together, these two instruments establish three-dimensional form. The second mechanism, known as the *finitorium*, consists of three instruments: the 'horizon'; the 'radius' and the 'perpendicular', each calibrated in line with the basic *exempeda*. The 'horizon' is a circular disc three 'feet' in diameter, attached to the top of the statue. From its centre the 'radius', three 'feet' in length, rotates to register the maximum extent of both arms, equal, as in Vitruvius' axiom, to the height of the figure. The 'perpendicular' – a plumb-line hanging from the 'radius' – moves in and out to pinpoint the extremities, particularly the arms, when animated in movement. Alberti could see that the ancients had created figures with arms outstretched, not confined to their sides, as with his contemporaries. His system would allow for this.

At the end of the book Alberti gives a 'canon' for the human figure in emulation of the Greek sculptor, Polykleitos. These proportions, taken from various models, register only the height, but, from these, the others can be calculated. This 'canon' is a 'mean' rather than an ideal, so that the sculptor, by keeping it in his head, as the painter would for standard forms of things in painting, might individualize his figure, making it tall, short etc. and, in detail, characterize its features. Thus his system, reflecting the co-ordination of elevation and ground-plan in projecting a building, was as much conceptual as practical. It showed how the sculptor might make a living person from inanimate stone. The *exempeda* establishes the abiding character, or ethos, evident in the form of a person. The *finitorium* establishes, through pose and movement, how that particular person would act when moved by the emotion, or pathos, of his thought. For the sculptor should aim, as he says, not merely to represent a man, but 'the entire appearance or body of one particular man, say Caesar or Cato, in this attitude and this dress, either seated or speaking in court, or some other known person'. As with painting, movement engages the viewer not only with the overt drama, but with the emotion which lies

below the surface. It presents an actual experience which at once catches the attention and affects the mind. Through it, art has the potential to influence and, indeed, alter accepted opinion. In antiquity, as Alberti says, the beauty of Phidias' statue of Jove at Elis, 'added not a little to the received religion'.

Alberti was writing when art was principally directed towards religion. Though couched in secular language, his views share the same background and identify the same instructive potential in art as that developed by medieval theologians. However, he was also writing at a time of incipient artistic licence. Usually this claim to licence was founded on the long-standing view that poetry and painting shared a common impulse in the imagination (*fantasia*). Instead, Alberti linked painting and, indeed, sculpture, with the more robust art of rhetoric, identifying the common impulse as invention – based on reason and industry rather than on whim and good fortune – which was to be judged in the harsh light of day. With more licence came more responsibility, so it was imperative that the painter and sculptor understood the 'secrets of nature', both physical and psychological, to make common ground between himself, his work and the onlooker, in order to present to sight truths, either philosophical or theological, which lay beyond the ravages of time.

The influence of the *De pictura* and the Italian *Della pittura* on both patronage, painting and artistic theory in the fifteenth century remained seminal and dynamic. Later, in the sixteenth and seventeenth centuries in Italy and then France, its adoption by the Academies perhaps played down its vitality. Alberti's view as to the primacy of painting, reflected in the so-called *paragone*, or comparison of the arts, explicated later by **Leonardo da Vinci**, may have allowed the *De statua* to recede. However, its influence can also be traced. The basic technology – used by Roman sculptors to reproduce Greek originals – known as 'pointing', was used by later marble sculptors, such as Canova. Albrecht Dürer, who knew the techniques of *De pictura*, based the proportions in his *Vier Bücher von menschlicher Proportion* (Four books on human proportion) of 1528 on Alberti's *exempeda*. The concept of an animate figure hidden in the block of marble is reiterated by **Michelangelo** and, finally, Francesco Bocchi's idea of *costume* – character demonstrated in attitude and expression – in sculpture developed in his *Eccellenza della statua di san Giorgio di Donatello* (The excellence of Donatello's statue of St George) of 1571, owes not a little to Alberti's brief, but incisive, text.

Biography

Leon Battista Alberti was born on 14 February 1404 in Genoa, the illegitimate son of Lorenzo di Benedetto Alberti, a member of a Florentine banking family then in exile. Educated at Padua from 1415–18 in the humanist Gymnasium of Gasparino Barzizza, he went on to study at Bologna University from 1421–8. In 1432 he was in Rome as secretary to Bishop Biagio Molin, head of the papal chancery under Pope Eugenius IV (1431–47). In 1432 he was also given the benefice of San Martino at Lastra a Signa near Florence and later became rector of Borgo San Lorenzo in Mugello and a canon of Florence Cathedral. He was in Ferrara for the Council on the re-unification of the Roman and Orthodox churches in 1438. He presented *De re aedificatoria* (On Building) to Pope Nicholas V on or before 1452. From *c.*1450 onwards he worked as an architect on buildings in Rimini, Florence and Mantua. He died in April 1472 in Rome.

Bibliography

Main texts

On Painting and Sculpture, trans. (with introduction and notes) C. Grayson, London, Phaidon Press, 1972.
On Painting, trans. C. Grayson (with introduction and notes by M. Kemp), Harmondsworth, Penguin Books, 1991.
On Painting, trans. (with introduction and notes) J.R. Spencer, New Haven and London, Yale University Press, 1956; revised 1966.

Secondary literature

Baxandall, M., *Giotto and the Orators: Humanist Observers of Painting in Italy and the Discovery of Pictorial Composition*, Oxford, Clarendon Press, 1971.
Borsi, F., *Leon Battista Alberti: the Complete Works*, Oxford, Phaidon Press, 1977.
Edgerton, Jr., S.Y., *The Renaissance Discovery of Linear Perspective*, New York, Harper & Row, 1975.
Gadol, J., *Leon Battista Alberti, Universal Man of the Early Renaissance*, Chicago, University of Chicago Press, 1969.
Grafton, A., *Leon Battista Albert, Master Builder of the Renaissance*, London, Allen Lane, 2000.
Greenstein, J.M., *Mantegna and Painting as Historical Narrative*, Chicago, University of Chicago Press, 1992.
Jarzombek, M., *On Leon Battista Alberti*, Cambridge, MA, The MIT Press, 1989.
Mancini, G., *Vita di Leon Battista Alberti*, Florence, 1882; reprinted, Rome, Bardi, 1967.
Rykwert, J. and A. Engel (eds), *Leon Battista Alberti,* Milan, Electra, 1994.

Tavernor, R., *On Alberti and the Art of Building*, New Haven, Yale University Press, 1998.

<div align="right">ROGER TARR</div>

LEONARDO DA VINCI (1452–1519)

ITALIAN ARTIST, ENGINEER, SCIENTIST AND WRITER

Leonardo da Vinci was one of the founders of the High Renaissance style in painting. In addition to his well-known reputation as an artist, he is also regarded as an important writer on art, natural science, and engineering. In striking contrast to the relatively small number of completed art works, Leonardo produced thousands of pages of text accompanied by illustrations. Pointing to this disparity, Giorgio **Vasari**, the Florentine artist and art writer, remarks in his biography of the artist in his *Lives of the Artists* that Leonardo 'accomplished far more in words than in deeds'. Leonardo's status as writer and thinker was widely recognized by his contemporaries. Benvenuto Cellini, the Florentine goldsmith and sculptor, recounts in his autobiography that King Francis I referred to the artist as a 'very great philosopher'. The 6,500 or so manuscript pages residing in important collections and libraries around the world are believed to constitute merely a small portion of the notes and drawings bequeathed by Leonardo to his student Francesco Melzi. To read Leonardo's writings in manuscript form requires formidable training and talent, since he wrote in reversed handwriting. The lack of punctuation or accents, and his idiosyncratic orthography compound the difficult task of translation. Furthermore, the artist often recorded unrelated ideas and drawings on a single page. Consequently, a veritable scholarly industry has evolved to piece together a coherent picture of his ideas. Important work still remains to be done on the originality, development, and influence of his ideas.

Although none of Leonardo's many projected treatises were published in his lifetime, his ideas were widely disseminated after his death. The *Codex Vaticanus Urbinas Latinus 1270*, the manuscript that forms the basis for later published compilations of Leonardo's ideas pertaining specifically to the art of painting, was compiled by Melzi around the middle of the sixteenth century from 18 of Leonardo's notebooks. Since Leonardo never completed a treatise on art in his own lifetime, we cannot be sure what form such a text might have

assumed. However, Melzi's anthology helped to put Leonardo's views on painting into wide circulation. Already, in the sixteenth and early seventeenth centuries, manuscript copies of the *Codex Urbinas* circulated in abridged form in Italy. One of these copies provided the basis for the first printed edition of Leonardo's writings. The so-called *Trattato della pittura* or *Treatise on Painting* was published simultaneously in Italian and French in Paris in 1651. Even before the first printed edition, the diffusion of Leonardo's ideas is evident in the many excerpts and paraphrases of his writings that appear in several languages, including Italian, Spanish, and English. As early as 1528, the publication of Castiglione's *Il libro del cortegiano* (*The Book of the Courtier*) introduced a number of Leonardo's orginal ideas on art to a European audience. The *Codex Urbinas* is now accessible to the modern reader in translation, as are published anthologies of other manuscript material.

Leonardo's significance as a writer on art resides in his demonstration of the intellectual power of art as a method of inquiry into nature. His writings on art must be considered within the wider context of his investigations into natural phenomena, since his artistic ideas are informed by themes that he pursued throughout all his scientific investigations. Moreover, his faith in the primacy of visual observation in his writings on nature serves to raise art to the level of a science. By placing the art of painting within his broader inquiries into natural philosophy, Leonardo contributed to the elevation of painting to the status of a liberal art.

Through his extensive studies of the natural world as artist–scientist, Leonardo laboured to extract rules from nature so that he could then remake nature in his own artistic works as the ultimate confirmation of the laws of nature. Leonardo's studies of the workings of nature yielded many manuscript pages on such topics as geometry, mechanics, military engineering, flying machines, the properties of plants, the motions of the heavens, geology, proportion, architecture, anatomy, the qualities of light, and the force of water. Many of these manuscripts were to form the basis for full-scale treatises that were never completed. Through this research, which had a profound impact on his artistic development, Leonardo aimed to show the inter-relatedness of nature and its underlying laws. His intense interest in movement works as a unifying thread through his many investigations, a fascination that is ultimately manifested in his attention to the relationship between motion and emotion in his art works. He writes: 'motion is the cause of every life' (H.141r, quoted in Kemp, 1981). He was intrigued by force, and the action of water upon the land. He

pursued these interests in his studies of the Arno and Tuscan topography. Water loomed large in his thought because it combined both motion and weight: it was the supremely dynamic element. This vision of a dynamic nature also informed his studies of anatomy. His projected book on anatomy was intended to reveal the human body in terms of the processes of growth, emotion, action, and perception. He was also intrigued by the parallel between nature and man, conveyed by the ancient idea that man was a microcosm of nature. He applied the metaphor of the human body to his studies of the earth. This metaphoric association is made visible in the so-called *Mona Lisa*, in which he suggests a parallel between the landscape and the image of the figure. By the end of his life Leonardo replaced the idea of microcosm with a sense of nature and man as having infinitely varied functions within the shared context of universal law. However, his belief in the essential unity of man and nature imbues much of his writing.

In those areas which touch most directly on Leonardo's practice as artist, specifically his investigations into proportion, anatomy, optics, perspective and movement, and in the anthology of writings known as the *Treatise on Painting*, his empirical methods of observation and recording set his work apart from previous texts on painting. The interdependence of the scientific and the artistic was mutually supportive. What makes Leonardo different from earlier writers on painting, including Leon Battista **Alberti**, Filarete, and Piero della Francesco, is his use of writing to record his own detailed studies of natural phenomena, combined with a close alliance between word and image to communicate his ideas. For Leonardo, drawing and writing went hand in hand. His visual and perceptual skills as an artist informed his scientific interests, and his scientific interests informed his painting. The exhaustive studies he made of human anatomy were expressed in minutely detailed drawings that could only come from the hand of a highly skilled and perceptive artist. To the discussions of linear perspective in the treatises of his predecessors Leonardo adds a multitude of empirical observations on aerial and colour perspective, as well as close studies of the qualities of light, colour, chiaroscuro, and their role in creating *rilievo* (relief).

Leonardo's empirical approach also informs his theories of move-ment in the *Treatise on Painting*. Leonardo believed, in a tradition established in writings on art by Leon Battista Alberti in the fifteenth century, that the motions of the body reveal the 'motions of the mind'. Yet, he was the first writer on art to attempt to demonstrate the empirical basis for this belief through dissection of the brain and

nervous system. In the section of the treatise on the human body and movement, his scientific investigations into human anatomy and the laws of mechanics extend and enrich previous work on this subject. His interest in motion led him to conduct extensive explorations of the ventricles of the brain responsible for motion. He believed these studies to be essential to painters. Below one of his diagrams of the network of neural 'chords' in the neck and shoulder, he wrote: 'This demonstration is as necessary to good draughtsmen as is the origin of words from Latin to good grammarians' (W.19021v; Kemp). His probing accounts of the relationship between physical movement and emotion, between gesture and expression, and their role in creating affective narrative made his *Treatise on Art* a foundational text for the teachings of the French Academy in the seventeenth century.

Related to Leonardo's goal of analysing the relationship between motion and emotion is his interest in the process of invention. Several passages on the role of the sketch in the *Treatise on Art* emphasize the creative power of the artistic imagination in a totally new way. Comparing the painter's act of invention to the poet's composition of verse, Leonardo advises artists that motion/emotion is best captured in a spontaneous and unfinished sketch rather than in a perfected drawing. To stimulate the mind to further inventions he even encourages painters to look at crumbling walls, glowing embers, speckled stones, clouds, or mould. These recommendations transform the sketch from its typical status as preparation for a particular work to a creative process dedicated to capturing the inner life of a figure.

Leonardo's emphasis on the power of the eye also renders his writings on painting distinct. The close integration of theory and practice that sets the *Treatise on Painting* apart from its predecessors is grounded in Leonardo's faith in visual observation allied with experience. He firmly believed that 'Wisdom is the daughter of experience' (Forster III 14r; Kemp). By his very method of inquiry, Leonardo promotes the eye to the level of the highest sense. In statements such as 'All our knowledge has its foundation in our sensations' (Triv.20v; Kemp) or 'True sciences are those which experience has caused to enter through the senses' (Urb.19r; Kemp), Leonardo elevates the art of painting to the status of scientific inquiry. His faith in knowledge gained by the judgement of sense was supported by his research into the structure and faculties of the brain, which provided an empirical basis for the notion of the eye as the window of the soul. He maintained that the eye was the most receptive of the senses to harmonic ratios and was itself a geometrical instrument capable of sensing the inherent design of nature.

Leonardo's belief in the primacy of the eye made the behaviour of light in space central to both his theory and his practice of art.

Leonardo's praise of the sense of sight and his conviction that painting is a science are ultimately related to his conception of the nobility of the painter. Although previous writers had argued for the nobility of the art of painting, Leonardo's achievement lies in tying such claims to the idea that painting was an investigative tool for the pursuit of scientific knowledge. In those writings known as the *paragone* (comparison or contest), which form the opening section of the *Codex Urbinas*, Leonardo argues for the supremacy of painting over the arts of poetry, music, and sculpture. Leonardo's case for painting forms the first important contribution to the Renaissance debates on the relative merits of the arts. Such debates were central to the rise of the status of the visual arts from mechanical to liberal arts. Leonardo presents a compelling picture of the nobility of the painter:

> The painter sits in front of his work at perfect ease. He is well dressed and wields a very light brush dipped in delicate colour. He adorns himself with the clothes he fancies; his home is clean and filled with delightful pictures and he is often accompanied by music or by the reading of various beautiful works.
>
> (Urb.20r–v; Kemp)

Leonardo's ideas on art made an important contribution not only to the theory and practice of art, but also to how art itself as a form of knowledge was understood during the Renaissance. The unique combination of word and image in his writings, allied with extensive empirical observations, altered the nature of writing on art. Through his research and writing, Leonardo transformed the practice of art theory into an investigative tool of unprecedented power.

Biography

Leonardo da Vinci was born on 15 April 1452 in Anchiano, near Vinci, the illegitimate son of a notary. He began as an apprentice in the studio of the sculptor Andrea Verrocchio in Florence but moved to Milan in 1482, where he worked for the court of Lodovico Sforza, Duke of Milan. In December 1499 he left Milan, and after a brief visit to Mantua returned to Florence in 1500. In 1502 he was appointed Cesare Borgia's 'architect and general engineer'. He was in Florence from 1503–6 as one of the engineers involved in a scheme to divert the River Arno; in Milan from 1506–13, working for the governor,

Charles II d'Ambroise; and in Rome from 1513–16, involved in military work that Giuliano de Medici was undertaking for Pope Leo X. He left for France 1516–17 at the request of French king, Francis I. He died on 2 May 1519 in Ambroise, near Tours.

Bibliography

Main texts

The Notebooks of Leonardo da Vinci, Edward MacCurdy (ed.), London, J. Cape, 1938.

Codex Urbinas Latinus 1270, trans. (with annotations) A. Philip McMahon, *Treatise on Painting*, introduction by Ludwig Heydenreich, 2 vols, Princeton, Princeton University Press, 1956.

Leonardo da Vinci on Painting, A Lost Book (Libro A), Carlo Pedretti, London, Peter Owen, 1965.

The Literary Works of Leonardo da Vinci, compiled and edited by J.P. Richter, commentary by Carlo Pedretti, 2 vols, Berkeley, University of California Press, 1977.

Leonardo on Painting, selection and trans. Martin Kemp and Margaret Walker, Martin Kemp(ed.), New Haven and London, Yale University Press, 1989.

Leonardo's Writings and Theory of Art, Leonardo da Vinci Selected Scholarship, Claire Farago (ed.), New York and London, Garland Publishing, 1999 (vol. IV).

Secondary literature

Clark, Kenneth, *Leonardo da Vinci*, Introduction by Martin Kemp, Harmondsworth, Middlesex, Viking, 1988.

Farago, Claire, *Leonardo Da Vinci's Paragone: A Critical Interpretation with a New Edition of the Text in the Codex Urbinas*, Leiden and New York, E.J. Brill, 1992.

Gombrich, Ernest, 'Leonardo's Method for Working out Compositions', in *An Overview of Leonardo's Careers and Projects Until c. 1500*, Leonardo da Vinci Selected Scholarship, Claire Farago (ed.), New York and London, Garland Publishing (1999), vol. II, pp. 114–33.

Kemp, Martin, *Leonardo Da Vinci: The Marvellous Works of Nature and Man*, Cambridge, MA, Harvard University Press, 1981.

Kemp, Martin, Roberts, J. *et al.*, *Leonardo da Vinci, Artist, Scientist, Inventor*, (with introduction by E.H. Gombrich, and an essay by P. Steadman), London and New Haven, Yale University Press, 1989.

Pedretti, Carlo, *Leonardo da Vinci: a Study in Chronology and Style*, London, Thames and Hudson, 1973.

Turner, Richard A., *Inventing Leonardo*, New York, Alfred A. Knopf, 1993.

Zwijnenberg, Robert, *The Writings and Drawings of Leonardo da Vinci: Order and Chaos in Early Modern Thought*, Cambridge and New York, Cambridge University Press, 1999.

ERIN J. CAMPBELL

MICHELANGELO BUONARROTI (1475–1564)

ITALIAN ARTIST

The prime sources for Michelangelo's ideas about art are his poems; only a handful of his many letters touch on aesthetics. In addition, we have comments and conversations, and accounts of his character, conduct and methods, recorded by contemporaries – above all, in the biographies of Condivi and Vasari. Yet despite this abundant if dispersed source material, critics are divided on whether a coherent or original theory of art emerges.

Although the poems now feature prominently in anthologies of Italian poetry, some critics claim that they are generic, rather amateurish exercises in 'Petrarchanism', a style of love poetry at which other artists also tried their hand (for instance Raphael and Bronzino). If this were true, then the poetry would teach us very little about Michelangelo's own opinions. As for the ear- and eye-witness accounts, these too are often said to be written by unreliable sources who put commonplace opinions into Michelangelo's mouth. It is symptomatic that the two modern book-length studies which have tried to clarify and vindicate Michelangelo's ideas about art (Clements; Summers) met with a generally hostile reception. Both authors were accused of making cavalier and inconsistent use of sources.

We do know that Michelangelo planned to present his views in a more systematic way in an illustrated anatomical treatise dealing with 'human action and movement' (Condivi), but this never materialized. Yet it is in part the unsystematic and fragmentary nature of Michelangelo's comments on art that have made them so influential and quotable. Much more than the sum of their parts, they cumulatively contributed to a new idea of the artist – as the solitary and wayward genius who makes and breaks rules at will. Critics have always pitted him against his contemporary Raphael, the balanced and sweet-tempered all-rounder. Raphael was regarded as the model artist by academicians from the late-sixteenth until the nineteenth century, when Michelangelo and his outsized imagination swept all before him.

Michelangelo's contemporaries and followers understood him to have broken decisively with the empirical and mathematical methods of the late fifteenth century. **Alberti**, **Leonardo** and Dürer drew up precise rules for proportion, and assumed that nature was based on general rules. Michelangelo is said to have advocated more intuitive methods. The theorist **Lomazzo** records a saying of his that 'all the reasonings of geometry and arithmetic, and all the proofs of perspective

were of no use to a man without an eye'. According to **Vasari**, Michelangelo believed 'it was necessary to have the compasses in the eyes and not in the hand, because the hands work and the eyes judge'. These concepts were associated almost exclusively with Michelangelo in the sixteenth century, and through his words and deeds, he became the focus for arguments about the nature of the creative process. A Frenchman records him late in life attacking a huge marble block with *furia*, cutting great chunks off it and completely outstripping his much younger assistants. The account has similarities with a woodcut published in 1527, in which Michelangelo assails the block clad only in a loin-cloth. This vehement and headstrong image of the artist appealed to those of a romantic disposition, and seemed to confirm the need for sublime impetuosity in art. Vasari gives us a rather different image of the artist in the studio. He describes the 'divine' Michelangelo being guided by a painstaking method of submerging a small-scale wax model in water and then lifting it out bit by bit, so he could see what forms to leave in place as he cut away the marble block, working from the front. Yet even this method was highly unorthodox, and many critics thought it left too much to chance.

Michelangelo's intense self-consciousness about method is in large part due to his self-image as a sculptor (he regarded himself as a sculptor rather than a painter). Of all the visual arts, sculpture was the most heavily dependent on tools and technology, and the most demanding in terms of labour and materials. For most art theorists, it had a lower status than the more 'gentlemanly' art of painting. Alberti and Leonardo had both affirmed that painting was the 'mistress' of the visual arts: it was more conceptually sophisticated and universal than sculpture in general, and statuary in particular. Such prejudices help explain why Donatello, the foremost fifteenth-century sculptor who was revered by Michelangelo, is the first artist to stress that art should *not* be made using mechanical means alone. When someone visited Donatello's studio, expecting to see his abacus – the presumed 'secret' of his art – the sculptor merely announced that he was his own abacus. If Michelangelo's later attempts to downplay measuring devices seemed so radical to his contemporaries, it was in part because he practiced an art in which they were still deemed crucial.

Michelangelo put a new stress on the idea of artistic integrity and unity. Quattrocento discussions of sculpture make much of mechanical devices which would allow both piecemeal and multiple fabrication of statues by large teams of sculptors. For Leonardo, this proved sculpture's inferiority, for whereas a cast 'shares with the original the

essential merits of the piece', painting 'retains its nobility, bringing honours singularly to its author and remaining precious and unique . . . such singularity gives it greater excellence than those things that are spread abroad'. During this period, the most frequently mass-produced modern sculptures were small, domestic-scale reliefs and statuettes, but Michelangelo made few of the former and none of the latter. He rejected the notion that he was an artist who ran a shop. His devotion to vast, single blocks of marble from which he would single-handedly carve colossal statues was the most compelling Renaissance attempt to assert the artwork's – and the artist's – singularity (some of his statues were none the less copied by others). One of the most striking and influential aspects of his work is its non-domestic scale and sentiment, and its lack of ingratiating anecdotal detail. Vasari used the term *terribilità* to account for the awesome grandeur and intensity of his work.

At times, Michelangelo seems to have conceived of beauty as something exalted and metaphysical. Vasari tells us that in his figures, he was only interested in establishing 'a certain harmony of grace in the whole, which nature does not present'. Some of his poems suggest a Neoplatonic conception of beauty that transcends the 'merely' sensory. In a sonnet which may have been written for the young nobleman, Tommaso de'Cavalieri, contemplation of the loved-one's eyes offers the artist a vision of divine beauty: 'It was not something mortal my eyes saw when in your beautiful eyes I found complete peace . . . the soul rises above to beauty's universal form' (*Poems*, no. 105). He wrote similar poems to an aristocratic widow, Vittoria Colonna, in which he 'ascends' by means of her eyes to her 'high [i.e. divine] beauty' (*Poems*, no. 166). Michelangelo revered the Florentine poet Dante, and most of these ideas can be found in the *Purgatorio* and *Paradiso*, but they also pervaded the Neoplatonic circles surrounding Lorenzo de Medici, and were popularized by books such as Castiglione's *Il libro del cortegiano* (*The Book of the Courtier*), published in Venice in 1528.

Art historians generally assume that this is the principal way in which Michelangelo conceived of beauty. Yet it is not always clear how such ideas relate to his art. **Winckelmann**, the high-priest of neo-classicism who revered Raphael, praised these poems for being elegant meditations on ideal beauty, but regretted the lack of ideal beauty in Michelangelo's art, which he found utterly devoid of grace. The most basic way in which these poems differ from his sculptures and paintings is that in the latter he tends to privilege the body over the face and eyes: his *David*, for example, looks sharply away from the

viewer, and we are instead invited to feast our eyes on his naked body. In keeping with this emphasis, Michelangelo repudiated portraiture, the artform where one is most clearly invited to focus on the face and eyes (only one accredited portrait by him survives, an idealized drawing of a young man). Portraiture loomed large in the imaginative universe of platonizing writers such as Petrarch and Castiglione. Some critics have argued that Leonardo, one of the greatest portrait painters of the Renaissance, was more in tune with Neoplatonic ideals than Michelangelo (Garin). We would have to be disappointed with the poems if this were all they had to say about beauty.

Yet Michelangelo also wrote poems that offer a far more physical and impure conception of beauty, and these suggest closer parallels with his art. Almost 40 poems are addressed to the so-called 'beautiful and cruel lady'. The relationship is humiliating and confrontational rather than elevating and consensual. If in the Neoplatonic poems beauty is ethereal and all-consuming, here it is material and rebarbative. So un-rarefied are these poems that one scholar calls them his 'most frivolous', and argues that they may well be juvenilia (Girardi). While it is possible that some were originally early works, Michelangelo was clearly not ashamed of them. He wanted to include them in a collection of his poetry that was to have been published in the late 1540s – together with the poems probably written for Cavalieri and Colonna. Some may even have been written for, or sent to, Colonna.

Far from being juvenilia, they are crucial for our understanding of Michelangelo's theory of art, for they belong to a tradition that begins with Dante's *rime petrose*, a series of long poems in which the beloved is as hard and rough as stone, and in which the poet's language is correspondingly harsh. This is an inversion of the Pygmalion myth, for here flesh has become stone (rather than vice-versa), and the lover/sculptor is rebuffed at every turn. By virtue of being rough, beauty is now inextricably linked to ugliness and uncouthness.

Michelangelo claimed that his own poetry was 'rough and clumsy' (*Poems*, no. 85). This predilection for roughness of form and content helps explain the rawness and primitivism of so much of his art. After the unveiling of the *Last Judgement* in 1541, his work was increasingly criticized for its lack of decorum and grace, and for putting form above content. But precisely these qualities would later endear him to modernists. Gauguin's ceramic sculpture *Oviri*, for example, is influenced by the Louvre *Dying Slave*, and both Picasso and Matisse owned casts of the *Slaves*.

Michelangelo also reworked the conventions of the *rime petrose* in order to express the frustrations of making sculpture. In the celebrated poem which begins 'The greatest artist does not have any concept which a single piece of marble does not itself contain within its excess' (*Poems*, no. 151), he compares his inability to extract an image from a single block to his inability to make his lady merciful, but in the end he expresses contrition, and blames his own *basso ingegno* (low intelligence). At the same time, however, he believed that the extreme technical difficulty of sculpture made it the supreme artform. In a letter written in 1547 to Benedetto Varchi in response to a questionnaire about the respective merits of painting and sculpture, Michelangelo asserted that sculpture was superior because of its greater 'difficulty, impediment and labour'. His own variations on the *rime petrose* asserted the central place of 'difficulty' in the aesthetic as well as in the erotic realm.

Michelangelo's main period of poetic activity was from 1532–47, when he composed poems for Cavalieri, Colonna, and 'the beautiful and cruel lady'. Colonna died in 1547, and few complete poems survive from after this date. The late poetry is increasingly morbid and death-fixated, and on several occasions he appears to repudiate the visual arts: 'Neither painting nor sculpting can any longer quieten my soul, turned now to that divine love which on the cross, to embrace us, opened wide its arms' (*Poems*, no. 285). In modern times, these poems have underpinned the image of Michelangelo as the troubled genius, too tormented to be able to finish his sculptures, but they also attest to his preoccupation with architecture in his final years. Analogies were often made between the plan of churches and the cross. Michelangelo had an anthropomorphic conception of architecture. He may well have thought of St Peter's as being analogous to the body of the crucified Christ, its unprecedented size allowing it to 'embrace' every worshipper (Summers). The all-embracing nature of St Peter's was the ultimate manifestation of Michelangelo's concern with structures of overwhelming size and scale.

Biography

Michelangelo Buonarotti was born on 6 March 1475 in Caprese, the son of a minor public servant. In 1488 he was apprenticed to the painters Domenico and Davide Ghirlandaio. From 1489–94 he was attached to the Medici household, where he studied sculpture. He moved to Rome in 1496, where he carved the *Pietà* 1498–9. He returned to Florence to carve his *David* 1501–4. In 1505 in Rome he

started the *Tomb of Julius II*. He painted the *Sistine Ceiling* from 1508–12. Thereafter he resumed the *Tomb of Julius II*, but from 1516–27 undertook architecture and sculpture projects for San Lorenzo, the Medici church in Florence. With the return of the Medici in 1530, he resumed work on San Lorenzo, but left Florence in 1534 and was appointed supreme architect, sculptor and painter to the papal palace. He worked on the *Last Judgement* from 1536–41 and undertook architectural projects, above all *St Peter's*. He died on 18 February 1564 in Rome.

Bibliography

Main texts

The Poems, trans. Christopher Ryan, London, J.M. Dent, 1996 (Parallel Italian/ English text).
The Letters of Michelangelo. Translated from the Original Tuscan, trans. E.H. Ramsden (ed.), 2 vols, London, Peter Owen, 1963.

Secondary literature

Barasch, M., *Theories of Art: From Plato to Winckelmann*, New York, New York University Press, 1985.
Blunt, Anthony, *Artistic Theory in Italy 1450–1600*, Oxford, Oxford University Press, 1962.
Clements, Robert J., *Michelangelo's Theory of Art*, New York, Gramercy, 1961.
Condivi, Ascanio, *The Life of Michelangelo*, trans. Alice Sedgwick Wohl, University Park, Pennsylvania State University, 1999.
Cropper, Elizabeth, 'Review of David Summers: Michelangelo and the language of art', *Art Bulletin* 65 (1983), pp. 157–62.
Garin, Eugenio, 'Thinker', in *The Complete Works of Michelangelo*, Mario Salmi (ed.), London, Macdonald, vol. 2, 1966.
Gilbert, Creighton, 'Review of R.J. Clements: Michelangelo's theory of art', *Art Bulletin* 44 (1962), pp. 347–55.
Girardi, Enzo Noè, 'Writer', in *The Complete Works of Michelangelo*, Mario Salmi (ed.), London, Macdonald, vol. 2, 1966.
Hall, James, *The World as Sculpture: the changing status of sculpture from the Renaissance to the present day*, London, Chatto & Windus, 1999.
Mendelsohn, Leatrice, *Paragoni: Benedetto Varchi's Due Lezzioni and Cinquecento Art Theory*, Ann Arbor, MI, UMI Research Press, 1982.
Summers, David, *Michelangelo and the Language of Art*, Princeton, Princeton University Press, 1981.
Vasari, Giorgio, *La Vita di Michelangelo*, Paola Barocchi (ed.), Milan-Naples, Riccardo Ricciardi, 5 vols, 1962.
—— *Lives of the Artists*, trans. George Bull, Harmondsworth, Penguin Books, 1987.
Wallace, William (ed.), *Michelangelo: Selected Scholarship in English*, vol. 5 *Drawings, Poetry and Miscellaneous Studies*, New York, Garland, 1995.

JAMES HALL

PIETRO ARETINO (1492–1556), PAOLO PINO (fl. 1534–65) and LODOVICO DOLCE (1508–68)

ITALIAN WRITER

ITALIAN PAINTER AND WRITER

ITALIAN WRITER AND SCHOLAR

Venice experienced a flurry of art writing around the middle of the sixteenth century. These works were part of an emerging body of texts that were published in Italian rather than Latin on various secular subjects, incuding love, beauty, women, music, and manners. Such books were written as much to entertain as to instruct. The writings on art represent a wide variety of forms and concerns, from descriptions of aristocratic collections to discourses on the symbolic meaning of colours. These works played an invaluable role by disseminating a vocabulary for analysing and appreciating art. They established an intellectual approach to artistic matters and aesthetic debates that had far-reaching implications for the development of art writing.

Venetian writing on art is often considered eclectic and impressionistic in contrast to the more systematic and scientifically oriented approaches characteristic of Florentine art writing. In fact, Venetian art writing constitutes an alternative tradition that is close both to the actual reception of art and the workshop experience of artists. Within this tradition, the perceptions of the non–professional beholder play an important role. Above all, Venetian art criticism and theory is marked by an appreciation of the expressive values and visual pleasures of colour and brushstroke. This distinctly Venetian attitude may be seen in the works of Pietro Aretino, Paolo Pino, and Lodovico Dolce. These writers value the sensual appeal of colour, the qualities of grace and *sprezzatura* (effortlessness), and the inspired touch of the artist. Such a poetics of viewing forms a distinct contrast to Florentine art theory and criticism, which emphasizes a rational approach to art based on the process of *disegno* or drawing, the science of perspective, and the study of anatomy and proportion.

Pietro Aretino was an Italian writer, poet, propagandist, critic, art broker, and collector. Although a Tuscan by birth, he spent the final two decades of his life in Venice, where he counted Titian and Jacopo Sansovino amongst his friends. He is often hailed as the founder of art criticism. A gifted critic rather than theoretician, Aretino captured the values of Venetian painting by recording his emotional response to the

expressive means employed by individual works of art. His descriptions of art works articulate for the first time in Renaissance art criticism the direct visual appeal of colour and brushstroke. Aretino's letters on art exerted a powerful influence on art writing, especially with respect to Titian's painting. Direct evidence of the impact of both specific descriptions and of his mode of criticism in general can be found in writers on art throughout the sixteenth and seventeenth centuries, including Giorgio **Vasari**, Lodovico Dolce, Raffaelo Borghini, Giambattista Marino, Carlo Ridolfi, Francesco Scannelli, and Marco Boschini.

The apparent spontaneity and directness that characterize the conversational tone of Aretino's art criticism are features of the letter form that he used to disseminate his ideas on art. His famous *Lettere*, which appeared in Venice in six volumes between 1537 and 1557, contain over 600 letters on art or artists, most of which were written for publication. Those concerning **Michelangelo**'s *Last Judgement*, and the one to Titian in which Aretino describes a scene on the Grand Canal, are the most well-known. At a time when Venice was the publishing capital of Europe, Aretino represents a new generation of professional writers who wrote in Italian not Latin, and used the press for both instruction and entertainment. The popularity of Aretino's letters attests to a growing interest in artistic matters on the part of the public. Through his letters, Aretino introduced the terminology for art criticism to a new reading Italian public. By focusing on contemporary art, he educated his readers in the reigning artistic styles, stimulated interest in art, confirmed and augmented the international reputation of Titian, and prepared the public for the next generation of painters represented by Tintoretto and Schiavone.

The central value of Aretino's art criticism is naturalism. He uses *ekphrasis*, a descriptive technique drawn from ancient rhetoric, to create word-pictures that conjure up in the minds of his readers the qualities of naturalism, spontaneity, and life-likeness which for him were the supreme values of painting. These characteristics are apparent in his famous description of a view near the Grand Canal that appears in a letter to Titian. In his depiction of the scene he evokes the sunset in terms of Titian's art:

> Oh, with what beautiful strokes the brushes of Nature pushed the azure into the distance ... In some places there appeared a green-blue and in others a blue-green which really seemed as if mixed by the errant fancies of nature ... With lights and shadows she hollowed and swelled whatever she wanted to

swell and hollow; so that I, who know that your brush is the very soul of her soul, burst out three or four times with: 'Oh Titian, where are you now?'

(Klein and Zerner, 55)

Such poetic word-pictures are based on a comparison between art and nature, a time-honoured theme that goes back to the Italian poet Petrarch. Aretino also combines his descriptions of paintings with a practical criticism that evaluates the particular skills of the artist in creating the work. His criticism respects the widely held Renaissance values of invention, decorum, and *disegno* or drawing, and he also reads meaning into facial expressions and gestures. The styles of Michelangelo and Raphael function as critical reference-points. Nevertheless, what sets Aretino's art criticism apart from central Italian writers is his response to the affective value of Venetian *colorito* or the application of colour with the brush. Aretino's descriptions of paintings teach his readers how to respond to colour and brushstroke as qualities central to the expression of emotion.

Paolo Pino was a Venetian painter and art theorist. He was a student of the Brescian artist Giovanni Girolamo Savoldo, who practised primarily in Venice. Pino's *Dialogo di pittura* (Dialogue on painting), published in Venice 1548, represents the first Venetian work of art theory. Indeed, Pino claims that the text is the first published treatise on painting in Italian. Leon Battista **Alberti**'s influential humanist treatise on painting *De pictura* (On painting), although written in the fifteenth century, was not published in its original Latin form until 1540, in Basle. Although the Italian translation was published in Venice in 1547, a year before Pino's treatise appeared in print, the close proximity of the two publications may explain Pino's contention that his was the first published text on painting in Italian. In any case, Pino wrote his treatise on painting not only because of the perceived lack of such works in Italian, but also because of his dissatisfaction with Alberti's text. Pino's criticism of Alberti reveals the key difference in their approaches to painting: according to Pino, Alberti looks at painting as a mathematician, whereas his intention is to write from the perspective of a painter.

The importance of Pino's *Dialogo di pittura* thus lies in the close alliance between theory and practice. Despite the fact that the organization and many of the terms are drawn from Alberti's treatise, Pino's revisions and departures from Alberti's scheme are based both on his Venetian sensibilities and the realities of contemporary artistic

practice. Although the work engages with many of the set themes dear to previous writers on art, such as the nobility of painting, the liberal education of the artist, and the comparison of painting and sculpture, they are presented in a fresh, Venetian context. Pino's organization of the elements of painting to emphasize colour and the process of execution reveals Venetian preoccupations. The importance of the artist's touch in the creative process, the belief that artists are born not made, and Pino's focus on the convincing visual effect of the work rather than on the precise mathematical use of perspective and perspective devices reflects the views of contemporary Venetian artists. Pino's account of the history of art from antiquity to his own time, which includes descriptions of contemporary painters from both Italy and abroad, establishes the author's own attitudes towards painting and is therefore especially valuable for its practical criticism delivered from the viewpoint of a Venetian artist.

Lodovico Dolce worked in Venice, the city of his birth, as a professional 'man of letters'. His writings on art are part of his wider production of publications in the vernacular aimed at a broad audience. His works include texts on marriage, women, memory, gems, love, emblems, Aristotelian philosophy and writings in such diverse genres as history, biography, literary criticism, poetry, and drama. He also produced translations and editions of other authors' works. In the realm of art, he wrote several important letters on artistic matters: a dialogue on colour entitled *Dialogo nel quale si ragiona della qualità, diversità e proprietà dei colori* (Dialogue in which is discussed the quality, diversity, and character of colours), published in Venice in 1564, and the work upon which his reputation as an art critic depends, the *Dialogo della pittura intitolato l'Aretino* (Dialogue on painting, called Aretino), published in Venice in 1557. There is some debate as to the degree to which the dialogue presents the views of Pietro Aretino after whom it is named, since Dolce knew Aretino, and edited his letters for publication. As a writer on artistic matters, Dolce represents the ideal depicted in Castiglione's *The Book of the Courtier* (*Il libro del cortegiano*, Venice 1528) of the enlightened, non-artist critic, a role reflected in Dolce's promotion of the right 'of certain men of fine intelligence' to judge art.

The discussion in the dialogue covers three more or less distinct topics: the nobility of painting; the elements needed for perfection in painting including ancient and modern examples; and the art of Titian. Many of Dolce's ideas are shaped either by rhetorical theory or central Italian art theory and criticism. His approach to composition and historiography is informed by Florentine art criticism and theory. Dolce recommends to the reader both Leon Battista Alberti's *Della*

pittura and Giorgio Vasari's *Vite*, two Florentine works published just a few years before the *Aretino*. From these authors Dolce draws his ideas about the *istoria* or narrative, the value of diligence, and the role of the works of antiquity and the great masters in the formation of style. However, what makes Dolce's writing uniquely Venetian is his focus on the artistic qualities that join together the genius and touch of the artist (*giudizio naturale, facilità,* and *sprezzatura*), with beauty that goes beyond commensurate proportion (*grazia* and *vaghezza*). He presents these concepts in the context of his polemical promotion of the naturalism of Venetian colourism exemplified by the art of Titian. For Dolce, the supreme test of an artist is not in drawing figures but in rendering human flesh and other substances of nature. According to Dolce, although many painters are proficient in drawing and invention, Titian alone represents perfect *colorito* (the act of applying colour). In the *paragone* or comparison between the art of Raphael, Michelangelo, and Titian which forms the central theme of the dialogue, the values of grace, nonchalance, and naturalism of colour lead Dolce to place the art of Raphael above Michelangelo, and to elevate the art of Titian, as chief representative of the Venetian school, above central Italian art.

Biographies

Pietro Aretino was born on 19 or 20 April 1492 in Arezzo, the son of a shoemaker. He lived in Perugia from before 1510–17 and moved to Rome *c.* 1517 after a brief period in Siena, joining the household of Agostino Chigi. He was valet to Pope Leo X and part of the circle of Cardinal Giulio de Medici. In 1522 he travelled to Bologna, Arezzo, Florence, Mantua, and Reggio, where he entered the service of the *condottiere* Giovanni delle Bande Nere. He returned to Rome in 1523 upon election of Cardinal Giulio de Medici to the Papacy (Clement VII). In 1524 he fled Rome when involved in a scandal over erotic poems he had written to accompany engravings of *modi*, or sexual positions, drawn by Giulio Romano. He sojourned briefly at the court of Duke Federico Gonzaga in Mantua before moving to Venice 1527. He died in 1556 in Venice.

Paolo Pino was born, lived, and died in Venice, *fl.* 1534–65. He was a pupil of the painter Giovanni Girolamo Savoldo.

Lodovico Dolce was born 1508 in Venice into a noble but impoverished Venetian family, the son of a state secretary who had

served as a *castaldo delle procuratorie* or steward to the public attorneys for the republic of Venice. He studied in Padua and worked as a professional writer in Venice, mainly for Giolito press. He died in January 1568 in Venice.

Bibliography

Main texts

Pietro Aretino:
Lettere sull'arte di Pietro Aretino, F. Pertile and E. Camesasca (eds), 3 vols, Milan, Edizioni del milione, 1957–60.
Paolo Pino:
Dialogo di pittura, R. Pallucchini and A. Pallucchini (eds), Venice, Edizioni de Guarnati, 1946.
Dialogo di pittura, in *Trattati d'arte del Cinquecento fra manierismo e controriforma*, P. Barocchi (ed.), vol. I, Bari, G. Laterza, 1960.
Paolo Pino's 'Dialogo di pittura': a translation with commentary, Mary Pardo, Ph.D. dissertation, Pittsburgh, 1984.
Dialogo di pittura, Susanna Falabella (ed.), Rome, Lithos, 2000.
Lodovico Dolce:
Dialogo della pittura intitolato l'Aretino, in *Trattati d'arte del Cinquecento fra manierismo e controriforma*, P. Barocchi (ed.), vol. I, Bari, G. Laterza, 1960.

Secondary literature

Anderson, J., 'Pietro Aretino and sacred imagery', in *Interpretazioni veneziane: Studi di storia dell'arte in onore di Michelangelo Muraro*, David Rosand (ed.), Venice, Arsenale Editrice, 1984.
Barasch, Moshe, *Light and Color in the Italian Renaissance Theory of Art*, New York, New York University Press, 1978.
Bernabei, Franco, 'Tiziano ed Ludovico Dolce', in *Tiziano e il manierismo europeo*, R. Pallucchini (ed.), Florence, Leo S. Olschki Editore, 1978.
Cairns, Christopher, *Pietro Aretino and the Republic of Venice*, Florence, Leo S. Olschki Editore, 1985.
Gilbert, Creighton, 'Antique frameworks for Renaissance art theory: Alberti and Pino', *Marsyas* 3 (1943), pp. 87–106.
Klein, Robert and Zerner, Henri, *Italian Art 1500–1600: Sources and Documents*, Englewood Cliffs, NJ, Prentice-Hall, 1966.
Labalme, Patricia, 'Personality and politics in Venice: Pietro Aretino', in *Titian: His World and His Legacy*, David Rosand (ed.), New York, Columbia University Press, 1982.
Land, Norman E., 'Ekphrasis and imagination: some observations on Pietro Aretino's art criticism', *Art Bulletin* LXVIII (June 1986), pp. 207–17.
—— *The Viewer as Poet: The Renaissance Response to Art*, University Park, Pennsylvania, The Pennsylvania State University Press, 1994.
Palladino, A. Lora, *Pietro Aretino: Orator and Art Theorist*, Ph.D. dissertation, Yale University, 1981.
Pardo, Mary, 'Testo e contesti del "Dialogo di pittura" ', in *Paolo Pino teorico d'arte e*

artista: il restauro della pala di Scorzè, Angelo Mazza (ed.), Scorzè, Treviso, Grafiche Italprint, 1992.

Pozzi, Mario, 'L'ut pictura poësis in un dialogo di L. Dolce', in *Lingua e cultura del cinquecento. Dolce, Aretino, Machiavelli, Guiciardini, Sarpi, Borghini*, Padua, Liviana Editrice, 1975.

Rosand, David, 'Titian and the critical tradition', in *Titian: His World and His Legacy*, David Rosand (ed.), New York, Columbia University Press, 1982.

—— *Painting in Sixteenth-Century Venice: Titian, Veronese, Tintoretto*, Cambridge and New York, Cambridge University Press, 1997.

Roskill, Mark W., *Dolce's 'Aretino' and Venetian Art Theory of the Cinquecento*, Toronto, University of Toronto Press (in association with the Renaissance Society of America), 2000.

Terpening, Ronnie H., *Lodovico Dolce, Renaissance Man of Letters*, Toronto, University of Toronto Press, 1997.

ERIN J. CAMPBELL

GIORGIO VASARI (1511–74)

ITALIAN PAINTER, ARCHITECT, AND ART HISTORIAN

Giorgio Vasari is often referred to as the father of art history. A painter and architect, he is best known as the author of the *Vite*, or *Lives of the Artists* (*Le vite de piu eccellenti architetti, pittori, et scultori italiani, da Cimabue insino a' tempi nostri* – The lives of the most excellent Italian architects, painters and sculptors, from Cimabue to our own times), first published in Florence in 1550, then revised and expanded in the 1568 edition (the only one to have been translated into English).

Vasari claims that he was inspired to write his book in 1546, during a gathering of humanists in Rome, which included his friend and adviser, the historian Paolo Giovio. Giovio had written a few brief biographies of artists in Latin, but Vasari pointed out to him that an artist would be able to offer a more practical understanding of the manner in which artists worked. Giovio persuaded Vasari to take up the task. Vasari had been conducting research on his own before this date, and his story of the book's genesis is at least in part a fiction; none the less, Giovio was a major influence on Vasari's writing and advised him on the first edition of the book.

Vasari's *Lives* combines a number of different ways of writing about the visual arts, based in part on ancient Roman rhetorical and literary genres. The *Lives* begins with a dedicatory letter to Duke Cosimo I. This is followed by a preface that, while it is not a technical manual, gives information for the non-artist about terminology and difficulties

associated with the techniques employed by artists in painting, sculpture, architecture and their affiliated arts (including, for example, copperplate engraving, stained glass, bronze casting, and the methods of vaulting).

The technical preface is followed by artists' biographies, divided into three chronological sections corresponding roughly to the fourteenth, fifteenth and sixteenth centuries. Each of these three sections also begins with a preface. It is in these prefaces that Vasari explains the underlying themes of his book. Among the most important concepts is the application of a biological model of history. He says that the arts, 'like human bodies, have their birth, their growth, their growing old, and their death'. The visual arts, which fell into decline after the perfection of Antiquity, experienced a rebirth during the time of the late thirteenth-century painter Cimabue. Vasari adds that one of the purposes behind the *Lives* is to ensure that, if the arts ever fall into decline again, artists will recognize how to revive them.

In Vasari's understanding, artists of the first age, beginning with Cimabue and Giotto, revived the visual arts through direct observation and imitation of the natural world. Vasari employs ideas derived from Pliny's *Natural History* (first century AD), especially an emphasis on artists who were the first to invent techniques or to employ stylistic advances. Thus, Giotto is praised as the first artist to clearly express human emotions. In the second age, which included figures such as Masaccio, **Ghiberti**, Donatello and Botticelli, artists improved both in inventiveness and the execution of their works, through careful observation of nature and the application of 'good rule, order, proportion, design, and style'. However, artists of this period relied too much upon close study and correct measurement and thus their works became dry and harsh, lacking in spontaneity and gracefulness. These qualities were provided by artists of the third age, beginning with **Leonardo da Vinci**, who benefited from seeing graceful examples of antique sculpture such as the *Laocoön* (discovered in 1506). These later artists, culminating in **Michelangelo**, employed a visual judgement that went beyond mere rules.

Of particular interest in Vasari's prefaces is his explanation of the concept and practice of *disegno*, a word that means both design and drawing. An artist achieves *disegno* by imitating the most beautiful things in nature and by combining parts of several beautiful human bodies into one ideal figure. This idealized figure then becomes the model for all the figures he subsequently creates. It is this ability to idealize that was especially important for the perfection of art in the third age. In the 1568 edition of the *Lives*, Vasari added a passage explaining in more detail the importance of *disegno* as the foundation,

or father, of painting, sculpture, and architecture. *Disegno* has its origin in the intellect. It recognizes proportionality in nature, and allows the artist not only to perceive numerical relationships between existing things, but also to create mental images of abstract universal forms – things that do not exist until the skill of the artist's hand can create them. In effect, *disegno* is the underlying principle of art and of nature, and the source of artistic judgement.

Vasari also explains in his prefaces that he did not want merely to provide lists of works of art and their locations (though he does supply this information); rather, he had two major goals. The first was to 'distinguish the better [artists and styles] from the good and the best from the better', and to help his readers understand 'the causes and the origins of the various styles and of the improvement and deterioration in the arts that has occurred at various times and in different individuals'. The second was to write the lives of artists so as to ensure their fame, and save them from the 'second death' of oblivion. In his view, 'the purpose of history is in making men prudent and teaching them how to live'. As was true of most Renaissance biographical writing, Vasari's biographies are constructed in a manner similar to ancient lives of illustrious men (such as Plutarch's *Lives*), whose actions are meant to provide exemplary lessons for the reader. Vasari works within the tradition of epideictic rhetoric, in which the major focus is the assigning of praise and blame. Thus, in the first edition of his book, each biography begins with a moralizing introduction, and ends with a poetic epitaph (often fictional). Due in part to the influence of his friend and adviser, the historian and philologist Vincenzo Borghini, Vasari in the second edition of the *Lives* softened the moral introductions to many of the biographies, and eliminated the epitaphs, but he did not eradicate the exemplary content. Raphael, for example, is, in Vasari's text, the ideal courtier-artist, the incarnation of magnanimity and gracefulness, always surrounded by adoring disciples; while Michelangelo, whose mastery of all three arts of *disegno* assures his position as the pre-eminent artist, embodies *terribilità* or awe-inspiring grandeur. Other artists provide less laudatory examples: Piero di Cosimo, who takes little care about his appearance or his mode of living, is an uncivilized eccentric, and his paintings equally are full of strange fancies; while Andrea del Castagno is accused (unjustly) of murdering his friend and rival Domenico Veneziano out of envy of his skill in using colour.

The biographies also explain facets of each artist's training, style, and artistic methods, whether praiseworthy or otherwise. One of Vasari's aims was to show that proficiency in art could be acquired

through diligence and training. He often provides lists of each master's best-known pupils, and also emphasizes how artists may train themselves by judiciously imitating the work of others. For example, in an addition made to Raphael's life in 1568, Vasari explains at length how Raphael acquired his own style through the successive imitation of the best characteristics of other artists' works: his master Perugino's sweetness; Leonardo's expressiveness and liveliness; Michelangelo's knowledge of anatomy and foreshortening; and the pleasant colouring and tonal qualities of Fra Bartolommeo. According to Vasari, Raphael had to acknowledge he would never be able to rival Michelangelo's mastery of the nude male figure, so he decided to excel in other skills. Vasari concludes:

> every man should be satisfied with doing willingly those things to which he feels inclined by natural instinct, and should not seek, out of competition, to put his hand to that which has not been given him by nature, in order not to labour in vain, and often to his shame and loss.

In the artists' biographies, Vasari often describes specific works of art, usually with an emphasis on their narrative qualities. Vasari usually begins his descriptions by seizing on compelling details that make the story as vivid as possible. Through the sheer accumulation of such details, the reader is invited to imaginatively reconstruct the picture in his own mind, including the emotional effect of viewing it. In his description of Giulio Romano's decoration of the *Room of the Giants* at the Palazzo del Tè in Mantua, for example, Vasari begins by describing the strange and unsettling shape of the room itself. He then provides details of the deities painted in dramatic foreshortening in the vault and the malformed giants on the walls below near the fireplace, which, when in use, makes the giants appear to be on fire. He ends by appealing to the reader's increasing sense of terror: 'Whoever enters that room and sees the windows, doors and so forth all distorted and apparently hurtling down, and the mountains and buildings falling, cannot but fear that everything will crash down upon him.' The function of these descriptions is, as **Alberti** had said about works of art themselves, 'to make the absent present'.

The first (1550) edition of the *Lives* began, in the preface to the first part, with a description of God creating the world; it ended with the only biography accorded to a living artist – Michelangelo – and his frescoed depiction of the *Last Judgement*. Thus Vasari's book, in its initial form, also echoed the entire scheme of history within a

Christian context. This unity of conception is somewhat lost in the 1568 edition, but it is replaced with large amounts of new information and a greater emphasis on historical accuracy. The technical preface was expanded by about 15 per cent, and more biographies were added, including those of several living artists. Partly due to the influence of Borghini, Vasari provided more data about patrons and collectors, and also expanded his discussion to artistic centres outside Florence and Rome (in 1566 he travelled throughout Italy collecting information about other cities). He also inserted independent 'discourses', sometimes disguised as biographies, on subjects including the history of printmaking and the engraving of gems and cameos. Many of these additions, and the insertion of new theoretical material such as his expanded discussion of *disegno*, may be attributed to Vasari's involvement with the founding in 1563 of the first state-sponsored school for the training of artists, the Florentine *Accademia del Disegno* (Academy of Design). The 1568 edition also included woodcut portraits of the artists.

Vasari's *Lives* had an immediate and profound impact, generating many similar biographical studies of artists, and many polemical responses. The 1550 edition soon sparked, among other things, a new biography of Michelangelo published by his pupil, Ascanio Condivi (1553), and the dialogue *Aretino* by the Venetian Lodovico **Dolce** (1557). The latter offered an alternative to Vasari's emphasis on *disegno*, by suggesting that invention and colouring were equally important divisions of painting. Vasari's tendency to focus on artists from Tuscany and Rome as most praiseworthy drew criticism from many later commentators, including the Bolognese Carracci family of painters, who made outraged marginal notations in their copy of the *Lives*, and their seventeenth-century biographer Count Cesare Malvasia (*Felsina pittrice, Vite de' pittori Bolognese*, 1678). Within the century following the publication of the *Lives*, numerous similar histories of art appeared in Italy, such as Giovanni Pietro **Bellori**, *Le Vite de' pittori, scultori ed architetti moderni* (1672), and Filippo Baldinucci, *Notizie de' professori del disegno da Cimabue in qua* (1681); and in several other countries, including Karel van **Mander**, *Schilderboeck* (1604), and Joachim von Sandrart, *Teutsche Academie* (1675). Vasari's *Lives* remains an indispensable primary source for the study of Renaissance art.

Vasari also authored less influential writings, including a description and explanation of his decoration of the Palazzo Vecchio, the *Ragionamenti*, which was published by his nephew and heir, Giorgio Vasari the Younger, in 1588; and a substantial and informative body of

correspondence. He claimed to have written a dialogue on art based on his discussions with Michelangelo, which he planned to publish, but this has been lost.

Biography

Giorgio Vasari was born in Arezzo, baptized on 30 July 1511. Taught at school in Arezzo, he began training as an artist with a French glass-painter in 1519. He went to Florence in 1524 to study with Medici heirs. In 1532 he studied in Rome. He was in the service of Alessandro de' Medici from 1532–7. He painted for Olivetan patrons from 1537–40 and 1544–6. He worked for Pietro **Aretino** in Venice 1541. He cultivated a friendship with Michelangelo in Rome 1542–4, and painted for Julius III from 1550–3. In 1555 he began the redecoration of Palazzo Vecchio, Florence, for Duke Cosimo I de' Medici. Beginning in 1560 he was Architect of the Uffizi. In 1563 he was one of the founders of the Florentine Accademia del Disegno. He began the frescoes of the *Last Judgement* in Florence's Duomo in 1572. He died 27 June 1574 in Florence.

Bibliography

Main texts

Two modern translations of Vasari's *Vite*:
Artists of the Renaissance: A Selection from Lives of the Artists, trans. George Bull, New York, Viking Press, 1978.
Lives of the Painters, Sculptors and Architects, 2 vols, trans. Gaston du C. DeVere, with an introduction and notes by David Ekserdjian, New York and Toronto, Alfred A. Knopf, 1996.
Correspondence:
Frey, K. and H.W. (eds), *Der literarische Nachlass Giorgio Vasaris*, Munich, 1923–40; repr. Hildesheim, 1982.

Secondary literature

Alpers, S., '*Ekphrasis* and aesthetic attitudes in Vasari's *Lives*', *Journal of the Warburg and Courtauld Institutes* 23 (1960), pp. 190–215.
Barolsky, Paul, *Giotto's Father and the Family of Vasari's Lives*, University Park, Pennsylvania State University Press, 1992.
Boase, T.S.R., *Giorgio Vasari: The Man and the Book,* Princeton, Princeton University Press, 1979.
Cast, David, 'Reading Vasari again: history, philosophy', *Word & Image* 9 (1993), pp. 29–38.
Goldstein, Carl, 'Rhetoric and art history in the Italian Renaissance and Baroque', *Art Bulletin* 73 (1991), pp. 641–52.
Jacks, Philip (ed.), *Vasari's Florence: Artists and Literati at the Medicean Court*, New York, Cambridge University Press, 1998.

Kallab, W., *Vasaristudien*, J. von Schlosser, Karl Graeser and B.G. Teubner (eds), Vienna and Leipzig, 1908.

Le Mollé, Roland, *Georges Vasari et le vocabulaire de la critique d'art dans les 'Vite'*, Grenoble, Ellug, 1988.

Rubin, Patricia, *Giorgio Vasari: Art and History*, New Haven and London, Yale University Press, 1995.

Exhibitions:

Giorgio Vasari: Principi, letterati e artiste nelle carte di Giorgio Vasari. Pittura vasariana dal 1532 al 1554, Sottochiesa di S. Francesco, Arezzo, 1981; catalogue published Florence, Edam, 1981.

SHARON GREGORY

GIOVAN PAOLO LOMAZZO (1538–1600) and FEDERICO ZUCCARO (1543–1609)

ITALIAN POET, THEORIST AND ARTIST

ITALIAN ARTIST, ACADEMICIAN AND THEORIST

The influence of rhetoric on Italian writing about the visual arts remained a major source of aesthetic vocabulary from the fifteenth to the seventeenth century. This made explanations of artistic content more accessible to the educated readership for whom a rhetorical training comprised a substantial part of the secondary school curriculum. Increasingly, the status of the visual arts was regarded by their apologists as on a par to that of the Liberal Arts, confirming the Classical topos of *ut pictura poesis* – 'as in painting, so in poetry' – and the analogy with rhetoric in their visual translation of an inventive idea, while contradicting their customary categorization as mechanical arts concerned with actions and material objects as often but not always stated in Classical sources. Skill had become a quantifiable factor in the assessment of the visual arts during the fifteenth century and **Vasari** had presented artistic versions of some Renaissance stereotypes of outstanding *virtù* (ability or prowess): **Leonardo da Vinci** as an artistic *uomo universale* (universal man); Raphael as the facile and elegant *cortegiano* (courtier); and **Michelangelo** Buonarotti as the divinely inspired, melancholic genius beset with *terribilità*. The foundation of the Accademia del Disegno at Florence in 1563 marked the first formal standardization of the artists' education in anatomy, perspective and similar subjects. Hitherto they had trained as artisan-apprentices in workshops. The academies for the visual arts in Florence, Bologna and Rome by the end of the century were closely connected with the local academies for the liberal arts, and some artists

with poetical propensities were members of both institutions, but it should be noted that no visual artist was elected to a literary academy on account of their visual work.

Several literary academicians tried their hand at writing about the visual arts, partly as an exercise in the old topos of the *paragone* or comparison between the arts; partly in order to extend the systemization of the arts and aesthetic experience. These writers and lecturers borrowed philosophical references, predictably from the main university authority, **Aristotle**. In the standard university text of moral philosophy, the *Nicomachean Ethics*, he had consigned art to the lowest level of intellectual activity, beneath prudence in the practical reason. According to Aristotelian psychology, sense impressions were relayed via the synthesizing 'commons sense' to the reasoning brain by the *fantasia* or imagination. This, together with memory, also assisted in the reassembly of sense-based images for mimetic plastic arts at the behest of artistic reasoning. All these mental activities were internal senses according to Aristotelian faculty psychology. The Italian translation and series of commentaries on the *Poetics* of Aristotle from the mid sixteenth century undoubtedly assisted the philosophical reconsideration of art's veristic, mimetic and affective qualities; while Aristotelian natural philosophy and medicine provided a model for combining theory and practice in expositions of the visual arts. That said, the most immediately practical guide addressed to artists after Vasari, the *De' veri precetti* of the painter-priest Giovanni Armenini of 1587, largely eschewed speculation in favour of delineating the appropriate subjects, colours and styles for public and private spaces.

Against this background we should set the writings of two other painters, both closely connected with academies, who reflected philosophically at no small length upon their activity, while trying in different bombastic ways to accord visual art a universal relevance, which was normally attributed to philosophical contemplation in the case of Lomazzo or to the reasoning mind, νοῦς (noûs), in the case of Zuccaro. Both cases would have some precedent for their reinterpretations of philosophical orthodoxy in literary criticism, humanist moralizing and guides to various practical topics (letter-writing, duelling, nobility). Previously, Leonardo had suggested that drawing might be regarded as a tool of inductive natural science, but he and other art writers remained conscious of the Aristotelian hierarchy of the intellectual faculties. Philosophical contemplation involved mental activity that was in its ideal form the human equivalent of divine thought (and therefore Thomas **Aquinas** had likened it to theology); it was the apogee of those arts pursued in *otium* (leisure). It had true

first principles as its object: whereas the productive arts, such as architecture, were subsidiary to the architectonic art of the active life, and politics were subject to chance and error. Aristotelian psychology was interpreted according to the Platonic or peripatetic leanings of the commentators: either ideas were channelled from above the actively reasoning soul, drew on sense-data below, or else divinely inspired mental faculties detached from their source engaged with the sensory material. For the visual arts, the ambivalent meanings of some Aristotelian terms did not help. For instance αἴσθησις (aisthesis) could refer to sensory and mental perception. The Thomist tendency to use Neoplatonic metaphors about 'shafts of divine light' in the mind were sometimes treated literally by Federico Zuccaro to indicate not merely the likeness of God in us but an active direct link in thought. Subsequent writers such as Agucchi (published 1646), Ridolfi (1648), **Bellori** (1664) and Volpato (1685) gave lofty Neoplatonic accounts of the descent of a design to the artist's brain from an abstract Ideal Form which the best artists could transfer to the appearance of the work. During the sixteenth century, the inherent contradiction of Neoplatonic descriptions of physical appearance had already been recognized in respect of the much eulogized 'temple' of beauty, Giovanna d'Aragona, besides less respectable ladies of note.

Giovan Paolo Lomazzo was a Milanese painter, writer and minor noble, sometime president of a psuedo-rustic literary academy, 'Delle Valle di Bregno', who went blind in 1571. His poetry appeared in print in the 1580s, his *Trattato della pittura* (Treatise on painting) was published in 1584, while the *Idea del tempio della pittura* (Idea of the temple of painting) appeared in 1590. A collection of imaginary dialogues on artistic topics remained in manuscript, but appears to date from 1565 and 1571. The *Trattato* is a relatively plain guide to picture-making with a theoretical and historical preface followed by seven books dealing respectively with proportion; movement, which is connected to decorum; colour; light; perspective; composition and form. In typical humanist manner, the *Trattato* contains a considerable amount of quotation, paraphrase and argument *ex auctoritate*, but the shorter *Idea* employs similar and additional sources for the altogether grander project of establishing painting as a microcosmic equivalent of cosmic perfection, drawing on Ficinian Platonism and Hermeticism, the memory theatre of Giulio Camillo, sympathetic magic derived from the *De occulta philosophia* of Heinrich Cornelius Agrippa, together with a large number of literary texts Classical and modern, to achieve this. It has been suggested that the *Idea* was composed out of material originally intended as prefaces for the *Trattato*, and that both

texts were repeatedly redrafted, with the bulk of the *Idea* written by the time that the *Trattato* was published. However, the extant *Idea* is clearly a later work, containing a number of deliberate changes even at the level of vocabulary: for instance, 'prudence' is systematically replaced by 'discretion' as the word for artistic judgement; as well as different borrowings, such as a wider range of Ficinian texts. It also has a more complex structure.

First, the *Idea* elaborates the formal definition by division into genus and species already found in the *Trattato*, where Lomazzo declares his demonstration will be in accordance with the order of doctrine where first principles are followed by their applications in contrast to natural order ascending from particulars towards the universal. In the *Idea* he explains that the first five of the component parts of painting are designated as theoretical and last two as practical subjects, with knowledge of the subsequent chapters being dependent on those preceding. Second, the components are arranged according to their metaphysical ranking corresponding to the sub-lunar and celestial worlds. The first five belong here below, on earth, and last two in heaven. The linking of epistemology with metaphysics may be compared to the controversies between the contemporary Paduan university professors, Francesco Piccolomini and Jacopo Zabarella, and continued through influential publications. Third, the *Idea* establishes a series of numerological associations between the best modern artists, the 'Seven Governors': Michelangelo, Gaudenzio Ferrari, Polidoro da Caravaggio, Leonardo da Vinci, Raphael, Mantegna and Titian; the astrological planets determining their respective temperaments; the component parts of painting of which they were adept; and the architectural features of an imaginary temple. Whereas Lomazzo had mentioned the influence of the planets on emotional states of represented figures in the *Trattato*, in the *Idea* he assigns each of the Governors an animal that personifies the effect of their planetary sign on the form of their work, arguing that these characteristics also had equivalent mathematical harmonies of proportion. In an unpublished treatise, the rhetorician and alchemist, Giulio Camillo had equated model Latin authors with the astrological planets as talismans of good taste. Camillo's *Idea del Theatro* (Idea of the theatre), first published in 1550, gathered encyclopaedic knowledge into an imaginary colosseum. Ultimately, both Lomazzo and Camillo depend on the Platonizing text the *Pimander* which described the planets as the product of the demiurge combining fire and air. This third-century Greek text attributed to a fictitious Egyptian, Hermes Trismegistus, had been translated by Marsilio Ficino in the fifteenth

century. The aim of this elaborate system in Lomazzo's theory is to overcome the contradiction between ideal beauty and its physical embodiment. Lomazzo sought to transcend the inherent imperfection of material form by ensuring a concord of its diverse ideal models and by providing as comprehensive direction as possible as to how artists could achieve this in their own work. Thus, besides a pictorial alchemy inspired by Marsilio Ficino's writings, Lomazzo lays down detailed prescriptions about the iconographic treatment of individual subjects as well as the appropriate qualities for the best painting. The main task of the artist was to determine how to achieve this ideal eurhythmy in the picture design with appropriate decorum in the composition and a correct representation of the subject. By definition, a stylistic synthesis of the seven Governors should perfectly encompass all possible forms.

Federico Zuccaro, together with his brother Taddeo, was widely employed as a Mannerist painter with a reputation for grand narrative and allegorical pictures. Having unsuccessfully proposed a curriculum including maths, physics and life drawing at the Florentine Accademia del Disegno, Federico Zuccaro was appointed president of the Accademia di San Luca at Rome, under the auspices of Cardinal Federigo Borromeo in 1593. The early historical account of the lectures and public debates held at that academy illustrate Zuccaro's emphasis on artistic theory, notwithstanding that by the middle of the decade the initiative was losing its audience. Zuccaro's own theoretical views were presented in three contexts: iconographical schemes depicting the status of the visual arts among liberal arts and virtues, notably inside his own Roman Palazzo; a long, poetical 'lament on the condition of painting'; and an encyclopaedic treatise known as the *Idea de' pittori, scultori ed architetti* (The Idea of Sculptors, Painters and Architects) (1607). Zuccaro was neither as well-read nor as comprehending as Lomazzo, although his scheme was simpler. Zuccaro elaborates a few basic notions culled from Aristotelian-based philosophy: first, that there was a hierarchy to thought; second, that *disegno* (design) could be equated not only to the inventive rhetorical idea, but also to reason in its wide diversity of forms. Where Aristotle talked about νοῦς, usually translated in Latin as *ratio* (reason), Zuccaro read *disegno* and accordingly the sort of thinking that artists engaged in could extend from contemplation to carving sculpture. Zuccaro also reinterpreted the Aristotelian distinction between internal and external senses in order to distinguish the process of mental visualization from working out how to execute the design in matter, whether in painting, sculpture or architecture. A similar distinction

had been used in a discourse addressed to the 'Christian Painter' by the reformist Cardinal of Bologna. In paraphrasing Aristotelian accounts of intellection, Zuccaro distinguishes between moral, artificial and natural *disegno*. Like contemporary writers on poetics and rhetoric, he allows for different degrees of imitation relative to invention and truth. Except where carried away by the divine light metaphor, Zuccaro endeavoured to maintain the orthodox view of the primacy of sensory impressions to which the *disegno intellettivo* (intellectual design) served as a qualitative scrutineer. The ideas of God or angels, being unlimited by matter, were necessarily better. Zuccaro was concerned to make the visual arts appear doctrinally as well as intellectually respectable: the ecclesiastical patron of the Accademia di San Luca was to publish his own Tridentine guide to religious art. Zuccaro's *Idea* was dedicated to the Duke of Savoy, an amateur practitioner, who also received the dedications of Lomazzo's *Trattato* and Giambattista Marino's *Dicerie sacre* in 1610. The *disegno interno* (internal design) and *esterno* (external) mentioned in Marino's account of painting almost certainly derive from Zuccaro.

As often in the Renaissance history of ideas, the individual occurrence of particular themes should be distinguished from its general currency. While both authors were read subsequently and philosophical comparisons were made, no Italian authors of the seventeenth century made similar claims. A number of literary critics produced treatises on a comparable grandiose scale to these texts, most notably the *Poetics* of Julius Scaliger. However, both Lomazzo and Zuccaro had indirect connection with the poet-philosopher Torquato Tasso and may reflect a more specific distribution of themes. A mutual poetical friend of Lomazzo and Tasso published a dialogue in 1591 about the functions and values primarily of visual art which was named after one of the speakers, a pupil of Lomazzo, Figino. Again, with reference to the writings of Marsilio Ficino among others, there is discussion about the truthfulness of art. Tasso wrote a dialogue on art and nature imagined as a conversation between members of the circle of Ficino and named after him. By this time Tasso shared a curial patron with Federico Zuccaro in Rome. And like Zuccaro, Tasso's characters debate whether God's creativity is the same as that of human artists. Both Lomazzo and Zuccaro develop a similar answer to Tasso by referring to God's providence as the divine complement to human prudential action. The *Trattato* of Lomazzo was translated into English by 1598. It was repeatedly mentioned during the seventeenth century, and broadly, the relative degree of idealism among Italian art writers can be gauged by whether they draw on the *Idea* as well as the *Trattato*

of Lomazzo. The French painter, Nicolas Poussin, quotes from the *Idea* in his definition of a pictorial beauty comprised of 'order, mode and space', which in turn came from Ficino's commentary on **Plato**'s *Symposium*. But by this time Platonism had fallen out of fashion in Italian university teaching of philosophy. Somewhat less prominently, Zuccaro's treatise continued to be cited in support of the liberal status of the visual arts and in comparisons between art and moral virtue. More especially his academy, despite temporary closure, had established a forum for more vigorous self-justification among artists, as well as a common language with connoisseurs. While later artist-apologists did not claim that their profession was philosophy, they were more ready to assume that it had a theoretical base at least related to mathematics, physics and ethical judgement.

Biographies

Giovan Paolo Lomazzo was born in 1538, probably near Saranno. He trained under Gaudenzio Ferrari and had contact with the famous doctor and autobiographer, Girolamo Cardano, and also Melzi, owner of Leonardo da Vinci's notebooks. He became 'Prince' of the Accademia della Valle del Blenio in 1568. In 1571 he went blind. His *Trattato della pittura* was published in 1584; his *Rime* in 1589; his *Idea del tempio della pittura* in 1590. His other writings remained in manuscript. His pupil Figino was the subject of a related dialogue by Canon Antonio Comanini in 1592. He died in 1600.

Federico Zuccaro was born in 1543, at Sant'Angelo near Urbino. He trained as a painter with his brother Taddeo, then executed commissions in Venice, Lombardy and Florence, where he attempted to reform the nascent Accademia del arte in 1565. In 1567 he took over the painting of the interior decoration of the Villa of Caprarola, near Viterbo. In 1574 he travelled in France, the Netherlands and England. He was appointed in 1580 to paint the Cappella Paolina by Gregory XIII. From 1585–9 he worked for Philip II of Spain. Returning to Rome, he refounded the Accademia di San Luca in 1593 and served as its President. Developing from his lectures at the academy were the *Origine et progresso dell'Accademia del Dissegno de' pittori, scultori et architetti di Roma* (Origin and Progress of the Academy of Design of the Painters, Sculptors and Architects of Rome) (1604); the following year *Lettera a prencipi et signori amatory del dissegno...* (A Letter to Princes and Gentlemen Enthusiasts of Design...). *L'Idea de'scultori, pittori e architetti* was published in 1607. He died in 1609.

Bibliography

Main texts

Lomazzo, G.P., *Trattato della pittura*, trans. Richard Haydocke as *A Tracte Containing the Artes of Curious Paintinge*, Oxford, 1598.

—— *Scritti sulle arti*, R.P. Ciardi (ed.), 2 vols, Florence, Centro Di, 1974.

Zuccaro, F., *Scritti d'arte di Federico Zuccaro*, D. Heikamp (ed.), Fonti per lo studio della storia dell'arte inedite e rare, 1, Florence, Il Cenacolo, 1961.

Secondary literature

Acidini Luchinat, C., *Taddeo e Federico Zuccari, fratelli pittori del Cinquecento*, 2 vols, Rome, Jandi Sapi Editori, 1999.

Ackermann, G., 'Lomazzo's treatise on painting', *Art Bulletin* 49 (1967), pp. 317–23.

Armenini, G.B., *De' ueri precetti della pittura libri tre*, Ravenna, Francesco Tebaldini, 1587; reprinted Hildesheim and New York, Olms Verlag, 1971.

Chambers, D.S. and F. Quiviger (eds), *Italian Academies of the Sixteenth Century*, London, The Warburg Institute, 1995.

Ferrari-Bravo, A.M.P., '"Il Figino ovvero de Fine della Pittura" di Gregorio Comanini', *Storia dell'Arte*, 13 (1972), pp. 57–66.

Michels, N., *Bewegung zwischen Ethos und Pathos zur Wirkungsästhetik italienischer Kunstheorie des 15 und 16 Jahrhunderts*, Münster, LIT Verlag 1988.

Ossola, C., *Autumno del Rinascimento 'Idea del Tempio' dell'arte nell'ultimo Cinquecento*, Florence, Leo S. Olschki Editore, 1971.

Panofsky, E., *Idea: A Concept in Art Theory* (*'Idea': ein Beitrag zur Begriffsgeschichte der alteren Kunsttheorie*, 1924), trans. J.J.S. Peake, New York, Harper & Row, 1968.

Spruit, L., *'Species intelligibilis': From Perception to Knowledge*, 2 vols, Leiden, New York and Cologne, E.J. Brill, 1994–5.

Weinberg, B., *A History of Literary Criticism in the Italian Renaissance*, 2 vols, Chicago, Chicago University Press, 1961.

NICK WEBB

KAREL VAN MANDER (1548–1606)

NETHERLANDISH PAINTER AND WRITER

Published in Haarlem in 1604, after ten years of research and writing, Karel van Mander's *Schilder-Boeck* (Book on picturing) offered the first fully formed theory of Netherlandish painting, drawing, and printmaking. Developing critical categories culled from Latin and vernacular sources, including humanist texts, workshop usage, and Italian treatises, van Mander embedded them in a historical scheme, using terms such as *inventie* (invention), *teyckenconst* (the art of delineation), and *wel verwen* (the art of colouring well) to chronicle the

history of Dutch and Flemish painting of the fifteenth and sixteenth centuries. Van Mander established the canon of fifteenth- and sixteenth-century masters that prevailed throughout the seventeenth century.

In a bold critical manoeuvre, van Mander organized his text to authorize the local pictorial tradition as equal to, yet different from, the distinguished lineages of Lombard, Venetian, Florentine, and Roman art. Alert to the competing claims of Tuscan *disegno* (design) and Venetian *colorito* (colour), grounded respectively in the 1568 edition of **Vasari**'s *Vite* and Lodovico **Dolce**'s *Aretino* of 1557, van Mander appropriated Italian critical categories, redefining them to accommodate the distinctive achievements of northern masters such as Jan van Eyck and Hendrick Goltzius. He also introduced new categories such as *netticheyt* (neatness, meticulousness, precision) and *reflexy-const* (the art of reflection), exemplifying them in the works of masters whose lives he recounted.

The *Schilder-Boeck* consists of six parts: it opens with the 'Grondt' (Groundwork), a long poem divided into 14 chapters that establish critical categories based on workshop practice; there follow the 'Levens' (Lives), three biographical sequences that chart the histories of ancient, Italian, and northern art; the text concludes with the 'Wtlegghingh' (Commentary), a mythological manual based on Ovid's *Metamorphoses*, and the 'Wtbeeldinge der figueren' (Depiction of figures), a lexicon of personifications. Books 2–4 of the 'Levens', develop terms introduced in the 'Grondt', embedding them in the local usage of three regional cultures, that of the ancient world, of Italy, and of the Netherlands. In effect, van Mander juxtaposes three parallel histories of art, tracking criteria applied differently as they migrate through changes of place and time.

Book 2, the history of ancient art, measured by standards found in Pliny, traces the stages by which painting becomes lifelike, surpassing nature by perfecting the artifice of imitation that simulates her. Pliny had shown how *ars*, the principles and skills that undergird the human impulse to transform nature, came to be valued above *natura*, the materials but also generative powers of nature. Van Mander applies Pliny's criteria, showing how Greek and Roman masters competed with nature and each other to produce the deceiving likeness.

Book 3, the Italian 'Lives', adjusts this scheme, revealing how Florentine, Roman, Venetian, and Lombard masters competed to improve the principles of narrative construction and its primary unit, the mobile human body. Van Mander took much of his material from Vasari's *Vite*, abbreviating Vasari's text but retaining much of its

essential structure and critical devices. He diverges from Vasari at the close of Book 3, where he chronicles the lives of contemporary masters famed for their *wel verwen* (fine colouring), who serve Venetian rather than Tuscan ideals. Having developed a *paragone* (comparative evaluation) of Venetian and Florentine pictorial manner, he then assumes a more conciliatory tone, suggesting that the future of Italian art rests with a plurality of masters – Jacopo Bassano, Federigo Barocci, Girolamo Muziano, and Caravaggio, among others – who exemplify various regional styles and who reconcile the criteria of *teyckenconst* (*disegno*) and *wel verwen*. Van Mander does this to contest Vasari's paradoxical assumption that Tuscan style sets the universal standard to which all masters must aspire, although its exemplars, especially Raphael and **Michelangelo**, are essentially inimitable. By demonstrating that modern masters have not only assimilated Tuscan *exempla* but also observed Venetian criteria, van Mander questions the pre-eminence of the Tuscan manner, showing that Raphael and Michelangelo could indeed be imitated and even surpassed.

By contrast with Books 2 and 3, the northern 'Lives', Book 4, is neither competitive nor progressive. As the opening biography of Jan van Eyck attests, the founding moment of northern art, Jan's discovery of oil-based pigments, has resulted in the painting of the Ghent Altarpiece, a canonical work whose perfection remains undiminished by time. It embraces all of nature and exhibits universal command of the *verscheydenheden* (varieties), the descriptive subjects and skills that encompass even the specializations of contemporary Dutch and Flemish masters. Because Jan's achievement is so comprehensive, he shapes the efforts of his successors, who pursue various options: like Gillis van Coninxloo, they may concentrate on a single subject, such as landscape, enriching its descriptive potential and power to engage the eyes; like Hans Vredeman de Vries, they may attempt to intensify the illusionistic appeal of painting, producing *trompe-l'oeil* that plays at the threshold between pictorial imagery and the visible world; or like Hendrick Goltzius, they may take pictorial manner itself as their object of imitation, translating the representational means of fellow masters with unparalleled fidelity. Van Coninxloo's landscapes are praised for having won the *paragone* of painting and sculpture, Vredeman de Vries's perspectives for their deceptive art that truly beguiles the eyes, and Goltzius's prints for their protean adaptability to local and foreign models.

By yoking three sets of 'Lives', van Mander devised a powerful intertextual sequence that differentiates ancient, Italian, and northern instances of pictorial prowess, inviting the reader to judge these

exempla in the context of three regional histories of art. Critical categories such as *teyckenconst* and *wel verwen* allow the reader to evaluate these examples. *Teyckenconst* translates *disegno*, and its pre-eminent Italian exponent is Michelangelo, praised by van Mander, who paraphrases Vasari, as the 'universal light of *teyckenconst*' (fol. 163v). Against Michelangelo, van Mander counterposes Goltzius, who, he tells us, resembles the Florentine master in many respects, and whose prints affirm his 'adept genius for *teyckenconst*' (fol. 284r). Goltzius is the indisputable master of the northern arts of *teyckenconst* – painting, drawing, and engraving – and as such, offers an alternative to the Tuscan arts of *disegno*, codified by Vasari as painting, sculpture, and architecture.

In Book 3, the Italian 'Lives', van Mander largely follows Vasari, tracing improvements in the practice of *teyckenconst* from Giotto to Michelangelo. *Teyckenconst* denotes the artist's powers of conception, expressed in and through the human body. Vasari had first united painting, sculpture, and architecture under the rubric *arti del disegno* (arts of *disegno*), defining *disegno* in Aristotelian terms as a process of cognition that negotiates between sight and mind, issuing in the delineation of *concetti purgati*, forms purged of their incidentals. Relying heavily on Benedetto Varchi's *Due lezzioni* (Two Lectures) of 1550, he asserts the nobility of painting and sculpture by characterizing both as processes that reconcile the ideal forms visualized by the artist's *concetti* (conceits) with the ideal forms realized in matter by the artist's hands.

Van Mander departs from Vasari by deleting the technical preface containing the definition of *disegno* as a process that leads from sensory perception to universal judgement. He also omitted Vasari's lives of sculptors and architects, allowing his definition of *teyckenconst* to arise directly from the biographies of Italian painters, chief among them Michelangelo. Rather than defining *teyckenconst* as a process of cognition based in Aristotelian epistemology, van Mander emphasizes that *teyckenconst* is a process constitutive of pictorial style.

For Goltzius, one of the paragons of northern art and Michelangelo's counterpart in Book 4, *teyckenconst* involves a strategic act of impersonation, as van Mander explains in his account of the *Circumcision*, part of the *Life of the Virgin*, the print series engraved by Goltzius in 1593–4. This series consists of six plates distilling the pictorial manner of various Italian and northern masters. In the *Circumcision*, for example, Goltzius imitates the *handelinghe* (handling, that is, pictorial manner) of Dürer, producing a new image rendered as if in the German master's hand.

Whereas Michelangelo perfects *teyckenconst* to foreground himself, deploying figures in novel ways that function as his signature, Goltzius retires into a programme of imitation that leads van Mander to dub him a 'rare Proteus or Vertumnus of art, who refashions himself into all forms of *handelinghen*' (fol. 285r). The notion that Goltzius is a latter-day Proteus, who converts himself into that which he imitates, camouflaging the traces of his handiwork, is a distinctive version of the conceit that the highest art is the art that conceals art. Implicit in this notion, formulated most fully by Lodovico Dolce in the *Aretino* of 1557 and later adapted by van Mander, is a critique of Michelangelo, the lover of explicit difficulty.

Michelangelo, Dolce argues, was preferred only by sculptors who responded solely to his *disegno* and *terribilità*, the stirring grandeur of his figures, whereas Raphael enjoyed the esteem of *literati* and his fellow painters. They responded to Raphael's *facilità*, his 'facility', the basis of his *maniera leggiadra e gentile*, his 'elegant and gentle manner'. Developing a paradox, Dolce avers that 'facility is most difficult to attain, that it is an art to conceal art', and finally, that the painter must combine *disegno* with the other necessary parts of art. Chief among these parts is *colorito*, whose most accomplished masters are the Venetians. He disputes the Florentine notion, codified in the 1550 edition of Vasari's *Vite*, that Michelangelo's *maniera* combines *grazia* (grace) with the mastery of *difficoltà* (explicit difficulty). Dolce reveres Raphael, then, because of his *facilità*, which is itself defined as *artificio*, an artifice, however, that conceals itself in seeming ease of invention and execution. He further describes *colorito*, the basis of Raphael's art that conceals art, as the handling of colours with a view to imitating nature, especially the appearance of flesh, its tints, softness, relief, and variety, as well as its response to the play of lights and shadows.

As he challenges Vasari's notion of *disegno*, so van Mander modifies Dolce's conception of *colorito*, appropriating it for the Netherlands. Van Mander devotes the last four chapters of the 'Groundwork' to *wel verwen* or *coloreren* (*colorito*), defining the handling of colours as the complement of drawing, whose dead strokes are enlivened by colours as the body is by the soul. Like Dolce, van Mander treats colouring as a function of the handling of colours within a heightened practice of imitation, but he diverges from the *Aretino* in crucial ways, chief among them in his notion of the nature and source of the delight engendered by beautiful colouring. He subsumes *wel verwen* into the larger notion of *natuerlijk malen* (natural painting, i.e., painting as does nature), divesting the human body of its exemplary status in order to accommodate the *verscheydenheden*, flower-painting and landscape in

particular. Van Mander explains what he means by natural painting in Chapter 11, 'On Sorting and Gathering Colours': he invites the painter to consider how nature distributes blossoms in springtime, suggesting that she be painted as she paints herself, her handling of saturated colors offering a touchstone of *natuerlijk malen* that has the power to seduce the eyes. He refers to the *Stephanoplocos* of Pausias, the famous ancient painting showing the maiden Glycera, the artist's beloved, plaiting wreaths in imitation of nature's varied handling of colours. In van Mander's version, Pausias becomes enamoured not simply of the beautiful Glycera, but even more of the 'uncommonly skillful way in which she knew how to gather flowers in the tens of thousands' (fol. 45r). The painter's aim must be to imitate nature, rather than surpassing her, and the locus of this practice of *wel verwen* will be the full scope of natural artifice, rather than the beautiful female body celebrated by Dolce. Van Mander's account of colouring extends his claim, made in Book 1, Chapter 7, 'On Reflection, Reverberation, and Re-reflection', that the modern Netherlandish school is legitimate heir to the ancient Sicyonian: 'just as Pictura formerly favoured Sicyon, she now favours Batavia' (fol. 32v). What distinguishes the Sicyonian school, he avers in the 'Life of Eupompus', its founder, is fidelity to nature.

Biography

Karel van Mander was born in 1548 in Meulebeke, West Flanders, Spanish Netherlands (now in Belgium), the son of landed gentry. He was trained by the poet/painter Lucas de Heere from 1566–7 and the painter Pieter Vlerick in 1568. He visited Italy from 1573–6 and was active in the circle of Federico **Zuccaro**. He returned to Flanders in 1577. In 1583 he migrated to Haarlem and was active in the circle of Hendrick Goltzius and Cornelis Corneliszoon. He was a converted Mennonite by 1588. In 1604 he moved to Amsterdam where he completed the Schilder-Boeck. He died on 2 September 1606 in Amsterdam.

Bibliography

Main texts

Het Schilder-Boeck . . ., Haarlem, 1604; Hessel Miedema (ed.), *The Lives of the Illustrious Netherlandish and German Painters, from the First Edition of the Schilder-Boeck (1603–4)*, 6 vols, Doornspijk, Davaco, 1994–9.
Den Nederduytschen Helicon . . ., Haarlem, 1610.

Secondary literature

Melion, Walter S., *Shaping the Netherlandish Canon: Karel van Mander's Schilder-Boeck*, Chicago, University of Chicago Press, 1991.

—— 'Karel van Mander et les origines du discours historique sur l'art dans les Pays-Bas au XVIIe siècle', in *Histoire de l'histoire de l'art de l'Antiquité au XVIIIe siècle*, Edouard Pommier (ed.), Paris, Musée du Louvre (1996), pp. 1–49.

Miedema, Hessel, *Karel van Mander: Den grondt der edel vry schilder-const*, 2 vols, Utrecht, Haentjens, Dekker, and Gumbert, 1973.

—— *Karel van Mander's Leven der moderne, oft dees-tijtsche doorluchtighe Italiaensche schilders en hun bron*, Alphen aan den Rijn, Canaletto, 1981.

—— *Kunst, kunstenaar en kunstwerk bij Karel van Mander: Een analyse van zijn Levenbeschrijvingen*, Alphen aan den Rijn, Canaletto, 1981.

Muylle, Jan, ' "Pier den Drol"– Karel van Mander en Pieter Bruegel: Bijdrage tot de literaire receptie van Pieter Bruegel's werk ca. 1600', in *Wort und Bild in der niederländischen Kunst und Literatur des 16. und 17. Jahrhunderts*, Herman Vekeman and Justus Müller Hofstede (eds), Erfstadt, Lukassen Verlag, 1983, pp. 137–44.

Reznicek, Emil K.J., 'Het Leerdicht van Karel van Mander en de acribie van Hessel Miedema', *Oud Holland* 89 (1975), pp. 102–28.

WALTER S. MELION

GIOVANNI PIETRO BELLORI (1615–96)

ITALIAN ART HISTORIAN

The writings of the seventeenth-century critic Giovanni Pietro Bellori had a profound impact on western conceptions of beauty and quality in art. Bellori developed a new system for the analysis of artworks, requiring precise and thorough consideration of each component of the object, including descriptions of each figure, informed interpretations of allegories and themes, analysis of proportions, colour, and grace. Central to Bellori's analysis of these components is a notion drawn from Neoplatonic thought – that beauty exists in the form of ideas and not in nature, and in order to create beauty in artworks the artist is required to copy these perfect ideas. Bellori's belief that the roots of beauty lay in perfect ideas accessible through reason resonated in art theory through to the nineteenth century.

Bellori spent his life in Rome working as a professional writer, connoisseur and antiquarian. As a connoisseur, Bellori later focused on empirical analysis of material evidence surrounding the artworks he considered. As an antiquarian, he sought to judge the quality of such works and to establish their place within canons. Before becoming a professional, however, Bellori studied under his uncle, the antiquarian,

Francesco Angeloni (d. 1652). While in his uncle's household, Bellori interacted with a variety of important scholars who engaged in Angeloni's circle, enjoyed access to Angeloni's collections of antiquities, and became intimately involved with his uncle's antiquarian writings. This education fostered Bellori's interests and greatly assisted in the development of his talents. From this environment Bellori first emerged as a poet and then as a writer of classical and early Christian antiquities. So interested was Bellori in antiquity and issues surrounding connoisseurship that he eventually served as the librarian to Queen Christina of Sweden, who resided in Rome. In addition, Bellori received the title 'Antiquario di Roma' (Antiquarian of Rome), an honour which was bestowed upon him by Pope Clement X. Bellori's keen and methodical interest in the observation of details, analysis of style, and the thorough collection of facts relevant to artworks, echoes through his literature.

Bellori wrote on a variety of topics significant to art theory. His most important publications include *Le vite de' pittori, scultori et architetti moderni* (The lives of modern painters, sculptors and architects) (1672), and his monograph on Raphael entitled *Descrizione delle imagini dipinti da Raffaelle d'Urbino nelle camere del Palazzo Vaticano* (Description of painting by Raphael in the Vatican Palace) (1696). Bellori's most important essay, however, *L'Idea del Pittore, Dello Schultore e Dell' Architetto, Scelta Delle Bellezze Naturali Superiori Alla Natura* (The Idea of the Painter, Sculptor and Architect, Superior to Nature by Selection from Natural Beauties) was a lecture first delivered to the Roman Accademia di San Luca (Academy of St Luke) in 1664 and published as the Introduction to his *Vite* in 1672. In this lecture Bellori outlined the key concept of his theory, the 'Idea'. From the Idea, artists could strive to recreate perfect beauty through their artworks.

The French painter Nicolas Poussin (1594–1665), who lived and worked in Rome, assisted Bellori in composing his *Vite*. Despite the book's dedication to Colbert, the founder of the French Academy, Bellori followed the model established by the well-known Tuscan writer **Vasari**. Like Vasari, Bellori presents biographical information about each artist, rich descriptions of the artists' finest artworks, and comments on styles and influences. In his *Lives of the Artists* (1550; 1568), Vasari included a wide range of artists whose work exhibited varying degrees of quality. Bellori, on the other hand, employed a more exclusive approach. Unlike Vasari, Bellori carefully selected each painter, sculptor, and architect based on the quality of the artworks that they produced. Those who met Bellori's rigorous standards include the painters Annibale Carracci, Agostino Carracci, Federico

Barocci, Michelangelo da Caravaggio, Giovanni Lanfranco, Nicholas Poussin, Peter Paul Rubens, Anthony van Dyck, and Domenichino; the sculptors Alessandro Algardi and Francois Duquesnoy; and the architect Domenico Fontana. Preceding each life, Bellori included a short vignette and engraved portrait of the artist discussed.

It is no coincidence that the majority of the artists that Bellori perceived to be the most superior worked in Rome. In Rome the most exquisite sculpture and architecture from antiquity could be accessed, and more importantly, Rome served as a locus for those artists whose work continued the antique style. For Bellori, artworks produced by the ancients exhibited the greatest beauty and perfection because of their blending of naturalism with idealism. Therefore those artists working in the sixteenth and seventeenth centuries who revived classical traditions also revived beauty in the arts.

In May 1664 Bellori delivered a lecture entitled 'L'Idea del pittore, dello scultore e del'architetto' (The idea of the painter, sculptor, and architect) to the Roman guild of painters, the Academy of St Luke. In addition to serving as the introduction to Bellori's *Lives*, which he later published, this paramount essay offers the most thorough and concise statement of Bellori's artistic programme and formulates the foundations for seventeenth-century classicism.

In the opening lines of Bellori's 'Introduction' he poetically describes the celestial roots of perfection in a way that resembles both **Plato**'s philosophy and the work of Neoplatonic writers like Marsilio Ficino (1433–99). For Bellori, beauty emerges not from nature, but from the realm of Ideas. According to Bellori, God created the original perfect Ideas, which continue to exist in the heavenly realm. Earthly forms, because of their composition of inferior matter, suffer from ugliness. Obvious flaws such as deformities and disproportions particularly plague humans and diminish their beauty. For this reason mere study of the live model is not sufficient if the artist wishes to create a beautiful human figure. Artists who work strictly from the observation therefore will never achieve perfection or beauty in their artworks. The other extreme, working completely from fantasy and not considering nature, results in imperfections and disharmony, as exemplified in the works of Mannerist artists like Giorgio Vasari, whose works clearly proclaim the artist's practice of drawing from memory and imagination. For Bellori, the artist must exercise a rational thought process and apply to nature the characteristics that the Idea is believed to exhibit. Instead of selecting one human to model an image after, the artists must, 'take from diverse bodies all that which in each single one is most perfect ... since it is difficult to find a single

one that is perfect'. Through the selection of the most beautiful and elegant natural forms, the artist may surpass nature and produce an ideal beauty.

Bellori finds evidence for the Idea and success in copying the Idea in order to create supreme beauty in the literature of ancient writers. He tells us that Cicero in *De oratore* (55 AD; The Orator) describes the perfection achieved by sculptors and painters when the artist surpasses nature through the manifestation of an intellectual ideal. Cicero supports this contention by referring to the Ancient Greek painter Zeuxis, who selected components of five separate virgins to create the single famous image of Helen. Nature simply could not produce a model perfect in all parts for Zeuxis to imitate. In Plato's *Timaeus,* Proclus points out that if one compares a man made by nature to a man made by a sculptor, the natural man will be less excellent. Bellori employs arguments from Seneca and Apollonius to prove the same point. In addition to ancient sources, Bellori finds support for his theory of beauty in the writings of **Alberti**, who also taught that one should select the most perfect parts from the most beautiful bodies. **Leonardo da Vinci**, Raphael, and Guido Reni also receive praise in Bellori's introduction for their excellence in surpassing nature. Similar notions of the Idea appear in Leonardo's notebooks, and Raphael, in a letter written to Baldassar Castiglione, discusses the choice of the most beautiful parts of models and an abstract idea that is separate from reality.

In addition to painting and sculpture, Bellori evaluates architecture in terms of a building's adherence to a more perfect architectural precedent. Instead of imitating abstract Ideas to create perfect structures, architects should strive to imitate other buildings of superior quality and utilize the 'most excellent forms of the orders'. The resulting buildings must be designed such that they exhibit 'order, arrangement, measure, and eurhythmy of whole and parts'. Bellori's description of the desired characteristics and the logical manner in which one makes the selection of models, lead to the conclusion that classic architecture constitutes the most perfect exemplars. Perfect ancient buildings therefore substitute for the Idea that the painter and sculptor must imitate. Once the ideal building is chosen from which to imitate, the architect, like God, draws from the ideal plan and then through manipulation of material, manifests the plan's form. Later sixteenth-century architects such as **Michelangelo** and Palladio employed a classical vocabulary, but their license in creating new buildings opposed Bellori's preference for a more direct interpretation of classic architecture.

The concepts outlined in Bellori's 'Introduction' extend into the rest of the *Lives* and subsequent literary endeavours. In his *Lives*, Bellori follows the introduction with the application of his theory to the artworks of the 12 previously listed best artists. When discussing the Bolognese brothers Agostino and Annibale Carracci, for example, Bellori praises their rejection of unnaturalistic forms and return to classic principles. Annibale Carracci also receives Bellori's praise for his dedication of the style of Raphael, the High Renaissance artist who constitutes the subject of Bellori's later work. In his monograph on Raphael, *Descrizione delle imagini dipinti da Raffaelle d'Urbino* ... , Bellori again extends his theory of beauty and the Idea. With the same thoroughness illustrated in his *Lives*, Bellori meticulously describes Raphael's frescoes in the Vatican along with other examples of Raphael's painting. Bellori describes each figure, addresses literary meanings, and analyses allegories and symbolism. Bellori praises Raphael for reaching perfection through the imitation of an ideal, and suggests that Raphael, instead of Michelangelo, was the true classicist who looked to the writers and artists from antiquity for inspiration.

Bellori's location of beauty in the imitation of perfect abstract ideals with the close observation of nature affected critical response to artworks. Both at the local and international levels, Bellori furnished viewers with a new approach for evaluating artworks. Also critical to Bellori's contribution to art history is his disciplined and thorough scope for considering the various components of the artwork. Bellori surpassed usual description and collected and analysed vast amounts of information that bore potential to inform the work of art. In his theory and method, Bellori articulated the ideals of future critics, such as Johann Joachim **Winckelmann**, and future academies through the nineteenth century.

Biography

Giovanni Pietro Bellori was born in 1615 in Rome and spent his early life with his uncle, the antiquarian Francesco Angeloni (d. 1652). In 1652 he joined the Accademia di San Luca (Academy of St Luke) in Rome. In May 1664 he delivered the introduction of *Lives* to the Academy of St Luke. He was made an honorary member of the French Academy in 1689 and later became Librarian to Queen Christina of Sweden in Rome. He served as Antiquarian of Rome from 1670–94. He died on 19 February 1696. *Lives*, written with Poussin, first appeared 1672.

Bibliography

Main texts

L' Idea del Pittore, Dello Schultore e Dell' Architetto, Scelta Delle Bellezze Naturali Superiori Alla Natura (The Idea of the Painter, Sculptor and Architect, Superior to Nature by Selection from Natural Beauties), 1664; Italian and English translation, in Erwin Panofsky, in *Idea: A Concept in Art Theory*, 1924; trans. J.J.S Peake, New York, Harper & Row Publishers, 1968 (Appendix II, pp. 154–177).

The Lives of Annibale and Agostino Carracci, 1672, trans. C. Enggass, with a foreword by R. Enggass, University Park and London, The Pennsylvania State University Press, 1968 (these are taken from *Le Vite*).

Le vite de' pittori, scultori et architetti moderni (The lives of modern painters, sculptors and architects), Rome, 1672.

Descrizione delle imagini dipinti da Raffaelle d'Urbino nelle camere del Palazzo Vaticano (Description of painting by Raphael in the Vatican Palace), Rome, 1696.

Secondary literature

Donahue, Kenneth, 'The ingenious Bellori', *Marsyas* 3 (1946), pp. 107–38.

Fernie, Eric, 'Giovanni Bellori', *Art History and its Methods: A Critical Anthology*, London, Phaidon Press (1995), pp. 58–61.

Mahon, Denis, *Studies in Seicento Art and Theory*, London, Warburg Institute, 1947.

Panofsky, Erwin, *'Idea': ein Beitrag zur Begriffsgeschichte der alteren Kunsttheorie*, 1924, trans. J.J.S Peake, *Idea: A Concept in Art Theory*, New York, Harper & Row Publishers, 1968.

Sauerländer, Willibald, 'From stilus to style: reflections on the fate of a notion', *Art History*, December, vol. 6, no. 3 (1983), pp. 253–70.

Schlosser Magnino, Julius, *La litteratura artistique: manual des sources de l'histoire de de l'art moderne*, Paris, Flammarion, 1984.

KAYLEE SPENCER-AHRENS

ANDRÉ FÉLIBIEN (1619–95)

FRENCH HISTORIAN AND WRITER ON ART

André Félibien's chief significance lies in the fact that he established a sustained art-historical discourse in France, notably in his *Entretiens sur les vies et les ouvrages des plus excellents peintres anciens et modern* (Conversations on the lives and works of the most excellent painters ancient and modern), published in ten parts between 1666 and 1688, and in particular his biography of Nicolas Poussin, in the eighth *Entretien*. His other important theoretical statement was the Preface to the lectures ('Conférences') given by members of the Académie Royale de Peinture et de Sculpture in Paris in 1667. In his *Principes de*

l'architecture, de la sculpture, de la peinture et des autres arts qui en dépendent . . . (The principles of architecture, sculpture, painting and other related arts . . .) of 1676 Félibien codified the essential principles of the art in a summary form.

Félibien also compiled a number of historiographic, and descriptive works, eulogies of the Châteaux of Vaux or Versailles, or descriptions of festivities at Versailles, in his capacity as Royal Historiographer. These are primarily official panegyric works, subservient first to Fouquet and then to Colbert, and of course the king. Another royal commission was the description of works of art in the royal collection, published from 1663 to 1667, and gathered together as *Recueil de descriptions de peintures et autres ouvrages faits pour le Roy* (A collection of descriptions of paintings and other works of art made for the king). However, in these Félibien also introduced critical concerns, such as the analysis of the expression of the 'passions', so that, for example, his description of the portrait of the king is in fact more than mere panegyric.

In his Preface to the lectures ('Conférences') on works in the royal collection held at the Académie Royale in 1667 (published in 1668), Félibien explores such concerns more fully. Here he enunciates the official academic views on artistic matters, though now free of obligation to praise the sovereign. He sets out the academic hierarchy of categories of painting, with history painting at the top, and other 'lesser' categories ranged below; this, together with his insistence on the importance of drawing or design (*le dessein*), has led to the view of him as a rigidly academic critic. It is true that, in the context of the Académie's concern to elevate the status of painting, the general bias is theoretical rather than practical. However, in other passages in the Preface, he shows himself more flexible, recognizing the importance of *couleur* (colour) as well as *dessein* (design), and of practice as well as theory. (Indeed, although critics termed him 'Le Brun's ape', Félibien's Preface did not satisfy the academy, and he was dismissed from the role of editor of the lectures.)

It was in the *Entretiens*, however, that Félibien had greatest scope for the expression of his interest in art-historical matters, free of subservience to both the king and the Académie, and in developing an appropriate vocabulary. Although publication continued until 1688, the genesis of the work was much earlier: in Félibien's visit to Rome in 1647–9 as secretary to the French Ambassador, Fontenay-Mareuil. Here Félibien met leading artists, in particular Nicolas Poussin. His journal records his conversations with Poussin, and the profound effect the artist's teaching and example had on him – indeed, he learned from

him the importance of joining practice and theory. His growing interest in theoretical aspects is indicated by the fact that he brought back a copy of **Leonardo da Vinci**'s *Trattato*, with the intention of translating it (a translation was made by Fréart de Chambray in 1651). He was determined, as he states in the Preface to the *Entretiens* 'to put into writing what I have learned concerning the fine arts, and to arrange in a certain order the observations I had made'.

Félibien had adumbrated the first part as early as 1660, in his *De l'origine de la peinture* (On the origin of the art of painting), eventually incorporated as an introduction to the first volume. The structure of the book is that of a conversation between the narrator and a friend, Pymandre; this conversational form was that adopted for the *Entretiens*, each of which, up to the eighth, opens in the gardens of one of the royal Châteaux. This form allowed a certain flexibility, whereby the author could move from historical account to biography, then to *ekphrasis*, and it also established the easy social tone suitable for Félibien's intended 'polite' audience – the *honnêtes gens*, persons of taste and discrimination. The form of the 'conversation' was popular at the time in France as a model for instruction and entertainment; it also has art-historical precedents, as in **Dolce**'s *Aretino* (1557). **Vasari**'s *Vite* (1550; 1568) had established a new type of biography of artists, with a historical framework charting the rise, development and summit of artistic achievement in Italy; his work inevitably provided the model on which most seventeenth-century biographies of artists were based, though some, such as **Bellori**, deliberately broke away from the chronological approach. **Van Mander** (*Schilder-Boeck*, 1604) had transposed Vasari's model to the international field, introducing lives of Netherlandish artists; this international scope was also to be found in Sandrart's *Teutsche Akademie* (1675). Félibien too gave his work an international dimension, although implicitly presenting Poussin's achievement as the crown of his series of biographies, and his conversational mode of presentation encouraged a more discursive tone.

The conversational form also helped to give coherence to the wide-ranging content of the ten books of the *Entretiens*: these ranged from an outline of the history of ancient art in the first *Entretien*, through to a discussion of the achievement of the Italian Renaissance, and the 'revival' of art by the Carracci after Mannerism; there is also a consideration of developments in other European countries – France, Flanders, and Holland – giving the volumes an international edge absent from Vasari's work. According to the original design, the biography of Poussin, as the heir to Raphael and Annibale Carracci, was to be the

culmination of the work (though in the event two more *Entretiens* were added, to discuss later developments). Poussin was seen as representing the balance between French and Italian art, and as having restored French prestige. In the Preface, Félibien declares that he will:

> [speak] in praise of a French Painter who is the honour and fame of our nation, and who may be said to have lifted the whole science of Painting as from the arms of Greece or Italy, to bring it to France, where the highest Learning and the finest Arts seem today to have retired.

In the earlier sections, Félibien draws heavily on the writings of Vasari and others, but the later *Entretiens* have a more personal ring, with Félibien's use of memoirs, letters and indeed his own experience in Rome and Paris. One may see a similar movement from a public to a more private sphere; in the eighth *Entretien*, which is set in Poussin's room rather than in a royal garden, the artist is praised as being 'his own master', a figure of rational detachment from public patronage.

The *Entretien* containing the biography of Poussin (although technically not the last) is generally considered as the most important. Here Félibien combines theoretical reflection with *ekphrasis* and personal recollection with historical account, in a fluent, clear and elegant literary style. In some respects it is based on Bellori's biography of 1672 (*Vite*), but has a different tone and biographical method. The conversational dialogue form allows for a degree of debate and reflection; like Bellori, Félibien makes use of documents such as letters or epitaphs, which give a documentary quality to the biography. Whereas Bellori lists Poussin's observations on painting separately at the end of his biography, Félibien integrates them into the text, linking them to specific artistic aims. In his description of certain paintings by Poussin (the *Israelites gathering the Manna* and *Eliezer and Rebecca*), Félibien follows the analytic method found in the 'Conférences' of the Académie, whereby all the elements of the painting are analysed systematically, in order to extract rules, and to demonstrate how they contribute to the general effect on the spectator. Other paintings are analysed more briefly, with reference to particular aspects, or to convey the general impression.

While the Preface to the Conférences, with its stress on theory, and reference to literary models, was influential for later art-historical approaches, it is the eighth *Entretien* that is generally agreed to be the summit of Félibien's own critical achievement, as well as his most

personal statement of his artistic beliefs. In it, the crucial development is from a descriptive, narrative mode to an analytic mode, concerned primarily with the formal means by which the painting makes its effect upon the spectator. This – together with the light that his biography throws upon his friend and mentor Poussin – is perhaps Félibien's most personal and lasting legacy to art-historical discourse.

Biography

André Félibien, Sieur des Avaux et de Javercy was born in May 1619 at Chartres. At 'around 14', he went to Paris to complete his education, where he moved in literary and artistic circles. In 1647 he was appointed Secretary to the Marquis de Fontenay-Mareuil, French Ambassador to the Papacy in Rome, and spent two formative years in Rome. Returning to Paris in 1649, he was introduced to Fouquet (finance minister and important patron). On Fouquet's disgrace in 1661, Félibien retired to Chartres. He was recalled to Paris by Colbert, and in 1666 he was appointed Historiographe du Roi, et des Bâtiments, Arts & Manufactures de France. He was Conseiller-honoraire of the Académie Royale de Peinture et de Sculpture, a member of the Académie Royale de l'Architecture from its inception (1671) and founder-member of Académie des inscriptions (1663). He died on 11 June 1695 in Paris.

Bibliography

Main texts

De l'origine de la peinture, Paris, 1666.
Entretiens sur les vies et les ouvrages des plus excellents peintres anciens et modernes, 5 vols, Paris, 1666–88; revised 6 vols 1725.
Conférences de l'Académie royale de peinture et de sculpture pendant l'année 1667, Paris, 1668; Mérot, A. (ed.), Paris, 1996.
Description sommaire du château de Versailles, Paris, 1674.
Principes de l'architecture, de la sculpture, de la peinture et des autres arts qui en dépendent, avec un dictionnaire des termes propres à chacun de ces arts, Paris, 1676.
Recueil de descriptions de peintures et autres ouvrages faits pour le Roy, Paris, 1689.
Mémoire pour servir à l'histoire des maisons royales, Paris, 1874 (part of lost MS of projected *Histoire des maisons royales et bastimens de France*).

Secondary literature

Delaporte, Yves, 'André Félibien en Italie', *Gazette des Beaux-Arts*, n.s. 5, LII (April 1958), pp. 193–214.
Démoris, René, 'Introduction', *Entretiens...* I and II, Paris, Société d'édition, 'Les Belles Lettres' (1987), pp. 9–73.

——'Le corps royal et l'imaginaire au 17e siècle: "Le portrait du Roy" par Félibien', in *Revue des sciences humaines*, 172 (1978), pp. 9–30.

——'Peinture et histoire: Félibien et la stratégie du récit historique au siècle de Louis XIV', in *Récit et histoire* (1984), pp. 23–30.

'Eloge funebre d'Andre Félibien', *Le Journal des Sçavans*, Paris (1695), pp. 459–65.

Germer, Stefan, 'Introduction', *Vies de Poussin: Bellori, Felibien, Passeri, Sandrart*, Paris, Macula, 1994.

Pace, Claire, *Félibien's Life of Poussin*, London, Zwemmer, 1980.

Puttfarken, Thomas, *The Discovery of Pictorial Composition*, London and New Haven, Yale University Press, 2000.

Teyssèdre, B., *L'Histoire de l'art vue du grand siècle*, Paris: René Julliard, 1964.

Thuillier, Jacques, 'Pour André Félibien', *XVIIe siècle*, no.35 (January–March 1983), pp. 67–90.

CLAIRE PACE

ROGER DE PILES (1635–1709)

FRENCH CRITIC AND WRITER

Roger de Piles established himself with his early writing, starting with a translation of, and commentary on, Dufresnoy's *De arte graphica* in 1669, as a leader of the *rubénistes* in their quarrel with the *poussinistes* who, under their leader Charles Lebrun, dominated the French Academy during its first decades. After Lebrun's demise he joined the Academy of Painting and Sculpture in 1699 and became its chief theorist, his ideas being set out in his academic lectures, which were published in 1708 under the title *Cours de peinture par principes* (Course on painting).

De Piles was always concerned with more than the relative achievements of Rubens or Poussin, or the respective merits of drawing or colouring. Central was the question of how properly to define the art of painting. Like **Lessing** a hundred years later, de Piles dismisses the equation *ut pictura poesis* (as in a painting, so in a poem) as inappropriate in view of the nature of the two arts; they speak differently to their respective audiences.

In an important way de Piles is more radical than Lessing: while the latter is determined to define the arts solely according to their means and what these means could achieve, he also insists on defining the end and aim of both sculpture and painting as the depiction of bodily beauty. It follows for Lessing that even in painting, drawing – being concerned with form – is more important than colouring, which is concerned only with the appearance of objects.

De Piles defines painting as the imitation of all the visible objects of nature on a flat surface. The nature and value of the respective object, whether a historical event or a still life, are extrinsic to this definition. Whether a painting is good or not does not depend on whether it is poetically moving or historically instructive, but whether or not it has the power to create a convincing illusion. But de Piles was not advocating crass naturalism: 'an able painter must never be the slave of nature; he must be her arbiter and discerning imitator ... and as long as a painting makes its effect and impresses itself agreeably on our eyes, that is all one can expect in this respect.'

De Piles is concerned neither with ideal bodily beauty nor with naturalism, but with the specific visual nature of pictorial imitation – with the visual effect of paintings. His demand that a picture 'makes its effects' is based on two things. First, painting cannot derive its importance from its subject matter: for any visible subject – a bowl of flowers or a battle – can be the subject of a painting. It is not a didactic art and so we cannot assume that people should feel obliged to look at paintings. It follows that if an artist wants a work to be noticed, he or she must make sure that it has enough 'visual effect' to draw spectators to it.

Second, the means of painting, from which it derives its definition (i.e. lines and colours on a flat surface), will not by their own nature allow a convincing 'naturalistic' imitation of the world (a point taken up by **Diderot**). Despite his use of some examples of visual deception, for de Piles illusion is not based on the mind mistaking a picture for objects of nature, but on our ability to abandon ourselves to a pictorial fiction that by its own force excludes our awareness of the real world (and of the flat surface and material presence of the picture). The precondition that allows such a fiction to work is unity – a unified total visual effect. Three closely related aspects of painting are essential for this unity: *l'oeconomie du tout ensemble, le coloris*, and *le clair-obscur* (the economy of the whole-together, the colouring, and the chiaroscuro). Though in the *Cours de peinture* de Piles deals with these aspects in separate chapters, this separation is artificial, for as light and shade are painted with colours, they are also part of colouring, i.e. the overall colour composition, and this is virtually identical with the *tout ensemble*.

The modernity of de Piles's notion of overall pictorial composition lies in the fact that he does not try to define its rules according to subject matter (e.g. history painting), but rather according to the nature of visual perception, our faculty of sight. His is the first theory of formal pictorial composition. According to the difference between focal and peripheral vision, the picture must have a clearly defined and forceful centre and become less defined and less forceful towards the

margins. As a centralized composition, it also has to have space and depth, and, in order to preserve the unity of the whole, de Piles recommends either convex or concave arrangements. These rules must be applied with discretion, however; they would defeat their own purpose if they became visually obvious.

For de Piles, the unified first effect of a painting is a truly aesthetic effect in that our faculty of vision, presented with an object composed according to the very structure of this faculty, gains a deep and lasting satisfaction in the full exercise of its powers. The dispersed objects of nature can never offer us the same satisfaction and pleasure. The formal unity of the *tout ensemble* can lead to, or can include, another profound visual effect: 'Harmony, wherever it is found, comes from arrangement and good order. There is harmony in morals as in physics; in the conduct of the lives of men, as in the bodies of men themselves'. The *tout harmonieux* of painting is primarily that of *coloris*, and its overall effect, brought about by the careful orchestration of the sympathies and antipathies of colours, is the visual equivalent of the moving aural effects of the harmonies of music.

By insisting on the importance of both visual unity and (as a part of it) visual harmony of colour composition, de Piles succeeds in undermining the orthodox division of artistic work into invention (a highly regarded intellectual activity) and execution (a lowly rated manual craft). The distinction between the 'liberal' and the 'mechanical' arts no longer concerns de Piles. There is, he claims, a specific science and intelligence of painting that embraces both the planning and the execution of the *tout harmonieux* (harmonious whole). This science comprises a thorough knowledge of artists' materials (like colours and their interaction), a full understanding of the ways in which these materials will affect the vision of the viewer, and an ability to plan and then execute a picture as a *tout harmonieux* and with *unité d'effet* (unity of effect).

If, in addition to having acquired and developed this *science de la peinture* (the science of painting), the artist is endowed with *génie* (genius) and has cultivated his *fureur pittoresque* (a play on Virgil's *furor poeticus*), he will instil in his work a force surpassing even the harmonious unity of the *tout ensemble*. To describe this ability, de Piles introduces the term *enthousiasme* (enthusiasm), borrowed from Nicolas Boileau's translation of Longinus's *On the Sublime*. However, an artist working in a state of enthusiasm must not disregard the rules of his science, for it is through the unity and harmony of the whole that artists transmit their enthusiasm to viewers, elevating them to a similar lofty state of mind:

> Enthusiasm carries us away without our noticing it and
> transports us ... as from one country to another without our
> being aware of it except through the pleasure that it causes us.
> It is to that surprising, yet just and reasonable, elevation that
> the painter as much as the poet should carry his work, if both
> want to arrive at that extraordinary *vrai-semblable* [verisimili-
> tude] that touches the heart and is the greatest merit of
> painting and poetry.

Here de Piles enters again into the traditional *paragone* (contest) with
poetry. In its supreme form of enthusiasm, wholly engaging us in an
elevating, absorbing and enthralling visual fiction, painting is the equal
of poetry. Like its sister arts, painting has the power to lift us out of our
ordinary life and to transport us to a higher experience of an altogether
different order.

De Piles's three key effects – of unity, harmony and enthusiasm –
are autonomous effects of painting. They provide us with an
experience *sui generis* of painting, not continuous with our sense of
the normal world. For the modern viewer, the art of Watteau or
Chardin, of Boucher or Fragonard, provides this experience more
easily, but perhaps also less forcefully, less 'enthusiastically', than that of
Rubens, which inspired de Piles in the first instance. Delacroix's
notion of the dreamlike quality of art insists on a similar discontinuity
between the two worlds; and while modern abstract art has taken the
idea of autonomous visual effects to its logical conclusion, it may in
the process have lost that essential part from which the whole of de
Piles's theory developed, the experience of visual fiction.

In the context of eighteenth- and nineteenth-century thinking
about the arts, de Piles's theory appears as an important pre-
philosophical attempt to separate what came to be known as aesthetic
effects from moral issues and a concern with knowledge. His
development of a theory of painting that impresses itself on its
viewers must be seen as part of an attempt to widen the public for art
by positing the judgement of taste as largely independent from the
knowledge of rules. De Piles's new public is no longer that of experts,
of learned artists and erudite connoisseurs, represented and promul-
gated by the academy:

> It would be a very strange thing if pictures were made only for
> painters, and concerts only for musicians. It is quite certain
> that *un homme d'esprit* who has not learned the rules of art, is

well able to judge a picture, even if he cannot always give the reasons for his feeling ... he will judge as *homme de bon sens.*

The *homme d'esprit, de bon sens,* deserves the right to judge; the knowledge of the rules and the history of art required for that purpose is limited and is provided by de Piles himself in his dialogues and his *Abrégé de la vie des peintres.* This, by his own admission, contains little that is new, yet it contains all that is needed: to know more would be pedantic, to know less would be scandalous. His playful *Balance des peintres,* appended to the *Cours de peinture,* in which he notoriously awards marks out of 20 for composition, drawing, colouring, and expression to all major European painters of the past, is often misunderstood as a pedantic application of rules. It was meant to be the opposite, an encouragement for a wider public to make up its own mind, and in this respect its popularity in eighteenth-century France is testimony to de Piles's success.

Biography

Roger de Piles was born on 7 October 1635 in Clamecy, Nivernais. He studied philosophy at the College du Plessis from 1651–3, then theology at the Sorbonne. From 1662, he was teacher for Michel, son of Charles Amelot, president of the Great Council. In 1673–4 he accompanied Michel Amelot on a tour of Italy. From 1682–5 he was secretary to Michel Amelot when French ambassador to Venice. In 1685 he undertook a spying mission to Germany and Austria. He visited Portugal with Amelot in 1686, then Switzerland in 1688. He undertook a further spying mission to the Netherlands in 1692 where he was imprisoned until 1697. He became a member of the Academy in 1699. De Piles died on 5 April 1709 in Paris.

Bibliography

Main texts

L'art de peinture de Charles-Alphonse du Fresnoy, traduit en françois, avec des remarques necessaires et tres-ample (Charles-Alphonse du Fresnoy's art of painting, translated into French, with necessary and expansive remarks), Paris, 1668.
Dialogue sur le coloris (Dialogue on colouring), Paris, 1673.
Conversations sur la connoissance de la peinture, et sur le jugement qu'on doit faire des tableaux (Conversations about knowledge of painting and about the judgement one should make concerning pictures), Paris, 1677.
Dissertation sur les ouvrages des plus fameux peintres, dédiée à Monseigneur le duc de Richelieu (Dissertation on the works of the most famous painters, dedicated to His Grace the Duke of Richelieu), Paris, 1681.

Abrégé de la vie des peintres, avec des réflexions sur leurs ouvrages, et un traité du peintre parfait, de la connoissance des desseins, et de l'utilité des estampes, Paris 1699; trans. John Savage as *The art of painting, and the lives of the painters* ... *Done from the French of Monsieur de Piles*, London, 1706; 2nd edn, *The Art of Painting with the Lives and the Characters... of the Most Eminent Painters*, London, 1744.

Cours de peinture par principes, Paris, 1708; trans. as *The Principles of Painting*, London, 1743.

Secondary literature

Alpers, Svetlana, 'Roger de Piles and the history of art', in *Kunst und Kunsttheorie, 1400–1900*, Peter Ganz (ed.), *Wolffenbütteler Forschungen*, vol 48, Wiesbaden, Harrassowitz, 1991.

Lichtenstein, Jacqueline, *La couleur éloquente: Rhétorique et peinture à l'âge classique*, Paris, Flammarion, 1989.

Puttfarken, Thomas, *Roger de Piles' Theory of Art*, New Haven and London, Yale University Press, 1985.

—— 'Roger de Piles, une littérature artistique destinée à un nouveau public', in *'Les Vies' d'artistes: Actes du colloque international organisé par le Service culturel de la musée du Louvre les Ier et 2eme Octobre 1993*, ed. Matthias Waschek, Louvre, Paris, 1996.

—— *The Discovery of Pictorial Composition: Theories of Order in European Painting 1400–1800*, New Haven and London, Yale University Press, 2000.

Teyssèdre, Bernard, *Roger de Piles et les débats sur le coloris au siècle de Louis XIV*, Paris, Bibliothèque des arts, 1957.

—— *L'histoire de l'art vue du grand siècle: Recherche sur l'abrégé de la vie des peintres par Roger de Piles et ses sources*, Paris, René Julliard, 1964.

THOMAS PUTTFARKEN

EARL OF SHAFTESBURY (1671–1713)

ENGLISH POLITICIAN AND PHILOSOPHER

The complete title of Shaftesbury's major work, *Characteristics of Men, Manners, Opinions, Times*, 1711, does not bring to mind the fine arts, architecture, or aesthetic theory, but rather diversified aspects of human behaviour during various historical periods. Yet Shaftesbury specifically affirmed as the principal aim of his writing 'to assert the reality of a beauty and charm in moral as well as natural subjects, and to demonstrate the reasonableness of a proportionate taste and determinate choice in life and manners'. Structurally the *Characteristics* is composed of a collection of previously published texts, comprising an essay on enthusiasm, another on humour, a treatise on religious doctrine, a dialogue on Platonic philosophy, and a soliloquy on the same theme. A separate volume contains miscellaneous reflections on Shaftesbury's handling of these apparently disparate topics. Although

his views on art and aesthetic theory are developed most forcefully throughout the *Characteristics*, they are given practical application in subsequent works, two of which were added to some editions of the *Characteristics* and the others not published at all until the twentieth century. He made it quite clear both in his personal life and writings that he did not conceive of the artist as a genius responding primarily to his own inspiration, but rather as a trained technician executing works conveying philosophic and moral truth.

During the Enlightenment, Shaftesbury's artistic theories received scant attention compared to those associated with religion and society. The *Characteristics* was known as 'the deists' Bible', and its most widely debated principle was that which maintained ridicule to be the test of truth. His contemporary Bernard Mandeville accused him of attempting 'to establish heathen virtue on the ruins of Christianity'. In Germany, however, Herder hailed him as the 'Virtuoso of Virtuosi', and in the nineteenth century his Platonic enthusiasms and rhapsodies were associated with Romantic imagination and sentimentalism.

Combining a deistical vindication of the providence of the universe with the Platonic notion of absolute good and beauty, Shaftesbury affirmed that divinity is inherent in beauty and beauty inherent in divinity, and that order and beauty are inseparable in both nature and human relationships. Making no distinction between morality and plastic form, he taught that the individual discerns truth, good and beauty by means of a moral sense, which is approached by means of taste. Although each individual's taste depends upon his personal inclinations and efforts, the foundations of beauty are absolute, consisting of form, not matter, and approached through the mind, not the senses. Although in this theoretical formulation Shaftesbury indicates that beauty and good are 'one and the same', he suggests by various comments interspersed throughout his work that in ordinary life aesthetic considerations are secondary to ethical. He clearly states that good taste or judgement is not innate but must be preceded by custom, practice, and culture. Even opinions developed by these means must be regulated through internal reason. Taste, like virtue, consists in practising self-control and in subjecting physical proclivities to the intellectual faculty.

Since the word *aesthetics* was not coined until the middle of the eighteenth century, Shaftesbury cannot literally be said to represent a link in the historical development of the intellectual discipline of that name. He derived his concepts of beauty and form directly from the ancients, preferring the Greeks to the Romans, and disparaging all subsequent treatments as Gothic, with the exception of French literary criticism. He has, nevertheless, been declared within recent years to be

the father of aesthetics, and more scholarly attention is now given to this aspect of the *Characteristics* than to any other. According to one interpretation, Shaftesbury affirms the possibility of viewing parts of the material world entirely as objects of the senses without regard to the manner in which they might affect other interests or attitudes we may have: those deriving, for example, from morals, manners, habits, and other social and intellectual elements. This perspective has been labelled 'aesthetic disinterest', which when carried to extremes leads to art for art's sake. In a sense it is true that Shaftesbury considered aesthetics as a separate branch of human experience such as sport, worship or science, but in another sense he considered aesthetic subject matter as an inherent and inseparable part of each individual personality. He regarded the appreciation of beauty as something far more complex and noble than narrow self-interest, drawing on his conviction of the interrelationship of morality and beauty and their conformity to truth and nature. He consequently believed that developing an interest in the fine arts would improve the general level of British morality and politeness, classifying among them not only sculpture and painting, but also music, dress, gardening and furniture. He assumed that 'the taste of beauty and the relish of what is decent, just and amiable perfects the character of the gentleman and the philosopher'.

The culmination of Shaftesbury's aesthetics lies in the concept of a scale or hierarchy of beauty, loosely parallel to the Great Chain of Being celebrated in Alexander Pope's *Essay on Man* (1733–4). One version of the scale, which Shaftesbury derives from **Plato**, ascends from the pleasures of the sense to those of the spirit, comprising three fundamental orders: first, the 'dead forms', created by man or nature, which have no intelligence or forming power of their own; second, the 'forms which form', possessing intelligence and limited forming power of their own; and, third, that which fashions minds themselves, the divine creator or Supreme Beauty. In a variant derived from Stoic philosophy, Shaftesbury's three divisions consist of things inanimate, animate, and mixed.

The first order represents symmetries whether in art or nature; the second, living beings from animals to men and from single individuals to social groups; and the third, from the union of body and mind in a single person to the same combination in a social order such as home, family or country. Shaftesbury introduces a further category without specifically identifying it, that of artistic theory. Here his main authorities are **Aristotle** and Horace and his main doctrine that of neo-classical unity, the portrayal of the general rather than the

particular in art. In literary and artistic compositions, exterior proportion and symmetry should harmonize with interior or poetical truth. Comparative estimates of artistic and literary value should in the long run be based on the *consensus gentium* or the opinion of the largest number of informed judges over a long period of time, for the public always judges right.

Immediately after the publication of the *Characteristics*, Shaftesbury attempted to put his aesthetic theories into practice by means of a literary genre known as 'Advice to A Painter', in which the author sets forth his concept of a particular subject for a painter to follow, taking into account theme, landscape, colours, climate, weather, time of day, and characters, real and symbolic, including their posture and facial expression. As usual Shaftesbury drew upon Greek predecessors, taking for his primary model a section of the *Memorabilia* of Socrates, related by Xenophon and recorded by Prodicus, in which Socrates discusses Hercules faced with the dilemma of declaring a preference for either Virtue or Pleasure as the two appear before him in human form. Shaftesbury wrote under the title *A Notion of the Historical Draught or Tablature of the Judgment of Hercules*, his own conception of the scene for the painter Paolo de Matteis to place on canvas, a tract which was published in later editions of the *Characteristics*. The topic and its background were reasonably familiar to Shaftesbury's readers since the relative section from Prodicus had very recently been translated in *The Tatler* no. 97.

Shaftesbury indicates that his task is to balance an allegorical concept with a representation on canvas that would be almost entirely realistic. The latter he calls 'historical truth', which he affirms must be kept subordinate to the allegorical, that he calls 'poetical' and is governed not so much by reality as by probability or plausibility. The painter must make clear that the confrontation between Hercules and the two goddesses takes place at a particular point in time, for if he departs in any manner from this single instant in time, he would interfere with the unity of design. By this injunction, Shaftesbury recognized before **Lessing** that the plastic arts are incapable of portraying continued action.

As a twin project to the *Notion*, Shaftesbury wrote *A Letter Concerning Design*, somewhat more abstract in subject matter and considerably more confined in length. Here he associates the fine arts with poetical and military progress, predicting that Britain will be a future leader in the pictorial arts, as France was in music, during the preceding century. This process, he assumes, will go beyond the lighter amusements to 'that higher, more serious, and noble part of imitation,

which relates to history, human nature, and the chief degree or order of beauty', that is, the rational part of life. He concludes that England has so far been backward in establishing institutions for the advancement of the arts, but since at present it does have an enlightened government (Shaftesbury's party the Whigs), future progress in the public domain of the fine arts should be possible.

In the midst of composing these papers on painting, Shaftesbury made plans for ornamental illustrations to be inserted in the appropriate sections of the second edition of the *Characteristics*. He issued detailed instructions to his publisher and printer, and strictly forbade the inclusion of any ornaments that he did not himself supply. The frontispiece was to be his own portrait painted several years previously by John Closterman and engraved by Gribelin. The ornaments were not to be simple or ordinary, but tools comparable to Shaftesbury's prose for communicating his primary mission in life: to inculcate the ideals of virtue and honesty and the love of liberty and mankind; to emphasize the concept of the interdependence of beauty and morality; to separate morals from organized religion; and to demonstrate the existence of a benevolent deity supervising a harmonious and orderly universe.

Biography

Anthony Ashley Cooper, Third Earl of Shaftesbury was born on 26 February 1671 in London. He was educated privately (1674–83) under the direction of John Locke, and attended Winchester College (1683–7). On leaving college he undertook a grand tour of Europe for three years. He was a Member of Parliament for Poole from 1695–98. He inherited the title Earl of Shaftesbury and entered the House of Lords in 1699. The same year he published *An Inquiry Concerning Virtue*. In 1702 he retired from public life and wrote the remaining works gathered in his *Characteristics* 1708–11. He died on 15 February 1713 in Naples.

Bibliography

Main texts

Characteristics of Men, Manners, Opinions, Times, London, 1711.

A Notion of the Historical Draught or Tablature of the Judgment of Hercules, London, 1713.

A Letter concerning the Art *or Science of Design* in some printings of the *Characteristics*, London, 1714.

Collected works:

Complete Works, Selected Letters, and Posthumous Writings, Standard Edition (8 vols), ed. Wolfram Benda *et al.*, Stuttgart, Fromann-Holzboog, 1981–2001. (Volume 1,5 of this edition, published in 2001 as *Aesthetics* contains all of Shaftesbury's writings concerning art, including manuscript material never before published.)

Secondary literature

Aldridge, A. Owen, 'Lord Shaftesbury's literary theories', *Philological Quarterly* XXIV (January 1945), pp. 46–64.

—— 'Shaftesbury and the deist manifesto', *Transactions of the American Philosophical Society* XLI (1951), pp. 297–385.

Arregui, Jorge V. and Pablo Arnau, 'Shaftesbury: father or critic of modern aesthetics?', *British Journal of Aesthetics* XXXIV (1994), pp. 350–62.

Brett, R. L., *The Third Earl of Shaftesbury: A Study in Eighteenth-Century Literary Theory*, London, Hutchinson's University Library, 1951.

Klein, Lawrence, 'The third Earl of Shaftesbury and the progress of politeness', *Eighteenth-Century Studies* XVIII (Winter 1984–85), pp. 186–214.

Marshall, David, 'Taste and aesthetics: Shaftesbury and Addison: criticism and the public taste', in H.B. Nisbet and Claude Rawson (eds), *The Cambridge History of Literary Criticism, IV, The Eighteenth Century*, Cambridge, Cambridge University Press, 1997.

Mortensen, Preben, 'Shaftesbury and the morality of art appreciation', *Journal of the History of Ideas* LV (1994), pp. 631–50.

Stolnitz, Jerome, 'On the significance of Lord Shaftesbury in modern aesthetic theory', *Philosophical Quarterly* XI (1961), pp. 97–113.

Townsend, Dabney, 'From Shaftesbury to Kant: the development of aesthetic experience', *Journal of the History of Ideas* XLVIII (April–June 1987), pp. 287–305.

Voitle, Robert, *The Third Earl of Shaftesbury, 1671–1713*, Baton Rouge, Louisiana State Press, 1984.

A. OWEN ALDRIDGE

WILLIAM HOGARTH (1697–1764)

BRITISH ARTIST

William Hogarth set pen to paper to record, and promulgate, his views upon the visual arts on four occasions: in an open letter sent to the *St James Evening Post* in 1737; a tract published in 1754 under the title *An Analysis of Beauty*; an unpublished 'apology for painters'; and a corpus of anecdotes of his life that were published posthumously by John Nichols. Of these only one, the *Analysis*, may properly be called a work of art theory. The rest relate more to the politics of the London art world and the artist's personal struggle to make a career. Far from being an abstract

intellectual exposition, the *Analysis* shares the distinct abrasive personal tone of Hogarth's other writings and should be studied in their context.

The *Analysis* reveals Hogarth's famous, and notorious, tendency toward aggressive independence of thought. It is at once an overtly personal statement and one with pretensions toward the revelation of universal truths. The author exhibits a brash self-confidence when entering perilous conceptual waters that retains the power to shock and amuse. He has no hesitation in claiming to reveal the secret causes of man's sense of beauty that had mystified more scholarly men than he. Accordingly, the publication of the *Analysis* was promoted with the aid of a subscription ticket featuring an engraving that celebrates the power of practical plain sense to circumvent the perplexities of theoretical reflection. It illustrates a probably apocryphal story from the life of Christopher Columbus who, requested to find a means of balancing an egg, simply cut off the end.

True to this commitment to 'plain sense', a much revered ideal of contemporary British Protestantism, Hogarth expressed his views in a refreshingly brusque style. Much as 'plain sense' was identified with 'common sense', Hogarth was unembarrassed to celebrate colloquial wisdom. Typical is a passage in which are described the connections between the beauty of an object, and its 'fitness' to perform its function. Hogarth concludes a paragraph with the enthusiastic statement that: 'When a vessel sails well, the sailors call her a beauty; the two ideas have such a connection!'

Setting out to provide an antidote to the scholarly ruminations of 'mere men of letters', Hogarth proceeds from a position of critical contempt for learning detached from empirical grounding. The *Analysis*, indeed, is a robust, though not particularly sophisticated, contribution to the British tradition of empirical philosophy. It is founded upon a confidently stated belief in the power of the eye to inform the mind of the true nature of things, a contention that Hogarth was disinclined to recognize as problematic. The introduction centres upon the argument that men should 'learn to see objects truly', without prejudice and preconception. Clear observation has, he infers, the capacity to render perspicacious the underlying 'principles' of nature. The development of such visual powers were also expected to guard against the unmerited veneration of art works by foreign masters that Hogarth believed to undermine the livelihood of modern British painters. In making the latter observation, Hogarth signalled his disinclination, even in a philosophical tract, to abandon completely a polemical hobbyhorse ridden in his other literary works.

Anti-bookish as Hogarth was, his views, as expressed in the *Analysis*, were founded upon, and make reference to, a wide reading. Some of this reading, as he disarmingly admits in the Preface, was conducted by learned friends with a command of foreign languages. Hogarth was also dependent upon friends in the writing of the work. Such were the limits to the painter's literary powers, that his authorship was justly questioned. Whilst the sentiments of the *Analysis* are consistent with the known voice of the declared author, much of the precise phraseology is probably that of ghost writers, in particular the literary cleric, Benjamin Hoadly (jr.).

Hogarth's text aimed to establish the claim of the artist, rather than the man of letters or connoisseur, to determine a 'system' of taste in the visual arts. In this respect, the *Analysis* reflects the consistent complaints in his other literary works that artists laboured to make their living against a plethora of prejudice generated by persons whose pretences toward 'judgement' were not grounded in a practical knowledge of the visual arts. As Hogarth posits in the Preface: man's sense of beauty is founded in his appreciation of 'grace', an attribute which literary connoisseurs have discerned but not been able to 'analyse'. The capacity of 'writers' had, he claimed, been limited to the perception of grace which, remaining indefinable, was described as the certain *'je ne sai crois'* of a work of art. A few artists, including himself, had, he argued, been able to improve upon this. Informed by practical experience, they had been able to arrive at a systematic and reasoned means of introducing this quality into their works. They alone are seen to have understood the 'causes and effects' of grace and beauty.

Hogarth claims to have rediscovered these 'causes and effects' through researches into an unconsidered heritage of artist's empirical observations; a heritage which is traced back through the maxims of **Michelangelo**, as recorded by **Lomazzo**, to the sculptors of ancient Greece. Michelangelo's recorded advice to a student that 'the whole mysterie of the arte' resides in the creation of a sense of motion, akin to the flickering of a flame, is cited as the central inspiration of Hogarth's own theory. The Renaissance artist's reported belief that beautiful figures shared a 'serpentlike' quality, underscores Hogarth's claim that grace resides in the current of a curvaceous 'line of beauty' through natural forms.

Hogarth adopted this 'line' as an emblem of his artistic identity, first introducing it to the public as a detail in his self-portrait of 1745. He admitted in his Preface that this line was received as an attempt to wrap his art in a sense of arcane mystery or 'hierogliphic'. However, he claimed in his defence that he was actually revealing the commonplace

law of his craft' a 'principle' so well known to good artists as to be
considered beyond the need for explication:

> painters and sculptors came to me to know the meaning of it,
> being as much puzzled as other people, till it came to have
> some explanation: but not till then, some found it out to be an
> acquaintance of theirs, tho' the account they could give of its
> properties was very near as satisfactory as that which a day-
> labourer who constantly uses the leaver, could give of that
> machine as a mechanical power.

The organization of text in the *Analysis* expressed the author's
determination to be systematic and clear in his modes of thought. The
first part of the book is divided into short and pithy chapters each
devoted to the elucidation of a principle: 'Fitness', 'Variety',
'Uniformity', 'Simplicity', 'Intricacy', and 'Quantity'. These 'princi-
ples' were considered to 'co-operate in the production of beauty,
mutually correcting and restraining each other occasionally'. The
remains of the book are devoted not to principles but to subjects of
traditional concern to artists: 'colour', 'lines', 'proportion', 'composi-
tion', 'attitude', and 'action'. Whilst these chapters tend to be longer
than those concerning 'principles', they essentially constitute embel-
lishments and digressions upon a thesis. Much of the intellectual
energy of the *Analysis* is concentrated in its first six chapters.

Regarded most broadly, the *Analysis* appears a thoroughly Lockean
statement. The theoretical basis of many of Hogarth's reflections upon
the 'principles' of grace can be traced to the *Essay Concerning Human
Understanding* (1690). It is to Locke, perhaps via the popularizing
medium of Addison's *Spectator* essays, that Hogarth owed his
preoccupation with the concepts of 'variety' and 'intricacy'. It was
probably from these sources that Hogarth borrowed his assertion that
the curiosity implanted in animal and human natures was founded
upon the primitive spirit of the hunt:

> This love of pursuit, merely as pursuit, is implanted in our
> natures, and design'd, no doubt, for necessary, and useful
> purposes. Animals have it evidently by instinct. The hound
> dislikes the games he so eagerly pursues, and even cats will risk
> the losing of their prey to chase it over again. It is a pleasing
> labour of the mind to solve the most difficult problems;
> allegories and riddles, trifling as they are, afford the mind
> amusement . . .

The eye has this sort of enjoyment in winding walks and serpentine rivers, and all sorts of objects, whose forms, as we shall see hereafter, are composed principally of what, I call, waving and serpentine lines.

Intricacy in form, therefore, I shall define to be that peculiarity in the lines, which compose it, that leads the eye on a wanton kind of chase, and from the pleasure it gives the mind, entitles it to the name beautiful: and it may be justly said, that the cause of the idea of grace more immediately resides in this principle, than in the other five, except variety; which indeed includes this, and all the others.

The reader is here encouraged to regard the discourse on 'intricacy' as the core to Hogarth's 'analysis'. The ultimate cause of man's appetite to experience the phenomena described as 'grace' and 'beauty' is traced to the requirement of his mind for a variety of sensual experience. All of Hogarth's 'principles' were subjugated to this Lockean precept. For instance, the human tendency to admire 'symmetry' is entertained but with the caveat that it is only when it is combined with 'variety' that this quality has the capability to please. To illustrate this point Hogarth refers, as was his wont, to the most commonplace of examples:

For when the head of a fine woman is turn'd a little to one side, which takes off from the exact similarity of the two sides of the face, and somewhat reclining, so varying still more from the straight and parallel lines of the formal front of the face: it is always looked upon as more pleasing. This is accordingly said to be a graceful air of the head.

Beyond the 'principles' overtly discussed in his text, Hogarth's was also fundamentally conditioned by one that remained un-stated – moderation. Only by existing in moderating combination are any of Hogarth's 'principles' deemed capable of conveying beauty. Even 'variety' was considered to require to submit in some degree to the order of symmetry and not to descend into gaudy novelty. Hogarth associates an excessive appetite for 'variety' with immaturity, observing that experimenting with sartorial novelties is a characteristic of silly intemperate youth. In his respect for moderation, and his tendency to regard this as a key to 'elegance', Hogarth is true to the conventional ideals of mid eighteenth-century politeness. His insistence upon the largely unqualified conflation of 'beauty' with 'grace', and simple

assumption that the function of beauty is to please, directly reflects the value placed upon agreeable sensations within 'polite' culture.

The *Analysis of Beauty* does not withstand much close inspection as a theory of aesthetics. It was, however, a much read, criticized and enjoyed work of literature. Quantifying the influence of the *Analysis* upon the future theory and practice of the visual arts is problematic. Some attempt at this task has been made by Ronald Paulson in his introduction to the most recent published edition (Yale University Press, 1997). It is tempting to regard the *Analysis* as a statement of the theoretical agenda behind a style of art, the English 'rococo'. By the time that Hogarth came to theorize upon 'the line of beauty', a host of London's painters, gardeners, sculptors and engravers had been exploring the grace of curvilinear form for decades. That an approach to design which had it roots in Parisian elegance should have found a rational defence in the words of a bluff apologist for British 'plain sense', a national type forged in opposition to French 'frippery', is a fine irony. It indicates that the lines upon which cultures develop tend to be more twisted and circuitous than Hogarth's famous 'line of beauty'.

Biography

William Hogarth was born on 10 November 1697 in London. Apprenticed to a silver engraver for a seven-year term in 1713, it was in the early 1720s that he began to produce prints, and about 1726 that he started to train as an oil painter. His first success as a painter, *The Beggar's Opera*, was produced in 1729. In 1732 he produced his first print series, *A Harlot's Progress*, and in 1743–5 came the *Marriage-à-la Mode* series. *The Four Stages of Cruelty* was published in 1751, *The Analysis of Beauty* in 1753 and in 1755 he completed a series devoted to the events of *An Election*. In 1762 he was to attack Pitt and Wilkes in a print entitled *The Times*. He died on 26 October 1764 in London.

Bibliography

Main texts

Analysis of Beauty. With the rejected passages from the manuscript drafts and autobiographical notes, ed. with introduction, Joseph Burke, Oxford, Clarendon Press, 1955.

The Analysis of Beauty, ed. with introduction and notes, Ronald Paulson, New Haven, CN, Yale University Press, 1997.

Nichols, John, *Anecdotes of William Hogarth Written by Himself*, London, 1833.

Secondary literature

Burke, Joseph, 'A classical aspect of Hogarth's "Theory of Art"', *Journal of the Warburg and Courtauld Institutes* 6 (1943), pp. 151–3.

Caygill, Howard, *Art of Judgement*, Oxford, Blackwell, 1989.

De Bolla, Peter, *The Discourse of the Sublime: History, Aesthetics and the Subject*, Oxford, Blackwell, 1989.

Dobai, Johannes, 'William Hogarth and Antoine Parent', *Journal of the Warburg and Courtauld Institutes* 31 (1986), pp. 336–82.

Hipple, J., *The Beautiful, the Sublime and the Picturesque in Eighteenth-Century British Aesthetic Theory*, Carbondale, 1957

Lippincott, Louise, *Selling Art in Georgian London*, New Haven and London, Yale University Press (for the Paul Mellon Centre for Studies in British Art), 1983.

Lomazzo, Giovanni Paolo, *Trattato dell'Arte Pittura, Scultura ed Architettura*, Milan, 1584; trans. Richard Haydocke as *A Tracte Containing the Artes of Curious Paintinge*, Oxford, 1598.

O'Connell, Sheila, 'An exploration of Hogarth's "Analysis of Beauty"', pl.1, fig.66', *Burlington Magazine* 126 (1984), pp. 33–4.

Paulson, Ronald, *Emblem and Expression, Meaning in English Art in the Eighteenth Century*, London, Thames and Hudson, 1976.

—— *Hogarth* (3 vols), New Brunswick, Rutgers University Press, 1991–1993.

Read, Stanley, 'Some observations on William Hogarth's *Analysis of Beauty*. A bibliographical study', *Huntington Library Quarterly*, 5 (1941–2), pp. 360–73.

MATTHEW CRASKE

DENIS DIDEROT (1713–84)

FRENCH WRITER, CRITIC AND PHILOSOPHER

Denis Diderot was, with Rousseau and Voltaire, one of the trinity of French Enlightenment *Philosophes*: thinkers and men of letters, notable for the multiplicity and variety of their talents. Diderot wrote plays, novels and philosophical tracts as well as taking chief responsibility for one of the most important publishing enterprises of the eighteenth century, the *Encyclopédie*. His art criticism, and his philosophy of art, must always be seen as developing alongside, and inseparably from, his wider intellectual interests in moral and political philosophy, and in the context of his considerable contribution as a creative and imaginative writer.

Diderot had shown interest in the visual arts from a fairly early stage in his philosophical career. The article 'Composition en peinture', written for the seventh volume of the *Encyclopédie*, demonstrates his knowledge not only of the tradition of French aesthetic thought (Roger **de Piles**, the Abbé du Bos, *et al.*), but also of contemporary

British thought (**Shaftesbury, Hogarth,** *et al.*). In some ways this article demonstrates the conservative tendencies in Diderot's early aesthetic thought – when he discusses painting he is really talking about the composition of history painting, and judging it strictly in accordance with the rules of drama, and especially the classical unities (of action, time and place). But even in this article, Diderot demonstrates a lively pictorial imagination, and maps philosophy onto art via an original and imaginative tableau illustrating the pictorial potential of **Plato**'s *Symposium*.

This particular combination of aesthetic conservatism and innovation, and the conjunction of analytical and creative, imaginative writing is also a feature of his dramatic treatises, written in 1757–8. In these, the *Entretiens sur le fils naturel* (Conversations on the natural son) of 1757 and the *De la poésie dramatique* (On dramatic poetry) of 1758, he argues for a fluid and mutually inspiring relationship between painting and dramatic poetry, and again creates an imaginary scene, based on Plato, this time a conception of the death of Socrates – an idea which, a generation later, would be taken up with enthusiasm by visual artists like Jacques-Louis David and Jean-François-Pierre Peyron.

Diderot's major contribution to art criticism, however, is undoubtedly his critical writings on the Salons, the free biennial public art exhibitions organized by the Académie Royale de Peinture et de Sculpture and held on a regular basis from the 1740s. The French Academy held a near-monopoly of prestige, and of talent, and so its exhibitions (of painting, sculpture and engravings) represented remarkable occasions to take the pulse of French visual culture. Diderot wrote his *Salon* reviews for a small group of subscribers to a manuscript journal, the *Correspondance Littéraire*, edited in its early years by Diderot's great friend and colleague, Friedrich Melchior Grimm. Its readership was a select band of (mostly foreign) nobles and aristocrats and the magazine was not allowed to circulate in Paris. There was, thus, little chance for his readers to actually attend the Salon with his work in their hands, and in some ways Diderot's long descriptions served as recreative *ekphrasis*, conjuring pictures Diderot's readers would probably never see. This explains on the one hand Diderot's often lengthy and scrupulous descriptions of the physical appearance of certain works, and on the other the freedom that Diderot enjoyed to mould imaginative dialogues and poetic excurses on the raw material in front of him.

Diderot wrote Salon criticism from 1759 to 1781, but the twin summits of his achievement as an art critic are the *Salons* of 1765 and 1767, whose length and complexity, both formal and philosophical,

are quite breathtaking and which were absolutely unprecedented in the (brief) history of art criticism up to this point. Philosophical inquisitiveness, imaginative analysis, and a highly personal, sometimes idiosyncratic authorial voice are the distinguishing marks of Diderot's art criticism and this combination places him at the beginning of what might be called the 'poetic line' in French art criticism, which was so strong a current in the nineteenth century and reached its apogee in the work of **Baudelaire**.

Such a varied and rich corpus of work as Diderot's art criticism defies neat pigeonholing, but it is still possible to isolate some key preoccupations and directions of thought. From his first Salon criticisms, of 1759 and 1761, it was already clear that Diderot was aiming at both a 'scientific' analysis (i.e. an exploration of the theme and construction of a given picture, analysing its central aspects, and then its subsidiary ones, structured according to logic and based on observation) and a wider moral and philosophical contemplation of works of art. At his best, he was also inspired to a highly imaginative and poetic engagement with the visual arts.

His analysis of the compositional features of paintings is inspired not only by his reading of the staple texts of academic art theory but by his own knowledge and interest in art, gained by access to some of the important private and princely collections of the time and by his conversations with practising artists. In judging art, Diderot often follows the kinds of precepts set out in *Composition en peinture* (Composition in painting) – he looks for an overall pictorial unity as a mark of a painting's success (as is the case in his praise for Doyen's *Le Miracle des Ardents*, for example) but his criteria for judgement are, importantly, often based on philosophical and moral rather than purely plastic considerations. The moral aspects of his criticism are perhaps discomforting for modern readers but are central to an understanding of his attempt to argue for painting as a fully fledged liberal art which must have a moral, improving dimension and a place in the public sphere. His adulation of the painter Jean-Baptiste Greuze (in the Salons of 1761, 1763 and 1765) and his frequent sallies against Boucher and Baudouin (Salons of 1759 and 1761) were motivated not primarily by concerns of painterly technique but of morality and the edification of their subject matter, a point made frequently in the *Salons* and stated explicitly in the *Essais sur la peinture* (Notes on painting; first published in 1795, but written in the 1760s). Of course, these heated invocations to virtue when describing Salon paintings such as Greuze's *Filial Piety* are part of a highly politicized discourse of spectacular virtue which contains within it a critique of the existing order.

This moral tone is, however, juxtaposed with a different voice, another register of language altogether, in the *Salons*, one which often exploits *argot*, colourful sexual pun, damning and cruel witticisms at the expense of artists, and a vivid, familiar and ludic language far removed from the rhetoric of virtue – which makes the *Salons* such entertaining reading. Could anyone but Diderot get away with analysing the difference between an oil painting and a sketch by recounting an anecdote about a well-endowed dwarf, as he does in the *Salon* of 1767?

Nor can Diderot resist commenting on the representation of female flesh in often explicitly sensual ways. In 1765, for example, in his analysis of Greuze's *Young Girl Blowing a Kiss from a Window*, his ludic description of the female figure is deliberately eroticized and self-mocking: 'What a mouth, what lips, what teeth, what a chest . . . she is drunk . . . she doesn't know what she is doing, and I don't know what I am writing.' This mischievous but complex voice, which acknowledges the erotics of spectatorship, must alert us to the fact that for Diderot, virtue is an ideal, a construct; and everywhere in his *Salons* one senses the sometimes delicious tensions involved in a project of art criticism which at once claims to be an insider's view of artistic creation and a programme for the public understanding of art.

Another creative tension in Diderot's art criticism is his conception of the organization and hierarchy of painting. In general, he remains in the thrall of those currents of academic and philosophical thought – stretching from Renaissance Humanism to such writers on art as André **Félibien**, Roger de Piles, and Jean-Baptiste du Bos – which espoused the doctrine of the hierarchy of genre, in which historical painting was of intrinsically greater worth than other genres, ranked downwards from genre painting to still life. However, Diderot's tendency is to create two broad categories (*peinture d'histoire* and the non-historical), and to try to argue that Greuze, for example, is best seen as a historical painter. In doing so, of course, he is trying to squeeze the innovations of modernity into the frameworks of classical thought. Unlike Baudelaire, he did not find an adequate way to theorise the 'painting of modern life'. Diderot's categorizations are still bound by subject matter, and thus, for example, his enthusiasm for Chardin is always hedged around by the sense in which, brilliant as he was, Chardin would remain an *ouvrier* (a mere artisan) and not an artist of ideas (as history painters were). In the context of later developments in art criticism, this might be seen as an anti-modern tendency.

Diderot could be withering and dismissive of art that he did not like. His most famous stinging critiques are often short and often barbed comments dismissing painters who irritated him: 'Hallez-vous

en' was his punning retort to Noel Hallé. The paintings which really appeal to Diderot often receive a more poetic treatment. Perhaps the most famous example of Diderot using a painting or series of paintings as the basis for an extended creative ruminescence is his engagement with Fragonard's *Corésus and Calirhoe* in his *Salon* of 1765. Instead of a direct description, Diderot weaves an elaborate philosophical fiction of a dialogue with Grimm, during which he imparts a vision in which he is trapped in conditions analogous to those of Plato's cave (from chapter VII of the *Republic*). The 'vision' which Diderot describes is of course, precisely the painting by Fragonard. In the *Salon* of 1767, he enters the landscapes of Vernet's paintings as a series of sites, as if imparting a picturesque travel narrative, which provides the basis for an incredibly wide-ranging series of observations over matters not only aesthetic but also moral and political. In both these two instances, Diderot uses art as a starting point for speculation on truth, nature or morality, and takes his reader far from mere description and judgement.

There is a clear tension between ideal and real in Diderot's art criticism. He often enthuses about the ability of a painter to capture a reality, to make spectators feel they are witness to a recreation of a real world. But for a philosopher like Diderot, reality is a slippery and problematic construct, and his art criticism tackles this issue when he examines portraits and the idea of likeness. But it is in the non-historical genres (landscape, still life, and so on) in which he is most insistent on a criteria of truth to reality: in historical painting, he is more concerned with the need for an 'ideal beauty', one which is not simply recreative of the physical world, but which engages with history, myth, or legend in imaginative and creative ways to convey the emotional truth of a moment.

One strategy Diderot frequently adopts is creative misdefinition: he often gives paintings new titles (he decided that Greuze's *Filial Piety* would be better entitled *The Reward for the Gift of a Good Education*) or invents narratives which he feels best explained what was going on in a painting, but which do not always match the viewing experience of those in front of the image. In this sense, Diderot's own imaginative and moral priorities sometimes cloud his pretensions to 'scientific' analysis. There is also a tendency in the *Salons* for Diderot to strain himself to prove what a 'painterly' imagination he has and how well he understands painterly practice – sometimes these appear to be protesting too much. Diderot's imagination remains profoundly theatrical and centred on the spectator rather than the artist. He is

concerned with effects, emotions and the associative and signifying power of art more than with its materiality and plasticity.

Diderot's importance to later art criticism should not be underestimated. The combination of seriousness of purpose with ironic, ludic and profoundly poetic tone in his most important work resonated with the Romantic generation, and impacted not only on Goethe and **Schiller**, but also on Stendhal and on Baudelaire. His blueprint of moral and political engagement with art in the public sphere, his abilities to recreate and create anew, and the intensity of his visions, all set blueprints which enabled art criticism to expand beyond the contingent and the merely judgemental. Freed from the parasitic confines of a description of the given, it could gain a literary and philosophic status of its own. Thus, Diderot opened up the field of criticism as a space of experiment and radical enquiry – and some of the more stimulating critics in more recent times, including Greenberg and Barthes, learned something from his method, even if they shared none of his ideals or principles. In the famous Vernet commentary in 1767, Diderot, following **Burke**, had claimed that: 'The imagination creates nothing'. His *Salons* stand as proof of the contrary.

Biography

Denis Diderot was born on 5 October 1713 in Langres, Haute-Marne. Educated by the Jesuits, he later, in 1733–44, made a living in Paris as hack, translator and publisher's assistant. From 1745–1772 he was one of the principal editors of, and contributors to, the *Encyclopédie*, the seminal work of the French Enlightenment. Diderot wrote novels (such as *Le neveu de Rameau*, 1761), studies on a wide range of scientific and philosophical subjects, and plays (including *Le Fils naturel*, 1757, and *Le père de famille*, 1758), their accompanying tracts signalling new directions in French theatre. He wrote his *Salon* criticism 1759–81. He died on 31 July 1784 in Paris.

Bibliography

Main texts

Diderot wrote *Salons* in 1759, 1761, 1763, 1765, 1767, 1769, 1771 [though his authorship of this *Salon* is disputed], 1775 and 1781. He also wrote short essays on painting. These are available in a variety of French editions, some more accessible than others. Only the *Salons* of 1765 and 1767 are as yet available in English translation.
Salons (1759–81), Seznec, J. and Adhémar, J. (eds), 4 vols, Oxford, Oxford University Press, 1957–67; rev. edn 1983.

Oeuvres esthétiques de Diderot, Vernière, P. (ed.), Paris, Garnier, 1959. (Includes *Essais sur la peinture*, 1795, and *Pensées détachées sur la peinture*, 1798.)
Diderot on Art, vol. I: *The Salon of 1765 and Notes on Painting*, and vol. II: *The Salon of 1767* trans. Goodman, J., introduction by T. Crow, New Haven and London, Yale University Press, 1995.
Selected Writings on Art and Literature, trans. Geoffrey Bremner, London, Penguin, 1994.

Collected works:
Oeuvres complètes de Diderot, xiv, Dieckmann, H., Proust, J., and Varloot, J. (eds), Paris, Hermann, 1984 (Diderot's writings on art as prepared for these volumes were reprinted in four paperback editions 1984–95).

Secondary literature

Brookner, Anita, *The Genius of the Future: Essays in French Art Criticism: Diderot, Stendhal, Baudelaire, Zola, the Brothers Goncourt, Huysmans*, London, Phaidon, 1971.
Bukdahl, E.M., *Diderot, critique d'art*, Copenhagen, Rosenkilde & Bagger, 1980.
Chouillet, J., *La Formation des idées esthétiques de Diderot*, Paris, Armand Colin, 1973.
Crow, Thomas, 'Introduction' to *Diderot on Art*, vol. 1, *The Salon of 1765 and Notes on Painting*, trans. J. Goodman, New Haven and London, Yale University Press, 1995.
Fontaine, A., *Les Doctrines d'art en France de Poussin à Diderot*, Paris, Renouard, 1909; repr. Geneva, Slatkine, 1970.
Fosca, François, *De Diderot à Valéry: les écrivains et les arts visuels*, Paris, A. Michel, 1960.
Furbank, P.N., *Diderot: A Critical Biography*, London, Mandarin, 1993.
Proust, J., 'L'Initiation artistique de Diderot', *Gazette des Beaux-Arts*, 5, LV (1960), pp. 225–32.
Sahut, M.-C. (ed.), *Diderot et l'art de Boucher à David*, exhibition catalogue, Paris, 1984. (This includes enlightening essays by Jean Starobinski and Régis Michel among others as well as much useful context about the *Salons*.)
Wilson, M. and Arthur M., *Diderot*, New York, Oxford University Press, 1972.

MARK LEDBURY

JOHANN JOACHIM WINCKELMANN (1717–68)

GERMAN ART HISTORIAN AND THEORIST

From the moment of its initial publication in German in 1764, Winckelmann's most important book, the *Geschichte der Kunst des Altertums* (*History of the Art of Antiquity*), had a far-reaching impact on the artistic and literary culture of the time. Its apologia for a purified and simplified Greek ideal in art played a formative role in that intensified engagement with the sculpture of Greek and Roman antiquity we now designate as neo-classicism. It also revolutionized and

gave a new impetus to art historical and archaeological studies. Winckelmann became an internationally acclaimed writer on art and the foremost antiquarian scholar of his day, one who radically redefined this specialist field of enquiry to make it central to late Enlightenment speculation about the history of ancient and modern culture. His work was seen as foundational text at a time when art history and classical archaeology were being established as modern academic disciplines, and several of the paradigms that this book put in circulation continued to be replicated and contested well into the twentieth century.

In the longer term, his writing on ancient art played a formative role in the radical rethinking of artistic and cultural norms initiated by German historicizing thinkers such as Herder, Goethe and **Hegel**. All were great admirers of Winckelmann, and deeply indebted to his historical reconstruction of ancient Greek art for their pioneering speculation about the differences between ancient and modern culture. The richly evocative, and at the same time historically dense, image of classical Greek sculpture he fashioned functioned for them as a cultural ideal which they saw as foundational and yet as increasingly at odds with a modern outlook.

The *History of the Art of Antiquity* enjoyed such a high reputation among Winckelmann's contemporaries partly because of its sheer intellectual scope and ambition, offering as it did a new, and compelling, synthesis of what was known about the arts of the ancient world. While it discussed Egyptian and Near Eastern art, its central concern was the historical evolution and aesthetic and ethical ideals of the ancient Greek tradition, including its later vicissitudes among the ancient Romans. Winckelmann was also a very fine writer who provided easily the most eloquent analysis available of the distinctive beauty of the classic masterpieces of ancient sculpture. His richly invested apologia for the Greek ideal, coming at a moment of intensified engagement with classical antiquity, both among intellectuals and the wealthy and fashionable, guaranteed his book a wide audience that is only very occasionally the lot of specialist scholarly studies. Its longer-term reverberations, however, depend on something more intangible, a sense of mission and purpose, a promise of larger insight to be gained from a close engagement with the finest visual artefacts surviving from the ancient Greek and Roman world.

Two aspects of Winckelmann's history of ancient art in particular distinguish it from earlier writing in the area. First, there is its ambition and conceptual complexity. It combines a self-consciously conceptual analysis with a historical or chronological presentation of empirical detail, a little like Rousseau's treatise *Discourse on the Origins and*

Foundations of Inequality among Men (1755). This is foregrounded in the underlying structure of the *History of the Art of Antiquity*, which divides into two parts. Part one, as Winckelmann put it, deals with history taken 'in the wider sense that it had in the Greek language' and elaborated into a 'system'. Part two, by contrast, is concerned with 'the history of art in the narrower sense, that is in relation to its external circumstances', and was conceived in a more conventional way as a 'narrative of its chronology and alterations'. Winckelmann's account of the rise and decline of ancient art echoes a preoccupation with broader patterns of historical development in Enlightenment thought fed by a widespread concern with symptoms of progress or decline in contemporary culture. Among other important instances of such a way of imagining the history of the ancient world, one could cite Edward Gibbon's *History of the Decline and Fall of the Roman Empire* (1776–88) and Montesquieu's *Thoughts on the Causes of the Greatness of the Romans and their Decadence* (1734).

While the impetus behind Winckelmann's new history of art had a lot to do with such general tendencies in Enlightenment thinking, it also related to developments within antiquarian studies and the art world. Most obviously, there was the new wave of excavating and collecting antiquities in Italy, of which the discovery of the Roman ruins at Herculaneum and Pompeii was the most striking instance. Wealthy connoisseurs and collectors were coming to Italy in increasing numbers, not only to see the masterpieces of antique art on display in the major Roman private collections, or the newly arranged public museums such as the Capitoline Museum, but also to acquire works for their own collections. For the less wealthy, Italy and Rome, in particular, gained new importance as the place of pilgrimage for an aesthetic education, a ritual which Winckelmann's writings on ancient art and his activities as a cicerone clearly fed.

Conditions of artistic taste were also important, above all the intensifying belief emerging in the mid-eighteenth century that a close engagement with the finest examples of antique art would lead to a renewal and purification of modern art practice. Winckelmann conceived his *History of the Art of Antiquity*, not only as making a contribution to antiquarian studies, but also as encouraging a revival of modern art through fostering a truer understanding of classical Greek models. Appearing in 1755, his first publication, *Gedanken über die Nachahmung der Griechischen Werke in der Malerei and Bildhauerkunst* (*Thoughts on the Imitation of the Works of the Greeks in Painting and Sculpture*), a short polemical treatise arguing for a return to the true principles of art embodied by the Greek ideal, contained his famous

slogan about the 'noble simplicity and calm [or still] grandeur' distinguishing antique from modern art. It was an unexpected international success, with translations soon appearing in French and English. Aside from the famous descriptions of key masterpieces of antique sculptures, such as the Laocoon, the Apollo Belvedere and the Belvedere Torso extracted from the *History of the Art of Antiquity*, this was probably his most widely read piece of writing.

A second novel aspect of Winckelmann's *History of the Art of Antiquity* crucial for its subsequent reputation was the emphasis it placed on visual and stylistic analysis. In the Preface, he described his aim as being, not only to define the rise, flourishing and decline of art, but also to account for 'the various styles of different peoples, periods and artists, and demonstrate this, as far as possible, with reference to the remaining works of antiquity'. The finer classical Greek and Roman remains were to be seen not only as offering the modern art lover a series of exemplary ideal works, and the antiquarian a fund of motifs yielding information about the symbols, cults and everyday practices of the ancients, as had been the norm in the text-based and iconographically orientated work of classical scholars prior to the mid-eighteenth century. These artefacts were to be analysed for what they revealed about the distinctive style of art among different peoples at different periods, while artistic style was taken to be symptomatic of people's material circumstances and characteristic mentality. Such an all-inclusive gesture proved very significant for the ambitions of later art history in its attempts to understand the aesthetic qualities of works of art in terms of the social and cultural circumstances that shaped their making.

As a result of Winckelmann's new historical synthesis, the classical artistic tradition no longer simply presented itself as a timeless ideal, but took on the character of a historical phenomenon, caught up in a cycle of development manifest in changes of style from the crudely archaic through successive refinements to a phase of classical perfection in the fifth and fourth centuries BC, and on from there to imitation and eventual decline. It is with Winckelmann that the modern distinction between an earlier, purer Greek tradition, and a later, imitative, and inherently inferior Greco-Roman one, first began to take hold. Such a historical perspective on the art of the ancient Greek and Roman world prepared the way for the flurry of archaeological activity in Greece and the Near East that got going at the turn of the century. Despite Winckelmann's claim to have introduced a new rigour in distinguishing true Greek work from later Roman or modern imitations and copies, it was still the case that almost all of the antiquities he thought might be associated with the ancient Greeks are

now seen as Greco-Roman copies or adaptations. Statues such as the Apollo Belvedere which he represented as the finest surviving exemplars of the Greek ideal are now mostly valued for what they reveal about artistic taste in Imperial Rome and are considered to be very different from the archaic and classical Greek work excavated in the nineteenth and twentieth centuries on which modern conceptions of ancient Greek sculpture are based.

This new historical dimension Winckelmann brought to understandings of the classic art of antiquity touched on people's deeply rooted assumptions that the finest existing ancient Greek and Roman sculptures existed as fixed, universal ideals of excellence, even if Winckelmann himself was no historicist. Starting with the tribute to him elaborated by Herder in 1778, and continuing with the later ones by Goethe and Hegel, Winckelmann came to be seen as having delineated the antique ideal with a vividness and specificity that made apparent how radically different it was from any classicism that might be practised in modern times. His historical schema provided later thinkers with a basis for viewing classical Greek art and culture from a perspective that problematized its status as a model for modern artists in ways that Winckelmann would have found unimaginable.

Later retrospective celebrations of Winckelmann, including those by Goethe and Hegel, still viewed his writing on ancient Greek art as a direct inspiration, at the same time that his mind-set came to be considered quite unmodern. He was seen as being able to embody the true spirit of the ancient world in ways that they were finding increasingly impossible. This ambivalent sense of Winckelmann as a figure whose writing provided a point of departure for a distinctively modern historicizing perspective, while he himself remained anchored in a pre-modern world, recurs in the most important tribute to Winckelmann from an English-speaking writer, Walter **Pater**'s essay dating from 1867, which was incorporated in the first edition of *Studies in the History of the Renaissance* (1873). Here, as with Goethe, Winckelmann was seen to be unselfconsciously living out the values of Greek antiquity. This image held a further charge for Pater because Winckelmann had written so eloquently and openly about Greek homoeroticism and had made an ancient Greek cult of male friendship and male beauty central to his whole outlook and way of life.

According to Pater, however, the qualities of Greek sculpture that Winckelmann had evoked with such passionate conviction and apparent immediacy, the 'unclassified purity of life' and the 'exquisite but abstract and colourless form', were slightly alien to a modern sensibility as well as being intensely captivating. He was acutely aware that the modern

compulsions and anxieties that drew him to this ideal also distanced him from it. Though less self-conscious than Pater about the preoccupations shaping his outlook on ancient Greek art, Winckelmann too had been aware of a historical gulf separating him from the ideal that fascinated him. In the conclusion to his *History of the Art of Antiquity*, speculating on why he had lingered so long on the demise and destruction of the Greek tradition, he explained how 'we have remaining to us, so to speak, only the shadowy outline of our desires: but this makes the desire for the objects we have lost ever more ardent'.

Biography

Johann Joachim Winckelmann was born on 9 December 1717 in Stendal, Prussia, the son of a cobbler. He studied theology at the University of Halle in 1738 and medicine at the University of Jena, from 1741–2. His first job was as a school teacher at Seehausen in Prussia. It was as librarian to Count von Bünau at Nöthnitz near Dresden 1747–54 that he came into contact with ancient art for the first time. In 1754 he converted to Roman Catholicism, and in 1755 moved to Rome. In 1758 he was to enter the service of Cardinal Alessandro Albani. He was appointed Commissioner of Antiquities in Rome 1763, and published *Geschichte der Kunst des Altertums* (*History of the Art of Antiquity*) in 1764. The victim of a murder, he died on 8 June 1768 in Trieste.

Bibliography

Main texts

Gedanken über die Nachahmung der Griechischen Werke in der Malerei and Bildhauerkunst, 1755; trans. Henry Fuseli as *Reflections on the Painting and Sculpture of the Greeks*, London, 1764; repr. in *Winckelmann: Writings on Art*, David Irwin (ed.), Phaidon, London, 1972. Original German edition reprinted in J.J. Winckelmann, *Kleine Schriften. Vorreden. Entwürfe*, Berlin, Walter de Gruyter, 1968.

Geschichte der Kunst des Altertums, Dresden, Walther, 1764 and 1776; trans. Henry Lodge as *The History of the Art of Antiquity*, Boston, Little Brown and Co., J. Monroe and Co. and J.R. Osgood and Co., 1856–72 (based on the second German edition published posthumously in 1776). An English translation of the first edition is to be published by the Getty Institute for Research in the Arts and Humanities, Los Angeles, 2003.

Briefe, Walter Rehm and Hans Diepolder (eds), Berlin, Walter de Gruyter, 1952–67.

Secondary literature

Davies, Whitney, 'Winckelmann's "homosexual" teleologies', in *Sexuality in the Ancient World*, N. B. Kampen (ed.), Cambridge, Cambridge University Press, 1996.

Dilly, Heinrich, *Kunstgeschichte als Institution. Studien zur Geschichte einer Diziplin* (Art history as institution: studies on the history of a discipline), Frankfurt am Main, Suhrkamp, 1979.

Fried, Michael, 'Antiquity now', *October* 37 (Summer 1986), pp. 87–97.

Gaehtgens, T.W. (ed.), *Johann Joachim Winckelmann 1717–1768*, Hamburg, Felix Meiner Verlag, 1986.

Gombrich, E.H., *Ideas of Progress and their Impact on Art*, New York, Cooper Union School of Art and Architecture, 1971.

Haskell, Francis, *History and its Images: Art and the Interpretation of the Past*, New Haven and London, Yale University Press, 1993.

Hatfield, Henry C., *Winckelmann and his German Critics 1755–1781: A Prelude to the Classical Age*, New York, King's Cross Press, 1943.

Jauss, H.R., 'History of art and pragmatic history', in *Toward an Aesthetic of Reception*, Brighton, Harvester, 1982.

Pater, Walter, 'Winckelmann', 1867, in *The Renaissance: Studies in Art and Poetry*, 1893; (ed.) D.L. Hill, Berkeley, Los Angeles and London, California University Press, 1980; (ed.) Adam Phillips, Oxford, Oxford University Press, 1986.

Potts, Alex, *Flesh and the Ideal: Winckelmann and the Origins of Art History*, New Haven and London, Yale University Press, 1994.

ALEX POTTS

JOSHUA REYNOLDS (1723–92)

BRITISH ARTIST AND WRITER

The writings of Sir Joshua Reynolds stand as one of the last and most important summations of a theoretical tradition which had dominated learned thinking about the visual arts from the fifteenth to the eighteenth centuries. Reynolds not only attempted to synthesize the ideas of such representatives of this tradition as the Italian Giorgio **Vasari** and the Frenchman Roger **de Piles**, but also sought, with mixed success, to update it in the light of the intellectual climate of eighteenth-century Britain.

Having made his mark as a portraitist in 1750s London, Reynolds first ventured into print in 1759 in three essays in Samuel Johnson's series *The Idler*. In 1768 he gained a more important platform when he became the first President of the new Royal Academy, in which position he delivered 15 annual, later biennial, lectures or 'Discourses' which together comprise a body of thinking about the visual arts of a significance without precedent in Britain.

The principal aim of Reynolds's Discourses, as with the Academy itself, was to foster a national school of painting in accordance with the criteria laid down by the theoretical tradition mentioned above; a

school which would, in other words, treat high 'historical' (i.e. religious, historical, allegorical and mythological) themes in an elevated manner. To this end, the Discourses addressed both the Academy's students, at whose annual prize-givings most of them were delivered, and a wider audience of leading cultural figures who either attended the lectures in person or would have been able to read them in print.

Reynolds's principal message to students was that diligent practice and the intensive study of the great art of the past were more important than natural talent. While in part attributable to a desire to encourage students in a teaching institution, this idea was also founded on Reynolds's own personal discovery that hard work and intelligent application might turn a painter of limited talents into a successful artist. The idea is also indicative of the way in which Reynolds, like so many thinkers of his day, was imbued with a painful sense of the inadequacy of modern achievements and a consequent belief that inspiration must be sought in the art of the past.

Addressing his wider audience, Reynolds used the Discourses to mount a public defence of the intellectual and social respectability of his art, seeking to refute the notion that painting was a mere mechanical craft or trade (because it was performed with the hands and for money) and not a liberal art (an intellectual discipline worthy of being conducted by the free, i.e. those not dependent on labour for their livelihood). This negative conception of painting had particular currency in Britain, where few painters other than portraitists, who were widely considered to be no more than mindless copiers of what was before them, were able to make a living. In the Discourses and the *Idler* letters, Reynolds drew upon earlier theory to show how painting might, if conducted properly, be a liberal art. Painters should, for example, eschew lower subjects like portraiture, still-life and landscape in favour of elevated historical themes. What painters should paint was, however, less important for Reynolds than how they should paint it. Central to his thought was the belief that painters should not simply copy the imperfect nature we see around us in every minute detail, but seek rather to depict nature in its ideal or perfect state.

The idea that painters should go beyond 'particular' nature and strive for some higher form of beauty or truth had been commonplace in art theory since the fifteenth century. Theorists varied in the recipes they offered for attaining this ideal, whether through the inductive procedure of combining the best features from several particular models into a new and more perfect whole (as applied by the Ancient Greek painter Zeuxis when asked to paint Helen of Troy) or through the deductive process of imagining forms more beautiful than any found in

particular nature (as Raphael claimed to have done in painting his *Galatea*). Reynolds's recipe was different again. He argued that in producing a given species nature is always striving towards a certain perfect form, and that it is this form in which true beauty lies. Although in practice every individual is an imperfect realization of that perfect form, the perfect form itself is knowable because all individual imperfections are deviations from its constant standard. If painters view many individual specimens and abstract from them the average, they will thus arrive at the perfect 'central form' in which truth and beauty lie. Since the abstraction of this 'general nature' is an intellectual process, unlike the purely mechanical process of copying particular nature, the painter, in practising it, affirms the intellectual nature of his art.

Although this is not what we mean by 'imitate nature' today, it would be a mistake to think that Reynolds wished painters to turn away from nature. He saw the close, even 'anatomical' study of particular nature as a necessary prerequisite to the abstraction of the general (although a shortcut might be sought through reference to the works of earlier artists who had performed similar feats of abstraction). Even the process of abstraction was not a turning from nature, but an arriving at a higher and purer form of nature divested of the deformities of individual specimens. In his insistence on starting with the particular and working towards the general Reynolds was, indeed, seeking to update the traditional art-theoretical preference for the ideal over the particular in the light of the empiricism which underlay British eighteenth-century epistemology, and most specifically the theory of general ideas advanced by the philosopher John Locke. It was a compromise for which he may have been indebted to his friend Samuel Johnson, who was concurrently proposing something similar for poets.

The theory of general nature is typical of the way in which Reynolds, for all his conservatism, was prepared to amend or qualify received opinion. This trait is more evident in his later thought, in which dogma increasingly gives way to nuanced critical judgements. In his earlier writings, for example, Reynolds had repeated the well-worn contrast between central Italian art of the sixteenth and seventeenth centuries (lauded for painting the ideal), and Venetian, Flemish and Dutch art (derided for copying the particular). He also attacked Venetian and Flemish art for being 'ornamental', seducing the eye with splendid colour while neglecting the more substantive quality of design. In the later Discourses, however, Reynolds proved more generous to Venetian and Netherlandish painting, a tendency still more apparent in his published annotations to the French painter Charles Du Fresnoy's *Art of Painting* (1783), and in his 'Journey to Flanders and Holland', an

account of pictures seen in the Netherlands in 1781 that first appeared in his posthumous *Works* in 1797. The hero of the 'Journey' is Rubens, an artist of whom Reynolds had earlier been critical but whose colour and handling astonished him when he confronted them at first hand. Reynolds even came to admit that **Michelangelo** and Raphael might have benefited from Rubens's mastery of colour, an eclecticism at odds with his denial in the *Idler* letters that the great Italians had anything to learn from Netherlandish art.

Discussions of colour and chiaroscuro are increasingly prominent in Reynolds's later writings, for all his conventional statements about the superiority of design in the earlier Discourses. He showed a capacity, unusual at the time, to attend to the colour and chiaroscuro of a painting regardless of its subject, even developing a means of sketching pictures entirely in terms of their patterns of light and shade. In his later writings Reynolds not only recommended this practice but also frequently referred to the 'shapes' formed by areas of light or colour, thus precociously foreshadowing the twentieth-century formalist tendency to conceive of composition as an organization of shapes and colours on a two-dimensional plane.

While Reynolds became more wide-ranging and less dogmatic in his later writings, it should not be thought that this constituted a fundamental shift in his outlook. He wished his corpus of writings to be considered as a whole, indicating, for example, that his remarks on Rubens did not contradict his earlier statements about the superiority of Italian art, but were rather offered as an amendment to them. Lest there should be any doubt that he remained loyal to the principles enunciated in his early writings, Reynolds devoted his final Discourse (1790) to Michelangelo, the artist he had extolled 30 years earlier in the *Idler* letters, for his capacity to paint nature in its most heightened form.

After Reynolds's death, his writings came to be seen as the cornerstone of the rising British school of painting which he had done so much to inspire. In many ways, however, they formed a most unsatisfactory blueprint for that school. In the first place, their attempt to update art theory for the modern intellectual climate fell rapidly into obsolescence. Most seriously, his compromise between the idealism of traditional art theory and modern empiricism came under attack from those who doubted both the philosophical validity of general ideas and the artistic desirability of their representation. According to William Hazlitt, Reynolds's theory of general nature had inspired paintings that were 'slovenly and unfinished', devoid of any meaningful detail. Hazlitt also questioned Reynolds's lack of interest in originality and obsession with the art of the past, thus taking a stance

that prefigured the more optimistic attitude to artistic progress taken by many nineteenth-century thinkers.

Reynolds's ideas were still more damagingly out of tune with the practical circumstances facing painters. They might inspire British artists to paint historical subjects and general nature, but British patrons continued to show little interest in the results. Reynolds himself had responded to the lack of demand for British history painting by historicizing his portraits – generalizing his sitter's features or dress, portraying them as allegorical figures, or drawing upon his rich visual memory and compendious art collection to offer witty or subtle references to past art (a practice which he justified as 'borrowing' and which prompted a fellow portraitist to accuse him of plagiarism). Young painters less willing to compromise in answering the call for a great British history painter were, however, faced with disaster. James Barry died destitute; Benjamin Haydon committed suicide. The rising middle-class public for art flocked instead around paintings of landscape or everyday life, often painted in the particular detail which Reynolds so despised. That many of the leading proponents of these latter genres had themselves been nurtured in the Academy would have been scant consolation for a man who had hoped to call forth a native school of history painting. Increasingly out of step with nineteenth-century thought, Reynolds's ideas fell slowly from favour. It is only recently that they have once again begun to receive a level of attention commensurate with their historical importance, a development which may owe much to their almost postmodern emphasis on a knowing play of reference to past art and ideas.

Biography

Joshua Reynolds was born on 16 July 1723 in Plympton, the son of a grammar school master. He was apprenticed to Thomas Hudson in London, 1740. From 1749–52 he travelled in Italy, returning via Paris. In 1753 he recommenced his career as portraitist in London. In 1764 he founded a literary society, the Club, whose members would include Dr Johnson, Edmund **Burke**, Goldsmith, and Sheridan. In 1768 he was elected first President of the Royal Academy, and in 1769 he was knighted and delivered his first Discourse to the Academy. In 1773 he was awarded a Doctorate of Civil Law at the University of Oxford. In 1781 he toured the Low Countries and Germany (another tour of the Low Countries followed in 1785). In 1784 he was appointed Painter in Ordinary to King George III. In 1790 he delivered his fifteenth and last Discourse to the Academy. He died on 23 February 1792 in London.

Bibliography

Main texts

Three letters to *The Idler*, nos 76 (29 September 1759), 79 (20 October 1759), 82 (10 November 1759); repr. in Reynolds, *Discourses*, Pat Rogers (ed.), London, Penguin (1992), pp. 347–58.

Each of the Discourses was published shortly after it was delivered. The first seven were published as:

Seven Discourses Delivered in the Royal Academy by the President, London, 1778.

All 15 were first published together in:

The Works of Sir Joshua Reynolds, vol I, Edmond Malone (ed.), London, 1797.

For the definitive modern edition:

Discourses on Art, Robert W. Wark (ed.), New Haven and London, Yale University Press, 1975.

The Art of Painting by Charles Alphonse Du Fresnoy translated into English Verse by William Mason MA with Annotations by Sir Joshua Reynolds, York, 1783; repr. in *The Works of Sir Joshua Reynolds*, vol. II, Edmond Malone (ed.), London, 1797.

'A journey to Flanders and Holland', in *The Works of Sir Joshua Reynolds*, Edmond Malone (ed.), London, 1797, vol. II. For a modern edition see Reynolds, *A Journey to Flanders and Holland*, Harry Mount (ed.), Cambridge, Cambridge University Press, 1996.

Secondary literature

Asfour, Amal, and Williamson, Paul, 'On Reynolds's use of de Piles, Locke, and Hume in his essays on Rubens and Gainsborough', *Journal of the Warburg and Courtauld Institutes* 60 (1997), pp. 215–29.

Barrell, John, *The Political Theory of Painting from Reynolds to Hazlitt*, New Haven and London, Yale University Press, 1986.

Gombrich, E.H., 'Reynolds's theory and practice of imitation', *Burlington Magazine* 130 (1942), pp. 40–5; repr. *Norm and Form*, Oxford, Phaidon Press, 1966.

Hazlitt, William, four essays on Reynolds's *Discourses* in *The Champion*, 27 November, 4 December, 25 December 1814, 8 January 1815; repr. in Reynolds, *Discourses on Art*, Robert W. Wark (ed.), New Haven and London, Yale University Press, 1975.

Hilles, Frederick Whiley, *The Literary Career of Sir Joshua Reynolds*, Cambridge, Cambridge University Press, 1936.

Hipple, Walter J. Jr, *The Beautiful, the Sublime, and the Picturesque in Eighteenth-Century British Aesthetic Theory*, Carbondale, Southern Illinois University Press, 1957.

Lipking, Lawrence, *The Ordering of the Arts in Eighteenth-Century England*, Princeton, Princeton University Press, 1970.

Mannings, David, 'An art-historical approach to Reynolds's Discourses', *The British Journal of Aesthetics* 16 (1976), pp. 354–66.

Mount, Harry, 'Reynolds, chiaroscuro and composition', in *Pictorial Composition from Medieval to Modern Art*, Paul Taylor and François Quiviger (eds), Warburg Institute Colloquia 6 (2000), pp. 172–97.

Postle, Martin, *Sir Joshua Reynolds: the Subject Pictures*, Cambridge, Cambridge University Press, 1995.

HARRY MOUNT

IMMANUEL KANT (1724–1804)

GERMAN PHILOSOPHER

Kant's *Kritik der Urteilskraft* (*Critique of Judgement*) – more specifically, its first half, 'Critique of Aesthetic Judgement' – enjoys the same seminal status in modern aesthetics as that of his two earlier Critiques, of 'pure' and 'practical' reason, in metaphysics and ethics respectively. It is at once the culmination of the intense eighteenth-century debate on beauty and taste and the fount and target of most later tendencies in aesthetics. The work has had hardly less impact upon art criticism and, indeed, upon the arts themselves, despite its relatively few sections explicitly devoted to art. (Unlike **Hegel**, who equated aesthetics with the philosophy of art, Kant uses the term 'aesthetic' to refer to a kind of 'subjective judgement' applied as much to natural objects as to artworks.) It testifies to both the richness and density of those sections that artists and art theorists of starkly opposed inclinations have appealed to Kant's authority – both 'formalists' and 'naturalists', for example, or champions both of 'art for art's sake' and of a moral purpose in art. Such appeals typically reflect one-sided emphases on elements in a discussion that Kant himself took to constitute a systematic whole.

That discussion begins with the problem, familiar from eighteenth-century philosophers like David Hume, of resolving a tension between two plausible views about aesthetic judgements. First, they are 'subjective' in the sense that they record feelings, like pleasure, rather than describe features of the objective world. Second, however, one is often entitled to 'contest' another person's judgement and insist on agreement with one's own. There is, as Kant puts it, an 'antinomy' between the 'thesis' that judgements of taste are not determined by concepts and the 'antithesis' that they must be ('otherwise we could not claim ... the assent of others') (§ 56). Kant's solution to this antinomy radicalizes a proposal of Hume's, according to which judgements that command assent are those of 'competent judges' who, *inter alia*, are without prejudice or bias. For Kant, a 'pure' aesthetic judgement must be *disinterested*, but this requires much more than

absence of prejudice. A 'pure' judgement must not only be uncontaminated by any desire for, and practical or moral interest in, the object judged: the judge must also be 'indifferent' both to the nature of the object and, indeed, to its actual existence (§ 2). If, thinking I am looking at a rose, I judge: 'That is beautiful', my judgement is not purely aesthetic if it is then affected by the discovery that the object is really a tulip, say, or that it is not an actual object at all (but, say, a laser projection). In other words, genuinely aesthetic judgements concern only 'appearances' or 'representations' – looks, sounds and so on – and not the actual objects, if any, with those appearances.

Kant argues that if my judgement is purely aesthetic in this sense, then it must command the assent of anyone else whose judgement is similarly disinterested. This is because everything personal and idiosyncratic – all desires, interests and the like – has been excluded, so that nothing remains that could cause two disinterested judges to disagree. A pure judgement of taste is subjective then, yet it has 'universal validity', for there is nothing personal, individual or culturally specific about the subjective feelings registered.

The idea that, in aesthetic judgement, we, so to speak, abstract ourselves from the actual world, including our own individual dispositions, has been immensely influential. It is, for example, at the core of Arthur **Schopenhauer**'s aesthetics. Kant, however, is not content to rest the solution to his antinomy on this idea alone, for he sees both our capacity for and pleasure in making disinterested judgements as deeply puzzling. Animals, after all, do not, as far as we can tell, enjoy such a capacity or pleasure. Disinterested pleasure cannot be a 'brute fact': it must have a 'determining ground', despite the fact that there is no 'determinate concept' under which an object falls – it has no objective feature – that could compel a particular aesthetic judgement. Kant's ingenious proposal is that, strictly, it is not objects or their appearances in which aesthetic pleasure is taken, but something – though something highly 'indeterminate' – about *ourselves*. Specifically, the pleasure is an awareness of our higher 'cognitive powers' – our imagination and understanding – at work together in what Kant calls a 'free play' (§§ 9–12). The objects we regard as beautiful are those apt to inspire exercises of the imagination that, without being tightly constrained by conceptual understanding, are not mere flights of fancy either. (In a particularly difficult passage, Kant refers to such objects as exhibiting 'purposiveness [or finality] without purpose' (§ 10). The idea seems to be that, in appreciating them, we cannot but regard them *as if* they had been designed by an

intelligent will and in a manner suited to the operation of our faculties.)

Although Kant sometimes gives the impression that consciousness of 'free play' is enjoyable for itself, he in fact proposes a deep explanation of this pleasure. It is, he writes, a pleasure 'consequent' upon the 'universal communicability' of my aesthetic experience (§ 9). Not only is universal agreement with my aesthetic judgement something I demand, the possibility of such agreement is the very source of the pleasure I take in making it. The point is not simply, or mainly, that we find pleasure in 'sociability', in not being eccentric 'outsiders'. Rather, the sense of my experience's being universally shared intimates the *humanity* that binds me and my fellows together. More exactly, because it is a *free* play of my faculties of which I am conscious in aesthetic experience, the latter evokes 'the supersensible substratum of humanity' – namely, the freedom of us rational, moral beings from nature. As Paul Guyer puts it, Kant shows how 'the very autonomy of aesthetic experience . . . allows it to serve as a palpable expression of the freedom that is the essence of morality' (in Kelly (ed.), 1998). Or, as Kant himself puts it, 'beauty is the symbol of morality', and from that very fact is 'derived' the pleasure that beauty affords us (§§ 59–60). This does not mean that moral concerns should influence aesthetic judgement: indeed, if they did, the judgement would not be aesthetic. It is precisely because the judgement is disinterested that it manifests freedom – albeit a freedom whose importance, ultimately, is as a guarantee of the possibility of morality. The disinterested attitude that may, in the early sections, have sounded like the accomplishment of dilettantes or 'aesthetes' turns out, then, to be the precondition for *experiencing* – as against merely *postulating* – the moral freedom that defines us as human.

None of Kant's discussion, as so far expounded, has any specific reference to art. Indeed, most of his examples of objects of aesthetic judgement have been taken from the world of nature, not culture. Moreover, when he refers to 'the superiority of natural to artificial beauty' and remarks that 'art can only be called beautiful . . . while it looks like nature' (§ 45), it seems that Kant relegates art to the level of a poor and vicarious substitute for nature. But this is not the case. The reference to nature's 'superiority' is making the strictly limited point that appreciation of nature is more apt than art appreciation to promote a certain kind of 'intellectual interest', a pleasure in the world's *being* a certain way and not simply in how things look, sound, smell, etc. As for the claim that art should look like nature, this is not advocating that painters should produce highly 'realistic' copies of

mountains, oceans or whatever for the benefit of those who are denied experience of the originals. The point, rather, is that a pure, disinterested appreciation of the formal features of an artwork requires prescinding from any concern for the intended content and purpose of the work. One must, as it were, be indifferent to its being an artefact rather than a product of nature.

Kant's emphasis on the formal features of works that inspire the free play of our faculties and invite aesthetic appreciation has inclined some art critics, like Clive Bell and Clement Greenberg, to suppose that he would have welcomed formalist and even abstractionist tendencies in modern art. But this is to ignore Kant's insistence that taste and purely aesthetic pleasure constitute only one aspect of art appreciation. While artworks are expected to be beautiful in form, an unrelenting diet of ones that are no more than that – wallpaper designs, for example – would soon be 'dulling'. Artworks should also be 'full of spirit [or soul, *Geist*]', so as to 'put [our] mental powers into swing' (§§ 49–50). Works that manifest this 'spirit' are those which present what Kant, somewhat infelicitously, calls 'aesthetic Ideas', and they are the product of 'genius'. It is in these two notions that Kant's main contribution to art theory, as distinct from aesthetics at large, resides.

Genius, in Kant's sense of the term, is peculiar to art: it is the 'innate disposition through which nature gives the Rule to art' (§ 46). The accomplishments of a scientific giant, like Newton, are, one might say, his own. The 'rules' – the method of enquiry used, the steps of inference taken, and so on – are his own responsibility, and ones that he can formulate and teach to others. The artist of genius, however, is a medium through which nature works: he or she is unable to formulate how a work comes about and the 'rule' followed cannot be taught or learned, even though the work becomes 'exemplary' for later artists. What such an artist produces or 'presents' are 'aesthetic Ideas'. These are not, despite the connotations of the word 'idea', mental items, but imaginative visual (or other observable) representations, such as paintings, that inspire rich processes of thought and imagination on the part of their audience. These 'Ideas' serve to 'body forth' or 'realize' in a sensory form matters that are 'invisible' and profound – eternity, love, creation, and so on. Crucially, these are matters of which we have only a meagre conceptual understanding, and to which ordinary, literal language is inadequate. By presenting aesthetic Ideas of such matters, the artist-genius furnishes 'much ineffable thought' and feeling, thereby expressing, enriching and communicating modes of understanding and experience in a way that ordinary discourse never could (§ 49).

Kant's picture of the artist-genius who expresses the ineffable is thoroughly consonant with the conception of art advocated by artists and philosophers of art, like Schelling, identified with the Romantic movement already underway at the end of the eighteenth century. It would be wrong, however, to describe Kant as an 'expressivist' if that term suggests, as it does for some later writers opposed to formalism, that artworks should be uninhibited outpourings of artists' emotions. For a start, it is not emotions but what Kant, somewhat confusingly, calls 'rational ideas' – eternity and the like – that the artist-genius 'realizes' in sensory form. Second, such an artist must *communicate*, ideally to all other human beings. To do this, he or she must pay due attention to the formal aspects of a work. Slapping paint onto a canvas any old how might 'release' an artist's feelings, but what is expressed may be detectable by no one other than the artist and his or her immediate coterie.

Despite, or rather because of, the autonomy of the aesthetic, it is clear that, for Kant, sensitivity both to beauty in general and to great art is integral to an authentically human life. Disinterested pleasure in the contemplation of nature intimates our freedom from the very thing contemplated, while the human products of 'spirit' or genius communicate and render palpable those profound thoughts that, together with moral freedom, distinguish humankind.

Biography

Immanuel Kant was born on 22 April 1724 in Königsberg, East Prussia, where he remained for his whole 80 years. He was educated at the Collegium Fredericanum (a Pietist academy) and at the University of Königsberg. Until 1755 he was a private tutor. From 1755–97, he taught a wide range of subjects at the University, and was appointed to the Chair of Logic and Metaphysics in 1770. He achieved international fame with the publication of three *Critiques* in 1781, 1788 and 1790 respectively. He died on 12 February 1804, receiving full honours from his city and university.

Bibliography

Main texts

Kritik der reinen Vernunft, 1781, rev. 1787; trans. W.S. Pluhar, *Critique of Pure Reason* Indianapolis, Hackett, 1996.
Kritik der practischen Vernunft, 1788; trans. L. White Beck, *Critique of Practical Reason*, Indianapolis, Bobbs-Merrill, 1956.

Kritik der Urteilskraft, 1790; trans. J.H. Bernard, *Critique of Judgement*, London, Macmillan, 1892; trans. W.S. Pluhar, Indianapolis, Hackett, 1987.

Secondary literature

Crawford, D.W., *Kant's Aesthetic Theory*, Madison, Wis., University of Wisconsin, 1974.

Guyer, Paul, *Kant and the Claims of Taste*, Cambridge, Cambridge University Press, 1997, rev. edn.

Kelly, Michael (ed.), *Encyclopedia of Aesthetics*, vol. 3, Oxford, Oxford University Press, 1998 (nine articles on Kant, pp. 26–62).

Kemal, Salim, *Kant and Fine Art,* Oxford, Clarendon Press, 1986.

Körner, Stephan, *Kant*, Harmondsworth, Penguin, 1970.

Mothersill, Mary, *Beauty Restored*, Oxford, Clarendon Press, 1984.

Schaper, Eva, *Studies in Kant's Aesthetics*, Edinburgh, Edinburgh University Press, 1979.

Scruton, Roger, *Kant*, Oxford, Oxford University Press, 1982.

DAVID E. COOPER

EDMUND BURKE (1729–97)

IRISH-BORN BRITISH STATESMAN AND WRITER

Burke's contribution to aesthetic theory, *A Philosophical Enquiry into the Origin of Our Ideas of the Sublime and the Beautiful* (1757), was an empirical investigation into the psychological and physiological basis of man's aesthetic experience, penned under the influence of other empiricist philosophers of the British Isles, such as **Shaftesbury**, Addison and Locke. In the 'Introduction on Taste', prefaced to the revised edition of the *Philosophical Enquiry* of 1759, and in Burke's analysis of beauty as a source of pleasure, he contributed to the development of two central aesthetic ideas of the eighteenth century. However, the historical significance of his text derives primarily from his interpretation of the sublime as an aesthetic category. This was to provide a philosophical basis for understanding man's aesthetic experience of aspects of nature and art which did not conform to eighteenth-century notions of beauty.

In eighteenth-century aesthetics taste was generally conceived as a rational attribute of men of sensibility who were self-aware of every nuance of their feelings. However, Burke followed Shaftesbury in conceiving direct sensory experience, unmediated by the faculty of reason, as the object of the faculty of taste, for which he postulated a physiological basis common to all mankind. Accordingly, he stated that

'the pleasure of all the senses, of the sight, and even of the Taste, that most ambiguous of the senses, is the same in all, high and low, learned and unlearned', as illustrated by the fact that 'all [men] concur in calling sweetness pleasant, and sourness and bitterness unpleasant' and that all find 'light ... more pleasing than darkness' and 'summer ... more agreeable than winter'. Thus in his conception of the faculty of taste, Burke established a universally valid, empirical benchmark against which to evaluate our aesthetic experience, not merely of visual phenomena, but of all sensory impressions.

Just as Burke identified a physiological basis for the faculty of taste, so he defined beauty as that which gives pleasure and 'causes love, yet excites nothing at all of desire' through its direct appeal to the senses. This represented a departure from the conception of beauty widely held by eighteenth-century thinkers for whom the art and culture of classical antiquity represented an ideal. It was in accordance with **Plato**'s view of the representation of nature in an idealized form as morally edifying that the classical doctrine of *mimesis* (imitation) was appropriated as the cornerstone of eighteenth-century aesthetic theory, and the symmetry, balance, and perfect proportions of a painting, sculpture or landscape deemed beautiful. In contradistinction to this view, Burke, who rejected the notion of beauty as a means of inspiring moral virtue, described as beautiful those physical character-istics of nature and art which give pleasure. He stated that 'since [beauty] is no creature of our reason, since it strikes us without any reference to use, ... we must conclude that beauty is, for the greater part, some quality in bodies', and identified 'smallness', 'smoothness', 'gradual variation', and 'delicacy' as beautiful 'sensible qualities'. In so doing he moved away from the notion of beauty as a purely visual phenomenon to account for the range of pleasant sensations to which sights, sounds, tastes, and smells give rise.

Underpinning the distinction Burke drew between the beautiful and the sublime was his recognition 'that pain and pleasure in their most simple and natural manner of affecting, are each of a positive nature, and by no means necessarily dependent on each other for their existence'. Accordingly, he differentiated between the 'positive pleasure' to which the beautiful gives rise, and the 'relative pleasure' or 'delight' which 'accompanies the removal of pain or danger'. He described how 'on being released from the severity of some cruel pain' we find ourselves in 'a state of much sobriety, impressed with a sense of awe, in a sort of tranquility shadowed with horror', and it was this feeling of 'delight' which Burke conceived as the essence of the sublime. He stated that:

> When danger or pain press too nearly, they are incapable of giving any delight, and are simply terrible; but at certain distances, and with certain modifications, they ... are delightful, as we everyday experience.

It was Burke's belief that 'the passions ... which are conversant about the preservation of the individual' and which 'turn chiefly on pain and danger, ... are the most powerful of all the passions' which gave the sublime the aesthetic credibility previously reserved for the beautiful.

Burke's formulation of the sublime as an aesthetic category represented a significant departure from its origins in classical antiquity as a category of rhetoric. The sublime was first codified in a first-century Greek treatise entitled *On the Sublime* attributed to Longinus, who conceived it as a stimulus of powerful emotion which found expression through the noble diction and imagery of an oration. It was this rhetorical notion of the sublime which 'acquired something of a cult status among the literary' in the early eighteenth century (Phillips, 1996). However, Burke was not concerned with the techniques by which an orator could inspire his listeners with astonishment and awe, but rather with explaining our experience of aspects of nature and art which, because they 'excite the ideas of pain and danger', are 'a source of the sublime'.

He identified characteristics of natural phenomena as sublime, such as 'vastness' and 'littleness', since 'as the great extreme of dimension is sublime, so the last extreme of littleness is in some measure sublime likewise'; 'magnificence', such as that of 'the starry heaven'; 'infinity and eternity', since 'there is nothing of which we really understand so little'; and 'obscurity', as exemplified by 'how greatly night adds to our dread, in all cases of danger, and how much the notions of ghosts and goblins, of which none can form clear ideas, affect minds'. For Burke, it was the capacity of art to assume these characteristics of nature which rendered it sublime, the complexity, uniformity, and magnificence of an art work being as awe-inspiring as the grandest aspects of nature. His recognition of 'excessive loudness' or the 'sudden cessation of sound', and of bitter tastes and 'intolerable stenches' as sublime enabled him to explain the sublimity of all our sense-impressions.

The historical significance of Burke's reformulation of the sublime as an aesthetic category was far-reaching. By acknowledging the aesthetic merit of art as an expressive medium, the value of which is derived not purely from the imitation or idealization of nature, but also from the emotions which the subject-matter of the work evokes,

Burke lent credibility to a range of art previously excluded from the neoclassical canon of beautiful masterpieces, such as the grotesque etchings of Jacques Callot and the paintings of Rembrandt. The high value Burke, like Rousseau, placed on man's feelings and immediate sensory experience provided the impetus for the *Sturm und Drang* movement of the 1770s, in which thinkers such as Herder, Hamann, and Goethe explored further the psychology of aesthetic perception. In the wake of this *Geniezeit* (time of genius), **Kant** reformulated the beautiful and the sublime to account for the interrelationship between man's rational and emotional faculties which he conceived as fundamental to human experience, and in so doing provided a philosophical basis for the aesthetics of Romanticism.

The importance the sublime assumed in late eighteenth- and early nineteenth-century aesthetic thought, and the enthusiasm for a wider range of art works which it ushered in, was reflected in the history of art of the period. The revival of Gothic architecture, the landscapes and seascapes of Caspar David Friedrich and J.M.W. Turner, and the grotesque engravings of Francisco Goya can all be understood as practical realizations of the sublime. Taste for the sublime was also reflected in developments in landscape gardening in the late eighteenth century, during which the popularity of the formal, neoclassical gardens associated with Capability Brown was superseded by enthusiasm for wild, open parkland in which nature was given free rein.

Burke devoted the last part of the *Philosophical Enquiry* to an investigation of the relationship between poetry and visual art, and suggested that whilst our aesthetic experience of the former derives from our 'sympathy' with the ideas and feelings evoked in a text, our appreciation of the latter is based primarily on its representational quality. He suggested that just as 'natural objects affect us, by the laws of that connexion, which Providence has established between certain motions and configurations of bodies, and certain consequent feelings in our minds', so 'painting affects in the same manner, but with the superadded pleasure of imitation'. By contrast he argued that 'poetry and rhetoric ... affect rather by sympathy than imitation', their purpose being 'to display rather the effect of things on the mind of the speaker, or of others, than to present a clear idea of the things themselves'. For Burke it was the ideas and emotions conveyed by words that lent them the capacity to evoke the sublime, as illustrated in novels such as Horace Walpole's *The Castle of Otranto* (1765) and Mary Shelley's *Frankenstein* (1818).

Thus, whilst Burke's philosophical investigation into the sensory basis of our aesthetic experience was a product of eighteenth-century empiricism, his recognition of the value of art in all its diversity, and in particular his codification of the sublime as an aesthetic category, was of seminal importance in the emergence of Romantic aesthetics. His ideas influenced the thinking of **Diderot, Lessing, Schiller,** Kant, and Coleridge amongst others, and as a mediator between the cult of sensibility (*Empfindsamkeit*), which found expression in the paintings of Jean-Honoré Fragonard and Antoine Watteau, and the Romanticism expressed in the paintings of William Blake and Eugène Delacroix, he was a pivotal figure in the development of the history of art of the eighteenth century.

Biography

Edmund Burke was born on 12 January 1729 in Dublin, the son of a Protestant attorney of the Irish Court of Exchequer. He studied for the BA degree at Trinity College Dublin from 1744–9 and thereafter for the bar at the Middle Temple, London from 1750–5. He published *Our Ideas of the Sublime and the Beautiful* in 1757, and the next year began *The Annual Register*, which he edited for about 30 years. He was Private Secretary to William Hamilton, Irish Chief Secretary, from 1759–64, and to the second Marquis of Rockingham, First Lord of the Treasury, from 1765–6. He was elected Member of Parliament for Wendover in 1766 and 1768, and for Bristol in 1774. *Reflections on the Revolution in France* was published in 1790. A year before his death he founded a boys' school at Penn in Buckinghamshire. He died on 9 July 1797 in Beaconsfield.

Bibliography

Main texts

A Philosophical Enquiry into the Origin of Our Ideas of the Sublime and the Beautiful, 1757; rev. 1759; Adam Phillips (ed.), Oxford and New York, Oxford University Press, 1990.

Secondary literature

Ashfield, Andrew and De Bolla, Peter (eds), *The Sublime: A Reader in British Eighteenth-Century Aesthetic Theory*, Cambridge, Cambridge University Press, 1996.
Chapman, Gerald W., *Edmund Burke: The Practical Imagination*, Oxford, Oxford University Press, 1967.

Dorsch, T.S. (trans.), *Classical Literary Criticism: Aristotle on the Art of Poetry, Horace on the Art of Poetry, Longinus on the Sublime*, London, Penguin, 1965.

Eagleton, Terry, *The Ideology of the Aesthetic*, Oxford, Blackwell, 1990.

Ferguson, Frances, 'The Sublime of Edmund Burke, or the Bathos of experience', *Glyph* 8 (1981), pp. 62–78.

Macpherson, C.B., *Burke*, Oxford, Oxford University Press, 1980.

Pappin, Joseph L., *The Metaphysics of Edmund Burke*, New York, Fordham University Press, 1993.

Simpson, David, 'Commentary on the Sublime', *Studies in Romanticism* 26 (1987), pp. 245–58.

Stanlis, Peter J., 'Burke and the sensibility of Rousseau', *Fordham University Quarterly* 36 (1961), pp. 246–76.

White, Stephen K., *Edmund Burke: Modernity, Politics, and Aesthetics*, California and London, Sage, 1994.

ABIGAIL CHANTLER

GOTTHOLD LESSING (1729–81)

GERMAN WRITER AND CRITIC

For much of the eighteenth century, the lack of any sense of national cultural identity between the disparate German states was compounded by the hegemony of French taste and Frenchified neoclassicism. It is against this background that Lessing's contribution to aesthetic theory, *Laokoon oder über die Grenzen der Malerei und Poesie* (Laocoon, or on the limits of painting and poetry) (1766), like that of his compatriot **Winckelmann**, has to be understood. As a study of the aesthetic principles underpinning the creation of the visual arts and literature of classical antiquity and governing our experience of them, Lessing's treatise was a product of the antiquarian studies he pursued during his stay in Breslau (1760–5). However, it was conceived not merely as a piece of antiquarian scholarship but as an aesthetic foundation for contemporary practice derived directly from the art and literature of the ancient Greeks, rather than from the works of their French epigones.

For Lessing and Winckelmann alike, fostering the appreciation and emulation of the art of classical antiquity represented a powerful means of nurturing a sense of German national identity because they conceived the culture of antiquity as a reflection of the moral virtue of the ancient Greeks. This is reflected in Winckelmann's famous pronouncement that 'the universal and predominant characteristic of the Greek masterpieces is a noble simplicity and tranquil grandeur,

both in posture and expression', insofar as he interpreted the nobility of the Greek heroes represented as evidence of their stoicism, and their tranquility as evidence of their spirituality. His appreciation of the 'simplicity' and 'grandeur' of such works was premised on a platonic conception of the representation of nature in an idealized form as beautiful and morally edifying. Similarly Lessing's view that when 'the wise Greek ... confined [art] solely to the imitation of beautiful bodies' he realized 'the ultimate purpose of art', was inextricably linked to his belief that:

> When beautiful men fashioned beautiful statues, these in their turn affected them, and the State had beautiful statues in part to thank for beautiful citizens.

As Nisbet (1985) suggests, the utopian vision of ancient Greece on which the aesthetics of Winckelmann and Lessing was founded 'provided an antidote to French culture', which was charged with alienating modern man from his natural feelings and instincts.

Yet whilst both Winckelmann and Lessing espoused platonizing neo-classicism from a distinctively Germanic perspective, it was by taking issue with remarks made by Winckelmann on the marble sculpture of Laocoon and his sons, created by Hagesandros, Athenodoros, and Polydoros around 25 BC, that Lessing began his *Laocoon* essay, written in his characteristically polemical style. The statue depicts a mythological scene, described in Virgil's *Aeneid*, in which the Trojan priest Laocoon and his two sons are strangled by serpents sent by the gods to punish Laocoon for attempting to prevent the Greeks from seizing Troy. Lessing challenged Winckelmann's explanation for the fact that, in the sculpture, Laocoon does not cry out with pain, since 'his mouth is not wide enough open to allow it', but rather 'emits an anxious and oppressed sigh'. Winckelmann attributed this to the stoical fortitude with which Laocoon endured his pain, and suggested that 'the expressions of the Greek figures, however strong their passions, reveal a great and dignified soul'. Lessing argued 'that outcries on the feeling of bodily pain, especially according to the ancient Greek way of thinking, can quite well consist with a great soul', as illustrated within the writings of Homer, and that therefore 'the expression of such a soul cannot be the reason why, nevertheless, the artist in his marble refuses to imitate this crying'. Rather Lessing suggested that this would have detracted from the beauty of the work and that the artist had 'to tone down cries to sighing; not because cries

betrayed an ignoble soul, but because they disfigure the face in an unpleasing manner'.

Underpinning Lessing's critique of Winckelmann's comments on the Laocoon group was his formulation of an aesthetic theory of the visual arts which was distinct from his formulation of the laws of poetry. He conceived the true purpose of the 'plastic arts' to be 'the imitation of beautiful bodies' through the juxtaposition in space of 'figures and colours', and suggested that 'the proper subjects of poetry' are 'actions' represented through a succession of 'articulate sounds in time'. By the time Lessing penned his *Laocoon* essay, this distinction was commonplace: Gombrich (1957) traces it back to Plato's *Cratylus* and, within the confines of the eighteenth century, it had been discussed by Du Bos, **Diderot**, and Edmund **Burke** among others. However, Lessing's formulation of the distinction specifically in relation to the art and literature of antiquity resulted in a more secure philosophical foundation for neo-classicism which, as Nisbet suggests, combined 'the deductive methods of Baumgarten, Moses Mendelssohn, and other thinkers of the Leibniz–Wolffian school' with 'the empirical methods favoured by the art-historian Winckelmann'.

The distinction Lessing drew between the spatial quality of the visual arts and the temporal nature of literature was complemented by a semiotic theory articulated earlier by his close friend Moses Mendelssohn. This theory distinguished between two kinds of representational signs: natural signs, which resemble the physical phenomena they signify, and arbitrary signs, which have no direct relationship to the concepts or objects signified, to which they are linked merely through their consistent usage within a culture. Whilst Lessing took pains to emphasize 'that both [painting and poetry] can be either natural or arbitrary', he condemned the use of arbitrary signs in painting as a departure 'from its true perfection', and suggested that 'conversely poetry draws all the closer to its true perfection, the closer it makes its arbitrary signs approach the natural'.

Accordingly, he condemned allegorical and historical painting, in which, through the incorporation of arbitrary signs into a picture, the artist attempts to endow his work with a conceptual meaning which, according to Lessing, it is the prerogative of literature to convey. He described 'the rage for allegorizing' – illustrated by the inclusion in a work of 'purely allegorical' symbols, such as 'the bridle in the hand of Temperance' or 'the pillar on which Steadfastness leans' – as an attempt to turn painting 'into a silent poem' with disregard for its true purpose as a means of representing physical beauty which is to be appreciated for its own sake. Whilst Lessing acknowledged that such

beauty could inspire moral virtue, he did not endorse the view, implicit in Winckelmann's explanation for Laocoon's 'oppressed sigh', that the natural signs with which beauty is represented can convey moral truths. His contrasting view of literature as a vehicle for the expression of such truths was premised on the conceptual content he attributed to linguistic representational signs which, in drama 'cease to be arbitrary signs, and become the natural signs of arbitrary things'.

Just as Lessing condemned 'the rage for description' in poetry as a futile attempt to evoke the appearance of physical phenomena with representational signs which lack a spatial dimension, so he was highly critical of artists who attempted to endow their paintings with a narrative content, as William **Hogarth** did in a series of pictures entitled *The Rake's Progress* (1735), which charts the moral decline of the rake from youthful waywardness to confinement in Bedlam. Lessing argued that 'the material limits of Art confine her imitative effort to one single moment' and that 'the painter in particular can use this single moment only from one point of vision'. By insisting that this moment must be 'the most pregnant, from which what precedes and follows will be most easily apprehended', Lessing situated the visual arts within a temporal framework which exists purely in the imagination of the artist and recipient of the work. It was by viewing the Laocoon group from within such a framework that Lessing defended the depiction of Laocoon's sigh as an anticipation of his shriek, which therefore 'gives free play to the imagination'. He proscribed the representation of a shriek on the grounds that the permanent embodiment of such a transient phenomenon is im-plausible and unsuited to sustained contemplation.

Lessing's aesthetic theory was informed by the belief he shared with many other eighteenth-century thinkers that the artist should seek to represent nature as realistically as possible. This view was voiced by Diderot (*Salon* 1763) who admired the depiction of 'nature itself' in paintings of Chardin which 'represent fruit and the accompaniments of a meal', and praised the way in which 'the objects come out of the canvas with a truth that deceives the eye'. However, as a neo–classicist, Lessing sought to confine naturalism in art within the constraints imposed by the doctrine of decorum or *bienséance* (propriety), which legitimized only the depiction of *la belle nature* (beautiful nature). Thus he expressed disdain for the work of Pyreicus, a genre painter of the Hellenistic period, 'who painted, with all the diligence of a Dutch artist, nothing but barbers' shops, filthy factories, donkeys and cabbages'. Furthermore, in accordance with his belief that the true purpose of art, as a representation of physical beauty, is to 'awaken

agreeable sensations', Lessing renounced the depiction of the ugly as that which 'awakens aversion without respect to the actual existence of the subject in which we perceive it'. Yet by endorsing Mendelssohn's view that 'the representations of fear, of sadness, of terror, of pity . . . can be resolved into pleasant sensations by the recollection that it is but an artistic deceit', and that such 'unpleasant emotions . . . gratify the mind, inasmuch as they never excite unmixed aversion, but . . . mingle their bitterness with pleasure', Lessing acknowledged the power of art to evoke the sublime as conceived by Burke.

Whilst therefore in the *Laocoon* essay Lessing provided a philosophical framework in which to understand the art of antiquity, his aesthetic theory was highly problematic in its normative pretensions: like much neo-classical criticism 'it assumed a stable psychology of human nature; a fundamental set of norms in the works themselves; a uniform working of human sensibility; and intelligence allowing us to reach conclusions which would be valid for all art and all literature' (Wellek, 1981). Moreover, the limitations of the doctrine of *mimesis* (imitation) — as the cornerstone of eighteenth-century aesthetic theory which failed to account for the aesthetic experience of non-representational art — were rendered even more acute by Lessing's view of 'the imitation of beautiful bodies' as the *raison d'être* of art. This view undermined the credibility of a whole range of art, such as the Gothic art of the medieval period, the genre-painting of seventeenth-century Dutch artists, and the still-life and landscape paintings of the eighteenth century. Similarly, Lessing's insistence that art must 'awaken agreeable sensations' effectively discredited the fantastic and grotesque pictures of artists such as Albrecht Dürer, Jacques Callot, and Francisco Goya.

However, despite the limitations of Lessing's aesthetic theory, the subsequent development of aspects of his thought bears witness to its historical significance. On the one hand, as a champion of the art, literature, and culture of ancient Greece, his writings provided a source of inspiration for the so-called Weimar classicism of **Schiller** and Goethe. On the other hand, whilst his 'inevitable compulsion to oppose the tide of fashion . . . made him impatient of the movement of Storm and Stress', he nevertheless articulated ideas that were of seminal importance in the emergence of Romanticism (Gombrich, 1957). His view of art as a mimetic medium did not exclude an appreciation of its expressive capacity, nor did his fidelity to classical rules of taste prevent him from realizing the value of artistic genius. Moreover, the prominence accorded to naturalism in his aesthetic thought was reinvented as the foundation for artistic practice in the

mid-nineteenth century, when Millet and Courbet sought to depict scenes from everyday life as realistically as possible.

Biography

Gotthold Ephraim Lessing was born on 22 January 1729 in Kamenz, Saxony, the son of a Protestant minister. He studied theology (and latterly medicine and philology) at Leipzig University from 1746–8. He worked as a freelance writer in Berlin from 1748–56 (gaining his Masters in Theology at Wittenberg Univerity in 1752), in Leipzig from 1756–8 and back in Berlin from 1758–60. In 1759 he was editor of the journal *Briefe, die Neueste Litteratur bretreffend* (Letters concerning Recent Literature). He was Regimental Secretary to Prussian General, Bogislaw Friedrich von Tauentzien, in Breslau from 1760–5 and wrote *Laokoon* in 1766. He returned to freelance writing in Berlin 1765–7 and Hamburg 1767–70. In 1767 he was theatre critic at the German National Theatre in Hamburg and from 1770–6 librarian at the Ducal Library in Wolfenbüttel. He died in Brunswick on 15 February 1781.

Bibliography

Main texts

Laocoon: oder über die Grenzen der Malerei und Poesie, 1766; trans. William A. Steel as *Laocoon, Nathan the Wise, Minna von Barnhelm*, London and New York, Dent, 1930; repr. 1967.
'Letter to Nicolai, 26 May 1769', in H.B. Nisbet (ed.), *German Aesthetic and Literary Criticism: Winckelmann, Lessing, Hamann, Herder, Schiller, Goethe*, Cambridge, Cambridge University Press, 1985.

Secondary literature

Diderot, Denis, *Selected Writings on Art and Literature*, trans. Geoffrey Bremner, London, Penguin, 1994.
Gombrich, E.H., 'Lecture on a master mind: Lessing', *Proceedings of the British Academy* 43 (1957), pp.133–56.
Goulding, Christine Manteghi, 'From *Witz* culture to cult of genius: Lessing and eighteenth-century aesthetics', *Monatshefte* 92 (2000), pp.111–22.
Hillen, Gerd, 'Gotthold Ephraim Lessing', in *Dictionary of Literary Biography*, vol. 97: *German Writers from the Enlightenment to Sturm und Drang, 1720–1764*, James Hardin and Christoph E. Schweitzer (eds), New York and London, Gale, 1990.
Nisbet, H.B. (ed.), *German Aesthetic and Literary Criticism: Winckelmann, Lessing, Hamann, Herder, Schiller, Goethe*, Cambridge, Cambridge University Press, 1985.
Richter, Simon, *Laocoon's Body and the Aesthetics of Pain: Winckelmann, Lessing, Herder, Moritz, Goethe*, Detroit, Wayne State University Press, 1992.
Savile, Anthony, *Aesthetic Reconstructions: The Seminal Writings of Lessing, Kant, and Schiller*, Oxford, Basil Blackwell, 1987.

Simpson, David (ed.), *The Origins of Modern Critical Thought: German Aesthetic and Literary Criticism from Lessing to Hegel*, Cambridge, Cambridge University Press, 1988.

Wellbery, David E., *Lessing's Laocoon: Semiotics and Aesthetics in the Age of Reason*, Cambridge, Cambridge University Press, 1984.

Wellek, René, *A History of Modern Criticism 1750–1950*, vol. 1: *The Later Eighteenth Century*, Cambridge, Cambridge University Press, 1981.

<div align="right">ABIGAIL CHANTLER</div>

FRIEDRICH SCHILLER (1759–1805)

GERMAN DRAMATIST AND CRITIC

Schiller's rather abstract aesthetic ideas were developed in the early 1790s, in the wake of the publication of **Kant**'s *Kritik der Urteilskraft* (*Critique of Judgement*) (1790), through the lectures on aesthetics he presented at Jena University and through the essays, treatises, and letters he produced during this period. Foremost amongst these were the series of letters on aesthetic education sent by Schiller to his benefactor, Prince Friedrich Christian of Schleswig-Holstein-Augustenburg, in 1793. Schiller subsequently rewrote these for publication in instalments in a new journal which he was editing, *Die Horen*, under the title *Über die ästhetische Erziehung des Menschen* (*On the Aesthetic Education of Man*) (1795).

Schiller's letters on aesthetic education were premised on his view of modern civilization as a corruption of nature – a view inaugurated in eighteenth-century thought by Rousseau's declaration that 'man was born free, and he is everywhere in chains'. Schiller, like Rousseau, attributed this corruption to the rationality of modern man, whose reason has 'wrested from him those very means of animality which are the condition of his humanity' and an essential prerequisite for artistic creativity. He described how in modern times art has been 'deprived of all encouragement' and 'flees from the noisy mart of our century', as an age in which: 'Necessity ... bends a degraded humanity beneath its tyrannous yoke' and in which 'Utility is the great idol'. However, Schiller did not join the 'back-to-nature' cult of Rousseau's disciples by presenting the condition of primitive man who lives solely by his senses as an ideal. Rather, like Kant, he sought to reconcile the rationality of modern man with his senses and instincts to ensure his moral freedom, and conceived aesthetic experience as the basis for achieving this goal.

The kinship between the philosophical outlook of Kant and Schiller was clearly reflected in their aesthetic thought. Kant conceived the 'play' of the imagination which the experience of beauty facilitates as a form of pre-conceptual engagement with one's 'objective sensations' which inspires a sense of moral virtue. Similarly, Schiller viewed beauty as 'living shape' which, through the interpenetration of its form and content, is the object of the 'play impulse' and therefore the source of man's moral freedom. He conceived this 'play impulse' as the interplay between two opposing drives: the *Stofftrieb* (sense-drive), as 'the urge to assimilate the world of senses', and the *Formtrieb* (form-drive), as 'the urge to subdue the world to the moral law'. Accordingly, he stated that:

> The first insists upon absolute reality: [man] is to turn everything that is mere form into world, and realize all his potentialities; the second insists upon absolute formality: he is to eradicate everything in himself that is merely world, and produce harmony in all its mutations.

Schiller viewed the 'aesthetic state', realized through the interplay of the *Stofftrieb* and the *Formtrieb*, as the basis for the reconciliation of man's sense and reason, and thereby for the formation of a liberal and organic society.

That Schiller, along with his close friend Goethe, found a model for this idealized society in the culture of ancient Greece is illustrative of the continuum in the history of ideas between the neo-classicism of **Winckelmann** and **Lessing**, and the so-called Weimar classicism of Schiller and Goethe. Like his compatriots, Schiller argued that the beauty of the art of classical antiquity was an expression of the moral virtue of the ancient Greeks. Thus he suggested that 'the Greek nature . . . united all the attractions of art and all the dignity of wisdom', and that:

> Combining fullness of form with fullness of content, at once philosophic and creative, at the same time tender and energetic, we see them uniting the youthfulness of fantasy with the manliness of reason in a splendid humanity.

It was Schiller's high regard for the organic unity of the culture of ancient Greece which inspired the conviction he first expressed in the *Kallias Letters* written to Körner in 1793, that aesthetic education was

the principal means of cultivating moral virtue: that 'it is through Beauty that we arrive at Freedom' and that 'the moral condition can be developed only from the aesthetic, not from the physical condition'.

Schiller's Platonizing neo-classicism, and, in particular, his eulogy of the culture of classical antiquity as an ideal to be emulated, coexisted uneasily with his recognition that 'both Science and Art pay homage to the spirit of the age' and that 'the artist is the child of his time'. Yet through this blend of neo-classicism and historicism, Schiller anticipated the Romantic view of history most clearly expounded by **Hegel**, who perceived a correlation between the history of art and the evolution of human spirituality, a correlation manifest in the diverse artistic forms through which the 'spirit' is expressed. This view of art history facilitated the re-evaluation of works of art and literature previously excluded from the neo-classical canon for failing to conform to eighteenth-century notions of beauty, and entailed attributing to such works an ahistorical, metaphysical meaning which rendered them of timeless aesthetic value.

Schiller's vision of the creation, through the aesthetic education of man, of a modern 'aesthetic state' that would revive the spirit of classical antiquity, was complemented in *Über naive und sentimentalische Dichtung* (*On Naive and Sentimental Poetry*) (1795–6) by his conception of a form of modern, reflective, 'sentimental' poetry no less valid than ancient, spontaneous, 'naïve' poetry. It was the dichotomy Schiller created between the 'naïve' and 'sentimental' which inspired the distinction Friedrich Schlegel drew between the 'classical' and 'romantic' to express the equal aesthetic status of ancient and modern literature – a distinction applied to the other arts to the same effect by *Frühromantiker* such as W.H. Wackenroder.

Thus, whilst, as Nisbet (1985) notes, Schiller viewed the Romantic movement of the 1790s 'with suspicion and disapproval', he nevertheless anticipated aspects of early-Romantic aesthetic theory. His conception of aesthetic experience as a reconciliation of two opposing drives was shared by *Frühromantiker* such as E.T.A. Hoffmann, who conceived *Besonnenheit* (rational awareness) and *Begeisterung* (enthusiasm) as the constituent qualities of an artistic genius; and by Karl Philipp Moritz, who distinguished between *Bildungskraft* (power of creativity) and *Empfindungsvermögen* (capacity of feeling).

Moreover, like the *Frühromantiker*, Schiller acknowledged that through the reconciliation of such polar opposites, art and literature could evoke the sublime. Whilst he did not devote any space to this aesthetic category in *Über die ästhetische Erziehung des Menschen* or in *Über naive und sentimentalische Dichtung*, it was discussed in his essays

Vom Erhabenen (Of the Sublime) (1793) and *Über das Erhabene* (*On the Sublime*) (1801), and in his treatise *Über Anmut und Würde* (On Grace and Dignity) (1793). Schiller's presentation, in *Über Anmut und Würde*, of grace as the physiological manifestation of beauty, and dignity as that of the sublime was an expression of his endorsement of Kant's view of the sublime as a means to inspire moral virtue, and therefore as the counterpart of beauty in aesthetic education. However, whilst Kant, in his *Critique of Judgement*, focused on 'the sublime in natural objects (since the sublime in art is always confined to the conditions that [art] must meet to be in harmony with nature)', Schiller followed Edmund **Burke** in acknowledging that art could be evocative of the sublime. Indeed, in *On the Sublime*, Schiller suggests that:

> It is true that nature herself supplies objects in abundance on which the perceptive faculty for the beautiful and sublime can be exercised; but man is here, as in other cases, better served at one remove than directly, and prefers to receive a subject matter prepared and selected by art rather than to drink scantily and with difficulty from the impure well of nature.

By placing the sublime on an equal footing with the beautiful, Schiller, along with many other late eighteenth- and early nineteenth-century aestheticians, provided an aesthetic basis for understanding paintings such as Caspar David Friedrich's painting *Der Wanderer über dem Nebelmeer* (*The Wanderer above the Mist*) (1818) and J.M.W. Turner's *Steamer in a Snowstorm* (1842) which, through their evocation of the grandeur of nature, arouse in us 'the feeling that we have within us a supersensible power' and an awareness 'of our vocation as being sublimely above nature' (Kant, [1790] 1987).

The blend of neo-classical and Romantic aesthetic ideas which characterized Schiller's aesthetic thought was reflected in his view of the relationship between the different arts. As Wellek (1981) comments, 'Schiller, while holding firmly to the neo-classical prescription of purity in the genres and in the different arts, still envisages some final union of the arts'. Schiller stated that:

> The different arts are becoming more and more similar in their effect on the mind, without any change in their objective boundaries. Music in its highest perfection must become form and affect us with the quiet power of antiquity; plastic art in its highest perfection must become music and move us by its immediate sensuous presence; poetry in its most perfect

development must grip us powerfully like music but at the same time surround us like sculpture with quiet clarity. The perfect style of each art is manifested when it knows how to remove its specific limitations and to assume a more general character by a wise use of its peculiarity, without, however, giving up its specific advantages.

(Schiller in Wellek, 1981)

In making this statement Schiller articulated a central tenet of Romantic aesthetics, voiced by Robert Schumann amongst others: that there is one aesthetic underpinning all artistic media. This view was premised on the Romantic conception of art as an expressive and spiritual medium which facilitates 'longing' (*Sehnsucht*) for the infinite – a view anticipated by Schiller's vision of aesthetic education as a means of cultivating man's moral instinct.

Thus, whilst Schiller did not comment specifically on the visual arts, he did make a significant contribution to the pool of aesthetic ideas which informed their creation and reception. On the one hand he followed his compatriots Winckelmann and Lessing in seeking to regenerate modern art (and society) through the emulation of the art of antiquity. On the other hand, against the backdrop of the political turmoil of the French Revolution, he grappled with the dilemma, bequeathed to the Romantics by Kant, of how to reconcile the rationality of modern man with his natural instincts and direct sensory experience of the world to ensure his moral freedom. In conceiving aesthetic education as the primary means of achieving this end, Schiller contributed to the specifically Germanic tradition of self-cultivation (*Bildung*), which was to blossom in the early nineteenth century in the writings of Solger, Schleiermacher and Humboldt, and he anticipated Karl **Marx**'s view of art as a means of overcoming the alienation of modern man.

Biography

Johann Christoph Friedrich von Schiller was born on 10 November 1759 in Marbach, Württemberg. He studied medicine at the Karlsschule from 1776–82, becoming a surgeon to a Württemberg regiment. His first play, *Die Räuber*, was performed in 1782. Banned from publishing by the Duke of Württemberg, he moved to Mannheim 1783, where he became the resident dramatist of the Mannheim Theatre. In 1789 he was appointed Professor of History at Jena University and in 1795 (with Johann Friedrich Cotta) founded the literary journal *Die Horen*, in

which he published *Über die ästhetische Erziehung des Menschen* and *Über das Erhabene*. He settled in Weimar from 1799 to 1805. *Maria Stuart* was first performed in 1800. He died in Weimar on 9 May 1805.

Bibliography

Main texts

Über die ästhetische Erziehung des Menschen, 1795; trans. Reginald Snell, *On the Aesthetic Education of Man: In a Series of Letters*, Bristol, Thoemmes Press, 1994.

Über naive und sentimentalische Dichtung, 1795–96 and *Über das Erhabene*, 1801, trans. Julius A. Elias *Naive and Sentimental Poetry* and *On the Sublime*, New York, Ungar Publishing, 1966.

The Correspondence of Schiller with Körner, 3 vols, trans. L. Simpson, London, 1849.

Secondary literature

Kant, Immanuel, *Critik der Urteilskraft,* 1790; trans. Werner S. Pluhar, *Critique of Judgment*, Indianapolis, Hackett, 1987.

Martin, Nicholas, *Nietzsche and Schiller: Untimely Aesthetics*, Oxford, Clarendon Press, 1996.

Martinson, Steven D., *Harmonious Tensions: The Writings of Friedrich Schiller*, London, Associated University Presses, 1996.

Nisbet, H.B. (ed.), *German Aesthetic and Literary Criticism: Winckelmann, Lessing, Hamann, Herder, Schiller, Goethe*, Cambridge, Cambridge University Press, 1985.

Pugh, David, *Dialectic of Love: Platonism in Schiller's Aesthetics*, Montreal, McGill-Queen's University Press, 1996.

Reed, T.J., *Schiller*, Oxford, Oxford University Press, 1991.

Rousseau, Jean Jacques, *The Social Contract*, trans. Maurice Cranston, London, Penguin, 1968.

Savile, Anthony, *Aesthetic Reconstructions: The Seminal Writings of Lessing, Kant and Schiller*, Oxford, Basil Blackwell, 1987.

Sychrava, Juliet, *Schiller to Derrida: Idealism in Aesthetics*, Cambridge, Cambridge University Press, 1989.

Wellek, René, *A History of Modern Criticism 1750–1950*, vol. 1: *The Later Eighteenth Century*, Cambridge, Cambridge University Press, 1981.

ABIGAIL CHANTLER

G.W.F. HEGEL (1770–1831)

GERMAN PHILOSOPHER

Georg Wilhelm Friedrich Hegel continues to be one of the crucial touchstones in the history of art and visual studies. It would not be much of an exaggeration to say that art history, as it developed in German-speaking countries in the nineteenth century (and was

exported to the further reaches of the academic world) is a combination of Hegel's speculative philosophy of art, and his grand narrative of its history, with the scrupulous methods of German philology which had been exercised first on classical texts. More recent theories of the visual, such as Sartre's and Lacan's (varying) conceptions of the 'gaze' are formulated in terms of Hegel's dialectical categories of subject and object; Derrida's project of deconstruction, including his writings on visual art, involves an unremitting critique of Hegel, but allows the latter to set much of the agenda. Marxist aesthetics is inconceivable without Hegel's dialectical history as both model and foil.

Hegel's aesthetics coincides both temporally and in spirit with the age of the museum; Karl Friedrich Schinkel's Altes Museum, for example, erected in Berlin at the time of Hegel's lectures on the fine arts was just a short walk from the philosopher's residence. The great European museums took the art of Greece as exemplary and offered the visitor a historically articulated tour of the art of the past, itself a virtual tour of the history of culture. In Hegel's system, truth develops historically, so that the history of art, religion, and philosophy are significant narratives that now, at the end of the day, display a meaningful pattern. Hegel's knowledge of art was no doubt the most prodigious and wide ranging of any philosopher until his own time, however parochial we now find some of his judgements (our greater perspicuity indebted in no small degree to the discipline he helped to found). Yet this knowledge came at the price, as Hegel acknowledged, of accepting art as a subject of what he called science (or *Wissenschaft*), rather than as the highest expression of the spirit or culture of an age. As he says in the *Aesthetik* (*Hegel's Aesthetics: Lectures on Fine Art*, 1979), 'the form of art has ceased to be the supreme need of the spirit. No matter how excellent we find the statues of the Greek gods, no matter how we see God the Father, Christ, and Mary so estimably and perfectly portrayed: it is no help; we bow the knee no longer'. This notorious pronouncement touches on what has been inaccurately called Hegel's 'death of art' thesis. While he never suggests that there has been or will be a cessation of artistic production and enjoyment, Hegel does speak, as here, of a change in the place of art within culture: it is ultimately replaced by philosophy and science, including the science of art. Hegel also speaks of a 'dissolution' (*Auflösung*) of art, that is, a fragmentation or unfolding such that art dissolves into its separate strands and is liberated for a vast variety of styles and modes, including especially the idiosyncrasies of irony and reflective humour;

we might think here of Picasso's restless experimentation with styles, or Marcel Duchamp's casting himself as a master of irony.

Hegel writes not of the 'visual arts' but of the 'formative arts' (*bildende Kunste*, or image-*making* arts), emphasizing not so much the static image (*Bild*) or structure, but the process of thought which gives meaning to artworks. Art is not an imitation of reality (as the Greeks supposed) or the source of a universal aesthetic experience (as **Kant** argued), but one of the ways, along with religion and philosophy, in which mind comes to know itself and to make itself known. In that sense, all art involves an original manifestation of thought. Consequently natural beauty, so important to Kant and the eighteenth century, is at most a vague indication of the genuine beauty of art; Hegel contributed heavily to the elimination of interest in natural beauty and even in such arts as landscape architecture that characterizes European aesthetics earlier. If art is eventually superseded by philosophy, it is still the case that its way of 'making visible', its very act of manifestation, is that which has served longest and most effectively as the educator of humankind. Hegel defines beauty as 'the sensuous shining [*Schein*, less happily translated as 'appearance'] of the Idea'. To unfold that sentence fully would require an immersion in Hegel's logic and philosophy of Spirit, but we can note two things:

- the Idea is not something unworldly and transcendent (as we might think of the Platonic idea), but is complex and comes about through a development, typically a historical one;
- art shines out or radiates, it *gives* itself.

If this last formulation begins to make art sound like divine grace, the resemblance is not accidental. For Hegel also understands art as the manifestation of God. In his philosophical version of trinitarian Christianity, God is not mysterious or incomprehensible, but makes himself (so Hegel genders the divine) manifest: as Father he is an enigmatic origin; as son he becomes incarnate and visible; in the Holy Spirit he manifests himself in the mind of the community (as in the productions of art, religion, and philosophy). In an important gesture Hegel rejects what he takes to be the Jewish and Islamic prohibition of the image and of art, which he sees as the result of their having an abstract theological view of the divine as simply One, without qualification. Hegel's aesthetics is perhaps the only philosophical attempt in modern times to address explicitly the iconoclastic controversy that occupied the attentions of medieval Christian orthodoxy and the Protestant Reformation. He insists that God does

indeed become visible in art, but he knows that the time for any fetishism of the image is long past, as art migrates from temple and church to the institution of the museum and the practice of disciplined study.

Hegel distinguishes three main forms of art in terms of the relation for each of idea and sensuous form, or, in religious language, of God and his manifestation. In *symbolic art* there is a rift between the two, such that the inner content or meaning is only indicated in a mysterious and ambivalent way, by what we see; here there is 'a secret foreboding and longing'. This is, for example, the art of ancient India and Egypt, in which either a dazzling profusion of forms (e.g. Hindu sculpture) or more minimal and enigmatic ones (the pyramids and sphinx), somehow are taken as symbols of the deepest meaning. Such art might be called *sublime* in its pointing to something seemingly incomprehensible, but Hegel challenges the privileged place of the sublime in eighteenth-century aesthetics, making it into a deficient or preliminary stage of beauty, characterized by formlessness and indeterminacy. This move is an answer to the Romantic fascination with deciphering the mysteries of the East, as they were seen by those participating in the European 'discovery' of the Other. It also shows an insensitivity to the dynamics of a relatively free play of interpretation that fascinated those same Romantics and which has achieved a recent theoretical form in deconstruction and other forms of post-structuralism. Hegel said that the answer to the riddle posed by the sphinx was man, and he took this to mean that as the human form emerges from the zoomorphic and abstract shapes of the symbolic, art comes into its own, finding a form adequate to its content. Architecture is the pre-eminent symbolic art, because it must shape its materials in accordance with heavy external constraints, notably gravity, which imposes limits on construction. Even so, there can be a romantic architecture (e.g. Gothic) in which matter seems to shed its weight and churches soar into the heavens, but such buildings are not typical of the art.

For Hegel, the glorious centre of the world of art is the *classical* form, whose principle is the full interpenetration of external form and internal content in the idealized figures of the Greek gods, based on the human body. He provides a speculative philosophical defence of the exemplary position of Greek sculpture that was promoted by thinkers like **Winckelmann** and Goethe. Like his predecessors and contemporaries, he is unaware of the vivid colouring of these works, and accordingly assumes that the figures' eyes are blank, which he takes to be a sign of a certain melancholy and sense of limitation, which

ultimately leads to the decline of the classical form. In what present-day readers must see as an extreme of rationalist ethnocentricity, Hegel even provides an argument to show the intrinsic superiority of the Greek profile, on the grounds that the relatively unbroken line of nose and forehead elevates the organ of smell, distinguishing such a face as sharply as possible from those animals in which the nose blends with the mouth in a snout, so excluding the mouth as the site of speech, thought, and intelligence. He dismisses the idea that there could be distinctive and equally valid models of facial beauty among the 'Chinese, Jews, and Egyptians' as 'superficial chatter'.

Romantic art is understood to be an art of the interior life, and Hegel finds that its themes are either explicitly indebted to or implicitly derivative from Christianity, which is understood as a religion that exalts the subjective life of the individual and that understands God himself as spirit. Romantic art is not limited by the cumbersome media of architecture and sculpture. Beauty is no longer the standard of art, but the truth of subjective experience. Art demonstrates this spiritual truth as an activity of feeling, thought, and expression: it may do this by representing the intensity of love (as in scenes of the Madonna and child) or even in the degradation of the body, as in the story of Christ's passion, involving 'grief, death, the mournful sense of nullity, the torment of spirit and body'. Painting is the liminal Romantic art; it abstracts from the world of three dimensions, but still necessarily presents a virtual space, and requires a two dimensional surface, unlike music which escapes into a disembodied world of sound or poetry whose images are wholly contained in imagination. So the visual arts are ultimately trumped by the linguistic ones, a pattern, noted by Derrida, that characterizes almost all traditional philosophies of art (Hegel does not consider the possibility of some significant interchange between painting and language, now a theme of great interest). He dismisses the possibility of a pre- or non-Christian painting that would fulfil the goals of the art, suggesting for example that the paintings of classical antiquity were meant only to fill wall space; their very presence is merely decorative and testifies to their failure to explore the reaches of subjective life. Hegel builds on **Lessing**'s typology of the arts (and anticipates Clement Greenberg's theory of modernism) when he insists that painting must be understood in terms of the opportunities and limits intrinsic in its two-dimensional medium. Whereas Lessing had argued that the medium limited painting to presenting static scenes and privileged moments (and hardly distinguished between painting and sculpture), Hegel claims that by reducing the third dimension the art offers a

virtual experience of interiority, the world as it is shaped and felt by the seeing and imaginative subject; even the depiction of banal objects is not concerned with 'the objects as they exist in reality, but in the purely contemplative interest in the external reflection of the internal life'. Hegel's history of painting begins with explicitly Christian themes, as in Italian Renaissance works: the 'perfection of painting' achieved by the 'great masters' (he discusses Raphael, Correggio, and Titian) 'is a peak of art that can be ascended only once by one people' (a judgement shared by other founders of art history such as Jacob **Burckhardt** and deeply engrained until recently in the discipline's construction of its narratives). Flemish and German painting (this last term includes the Dutch) go even further in abandoning the classical ideal that still haunts the Italian masters; the Protestant movement is anticipated and realized in art that enriches religious themes with an attention to detailed appearances, including landscape and the texture of everyday work and social life. Finally, painting dispenses with explicit religious themes; in Dutch genre scenes and still life there is 'a concrete piety in mundane affairs'. This art achieves a kind of poetry in its display of the entire external world as coloured by human imagination. Hegel sees Dutch painting as the realization of the divine in the everyday, and so brings his discussion of the visual arts to a close here. Although he makes scattered remarks about more recent painters (and fails to notice important contemporaries like Caspar David Friedrich), Hegel believes that the heights of painting have already been achieved by the Italians and the Germans.

Almost two hundred years later, Hegel's account of what we now call the visual arts is likely to seem severely limited by the art historical knowledge of his age. Yet his work was indispensable in furthering the discipline that allows us to make such criticisms. If we were to seek resources in his thought for dealing with a wider range of art, including contemporary work, we should focus as Arthur Danto does, for example, on the principle of reflection and self-consciousness that Hegel finds essential in romantic art and on his sense that art is strongest when it involves a critical response to its own history. We should also recall that what we have left of Hegel's *Aesthetik* is largely a compilation of his own and his students' notes, not a finished manuscript. This can be supplemented by his treatment of the 'Religion of Art' in his *Phänomenologie des Geistes* (*Phenomenology of Spirit*), which is concerned with the complex, dynamic relations among artist, work, and audience, although its historical scope is limited to the Greeks and their immediate predecessors. There Hegel describes the 'abstract' (sculptural) work which sets up something of

an obstacle between artist and audience, because the latter fails to see the effort, thought, and struggles of the sculptor. This is contrasted with the 'living' work, composed of human bodies in motion (the Olympic games, the dance) or the 'spiritual' work, which involves a language shared by artist and audience. Translating this analysis into contemporary terms, we find Hegel wrestling with questions having to do with the relation between artist's intention and critical interpretation, and with forms of art that could be compared with more recent tendencies and forms such as ('abstract') minimalism or ('living' and 'spiritual') performance art.

Biography

Georg Wilhelm Friedrich Hegel was born on 27 August 1770 in Stuttgart, the son of a minor civil servant at the court of the Duchy of Württenberg. He studied theology at the Tübingen Seminary from 1788–93 and later, from 1793–1801 was a tutor in Bern and Frankfurt am Main. He was a private lecturer and then professor at the University of Jena from 1801–6. In 1807 he became the editor of the *Bamburger Zeitung*, a Catholic newspaper and in the same year wrote *Phenomenology of Spirit*. He was Rector of the Nuremberg Gymnasium from 1808–16; full professor at the University of Heidelberg from 1816–8 and then the University of Berlin from 1818–31. He died in Berlin on 14 November 1831.

Bibliography

Main texts

Phänomenologie des Geistes, 1807, trans. A.V. Miller, *Phenomenology of Spirit* , New York, Oxford University Press, 1977.
Aesthetik, 1835–8, trans. T.M. Knox, *Hegel's Aesthetics: Lectures on Fine Art*, Oxford, Oxford University Press, 2 vols, 1979.
Vorlesungen über die Philosophie der Geschichte, 1840, trans. J. Sibree, *Philosophy of History*, New York, Dover Publications, 1956.

Secondary literature

Besançon, Alain, *L'image interdite: une histoire intellectuale de l'iconoclasme*, 1994, trans. Jane Marie Todd, *The Forbidden Image: An Intellectual History of Iconoclasm*, Chicago, University of Chicago Press, 2000. (See chapter 6:2 'Hegel: nostalgia for the image'.)
Bungay, Stephen, *Beauty and Truth: A Study of Hegel's Aesthetics*, Oxford, Oxford University Press, 1984.
Derrida, Jacques, *Glas*, 1974, trans. John P. Leavey, *Glas*, Lincoln, University of Nebraska Press, 1987.

Desmond, William, *Art and the Absolute: A Study of Hegel's Aesthetics*, Albany, State University of New York Press, 1986.

Pöggeler, Otto (ed.), *Hegel in Berlin*, Berlin, Staats Bibliothek Prussischer Kulturbesitz, 1981.

Shapiro, Gary, 'Hegel's dialectic of artistic meaning', *Journal of Aesthetics and Art Criticism*, Vol XXXV, no. 1 (1976), pp. 23–35.

Steinkraus, Warren, and Schmitz, Kenneth (eds), *Art and Logic in Hegel's Philosophy*, New York, Humanities Press, 1980.

Winfield, Richard Dien, *Systematic Aesthetics*, Gainesville, University of Florida, 1995.

Wyss, Beat, *Trauer der Vollendung*, 1985, trans. Caroline Dobson Saltzwedel, *Hegel's Art History and the Critique of Modernity*, Cambridge, Cambridge University Press, 1999.

GARY SHAPIRO

ARTHUR SCHOPENHAUER (1788–1860)

GERMAN PHILOSOPHER

Schopenhauer's philosophy of art is one of the most significant in the history of modern thought, influencing a wide range of important writers, musicians and artists at the end of the nineteenth and beginning of the twentieth century. This influence was in part due to the pivotal role Schopenhauer attributes to art and artistic genius in his otherwise generally pessimistic view of the human condition as well as to the striking literary merits of his prose style. Schopenhauer's philosophy of art is presented in Book 3, together with the Supplementary Essays to Book 3, of his principal work, *Die Welt als Wille und Vorstellung* (*The World as Will and Idea*), and is not fully intelligible independently of the larger philosophical system.

The foundation of Schopenhauer's metaphysics is **Kant**'s distinction between 'things-as-they-appear-to-us' (the world as Representation) and 'things-in-themselves': in other words the distinction between things as we perceive them in space and time causally interacting in accordance with natural laws, and things as they are independently of our awareness of them, non-spatial, non-temporal, a-causal. Whereas Kant maintains that things-in-themselves are unknowable, Schopenhauer claims to have understood their real inner nature to be Will, Will to Life (*Wille zum Leben*), a blind, ceaselessly striving impulse which manifests itself in, and through our consciousness of, the spatio–temporal world of living and non-living things and which is the ultimate source of the conflict and the suffering endemic to temporal

existence. According to Schopenhauer, 'everywhere in nature we see contest, struggle and the fluctuation of victory' ([1819] 1995: §27): at the level of inorganic matter, the force of gravity opposes the force of magnetism; in the animal kingdom, creatures struggle for survival. Human life too, as manifestation of Will, is a scene of perpetual conflict: every human individual, whether consciously or not, is driven to satisfy desires, often at the expense of the well-being of other people. The most obvious example is sexual desire, the principal means of the Will's urge to perpetuate itself. Suffering is the keynote of life, either in the form of the frustration of unfulfilled desire or in the form of fulfilled desire leading either to boredom or to the renewal of yet more urgent desire – a ceaseless, futile cycle, signifying nothing, leading nowhere except to death. Salvation is possible, Schopenhauer maintains, only through a loving identification with all things, leading to renunciation of the will to live.

Aesthetic experience provides a temporary respite from the cares of daily life, for aesthetic experience, as Schopenhauer understands it, occurs through the suspension or transcendence of practical desire. Whereas, ordinarily, we attend to things only in so far as they serve our purposes, in aesthetic experience, it is often said, we attend to things for their own sake. In Schopenhauer's words: 'Raised up by the power of the mind, we relinquish the ordinary way of considering things ... we no longer consider the where, the when, the why and the whither in things, but simply and solely the *what*' (§34). Thus, in contemplating a flower or a sunset, we have no purpose other than contemplating what is before us: we 'devote the whole power of our mind to perception ... we lose ourselves entirely in this object', thereby eliminating from consciousness the aims and desires which fuel our practical lives and which are the source of pain. Aesthetic experience is, then, a pure pleasure. In this way, we rise above the cycle of suffering, we break free from the servitude of the Will, if only temporarily. Works of art also provide the possibility of the pleasure of Will-free contemplation; but art, the work of genius, derives from the contemplation of nature.

For most people aesthetic experience is fleeting, not simply because they do not have 'the time to stand and stare', but also because they lack sufficient mental power. This is what distinguishes genius from ordinary mortals. He – and here Schopenhauer really means the male of the species – the genius, has the ability to concentrate on the 'what' of experience to an abnormal degree. In addition, he has the ability to create works of art which make it possible for other people to see things as he sees them. The artist of genius contemplates the flower

and (like Van Gogh) creates a painting of the flower or (like Wordsworth) writes a poem about the flower which makes clear to his audience the content of his experience of contemplating the flower. However, this account of artistic genius is distinguished from familiar Romantic conceptions of genius (which emphasize emotional self-expression) by Schopenhauer's theory of the cognitive content of aesthetic experience. Just because aesthetic experience requires the elimination of particular desires and purposes from consciousness, it achieves a non-subjective awareness, an objective perception or knowledge of what is contemplated. Accordingly, Schopenhauer maintains that 'the gift of genius is nothing but the most complete *objectivity*' (§36), for the genius is able to contemplate things *sub specie aeternitatis*. The artistic genius sees more deeply into the nature of things than any scientist ever can, for he perceives the essence of the things he contemplates. Thus, just as the genius sets aside personal projects and idiosyncrasies in achieving aesthetic experience, so too *what* the genius perceives in aesthetic experience is divested of its familiar and trivial trappings: not only the subject but also the object of aesthetic experience undergoes a transformation – the knowing individual is transformed into the pure knowing subject which knows the timeless essence of the perceived object, what Schopenhauer, following **Plato**, calls the 'Idea' of the species of the object. In this way, the artist's attention to ephemeral particular things yields insight into universal truth which provides the content of great works of art. Shakespeare's *Hamlet*, a story, albeit fictional, of specific events in the life of a Prince of Denmark, is nevertheless a revelation of the human condition.

The (Platonic) Ideas are the direct manifestation of the metaphysical Will and constitute the underlying realities of spatio–temporal things in the world as Representation. All forms of art, with the exception of music, consist in the presentation of the Ideas through the depiction of or manipulation of particular things. Furthermore, there is a hierarchy in the arts corresponding to the hierarchical ordering of the Ideas. The metaphysical Will strives for the highest possible objectification of itself and the Ideas eternally manifest the different grades of the Will's objectification. Phenomena exemplifying a higher Idea arise out of a conflict between phenomena exemplifying a lower Idea. This is most obvious in the animal kingdom: while some animals feed on vegetables, other animals feed on them, and so on until we reach the human species, the highest grade of the Will's objectification manifesting itself in the form the self-conscious knowing subject. The highest forms of art are those fully exhibiting the highest Ideas –

poetry and tragedy have as their subject the weal and woe of humanity itself – while architecture, which exhibits the Ideas of inorganic phenomena such as gravity and rigidity, comes at the bottom of the artistic hierarchy. Landscape gardening and landscape painting, exhibiting the Ideas of vegetable life, occupy a higher status than architecture; painting and sculpture of animals are higher still in virtue of their exhibition of the Ideas of animal life; even higher are portrait painting and human sculptures which display the Ideas of humanity. Music, by not presenting the Ideas, 'stands quite apart from all the [other arts]' (§52); yet, instead of treating it as inferior, as other philosophers had done, Schopenhauer acknowledges its status as 'a great and exceedingly fine art'. 'The inexpressible depth of all music' is due to the fact that it expresses the inner nature of human emotions, the very essence of human existence: through its dynamic structure, music constitutes a direct manifestation of the metaphysical Will's essentially restless, striving character.

Wagner put Schopenhauer's doctrines on music into practice (with the endorsement of **Nietzsche** in *The Birth of Tragedy out of the Spirit of Music*, 1872) in his later music-dramas, in which the orchestral music reveals the inner thoughts and feelings of the characters on stage. Novelists such as **Tolstoy**, Hardy, Mann, Proust, as well as dramatists such as Beckett, were also inspired by Schopenhauer's gloomy perspective on existence and motivation, and by his view of the artist's ability uniquely to convey the ultimate truths of the human condition, though few subscribed to his account of the experience of tragedy as a preparation for the renunciation of the Will. Despite the lower status Schopenhauer accords to the visual arts, his views have also been influential in the development of architecture and painting.

Schopenhauer recognizes that architecture has a practical and an artistic dimension, the former, in servicing the Will, being antithetical to the latter. Considered as a fine art, the aim of architecture is to manifest Ideas such as 'gravity, cohesion, rigidity, hardness' (§43), which are the lowest grades of the Will's objectivity in the natural world. Since phenomena which embody these Ideas are in conflict – the rigidity of stone resists the pull of gravity towards earth – the true purpose of the art of architecture is 'to make this conflict appear with perfect distinctness in many different ways', thereby revealing the discord constitutive of the inner nature of the Will. Every part of a building has to play a role in displaying the conflict between gravity and rigidity such that 'if it were possible to remove some part the whole would inevitably collapse'. Schopenhauer's conclusion that, since the form of every part must be determined 'by its relation and

purpose to the whole', ornamentation is an architectural irrelevance, thereby anticipating Adolf Loos's doctrine that 'form follows function'.

The principal subjects of sculpture and painting concern humanity, the highest grade of objectification of the Will. Whereas sculpture emphasizes human beauty, 'the Idea of man in general, completely and fully expressed in the perceived form' (§45), painting is also capable of displaying individual human character 'appearing in emotion, passion, alternations of knowing and willing, which can be depicted only by the expression of the face and its countenance'. Schopenhauer acknowledges that Greek sculpture succeeded in capturing the ideal of human beauty, though not empirically, but through an *a priori* anticipation of what nature strives to present. The Greek genius, 'recognizing in the individual thing its Idea, he, so to speak, *understands nature's half spoken words*. He expresses clearly what she merely stammers. He impresses on the hard marble the beauty of the form which nature failed to achieve in a thousand attempts . . .' As he notes in Supplementary Essay XXXVI, since 'expression, passion and character' dominate painting, painting, unlike sculpture, may 'depict even ugly faces and emaciated figures'. The portrait painter reveals the enduring character of the individual whose appearance he captures. In painting, as in all the arts, imitation of appearances is never an end in itself but always in the service of displaying the inner or universal significance of what is depicted. Through this aesthetic, Schopenhauer is able to correct the injustice to Dutch painting when it is praised for its technical skill over the triviality of its subject. 'No individual and no action can be without significance; in all and through all, the Idea of mankind unfolds itself more and more. Therefore no event in the life of man can possibly be excluded from painting' (§48). It is this view of the philosophical or spiritual significance of painting which influenced the French Symbolists at the end of the nineteenth century, inspiring revolt against photographic realism.

Biography

Arthur Schopenhauer was born on 22 February 1788 in Danzig (now Gdansk), son of Heinrich, a businessman, and Joanna (neé Trosiener), a writer. He entered the family business and trained as merchant from 1803–7. He attended Gotha Gymnasium from 1807–9. He studied science then philosophy at Göttingen University, from 1809–11 and then philosophy at Berlin University from 1811–13. His

doctoral dissertation entitled *Über die vierfache Wurzel des Satzes vom zureichenden Grunde* (*The Fourfold Root of the Principle of Sufficient Reason*) was published in 1813. *Die Welt als Wille und Vorstellung* (*The World as Will and Idea*) was published in 1818. In 1819 he was appointed to a lectureship at Berlin University, where he lectured in 1820 and 1826 without success. In 1831 he left Berlin. From 1833–60 he lived in Frankfurt-am-Main. He died in Frankfurt am Main on 21 September 1860.

Bibliography

Main texts

Die Welt als Wille und Vorstellung, 1819; 2nd edn 1844; trans. E.F.J. Payne, *The World as Will and Representation*, New york, Dover, 2 vols, 1969; (ed.) D. Berman, trans J. Berman, *The World as Will and Idea*, London, Everyman, 1995.

Zur Metaphysik des Schönen und Aesthetik 'On the Metaphysics of the Beautiful and Aesthetics', in *Parerga and Paralipomena, Short Philosophical Essays*, trans. E.J.F. Payne, Oxford, Clarendon Press, 2 vols, 1974; repr. 2001.

Secondary literature

Atwell, J.E., *Schopenhauer on the Character of the World: The Metaphysics of Will*, Berkeley, University of California Press, 1995.

Copleston, F., *Arthur Schopenhauer*, London, Burns Oates & Washbourne, 1946.

Gardiner, P., *Schopenhauer*, Harmondsworth, Penguin Books, 1963.

Hamlyn, D.W., *Schopenhauer*, London, Routledge, 1980.

Jacquette, D. (ed.), *Schopenhauer, Philosophy and the Arts*, Cambridge, Cambridge University Press, 1996.

Janaway, C., *Schopenhauer*, Oxford, Oxford University Press, 1994; repr. as *Schopenhauer, A Very Short Introduction,* Oxford University Press, 2002.

—— *The Cambridge Companion to Schopenhauer*, Cambridge, Cambridge University Press, 1999.

Magee, B., *The Philosophy of Schopenhauer*, Oxford, Oxford University Press, 1983.

Tanner, Michael, *Schopenhauer, Metaphysics and Art*, London, Phoenix, 1998.

Young, J., *Willing and Unwilling: A Study in the Philosophy of Arthur Schopenhauer*, Dordrecht and Boston, M. Nijhoff, 1987.

PETER LEWIS

SØREN KIERKEGAARD (1813–55)

DANISH WRITER AND RELIGIOUS THINKER

Kierkegaard is a writer who escapes easy definition and whose works could variously be claimed by philosophy, theology and literature. His

career as a writer came at the end of what is known as the Golden Age of Danish art and literature and it reflects the sense of disillusion that gathered momentum from the late 1830s onwards – disillusion not only with the more fantastic claims made for art by the Romantics, but also with the more complacent contemporary realism of the Hegelians. The question of art (in the most general sense) and of the artist as a specific human type pervades Kierkegaard's writings. He wrote, for example, of the 'three stages' of human life as being the aesthetic, the ethical and the religious, and he saw the fault of his age in its being content to live in what he regarded as merely aesthetic categories (an analysis connected with his view that the established Church of Denmark was incapable of grasping the radical existential challenge of authentic Christianity). The Hegelians' privileging of knowledge over faith was only one symptom of this situation and essentially on a par with the Romantics' privileging of poetry over reality.

Thus far it would seem plausible to enlist Kierkegaard in the historical roll-call of Protestant iconoclasts, but his relation to art and artist alike was by no means simple. His most significant critique of the aesthetic comes in works such as *Enten-Eller* (*Either/Or*), *Gjentagelsen* (*Repetition*), and *Stadier på Livets Vej* (*Stages on Life's Way*) – works that themselves have the form of novels and that are often exquisitely crafted as literature. Even in his later, generally bleaker, period he was still able to produce positive and insightful essays on the contemporary theatre, and to write a passionate, ironic and often intensely (and self-consciously) figurative prose.

Most of Kierkegaard's writings relating to art belong more directly to literature than to the visual arts. Indeed, there are very few references in his work to contemporary painting or sculpture. Apart from Thorvaldsen's sculpture of Christ in the Church of Our Lady in Copenhagen which Kierkegaard attended, most of the references are to illustrations in popular books, and to judge by the cards he sent his fiancée his own taste may have bordered on kitsch. He argues at one point that crude Nüremberg prints are more suitable for depicting religious scenes than works of great art, precisely because of their palpable inadequacy. Nevertheless, his works are full of stimulus for reflection on visual art and, in particular, on the relationship between art, ethics and religion in the condition of modernity.

Although expressly critical of both Romanticism and Hegelianism, Kierkegaard's conceptual and critical apparatus was largely shaped by these sources. Determinative for all his writings about art is the distinction between the plastic and the musical arts associated with **Lessing**'s *Laocoon*. **Hegel** used this distinction to construct a

hierarchical system of forms of art, marking the passage of 'Spirit' from its immersion in pure exteriority and objectivity (represented in architecture and sculpture) via painting and music to the inwardness and subjectivity of poetry. According to Hegel, this system was also manifested in a historical progression that saw the earlier predominance of spatially determined forms yield to those better able to express the historical and subjective nature of the modern world. A crucial distinction is that between classical and Romantic art, the former being supremely exemplified in Greek sculpture, the latter expressing in painting, music and poetry the 'wealth of inwardness' brought to view by the Christian view of God as humanly incarnate. Ultimately, however, this inwardness finds its truest expression in religious faith and conceptual thought, neither of which can ever be adequately expressed in aesthetic forms. Though art will go on being produced and enjoyed, the deepest interests of the contemporary world lie outside the aesthetic.

Like Hegel, Kierkegaard sees a 'spiritualizing' of art that operates both in formal and historical terms. This is most clearly seen in his essay 'The Tragic in Ancient Drama Reflected in the Tragic in Modern Drama' in *Either/Or* Part One. In this essay he compares the Greek Antigone with an imaginary modern counterpart. The Greek Antigone, he argues, is an individual whose fate is submerged in that of a common destiny. In agreement with Hegel's view of tragedy, she is the bearer of the substantial values of her society (specifically of family obligations). A modern Antigone, Kierkegaard suggests, would be very different. Her drama would be one of pure inwardness and subjectivity. Perhaps her tragedy would be that, as the daughter of Oedipus, she alone would know the truth of her parentage. Her drama is thus the drama of an inner trial of conscience: should she conceal or reveal this terrible secret? The greater degree of reflection that characterizes modernity, however, means that there is little role left for fate. What interests us is only what can be the matter of reflective, responsible decision. At this point the categories of ethics supervene upon those of aesthetics. Once we are into judgements about whether a person was right or wrong to act in such a way the mystique of sympathy essential to earlier tragedy cannot survive. Again, Kierkegaard seems to agree with Hegel that the reflectiveness of modernity is intrinsically detrimental to essential artistic values, although Kierkegaard relates this reflectiveness more to ethics than to knowledge.

In accordance with this emphasis, *Either/Or* centres on the conflict between aesthetic and ethical approaches to reality. The implied argument is that not only is the ethical morally preferable (arguably a

truism) but that the ethical corresponds better to the nature of contemporary reality. It is also telling that the supreme exponent of the aesthetic point of view in *Either/Or*, Johannes the Seducer, is repeatedly described (both by himself and by his ethical critic) as a virtuoso of the visual. The ethicist tells us a story about the aesthete's seductive stratagem of reducing to confusion a girl he has taken a fancy to by watching her in the mirror on the wall of a café, until she looks up and see his gaze fixed upon her. As opposed to the pure lust of a Don Juan (described in the first essay of *Either/Or*), this is the epitome of modernity's reflective love: love not of the girl herself, but of her image. You are like a daguerreotype, the ethicist tells the aesthete, signalling the links between aesthetic voyeurism and the modern urban culture of spectatorship epitomized in the *flâneur* and dandy. *The Seducer's Diary* (in *Either/Or*) gives us many glimpses into the Seducer's visual philosophy. He too likes looking at girls in mirrors, but in doing so he laments the mirror's inability to do anything more than reflect her image: it cannot keep that image once she has moved away from it and it cannot reveal the secrets of her heart – indeed if she were to speak that secret to it, her very breath would obscure her image in the moment of speaking. He, however, knows how to recollect the image in such a way as to penetrate the meaning that the mere image cannot hold. Even as he looks at her image in the mirror, she has become no more than 'a picture formed in recollection even in the moment when she is present'. The issue is not the image itself, but how one looks at the image, how one sees. And the Seducer is proud of his capacity for vision, claiming that his eye is so sensitive that it can feel the quality of a woman's skin. More than this, the way in which he sees determines how he himself is seen (he claims). Watching a young girl descending from her carriage, he places himself under a street lamp in order, he says strangely, to make it impossible for her to see him: 'one is only ever invisible to the extent that one is seen, but one is only ever seen to the extent that one sees'. This is partially clarified when he reveals himself by stepping out past her and letting his 'side-glance' fall on her – 'one doesn't forget my side-glance so easily', he boasts. In this purest of egoists and purest of voyeurs, 'I' and 'eye' have become identical.

In *Either/Or* itself this apotheosis of the male gaze is challenged by an ethical point of view that hinges on the inward choice by which the self acquires continuity through time, and that cannot be adequately expressed in any of the particular images that might express one or other moment of its passage through life. Hegel, too, as we have seen, claims that pure thought ultimately transcends any possible expression in mere image. Nevertheless, Hegel still maintains the essential continuity

between image and idea. Limited by its externality and corporeality, the image is necessarily inadequate to the idea but, in its own way, it still contains or signifies the idea. For Kierkegaard, however, the breach between image and inner truth is far more radical. Indeed there are cases where the outer image is in complete contradiction to its inner meaning. This is already known by the Seducer and is exploited by the aesthete's penchant for irony but it acquires a more serious expression in the Incarnation, in faith's claim that an individual man, the object of normal, everyday vision and representation, is also God. This, Kierkegaard says, is 'a sign of contradiction'.

With regard to the religious, even the inwardness of the ethical is problematic. In *Frygt og Bæven* (*Fear and Trembling*), Kierkegaard uses the biblical story of Abraham being called to sacrifice Isaac to show how religious decisions may break with the ethical requirement of universalizability. Moral principles must be susceptible to explanation, but Abraham is completely incomprehensible. Reason is as inadequate as art in the face of such spiritual trials. As Kierkegaard puts it in *Stages on Life's Way*, 'if it is true that the time of immediacy [i.e. the age of poetry and art] is past, then what matters is to gain the religious, nothing in between can help'. Yet since neither God nor the self can ever be adequately conceived or represented, we are constantly exposed to anxiety, despair and tragedy, seeking our truth in what we cannot know or depict.

Kierkegaard opposes the religious to the aesthetic, but it has been claimed that what he describes as 'the religious' is very close to the condition of the artist in the situation of modernity, no longer supported or, it may be, constrained by principles of beauty and harmony. In a world of reflection, where images are not naïve imitations of inner states or external objects but the matter of reflection, quotation and critique, artists too must struggle against the immediate associations and easy readings of the images they use and produce. Mark Rothko saw in Kierkegaard's Abraham a paradigm of the modern artist whose need for expression forced him to contest all conventional modes of representation. No less than the religious critic, the modern artist repeatedly enacts a counter-movement to the culture of spectatorship. If Kierkegaard rejects an aesthetic of beauty he is fascinated by the possibilities unleashed by the disjunction of image and meaning, and the vertiginous distortions of vision that highlight the requirement of subjective interpretation: he writes of an illusionistic picture of Napoleon's tomb in which the figure of Napoleon appears between the trees that crown the tomb; of what he calls 'shadowgraphs', whose true shape only appears when they are

projected against a wall; of binoculars in which one lens magnifies and another reduces; of a man with a telescope who leaps into the water to save a drowning animal only to discover it is just a ladybird; of a telescope with a hidden rear-view mirror. Inhabiting the same world as the modern artist, Kierkegaard's critique of the aesthetic cannot be read as a simple rejection of art. The problem he sets himself concerning the authentic communication of religious truth may differ in intention and media from the problematic of modern art, but there are important analogies that make Kierkegaard an important resource for working artists and for aesthetic theory.

Biography

Søren Aabye Kierkegaard was born on 5 May 1813 in Copenhagen, the son of a retired cloth merchant whose death in 1838 left Søren with a substantial private income. He studied theology at Copenhagen University from 1830–41 and completed a Master's Thesis *On the Concept of Irony* in 1841. He was engaged to Regine Olsen from 1840–1, but broke off the engagement for obscure reasons connected with his inner religious crisis. After a brief period in Berlin he returned to Denmark and between 1843–6 published the pseudonymous books on which his reputation rests. Victim of a defamatory press campaign in 1846, he became more reclusive, though he continued to write books on religion, culture and aesthetics. In 1854–5 he wrote a series of articles and pamphlets attacking the established Church. He died in Copenhagen on 11 November 1855.

Bibliography

Main texts

Enten-Eller, 1843, trans. Howard V. and Edna H. Hong, *Either/Or I & II*, Princeton, Princeton University Press, 1987.
Frygt og Bæven; Gjentagelsen, 1843, trans. Howard V. and Edna H. Hong, *Fear and Trembling* and *Repetition*, Princeton, Princeton University Press, 1983.
Stadier på Livets Vej, 1845, trans. Howard V. and Edna H. Hong, *Stages on Life's Way*, Princeton, Princeton University Press, 1993.
Papers and Journals (a selection), trans. Alastair Hannay, London, Penguin, 1996.
(There are also translations by Hannay of *Fear and Trembling* and *Either/Or* [abridged], both in Penguin Classics.)

Secondary literature

Adorno, T.W., *Kierkegaard: Konstruktion des ästhetischen*, 1933, trans. Robert Hullot-Kentor, *Kierkegaard: the Construction of the Aesthetic*, Minneapolis, University of Minnesota Press, 1989.

Erne, Paul Thomas, *Lebenskunst: Aneignung ästhetischer Erfahrung. Ein theologischer Beitrag zur Ästhetik im Anschluss an Kierkegaard*, Kampen, Pharos, 1994.

Linnet, R., *Kierkegaard og blikkets koder*, Copenhagen, Center for Urbanitet og Æstetik, 1996.

Pattison, George, *Kierkegaard: The Aesthetic and the Religious*, London, SCM Press, 1999.

—— *'Poor Paris!' Kierkegaard's Critique of the Spectacular City*, Berlin, Walter de Gruyter, 1999.

—— *Kierkegaard, Religion and the Nineteenth Century Crisis of Culture*, Cambridge, Cambridge University Press, 2002.

Tøjner, P.E., Garff, J. and Dehs, J., *Kierkegaards Æstetik*, Copenhagen, Gyldendal, 1995.

GEORGE PATTISON

KARL MARX (1818–83)

GERMAN PHILOSOPHER

As in his understanding of philosophy and history generally, Marx derived his major initial insights into aesthetics from **Hegel**. From Hegel's *Lectures on Fine Art* (1835–8) he learned that art develops dialectically along with the rest of human culture. Marx did not agree with Hegel's spiritual interpretation of philosophy, history, and art, but retained the dialectical structure, which he understood to be driven by material forces.

Although Marx did not address aesthetics in a systematic way, he had clear and definite ideas about art as a cultural manifestation. Marx's ideology changed very little during the course of his career, the ideas that he entertained about the ways in which culture worked perhaps least of all. Culture in the modern world, he argued, arose from man's alienation under capitalism. In the *Economic and Philosophic Manuscripts of 1844*, which served him as a sourcebook for many of his later writings, he claimed that capitalism produced wonders for the rich but 'imbecility and cretinism for the worker'. Only the end of the profit system and its replacement by communism could save mankind from increasingly gross forms of exploitation. That Marx found solace in the great literature of past ages became evident from his extensive use in the fourth manuscript of quotations by Goethe and Shakespeare on the evil 'omnipotence of money'. He completely identified with their critical sentiments, adding that industrial capitalism had aggravated and augmented the age-old problems of greed.

In one of his earliest books, *Die Deutsche Ideologie* (*The German Ideology*) (1846), Marx explained his central idea about art. Take the example of Raphael, he began. To understand the career of this Renaissance artist, it is not enough simply to consider his genius: 'Whether an individual like Raphael succeeds in developing his talent depends wholly on demand, which in turn depends on the division of labour and the conditions of human culture resulting from it'. In other words, the socio-economic context of Renaissance Rome afforded Raphael the professional possibilities without which no one ever would have heard of him. Marx thus opposed the 'great man of history' approach to art and emphasized instead the crucial role that demand plays in art history. More than anything else, the artist needs an audience, and it is society that provides this. Marx would always argue that individual personalities are subordinate to their economic and class relations in society. Culture, along with everything else in history, reflects class forces, which, in turn, emanate from the material production of life or what Marx called the real ground of history. The distinction here is between the economic 'base' and the cultural 'superstructure'. Class conflict drove the historical process and thoroughly conditioned the history of art.

For succinctness of argument and vividness of style, *Manifest der Kommunistischen Partei* (*The Communist Manifesto*) (1848) is Marx's best known book, and it contains some trenchant observations about culture. He predicted that the creation of the world market would bring to a dreadful climax the long course of capitalist exploitation. The consequences of this inchoate but obviously tremendous development could be seen in every field of human endeavour, but Marx emphasized the social and cultural consequences most of all. Industrial capitalism and the resulting intensification of market forces had plunged the advanced societies of the west into a dizzying whirl: 'Constant revolutionizing of production, uninterrupted disturbance of all social conditions, everlasting uncertainty and agitation distinguish the bourgeois epoch from earlier ones'. Traditional values could not resist such an onslaught. Culture in all of its forms would have to change in conformity with the transformation of the mode of production.

The dynamics of the class struggle inevitably pushed the capitalist system toward crisis. Bourgeois society had accomplished miracles in producing wealth, but it 'is like the sorcerer who is no longer able to control the powers of the nether world whom he has called up by his spells'. Enter the proletariat, which would grow along with capitalism but then usher in the communist order; with the revolution, men at

last would become free to develop their full humanity. Communism, unconcerned about the profits that totally dominated pedagogy under capitalism, would educate the whole man. Art, therefore, would no longer be the special aesthetic province of the ruling classes, but the natural condition of every life.

In permanent exile after the failed revolutions of 1848, Marx set out to write a six-part treatise on economics in which he proposed to examine capital, landed property, wage labour, the state, foreign trade, and the world market. In pursuit of this design, he wrote hundreds of pages of notes to himself, but would never finish the general work that he set out to write. The notes, which were published as the *Grundrisse der Kritik der Politischen Ökonomie* in 1939, contain the sole indicators of Marx's complete economic theory.

In the Introduction to the *Grundrisse*, Marx comments on the complex relationship between art and society. Although society always had to be understood as the premise of art, these two spheres evidently did not evolve through history as a readily ascertainable series of economic causes and aesthetic effects. He wondered why, for example, modern man still responded to the aesthetic appeal of classical Greek art. The ancient Greeks had lived amidst primitive economic conditions and yet had produced timeless art and poetry. Marx could only explain the enduring appeal of Greek civilization by calling attention to the 'eternal charm' that the historical childhood of humanity holds for us. Immature social conditions had given rise 'to this art [which] can never recur', and we moderns appreciate it not for any social or economic reason but for its aesthetic power and beauty. Marx did not think that all culture was the same. He responded to 'great' art and literature, noting that their intrinsic qualities cannot be reduced to contemporary political and class issues.

Convinced that the Industrial Revolution had resulted in a terrible disaster for culture, Marx echoed many of the Romantics' complaints against modernity. But unlike Romantic reactionaries who objected to modernization on principle, Marx wanted it to come under communist auspices. Only a communal mode of production could stop the relentless forces of profiteering unleashed by capitalism and create a fully human culture. Meanwhile, alienation would afflict every individual caught in the trap of capitalist modernization.

For the rest of his life, Marx devoted as much time and energy as he could to a systematization of the fragmentary ideas and lines of thought in the *Grundrisse*. Failing health and one financial crisis after another forced him to delay publication of his research on economics. Not until 1859 did he present a manuscript to his publisher in

Germany, *Zur Kritik der Politischen Ökonomie* (*A Contribution to the Critique of Political Economy*). The book dealt only in a limited and tentative way with the first theme of the *Grundrisse* – capital – and passed virtually unnoticed in the intellectual world.

Nevertheless, *A Contribution to the Critique of Political Economy* became a landmark publication for Marxists because in it, as the book's editors for the Collected Works edition observed, Marx 'made public for the first time some of the findings of his theoretical research'. In the 'Preface', Marx pithily explained what he called 'the guiding principle of my studies'. History could only be understood in the complex relational terms that existed between the economic substructure and the cultural superstructure. He had shown in numerous earlier works how the mode of production conditions the general process of social, political, intellectual, and aesthetic life. Now, however, he rendered the point fully explicit as the theoretical basis of Marxism.

For the depth of its research and the topical range of its concerns, however, *Das Kapital* (*Capital*) (1867) eclipsed *A Contribution to the Critique of Political Economy*. In the intellectual history of Europe, *Capital* occupies the supreme place of eminence in the socialist left's attack on the world that the money power of industrial capital created. As always, Marx sought to change reality, not merely to analyse it. *Capital* is a typical Marx book in its combination of rigorous socio-economic analysis and energetic propaganda for the proletarian cause. It remains the foremost example of applied historical materialism. Between *A Contribution to the Critique of Political Economy* and *Capital*, Marx had read Darwin's *Origin of Species* (1859), a book that gave him a new way of thinking about the historical dialectic. Under the influence of Darwin, Marx came to view the formation of society as a process analogous to that of the natural world.

Capital is Marx's deepest and fullest analysis of how cultural alienation arises from the economic mode of production in capitalist society. Marx traced the origins of capitalism to the decay of feudalism, some time in the fourteenth century. The making of the English working class, in the title wording of E.P. Thompson's famous book, began then. Marx, like Thompson, saw the entire process as one of relentless exploitation, cultural deracination, and psychological trauma. Capitalism expropriated the serfs: 'And the history of their expropriation is written in the annals of mankind in letters of blood and fire'. Capitalism has existed solely to augment the wealth of the business elites at the expense of the poor. The dreadful scourge of capitalism has both shaped and been reflected in the culture of the modern world.

The impact of Marx's ideas on the analysis of art and culture generally has been profound, though those drawing on his ideas have developed widely diverging views. The vast Marxist literature about the imposition of the capitalist hegemony, the reification of bourgeois society, the one-dimensionality of man under capitalism, and the prevalence of false consciousness in the modern world is a network of rivulets criss-crossing the intellectual landscape of the twentieth century. Antonio Gramsci, Georg Lukács, Herbert Marcuse, Walter Benjamin, Theodor Adorno take their general direction from the Marx of *Capital*. Marx's assertion in this book about the domination of the capitalist over the worker, the thing over the person, and the product over the producer, unite all of these thinkers in a recognizably Marxist tradition of social and cultural criticism. Other thinkers who have benefited from Marx's theories about society and culture include Meyer Schapiro, F.D. Klingender, Max Raphael, Ernst Fischer, Arnold Hauser, Frederick Antal, John Berger, Jean Baudrillard, and T.J. Clark. Marxism continues to be a source of illumination for social approaches to art history.

Biography

Karl Heinrich Marx was born on 5 May 1818 in Trier, Prussia, the son of a lawyer who converted from Judaism to Christianity. He was baptized a Lutheran but later became an atheist. He studied first at Bonn and then Berlin before taking his Doctor of Philosophy degree from the University of Jena in 1841. He was the editor of the *Rheinische Zeitung*. In Parisian exile because of his radical politics, he continued to work as a journalist and began writing books. He moved to England after the failed Revolutions of 1848 and eked out a precarious living from journalism and subsidies from his collaborator, Friedrich Engels. He died on 14 March 1883 in London.

Bibliography

Main texts

Die Deutsche Ideologie, with Friedrich Engels, 1932, *The German Ideology*, (ed.) with introduction by C.J. Arthur, London, Lawrence & Wishart, 1970.
Grundrisse der Kritik der Politischen Ökonomie, 1939, trans. David McLellan, *Marx's 'Grundrisse'*, London, Macmillan, 1980 (selections).
Economic and Philosophic Manuscripts of 1844, trans. Martin Milligan, Moscow, Foreign Languages Publishing House, 1959; New York, International Publishers, 1964.

Manifest der Kommunistischen Partei, with Friedrich Engels, 1848, *The Communist Manifesto*, (ed.) with introduction by David McLellan, Oxford and New York, Oxford University Press, 1992.

Zur Kritik der Politischen Ökonomie, 1859, trans. S.W. Ryazanskaya, *A Contribution to the Critique of Political Economy*, (ed.) with introduction by Maurice Dobb, London, Lawrence & Wishart, 1971.

Das Kapital: Kritik der Politischen Ökonomie, 1867, trans. Ben Fowkes, *Capital: A Critique of Political Economy*, with introduction by Ernest Mandel, New York, Vintage Books, 1977.

Collected works:

with Friedrich Engels, *Werke*, Berlin, Dietz, 1956–1968.

with Friedrich Engels, *Collected Works*, New York, International Publishers, 1975–1998.

Secondary literature

Adorno, Theodor W., *Aesthetic Theory* (*Ästhetische Theorie*), Gretel Adorno and Rolf Tiedemann (eds), Minneapolis, University of Minnesota Press, 1997.

Arvon, Henri, *Marxist Esthetics*, Ithaca, New York, Cornell University Press, 1973.

Baxandall, Lee, *Marx and Esthetics: A Selected Annotated Bibliography*, New York, Humanities Press, 1973.

Eagleton, Terry, *The Ideology of the Aesthetic*, Oxford, Blackwell, 1990.

Hauser, Arnold, *The Philosophy of Art History*, New York, Knopf, 1959.

Lang, Berel and Forrest Williams (eds), *Marxism and Art: Writings in Aesthetics and Criticism*, New York, McKay, 1972.

Lukács, Georg, *Studies in European Realism*, London, Hillway, 1950.

Nelson, Cary and Lawrence Grossberg (eds), *Marxism and the Interpretation of Culture*, Urbana, Illinois, University of Illinois Press, 1988.

Raphael, Max, *The Demands of Art*, Princeton, New Jersey, Princeton University Press, 1968.

Solomon, Maynard (ed.), *Marxism and Art: Essays Classic and Contemporary*, New York, Knopf, 1973.

RICHARD DRAKE

JACOB BURCKHARDT (1818–97)

SWISS HISTORIAN

Inspired by the philosophy of Arthur **Schopenhauer** and by the pioneering University of Berlin art historian Franz Kugler, Jacob Burckhardt sought to use art as a means of understanding the Zeitgeist, or spirit, of an era. From these two men in particular, Burckhardt derived the idea of art's unique historical importance as the most accurate gauge of a society's creativity and ultimate worth. According to Burckhardt, the capacity to produce genuine artists – that is, individuals of heightened perception who could extract from the chaos

of human experience the deepest truths of our nature – determined the standing of a society in the hierarchy of world civilizations.

In Burckhardt's first book, *Die Zeit Constantins des Grossen* (*The Age of Constantine the Great*) (1852), he traced the decline of Rome through its faltering art. Beginning in the middle of the second century AD, Roman art degenerated into a state of 'mere repetition' and 'internal impoverishment'. Thus ended six centuries of organic aesthetic growth in the western world. The magnificent advance of western art had begun with the Greeks for whom 'art in the highest sense of the word was once the breath of life ...' The Romans adopted Greek art, enriched it, and passed it on to the entire west. Their decline stemmed from political, economic, and military causes, but Burckhardt thought that the process of decay stood most clearly revealed in the art of the third and fourth centuries.

The advent of Christianity did not result in a reversal of decline in Roman art. Although Burckhardt energetically defended Christianity against the charge that it bore responsibility for the fall of Rome, he willingly conceded that early Christian artists did not belong in the same category of excellence as the greatest pagan geniuses. He had a low opinion of 'message' art, and the crudity and bluntness of Christian propaganda offended his aesthetic sensibilities: 'Art had become serviceable to a symbol which lay outside of itself.'

Interested though Burckhardt was in the social context of culture, and in the pivotal role played by its 'purchasers', he believed with Schopenhauer that the highest forms of art belonged to the 'sublime' realm of universal truth. Artists were great in proportion to their capacity to create works that would give ordinary mortals access to life's transcendent meanings. Even if art could only be understood historically in connection with the social forces that had given it life, ultimately it had its own 'internal laws' and stood outside history as the universal measure of civilization. Literature, in particular, faithfully mirrored the health of cultures. For example, during its long decline Rome produced increasingly deplorable 'grammatical tricks with words and verses'.

Burckhardt's politically and culturally conservative ideas, derived from his boundless admiration for Schopenhauer, came to the fore in *The Age of Constantine the Great*, with his frequent asides to the reader about the shocking failures of modern education to provide an adequate basis for the cultivation and appreciation of great art. Friedrich **Nietzsche**, who would meet Burckhardt many years later when the two men were colleagues at the University of Basel, took

this pessimism about the modern world to novel extremes in his notorious works of philosophical genius.

In 1854, Burckhardt wrote the enormously popular *Der Cicerone: eine Anleitung zum Genuss der Kunstwerke Italiens* (*The Cicerone: An Art Guide to Painting in Italy for the Use of Travellers and Students*), which over the next three generations became the standard guidebook for art connoisseurs in Italy. It went through seven editions in his lifetime, and on the basis of its success he secured a teaching position at the Zurich Polytechnic. A popular rather than a scholarly book, the *Cicerone* reveals Burckhardt's skill as a writer but not the originality of his thought about art.

Die Cultur der Renaissance in Italien (*The Civilization of the Renaissance in Italy*) (1860) established Burckhardt's reputation as one of the leading historians in Europe and became a key work in defining our conception of the Renaissance. Once again, he singled out the arts as a vital theme in history. By his standard, Renaissance Italy formed a pair with Periclean Athens as the foremost creative forces in all of western civilization. Setting out to explore the reasons for Italy's artistic supremacy in the modern world, he characterized his book as an 'essay in the strictest sense of the word'. Burckhardt first sketched the unique political context in which the Renaissance occurred. The Guelph–Ghibelline Wars had left Italy in a political condition essentially different from that of other European countries. In the Renaissance city-states 'for the first time we detect the modern political spirit of Europe, surrendered freely to its own instincts, often displaying the worst features of an unbridled egotism'. Here the state emerged as 'a work of art', the creation of illegitimate rulers who lived by their wits and based their governments on power considerations alone. Only such a society could have produced Machiavelli, who for Burckhardt stood out as the paramount symbol of the age.

The extraordinariness of Italy produced a cultural revolution that manifested itself in manners, mores, education, and – above all – the arts. Burckhardt emphasized the uniqueness of the Renaissance: 'We must insist upon it as one of the chief propositions of this book, that it was not the revival of antiquity alone, but its union with the genius of the Italian people which achieved the conquest of the western world'. The Italians became 'the first-born among the sons of modern Europe'.

Interested in social history, and a real pioneer of it, as his brilliant chapter 'Society and Festivals' demonstrates, Burckhardt held that before the cultural revolution of the Renaissance could develop there first had to arise a social world that 'felt the want of culture and had the

leisure and the means to obtain it'. Society as a whole helped to shape that which existed in no other country, 'a widespread interest in artistic production and an intelligent and critical public opinion'.

Nevertheless, Burckhardt took an essentially elitist approach in history, noting that 'in by far the greater number of cases, we have to do, not with the general culture of the people, but with the utterances of individuals or learned circles'. He explained that 'there are men who are by nature mirrors of what surrounds them', such as Leon Battista **Alberti** and **Leonardo da Vinci**. Burckhardt claimed to be writing about the upper classes because we are better informed about them, but he explicitly encouraged historians to concern themselves with any topic for which evidence would permit scholarly research. The problem with writing the history of the masses, he thought, is that so little real evidence about them remained.

Though scattered references to Renaissance artists appear in *The Civilization of the Renaissance in Italy*, the book is not a work of art history. In view of Burckhardt's training and professional interest in art history, such a striking omission can only be explained by his expectation that he would devote a separate volume to the subject. Burckhardt, however, never completed another scholarly book. His *Die Geschichte der Renaissance in Italien* (The History of the Renaissance in Italy) (1867) was a handbook on Italian architecture.

Famous throughout Europe, Burckhardt declined the offer to replace Leopold von Ranke at the University of Berlin. Finding his deepest satisfaction as a teacher of small classes at the University of Basel, he built a monumental reputation for brilliance as a lecturer. Nietzsche, who said that Burckhardt was the only university professor from whom he ever learned anything, paid extravagant tribute to his astringent and ironic style in the classroom. Numerous manuscripts based on his lectures came to light after his death, and they were published under the following titles: *The History of Greek Culture* (4 volumes, 1898–1902), in which the third volume is devoted to art; *Reflections on History* (1943); and *Judgments on History and Historians* (1958). A manuscript on the life of Peter Paul Rubens, the value of which Burckhardt doubted and did not want published until after his death, appeared in 1898 as *Erinnerungen aus Rubens* (translated as *Recollections of Rubens*).

Of these posthumous publications, *Weltgeschichtliche Betrachtungen* (*Reflections on History*) most fully reveals Burckhardt's attachment to the idea that the true worth of societies must be measured by the quality of their art. He asserted that art was the most extraordinary and enigmatic creation of the human spirit. The great creative spirits who 'appear and lay down lines which are followed by whole epochs and peoples to the

point of one-sidedness' gave history its ultimate meaning. The great question in history had to do with why some societies, such as Athens and Florence, produce a disproportionate number of such individuals. In *Reflections on History*, Burckhardt speculated on the reasons for the unevenness of artistic production from one society to the next in place and time. This eminent professor ruled out great educational facilities as a factor in aesthetic creativity, holding that universities specialized mainly in the promotion of 'inflated nonentities'. Education had nothing to do with genius, which could only arise spontaneously from the attunement of an entire society to the wonder of an animating faith. Contemplating the culture of medieval Europe, Burckhardt proclaimed that 'the lofty spires of a hundred cathedrals' rendered ridiculous the cultural pretensions of modern man, who had no faith in anything and, therefore, could neither produce nor appreciate great art. 'Our vulgar hatred of everything that is different from ourselves' sealed the fate of the modern era as one of the narrowest and least creative in all of human history. Art and poetry 'are in our day in the most wretched plight, for they have no spiritual home in our ugly, restless world, and any creative spontaneity is seriously undermined'.

Burckhardt's ideas about art history continue to serve as an inspiration or a challenge for historians today. He is still at the centre of the debates not only about the Renaissance, but about historical methodology as well. What Burckhardt wrote about Machiavelli in *The Civilization of the Renaissance in Italy* applies to his own work as well: 'We might find something to say against every line of the *Storie fiorentine* [Machiavelli's history of Florence], and yet the great and unique value of the whole would remain unaffected.'

Biography

Jacob (Jakob) Christoph Burckhardt was born on 25 May 1818 in Basel, to a patrician clerical family. He received a classical education, then briefly studied theology at the University of Basel before turning to history at the University of Berlin, studying history with Leopold von Ranke and Johann G. Droysen, and receiving his Ph.D. in 1843. After returning to Switzerland, he was to combine newspaper work with lecturing at the University of Basel. He secured a chair of history at the Zurich Polytechnic where he taught from 1855–8. He returned to the University of Basel in 1859 and remained there for the rest of his life. He died on 25 May 1897 in Basel.

Bibliography

Main texts

Die Zeit Constantins des Grossen, 1852, trans. Moses Hadas, *The Age of Constantine the Great*, Garden City, NY, Doubleday, 1949.

Der Cicerone: eine Anleitung zum Genuss der Kunstwerke Italiens, 1854, trans. A.H. Clough, *The Cicerone: An Art Guide to Painting in Italy for the Use of Travellers and Students* with a Preface by P.G. Konody, New York, Scribner, 1908.

Die Cultur der Renaissance in Italien, 1860, trans. S.G.C. Middlemore, *The Civilization of the Renaissance in Italy*, London, G. Allen & Unwin, and New York, Macmillan, 1890.

Die Geschichte der Renaissance in Italien (The history of the Renaissance in Italy), Berlin, 1867.

Erinnerungen aus Rubens, 1898, trans. Mary Hottinger, (ed.) and introduction by H. Gerson, *Recollections of Rubens* (with selected letters by Rubens trans. R.H. Boothroyd and I. Grafe), New York, Phaidon, 1950.

Griechische Kulturgeschichte, 1898–1902, trans. Sheila Stern *The Greeks and Greek Civilization*, Oswyn Murray (ed.), London, HarperCollins, 1998.

Weltgeschichtliche Betrachtungen, 1905, trans. M.D.H., London, *Reflections on History*, London, G. Allen & Unwin, 1943.

Historische Fragmente aus dem Nachlass, 1929, trans. Harry Zohn, *Judgments on History and Historians*, with Introduction by H.R. Trevor-Roper, Boston, Beacon Press, 1958.

Secondary literature

Dru, Alexander (ed.), *The Letters of Jacob Burckhardt*, London, Routledge, and New York, Pantheon, 1955.

Ferguson, Wallace K., *The Renaissance in Historical Thought: Five Centuries of Interpretation,* Boston, Houghton Mifflin, 1948.

Gilbert, Felix, *History: Politics or Culture? Reflections on Ranke and Burckhardt*, Princeton, Princeton University Press, 1990.

Janssen, E.M., *Jacob Burckhardt und die Renaissance* Assen, Netherlands, van Gorcum, 1970.

Kaegi, Werner, *Jacob Burckhardt: eine Biographie*, 7 vols, Basel, Schwabe, 1947–82.

Central Renaissance Conference, *Jacob Burckhardt and the Renaissance: A Hundred Years After*, Lawrence, University of Kansas Press, 1960.

RICHARD DRAKE

JOHN RUSKIN (1819–1900)

ENGLISH CRITIC AND WRITER

In the course of his 60-year career, the prolific Victorian controversialist and polymath, John Ruskin, became an institution: Britain's national art critic. Roger Fry's Oedipal complaint in 1920

that Ruskin's 'exuberant ... ill-regulated mind had spun' a harmful 'web of ethical questions, distorted by aesthetic prejudices', signalled the rise of Modernism and fifty years of neglect for Ruskin's writings. But when the patriotically renamed Tate Britain Gallery was inaugurated in 2000 with the exhibition, *Ruskin, Turner and the Pre-Raphaelites*, the centenary of Ruskin's death saw thereby his reaffirmation as the founding figure who had canonically dubbed and inspired, the nation's 'modern painters'.

Uniquely propitious circumstances enabled Ruskin's success. After the Napoleonic Wars, a new kind of non-aristocratic patron, the enterprising businessman, flourished, and invested heavily in British art. So in the 1840s, Ruskin's prosperous neighbours – the coachbuilder, Windus, and the whale oil merchant, Bicknell – opened their fine British collections to him, while he and his father, the self-made sherry importer, John James Ruskin, collected paintings (Turner watercolours especially). John's affluent, socially ambitious father also sponsored his career as champion of Turner in *Modern Painters* 1 (1843), and of the Pre-Raphaelite Brotherhood (PRB) from 1851. Thus Ruskin both formulated and extended a taste for contemporary art acquired from his father's milieu, while as a critic–patron he would commission and buy works he criticized, and invest personally in the careers of a series of protégés, such as Millais, Rossetti and Burne-Jones. However, relations between patron and favourite were always ambivalent and competitive.

Modern Painters 1 spawned an unforeseen five-part series and redeemed the reputation of the veteran landscapist, Turner, from the ravages of *Blackwood's*. Then Ruskin wrote two pairs of letters to *The Times* (1851, 1854) that saved the embryonic PRB from critical perdition. Thus Ruskin rehabilitated British art writing, by transforming it from the blood sport of partisan periodicals, into a means of critical redemption. Hence, Charlotte Brontë would testify that having, 'only had instinct to guide' her judgements of art, Ruskin 'seems to give me eyes ... Who can read these glowing descriptions of Turner's works without longing to see them?'

Ruskin's great gift for teaching his readers visual literacy can partly be quantified. Unlike reviewers, Ruskin wrote extensively about paintings' distinctive pictorial qualities, such as their form and iconography. Ruskin's bravura account of a Turner oil his father would soon buy for him – *Slavers Throwing Overboard the Dead and Dying* (1840) – exemplifies how he found what Milton called an 'answerable style' worthy of his elevated subject:

Purple and blue, the lurid shadows of the hollow breakers are cast upon the mist of night, which [advances] like the shadow of death upon the guilty ship as it labours amidst the lightning of the sea, its thin masts written upon the sky in lines of blood . . . incarnadines the multitudinous sea . . . [I]f I were reduced to rest Turner's immortality upon any single work, I would choose this.

Such set-pieces became Ruskin's much-anthologized hallmark, and led to his being regarded as a supreme word-painter and stylist. Yet *Modern Painters* 1 was also a treatise designed to prove 'that Turner *is* like nature, and paints more of nature than' anyone 'who ever lived'. So the canonical landscapes of Claude, Cuyp, and the 'unpardonable' Canaletto, were repudiated as misrepresentations, whereas Turner constituted the culmination of an honourable native tradition that included two watercolourists who had tutored Ruskin: J.D. Harding and Copley Fielding.

After volume 1, Ruskin's topical title *Modern Painters* began to seem a misnomer, as over the next 17 years the series digressed extravagantly. The fluctuations in Ruskin's output, his contradictoriness, and the extreme unevenness of his oeuvre, can be attributed to five factors: Ruskin wrote when – and almost whatever – he wanted, because his father underwrote his publications; his diverging interests; radical changes in belief and thinking; the proliferation of projects in which he was involved; his experiments in genre and publication form. One distraction from *Modern Painters* was Ruskin's invidious *Academy Notes* (1855–9, 1875), an annual that promoted Ruskinian Pre-Raphaelitism and competed aggressively with the Royal Academy's catalogue. Ruskin soon discontinued *Notes* because the demands of writing a yearly review to a deadline proved overwhelming, and because he antagonized too many modern painters! Ruskin's best criticism had the fearless integrity of his defence of Turner. But at its worst, his writing became indistinguishable from the scurrilous review, as the libelous attack on Whistler as a 'Cockney . . . coxcomb' in 1877 demonstrates.

Thus *Modern Painters* 1 juxtaposed extreme sensitivity with outrageous xenophobia. Ruskin's relative ignorance of European art was tempered in *Modern Painters* 2 (1846), which never mentioned Turner, but celebrated Ruskin's latest discoveries: the works of Fra Angelico and Tintoretto seen on seminal visits to Florence and Venice in 1845. Now Ruskin's criticism operated within a new, typological framework that would both inspire the religious paintings of Holman

Hunt when he read *Modern Painters* 2, and later enable Ruskin to interpret the symbolism of Hunt's *Light of the World* and *Awakening Conscience* convincingly to an uncomprehending public.

Ruskin's exegeses of sacred art established his reputation as a sage, a daring secular prophet who risked alienating readers by exposing their folly, but who had thus far always been able to win them over by providing inspired readings of art that converted them to his ways of seeing. But when *Modern Painters* 3 and 4 appeared (1856), Ruskin's crumbling faith meant that he would try his readers' patience again, by abandoning Evangelical criticism. The defensive-sounding subtitle of *Modern Painters* 3, 'Of Many Things', reveals that both series and sage were slaves to digression – and the unforeseen. Ruskin put in the foundations for volume 1 by tracing the origins of the feeling for landscape that produced Turner. He also attempted to link *Modern Painters* 1 and 2 retrospectively by critiquing the Grand Style of art; contrasting the false ideal in Religious Art, with the true, Purist, Naturalist and Grotesque, ideals; and surveying Classical (Homer's), Medieval (Dante's), and Modern (Scott's) landscape.

Ruskin strategically paired seminal ideas of the 'grotesque' and the 'Pathetic Fallacy'. A 'fine grotesque' – of the sort found in the poetry of Spenser and Dante, and, Ruskin hoped, in future grotesque, realist paintings by Watts and Rossetti – was: 'the expression ... by a series of symbols thrown' boldly together, 'of truths which it would have taken a long time to express' verbally; 'the connection is left for the beholder to work out ... the gaps, left or overleaped by ... the imagination'. In contrast, the 'Pathetic Fallacy' was a distortion projected onto the external world by the poet's disturbed emotions. A strong characteristic of his own writing, Ruskin saw the 'Pathetic Fallacy' as being symptomatic of Romanticism and contemporary poetry: the work of 'second order' poets like Keats and Tennyson.

Grotesqueness pervaded *Modern Painters* 4 and 5. *Modern Painters* 4 claimed that Turner had perfected the picturesque mode, because he used it to express pity for human suffering. Ruskin then detailed how Turner's mountain-scapes were imaginative yet truthful – often by retracing the artist's footsteps, and forensically reconstructing Turner's Alpine views. Despite proclaiming a natural theologian's belief that mountains were the earth's 'great cathedrals', Ruskin knew that the fossil record betrayed God's disappearance, and therefore gave disturbed accounts of the 'unspeakable' horrors of poverty-stricken mountain life.

Two life-crises in 1858 determined the despairing character of *Modern Painters* 5. First, while sorting the 19,000 drawings in Turner's bequest to the nation in the National Gallery (works now housed in

Turner's Clore Gallery at Tate Britain), Ruskin discovered porno-graphic pictures. Many were secretly burnt, but Ruskin covertly saved some. Second, Ruskin was 'un-converted' to a 'Religion of Humanity' in Turin, after an epiphany before Veronese's *Presentation of the Queen of Sheba*, and an anti-epiphany before a fundamentalist preacher. Hence, *Modern Painters* closed with Turner recast as an apocalyptic mythologist of the triumph of the 'dragon' (overdetermined type of the Satanic beast, dinosaur, phallus, and industrial capitalism), in *The Garden of the Hesperides* (1806) and *Apollo and Python* (1811).

Between 1861–70 Ruskin wrote little art criticism. Consequently it is often thought that because he also began to publish on political economy in *Unto this Last* – the controversial assault, greatly admired by Gandhi, on *laissez-faire* principles – in 1860, that this year marks an irrevocable shift to social criticism. Yet Ruskin had always been an acutely socially aware cultural critic. He had linked art and society in *The Political Economy of Art* in 1857; *Modern Painters* 4 and 5 had expressed profound anxieties about the human condition, and Ruskin believed that architecture was, 'the embodiment of the Polity, Life, History and Religious faith of nations'. Thus *The Seven Lamps of Architecture* (1849) had conclusively appropriated the Gothic Revival from Pugin and Catholicism for Evangelical Britain, by advocating such principles as Sacrifice, Truth, and Obedience. Correspondingly, *The Stones of Venice* series (1851, 1853) demonstrated that Britain's salvation depended on the rehabilitation of its national architecture, and *Seven Lamps* and *Stones* became templates for such architects as Butterfield and Street, as the polychromatic, High Victorian Gothic building became ubiquitous in the nation's high streets.

Stones demonized the alleged soulless perfectionism of Renaissance culture. Its key chapter was Ruskin's utopian account of 'The Nature of Gothic', which argued that medieval craftsmen possessed a creativity denied their counterparts in the mechanized – soullessly perfectionist – nineteenth century, because their work embodied traits of: Savageness or Rudeness; Love of Change and Nature; Disturbed Imagination; Obstinacy and Generosity. This chapter was issued by F.J. Furnivall, a founder of the Working Men's College in London, to artisans who Ruskin had taught there since 1854, and lovingly reprinted by Ruskin's influential disciple, William **Morris**, at his Kelmscott Press. Ruskin's links with influential fellow Christ Church alumni resulted in the decision to use Benjamin Woodward's Ruskinian Gothic design for the building of the Oxford Museum of natural history, and Ruskin himself designed foliage decorations for the capitals.

A brilliant lecturer since the 1850s, Ruskin returned to art criticism when he was elected first Slade Professor of Fine Art at Oxford in 1869. In his 1883 *Art of England* lectures Ruskin reassessed the state of the nation's painting. He renounced his most difficult protégé, the late Rossetti, because he lacked sincerity, and had failed to excel in 'grotesque realism' as *Modern Painters* 3 had foretold he ought. But Rossetti's pupil, Burne-Jones, was declared a master of myth, the category of art which the un-converted Ruskin had evolved to recuperate his lost Gothic ideal of grotesque realism. Ruskin similarly praised the work of his latest protégé, Kate Greenaway, along with Helen Allingham, by presenting them as the female counterparts of Burne-Jones. These creators of 'legendary' fairy art for children demonstrated the coherence, and represented the fulfilment, of Ruskin's prophecies about England's art.

Whether or not it is true, as D.H. Lawrence believed, that the 'Ruskinite' was damned by 'self-righteousness', to this day generations of influential Oxford alumni (and countless non-Oxonians) from Morris to Slade Professor Kenneth Clark, have been Ruskinists. Yet Ruskin also met strong resistance at Oxford, both from some University authorities, and in the shape of **Pater**'s *Renaissance* (1873, 1893) – a work written to subvert Ruskin's view that this period of cultural history was a 'foul torrent'. None the less Oxford's institutional recognition was a triumph, completing Ruskin's colonization of every British class, by formalizing his position in the nation's establishment. Ruskin's empire-building mission at Oxford was conservative reform: to exhort upper-class gentlemen to take their responsibilities as the nation's cultural leaders seriously. So he immediately consolidated his power base by endowing a drawing mastership, because he wanted to counteract the South Kensington system of instruction, and by starting a Ruskin Art Collection in 1871. Edward Said observes that Ruskin's oeuvre is 'framed' by his inaugural lecture as Slade Professor ('will you, youths of England, make your country again ... a sceptred isle ... mistress of Learning and of the Arts?'), because it connected 'his ideas about British world domination to his aesthetic and moral philosophy'. For this reason alone Ruskin's writings pose questions that represent a formidable continuing challenge to his world readers.

Biography

John Ruskin was born on 8 February 1819 in London, the only child of Scots parents: vintner, John James Ruskin, and Evangelical mother,

Margaret. In 1825 they took the first of many family tours to Europe. Ruskin studied as a gentleman–commoner at Christ Church, Oxford from 1837–9 and 1842. In 1848 he married Effie Gray, but the marriage was annulled on grounds of non-consummation in 1854. He was 'un-converted' in Turin in 1858. Elected first Slade Professor of Fine Art at Oxford 1869, he held tenures from 1870–8 and 1883–5. He set up George Allen as his personal publisher, founded the Guild of St George and purchased Brantwood, Cumbria, in 1871. He was reconverted to a form of belief in Assisi in 1874. In 1878 he had the first of a series of mental breakdowns. He died on 20 January 1900 in Brantwood.

Bibliography

Main texts

Ruskin's writings on art are collected in:

The Works of John Ruskin, ed. E.T. Cook and A. Wedderburn, 39 vols, London, George Allen, 1904. This edition is also available as a Cambridge University Press CD-Rom, 1996.

Volume 1 'The poetry of architecture' (1837–8).

Volumes 3–7 *Modern Painters* vol 1 (1843), vol 2 (1846), vols 3, 4 (1856), vol 5 (1860).

Volume 8 *The Seven Lamps of Architecture* (1849).

Volume 9–11 *The Stones of Venice* vol 1 (1851), vols 2, 3 (1853).

Volume 12 *Lectures on Architecture and Painting* (1854), Reviews, Letters and Pamphlets on Art (includes material on the Pre-Raphaelites, 1844–54).

Volume 14 *Academy Notes* (1855–9, 1875).

Volume 16 *The Political Economy of Art* (1857), retitled *A Joy Forever* in 1880.

Volume 23 *Val d'Arno: Ten Lectures on Tuscan Art* (1873), *The Schools of Florence* (1874).

Volume 33 *The Art of England* (1883), *The Bible of Amiens* (1884).

A selection can be found in:

The Art Criticism of John Ruskin, (ed.) with introduction by Robert L. Herbert, New York, Anchor books, 1964.

Secondary literature

Birch, Dinah, *Ruskin's Myths*, Oxford, Clarendon, 1988.

Bradley, J.L. (ed.), *Ruskin: The Critical Heritage*, London, Routledge, 1984.

Brooks, Michael, *John Ruskin and Victorian Architecture,* London, Thames & Hudson, 1989.

Casteras, Susan *et al.*, *John Ruskin and the Victorian Eye*, New York, Harry H. Abrams and Phoenix Art Museum, 1993.

Cianci, Giovanni and Peter Nicholls (eds), *Ruskin and Modernism*, Basingstoke, Palgrave, 2001.

Hewison, Robert, Warrell, Ian and Wildman, Stephen, *Ruskin, Turner and the Pre-Raphaelites*, London, Tate Gallery Publishing, 2000.

Hilton, Tim, *John Ruskin: The Early Years*, New Haven, Yale University Press, 1985.

—— *John Ruskin: The Later Years*, New Haven, Yale University Press, 2000.

Landow, George, *The Aesthetic and Critical Theories of John Ruskin*, Princeton, Princeton University Press, 1971.

O'Gorman, Francis, *Late Ruskin: New Contexts*, Aldershot, Ashgate, 2001.

Wheeler, Michael and Whiteley, Nigel (eds), *The Lamp of Memory: Ruskin, Tradition and Architecture*, Manchester, Manchester University Press, 1992.

ANDREW ROBERT LENG

EUGÈNE FROMENTIN (1820–76)

FRENCH ARTIST AND WRITER

Eugène Fromentin's writings on art are unique in nineteenth-century France, in that, not only do they belong to the illustrious tradition of authors, such as **Diderot**, Stendhal or **Baudelaire**, writing about art, but they are the work of a practising painter, indeed of a man best known in his lifetime as an artist (his most famous paintings include *La Curée* (1863, Musée d'Orsay, Paris) and *La Chasse au héron (Algérie)* (1865, Musée Condé, Chantilly). Fromentin, in a sense, is on the inside track, in that he is immediately sensitive to the technical problems faced by the painters whose work he is discussing. Yet he carries this learning lightly, deliberately setting out to appeal to a wider, non-professional audience. In addition to his credentials as a painter and a writer, Fromentin had the added advantage of being a brilliant conversationalist and was particularly praised by the **Goncourt** brothers for his capacity to discuss aesthetics in a totally engaging way. It is perhaps this quality, above all others, which has ensured the durability of his study of seventeenth-century Dutch and Flemish art in *Les Maîtres d'autrefois* (1876; translated as *The Masters of Past Time*), long after many of the factual details in this work have been superseded by subsequent research and scholarship.

In the field of literature, Fromentin is best known for his autobiographical novel, *Dominique* (1862), a work which André Gide ranked among his top ten novels. It tells a tale of the impossible love of a young man for a married woman, set in a specific landscape, that of the flat, sweeping expanses of the western coast-line of France, in the area of La Rochelle, where Fromentin himself was born and died. This countryside, as pointed out by Roland Barthes (in *Le Degré zéro de l'écriture*, 1972), was not merely a backdrop to the unfolding plot of

Dominique: it was the focal point of the author–narrator's passion. In this regard, Fromentin's novel was the logical follow-on from his two earlier books, *Un Eté dans le Sahara* (1854; A summer in the Sahara) and *Une Année dans le Sahel* (1856; translated as *Between Sea and Sahara: An Algerian Journal*), based on his travels in Algeria, which provided the inspiration for his work as an Orientalist painter. With hindsight, however, the earlier of these two travel books, *Un Eté dans le Sahara*, may be seen as Fromentin's most innovative work, precisely in its evocation of landscape. The broad vistas of the desert are conjured up like an art book without pictures, or, to adapt a phrase used tellingly by Michel Chaillou, like a somnambulist writing with his eyes closed. The image is helpful for two reasons. The movement of the somnambulist captures Fromentin's love of travel, not so much for the hassle of the journey, but for the thread which it afforded him on which to string his impressions, with a minimum of formal structure. Writing with one's eyes closed, especially when gifted with unusual acuity of vision, pinpoints Fromentin's ability to write like a painter: not jumbling the two media, which would be impossible anyway, but seeking out that no-man's-land between painting and writing, that zone of consciousness through which all artists travel mentally, before ever approaching an easel.

Les Maîtres d'autrefois was not Fromentin's only work of art criticism. Apart from some youthful poetry, much of which he destroyed, his first published work was a set of two articles for a local periodical, based on the Salon of 1845. He who, despite major paternal opposition, had falteringly begun his career as a painter, quoted from the third-century Roman rhetorician, Aelean, in saying that art is best seen by artists. This was not a major Salon, in terms of the paintings exhibited, but it was memorable, in that it inspired the first publication of both Fromentin and of Baudelaire, one year his junior. Both men, though coming from vastly different backgrounds, shared a common pleasure in art, which is suggestive rather than systematic. In this, they were both very different from the established art critic, Théophile Thoré, who also wrote about the Salon of 1845, but in terms of art for man, rather than art for art, in consonance with his Saint-Simonian views.

Fromentin's second work of art criticism was his unfinished *Programme de critique* (1864). Though fragmentary, this manuscript anticipates *Les Maîtres d'autrefois* in many ways. It is composed as a conversation, in which Fromentin aligns himself with his audience, empathizing particularly with the dilettantes, whom he had typified in the person of Dominique and with whom he would later identify

himself in the Preface to *Les Maîtres d'autrefois*. It also contains the title of the later work in embryo, in the observation that it is all very well to disown one's masters, but they have to be replaced with others. This, in essence, was what Fromentin sought to do, when he travelled to Belgium and the Netherlands in 1875, seeking to show the rising Impressionists the error of their ways and urging them to go back to the Old Masters.

It is important to set *Les Maîtres d'autrefois* in context. It was published only two years after the major confrontation of 1874, when, two weeks before the opening of the Salon, the painters' co-operative, or *Société anonyme*, inaugurated its first independent exhibition in the gallery of Nadar, the photographer. This event, though not quite marking the birth of 'Impressionism', as is often suggested, nevertheless heralded innovations which had their origins in the previous decade. In 1863, Fromentin was not yet a member of the jury which excluded Manet's *Déjeuner sur l'herbe*, but, from the following year until his death in 1876, he belonged to those stalwart defenders of the faith in academic art. In 1874, he made not the slightest reference to the exhibition at Nadar's, in any of his notes or letters. He would, no doubt, have considered it beyond the pale of respectability for an august member of the Salon jury. What is interesting, in relation to this particular power struggle, is that, in many ways, it was a re-enactment of the one in which Fromentin had engaged, as a young man, kicking against the traces of authority, as represented by the neo-classical views on art held by his father. Only, this time round, the roles were reversed. Fromentin and his fellow-members of the jury were opposed to the younger painters, essentially because of their lack of finish. Fromentin's life-long endorsement of the view of Valenciennes (in *Eléments de perspective pratique*, 1800), that the sketch can have no place in the finished painting, was at the heart of his lack of sympathy with the contemporary developments in landscape, which otherwise had much in common with his own advocacy of suggestive art. In *Les Maîtres d'autrefois*, an entire chapter on the history of French landscape painting in the nineteenth century bears witness to the tussle within Fromentin between the old and the new.

However, the anti-Impressionist mission did not work out exactly as expected, especially as far as Frans Hals was concerned. When Fromentin left Paris for the Low Countries, he was prejudiced against Hals, who was seen as having a formative influence on the budding Impressionists. Too discreet to mention Manet by name, Fromentin, in his notebooks and correspondence, leaves no doubt as to the identity of the contemporary painter primarily targeted by references to his

'young friends' or to the 'Neo-Colorists'. The *Fisher Boy*, in the Art Gallery at Antwerp, conformed to Fromentin's expectations of Hals. 'Decidedly too fashionable', he jotted down in his notebook. However, as soon as he entered the Frans Hals Museum in Haarlem, Fromentin knew he would have to eat his words. This, as Pierre Golliet has written, was to be his 'road to Damascus'. 'Never has anyone painted better nor ever will', concluded Fromentin, in *Les Maîtres d'autrefois*. His analysis of the *Regents and Regentesses of the Haarlem Almshouse* was particularly memorable. Lack of finish and *alla prima* painting, characteristics frequently associated with Hals, continued to be anathema to Fromentin, notwithstanding the deep admiration which he came to share with the modern artists for Hals as an outstanding practitioner.

Apart from contemporary polemics, there was another tension underlying the composition of *Les Maîtres d'autrefois*. Fromentin frequently characterized himself in terms of an underlying duality, torn, as he was, between filial devotion and mature independence, between order and adventure: 'a painter in two languages', as Sainte-Beuve put it, two languages – radically different in form, but often seeming more like variations on a theme. At secondary school, Fromentin was an excellent classical scholar and there developed the rhetorical skills of thesis, antithesis and synthesis, which led his father to believe that he might have become a distinguished lawyer (the profession he would have preferred for his talented younger son) and which caused Fromentin, as a writer, at times to distort his argument, in the interests of maintaining a balance of opposites. In this way, for example, he falsified the roles of Van Noort and Van Veen as teachers of Rubens. One is even tempted to see an element of autobiography in the way in which Rubens is shown as harmonizing all his inner tensions, just as Fromentin wished he himself might do: single-minded of purpose, masterfully wielding his brush on the canvas and then, 'after an afternoon of brisk, merry work', with equal skill, mounting on horseback to socialize or attend to some diplomatic mission.

Fromentin cast Rubens in so positive a light that, given his propensity for antithesis and balance, he almost had to present Rembrandt as a kind of polar opposite. Indeed, Fromentin identified Rembrandt with the dreams of his own youth, his struggle against the authority both of his father and of the painterly conventions of the time. So, he portrayed Rembrandt as a dual personality, whose conflicting aims led to the introduction of fatal flaws in his work. The 'chimerical dreams', which Dominique guiltily entertained, were criticized by Fromentin in the work of Rembrandt. Indeed, the one

painting by the master to emerge unscathed was his great portrait of the Burgomaster, Jan Six, an 'un-chimerical picture' of an 'un-chimerical personage'.

The end-product, however, left Fromentin uneasy, particularly with regard to Rembrandt's *The Night Watch*. Here was a group portrait, in which one could not be sure what time of night or day it was supposed to be, in which it was not clear where the people depicted were meant to be going, while an incomprehensible little person was running among the legs of the guards. Fromentin told his wife that Rembrandt kept him from sleeping. He knew he was going against accepted opinion, which held the work to be a masterpiece. Indeed, the overall strength of Fromentin's book was weakened, as a result, and alienated many of his potential admirers, such as Gustave Moreau, who tried to talk him out of it, or, to a lesser extent, Edmond de Goncourt, who gently chided him for underplaying the greatness of Rembrandt. To some extent, Fromentin's anti-modernist agenda was getting in the way. If he was criticizing his younger compatriots for their unfinished representation of the external world by daylight, then, in all fairness, he would have to apply the same criterion to Rembrandt's rendering of objects by night light. In this respect, Fromentin fell into a trap of his own making.

However, just as landscape was central to *Dominique*, so, too, it may be thought of as key to the greatness of *Les Maîtres d'autrefois*. First, the landscapist, Jacob van Ruisdael, was an artist who seemed to Fromentin to have arrived at a position of mature melancholy, without having to resolve adversarial conflicts, of the type which he had tracked in relation to Rembrandt. Second, Fromentin identified with these landscape paintings themselves. Ruisdael was amongst the first to paint unpeopled scenes and, in the vanishing perspectives of his panoramic views, coupled with the immensity of his skyscapes, Fromentin detected an extension of the painter's personality, akin to that which he himself knew from the vistas of the Sahara, the Atlantic coastline or the Low Countries. Ruisdael, in short, left us a 'portrait' of Holland. In relation to Ruisdael's painting of *The Mill near Wijk*, Fromentin excelled himself in his evocation of the sky, the shifting architecture of the clouds climbing to the top of the canvas, emblematizing the stasis and flux, so characteristic of his own aesthetic universe.

Indeed, it is one of the ironies of fate that Fromentin, who set out to teach a lesson to the Impressionists, ended by excelling in a form of art criticism, which is itself germane to the principles of Impressionism. He describes the precise weather conditions at the Mauritshuis in The Hague, and does a pen-picture of the nearby *Vijver*, or fish-pond,

in terms which make the peripheral and contingent details of the visit appear as important as the content of the interior.

Perhaps more clearly than any other medium, painting in the seventeenth-century Dutch Republic shows the transition from a verbally prescribed and hierarchically organized visual world to relatively unmediated representation. It was, as Fromentin observed, the ability of painting to resemble reality, which was part of the destiny of Holland. He highlighted the difficulty of separating art, as such, from the world of which it was an imitation. He has us enter a Dutch town square, with the suggestion that we only need to raise our heads to see the sky. Conversely, he described the sky at Scheveningen as 'well modelled, well drawn and well painted'.

In this life-like representation, 'without any adornment', a revolution in perception had taken place. In an argument which he may have derived partially from **Taine** (whose *Philosophie de l'art dans les Pays-Bas* (1868) he consulted after his journey to the Low Countries and when writing up his manuscript), Fromentin characterized Italian Renaissance painting as one of elimination and synthesis, prioritizing the absolute over the relative, perceiving nature as she is, but pleased to paint her as she is not. Such art was anthropomorphic. By contrast, Dutch seventeeth-century painting had, as its concern, 'to put man back into his place and, if necessary, to do without him'.

In looking forward to a type of painting without developed subject matter, Fromentin was more modern than he knew. In working on his text, he was anxious to give complete coverage, historical and geographic, so as to conjure up for his readers the total environment of the works he was discussing. Before making the journey, he had consulted *Rubens et l'Ecole d'Anvers* (Rubens and the Antwerpen School) (1854), by Alfred Michiels, and had read extracts from *Musées de la Hollande* (Museums of Holland) (1858–60), by Thoré, but worried that he had been pipped at the post by Taine, whose book he only read when he got home. It is true that he conjures up an entire nation with an atmospheric realism such as to impress patriotic poets, ranging from the Irish Thomas MacGreevy (*Old Ireland*, 8 and 15 October 1921) to the Polish writer Zbigniew Herbert (*Still Life with a Bridle*, 1991), and to suggest to critics as perceptive as Flaubert the possible influence of Taine. However, the latter's famous, tripartite, deterministic definition of all art in terms of race, environment and time (*la race, le milieu* and *le moment*) left little room for the subtlety of Fromentin's richly suggestive evocations of specific paintings. Para-doxically, by his one-to-one approach to the reader and by grafting his art criticism on to the well-worn ground-plan of his earlier travel

books, Fromentin, in *Les Maîtres d'autrefois*, not only drew up his own artistic testament, but, through his personal self-exploration, reached out to others in ways which defy the passage of time.

Biography

Eugène-Samuel-Auguste Fromentin was born on 24 October 1820 in La Rochelle, the second son of Dr Toussaint Fromentin, Founder–Director of the first purpose-built psychiatric hospital in France. In Paris, he studied law 1839–43 and painting, with Jean-Charles Rémond 1843 and Louis Cabat, 1843–5. He travelled three times to Algeria (1846, 1847–8, 1852–3), once to Egypt (1869), once to Venice (1870) and once to the Low Countries (1875). At the Salon of 1849 he was awarded a Second Class Medal. He was a member of the Salon jury from 1864–76 and was awarded the Legion of Honour (*officier*) in 1869. He died on 27 August 1876 in La Rochelle.

Bibliography

Main texts

'Le Salon de 1845', *Revue organique des Départements de l'Ouest*, 1845, pp. 194–208, 258–72; repr. in Eugène Fromentin, *Œuvres complètes*, Guy Sagnes (ed.), Bibliothèque de la Pléiade, Paris, Gallimard, 1984.

Les Maîtres d'autrefois, 1876, trans. Mary C. Robbins, *The Old Masters of Belgium and Holland*, Boston and New York, Houghton Mifflin Co., 1882; repr. with introduction by Meyer Schapiro, New York, Schocken Books, 1963; trans. A. Boyle, *The Masters of Past Time*, London, Dent, 1913; repr. with introduction and notes by H. Gerson, London, Phaidon, 1948.

Collected works:

Œuvres complètes, Guy Sagnes (ed.), Bibliothèque de la Pléiade, Paris, Gallimard, 1984.

Secondary literature

Christin, Anne-Marie, 'Fromentin critique d'art ou la rhétorique du vide', *Cahiers de l'Association internationale des études françaises*, 37 (1985), pp. 193–212.

Golliet, Pierre, 'La Redécouverte de Frans Hals: Thoré-Burger, Edouard Manet, Eugène Fromentin', *Colloque Eugène Fromentin* (1976), Travaux et mémoires de la Maison Descartes, Amsterdam, No. 1, Lille, Publications de l'Université Lille III (1979), pp. 53–87.

—— *Jacob van Ruisdael vu par Eugène Fromentin dans* Les Maîtres d'autrefois, Nijmegen, Katholieke Universiteit, 1984 (final lecture given to the Catholic University of Nijmegen, 18 May 1984).

Schapiro, Meyer, 'Fromentin as a critic', *Partisan Review* (January 1949), pp. 5–51; repr. as Introduction to Fromentin, *The Old Masters of Belgium and Holland*, New York, Schocken Books, 1963 and in Fromentin, *Theory and Philosophy of Art: Style, Artist and Society, Selected Papers*, New York, George Braziller, 1994.

Thompson, James and Wright, Barbara *La Vie et l'œuvre d'Eugène Fromentin*, Paris, ACR, 1987.

Wright, Barbara, 'Epistolarité et autobiographie: le rôle de Rubens dans l'évolution de l'œuvre d'Eugène Fromentin', in *Nouvelles Approches de l'épistolaire*, Paris, Honoré Champion, 1996, pp. 71–9.

—— *Eugène Fromentin: A Life in Art and Letters*, Bern, Peter Lang, 2000.

<div align="right">BARBARA WRIGHT</div>

CHARLES BAUDELAIRE (1821–67)

FRENCH POET AND CRITIC

Widely held to be the greatest of the nineteenth-century French art critics, Baudelaire's vision of the function of both art and criticism played a vital role in the development of modernism. If the poet himself is to be believed, his unique passion for the visual arts was instilled in him by his father, an art lover and amateur painter, who died when Baudelaire was seven years old. Traces of this love of art can be seen throughout Baudelaire's writing, in his letters, his poetry, and in his prose poems, as well as in his dazzling articles of art criticism. In addition to several shorter pieces, he left three articles devoted to the annual art salons, those of 1845, 1846 and 1859, several studies of caricature both French and foreign, an analysis of Constantin Guys, presented as the painter of modern art, and an exploration of the life and work of Eugène Delacroix. Nothing if not provocative, Baudelaire's *Salons* illustrate his conviction that the best criticism was that which was amusing and poetic (*amusante et poétique*), criticism that was not afraid to reveal the work of art reflected through his own individual temperament. Impartial and independent, but passionate and opinionated (*partiale, passionnée, politique*) he refuses to adopt any specific system for his art criticism, preferring instead to take as his primary focus the pleasure a work of art gives, and to seek out the reasons for that pleasure. He argued that a painting was a machine, 'all the systems of which are comprehensible for a practiced eye; where everything is there for a reason, if the painting is good; where a tone is always destined to bring out the best in another tone; and where an occasional error in the drawing is sometimes necessary if something more important was not to be sacrificed' (*Salon of 1846*).

Always eager to transform keen pleasure (*volupté*) into under-standing (*connaissance*), Baudelaire strives throughout his criticism to analyse and comprehend the machinery of art. Two elements

predominate in his search for understanding. First, his conviction that art is to be judged not on grounds of morality or some value external to art itself, for instance 'truth to nature'. What matters is that the artist must be free to choose his or her subject matter, but must transform that subject matter into a work of 'beauty'. The beauty of the final creation is, therefore, the sole criterion for the critic. Second, he was resolutely modern in his search for beauty, seeking out those whom he believed were able to convey the heroism of modern life. For him this meant seizing both the ephemeral, the element that most links a particular subject to its specific time, and the eternal, that which ties the subject to timeless aspects of beauty. The ability to extract the eternal from the transient is what draws him to the great Romantic artist Delacroix and to the relatively minor painter, Constantin Guys. He was less attracted to Courbet and Manet, whose realism seemed to him too mundane, insufficiently transformed by the power of that queen of faculties, the imagination, into what is 'completely real only in another world'.

It was the search for that element of the transient that led him to delight in the works of Guys, whose sketchy watercolours and engravings of contemporary city life seemed to him to offer a visual parallel to Balzac's masterful exploration of the heroism of modern life. Curiosity, Baudelaire maintains, is the trigger for Guys's work, a curiosity that resembles that of children, for, as he asserts in a famous formula, genius is nothing other than '*childhood rediscovered* by an act of will, but childhood endowed, in order to express itself, with the adult organs and the analytical mind that allows it to organize the sum of material that has been amassed unwittingly'. Extracting the eternal from the transitory and the fleeting, Guys is able to capture modernity, and what is more, to lend it the beauty that comes from also being able to perceive the eternal and the immutable.

In Guys, Baudelaire may have found an ideal exponent of modernism, but the artist who represents for him the summit of contemporary achievement both in terms of outstanding quality and impressive, even daunting quantity, is Eugène Delacroix. In him Baudelaire finds the finest translation of the 'impalpable, the dream, nerves and soul' (*c'est l'impalpable, c'est le rêve, c'est les nerfs, c'est l'âme*), a translation, moreover, brought about simply by contour and colour, combined with a profound familiarity with nature. In a striking metaphor, Baudelaire asserts that for Delacroix nature is 'a vast dictionary whose leaves he flips over and consults with a sure and deep gaze', thus enabling him to sacrifice details to the overall effect without any loss in the power of his depiction. Like Baudelaire himself,

Delacroix combined 'a passionate love of passion and a cold determination to seek out the means of expressing passion in the most visible way.'

Despite the range of his interest in art, Baudelaire's response to sculpture was less straightforward than his reaction to painting. In his *Salon of 1846* he asks the notorious question: 'Why is sculpture tiresome [*ennuyeuse*]'? He swiftly provides his own answer: 'Brutal and positive, like nature herself, sculpture is at the same time indeterminate, constantly eluding our grasp, because it reveals too many faces at the same time.' While painters can determine the focus their viewers must adopt, statues by their very nature leave themselves open to being seen from inappropriate angles. Later, however, a statue of Ernest Christophe, which transformed this defect into a virtue, revealing its full truth only when the viewer had walked around it, stimulated Baudelaire not just to pay him homage in his *Salon of 1859*, but also to write a poem, 'Le Masque', that illustrates his own adage that the best criticism of a work of art could well be a sonnet or an elegy.

The determination not just to describe his response but also to analyse that response characterizes the tone of his art criticism. The Romantics' fascination with colour and the scientific studies of colour that had influenced many of them find a reflection in Baudelaire's writing as he sets out both to explore his own delight in colour and his desire to understand its effects. 'The air', he notes in his 1846 *Salon* 'plays so great a role in the theory of colour that if a landscape painter were to paint the leaves of a tree as he sees them, the tone he obtained would be false, because the expanse of air is far less between the spectator and the painting than between the spectator and nature'.

A lover of the undulating line and an exponent of the art of surprise, Baudelaire offers in his art reviews a sinuous exploration of the works themselves, the movements and convictions of the day, and the opinions of critics and writers distilled from his eclectic reading. His images are frequently arresting, as the following example illustrates: 'the most appetizing dishes, jokes cooked with the highest attention, the most sharply seasoned culinary products offered less of a mixture and less excitement, breathed out less wild pleasure for the nose and palate of a food lover that the paintings of M. Decamps for an art lover'.

His art criticism sparkles with opinions, apothegms, and provocations. Portraits, he asserts, offer an idealized reconstruction of individuals, demanding both observation and imagination. Landscapes have value only because of the ideas and emotions that humans attach to it, through the allegories, metaphors and comparisons they suggest.

An artist could not merely depict nature, but had to interpret it in order to tap its vast symbolic potential. He was one of the first to realize the powerful possibilities of the city as a subject for poets and painters, depicting these possibilities as offering 'the nobility and beauty that result from a strong agglomeration of men and monuments, the profound and complicated charm of a capital that has grown old in the glories and tribulations of life' (*Salon of 1846*).

The modernism Baudelaire attributes to both Delacroix and Guys is also what he seeks in caricature, or more precisely it is that blend of the ephemeral and the permanent, however strange it may be to contemplate that 'ungraspable element of beauty in works whose aim is to reveal to humanity its own moral and physical ugliness'. Since laughter, Baudelaire argued, was essentially human, it was also essentially contradictory, marked by the double sign of infinite greatness and infinite pettiness that he saw as essential to his own nature, torn between the double postulations of good and evil. Caricature's combination of elements allowed it to seize the moment while remaining the most faithful mirror of life. While much of Baudelaire's study attempts to differentiate among the characteristics that mark the comic of a range of nationalities, it is also a showcase for what he most values in art more generally. The passionate response that bursts forth in a work of art like an 'explosion in the expression', the translation of the apparently banal into the fantastic, the ability to make the monstrous seem realistic, all these are elements that not only attract his attention, whatever the artistic genre in which they appear, but that also stamp his own creative works.

Biography

Charles-Pierre Baudelaire was born on 9 April 1821 in Paris. His father, a civil servant, died in 1827, and his mother married the army officer and later diplomat Jacques Aupick. He was educated at the Collège Royal in Lyon and from 1836–39 at the Lycée Louis-le-Grand, Paris. In 1841–42 his stepfather sent him on a voyage meant to take him to India, but he left the ship at Mauritius and returned to Paris. On the publication of the first edition of his celebrated poetry collection *Les Fleurs du mal* in 1857 he was condemned for immorality. He translated the prose works of Edgar Allen Poe, wrote prose poems and a short novel, *La Fanfarlo* (1847), an adaptation of Thomas De Quincey's *Confessions of an English Opium Eater*, and a series of articles devoted to literary and art criticism. He died on 31 August 1867 in Paris.

Bibliography

Main texts

The Painter of Modern Life and Other Essays, trans. Jonathan Mayne (ed.), New York, Da Capo Press, 1964.

Art in Paris 1845–1862; Salons and Other Exhibitions Reviewed by Charles Baudelaire, trans. Jonathan Mayne (ed.), London, New York, Phaidon, 1965.

Selected Writings on Art and Literature, trans. P.E. Charvet, London and New York, Penguin, 1972.

Collected works:

Œuvres complètes, C. Pichois (ed.), Paris, Gallimard, 1973.

Secondary literature

Bowness, Alan, *Poetry and Painting: Baudelaire, Mallarmé, Apollinaire, and their Painter Friends,* Oxford, Clarendon Press, 1995.

Carrier, David, *High Art: Charles Baudelaire and the Origins of Modernist Painting*, University Park, Pennsylvania State University Press, 1996.

Coven, Jeffrey, *Baudelaire's Voyages: The Poet and His Painters*, Boston, Little Brown and Co., 1993 (with an essay by Dore Ashton).

Drost, Wolfgang, 'Des principes esthétiques de la critique d'art du dernier Baudelaire, de Manet au Symbolisme', in Jean-Paul Bouillon (ed.), *La Critique d'art en France 1850–1900*, Saint-Etienne, Université de Saint-Etienne, 1989.

Hannoosh, Michele, *Baudelaire and Caricature: From the Comic to an Art of Modernity*, University Park, Pennsylvania State University Press, 1992.

Hiddelston, J.A., 'From Boudin et Guys, from landscape to the painting of modern life', in Keith Cameron and James Kearns (eds), *Le Champ littéraire, 1860–1900, études offertes à Michael Pakenham*, Amsterdam, Rodopi, 1996.

McLees, Ainslie Armstrong, *Baudelaire's Argot Plastique: Poetic Caricature and Modernism*, Athens, University of Georgia Press, 1989.

Mickel, Emanuel J., 'Baudelaire's "Peintre de la vie moderne"', *Symposium* 38: 3 (Fall 1984), pp. 234–3.

Raser, Timothy Bell, *A Poetics of Art Criticism: The Case of Baudelaire*, Chapel Hill, University of North Carolina, Department of Romance Languages, 1989.

Smith, Paul, 'Le Peintre de la vie moderne' and 'La Peinture de la vie ancienne', in Richard Hobbs (ed.), *Impressions of French Modernity: Art and Literature in France 1850–1900*, Manchester, England, Manchester University, 1998.

ROSEMARY LLOYD

EDMOND (1822–96) and JULES (1830–70) DE GONCOURT

FRENCH WRITERS AND CRITICS

Edmond and Jules de Goncourt circulated in both the literary and artistic elites of the nineteenth century. As authors and amateur artists, the brothers earned a reputation for refined elegance as precious dandies, living in a rarefied world dedicated purely to art and its

sensual appreciation. In spite of the brothers' ubiquity in the art world, their aesthetic ideas are perhaps less known than their *Journal* and novels, often found distasteful today, due to the brothers' elitist, racist, and misogynist attitudes.

Within a total oeuvre that numbers in the hundreds, their body of art criticism spanned an array of periods and modes, from the modern school of French landscape painting, to eighteenth-century Rococo, passing by the Italian primitives and including Japanese art. Recognized as innovators in the genre of the naturalist novel, the Goncourts nevertheless shocked later observers by not fully endorsing the Impressionists, often considered to have made the same advances in the visual arts that the generation of Flaubert, the Goncourts, and Zola made in literature.

The Goncourts' weighty *Journal: Mémoires d'une vie littéraire* covers the period 1851–96 and contains their reactions to the people and events of their time. The ideas expressed remain difficult to summarize, due to the frequent contradictions and reversals of opinion. More important, perhaps, than any particular entry, was the overall agenda of the text. Written in a journalistic, often staccato style that attempted to capture the ephemeral, fleeting aspects of modern life and conversation, the *Journal* stands as a monument of the nineteenth-century man of letter's relationship to the society in which he lived. As such, it participated in a vision of modernity articulated by writers such as Théophile Gautier and Charles **Baudelaire** and remains a rich source of information on a range of subjects, from the activities of famous writers and artists to the modernization of Paris, and the evolution of aesthetic and literary taste.

The *Journal*, as much as it proclaimed itself to be a thoroughly modern document with this ideological programme, however, does not read as a celebration of that same modernity. Marked by an overwhelming pessimism, the Goncourts' *Journal* betrayed the degeneration – physical, moral, and aesthetic – that was the underbelly of the century's positivist embrace of technology and progress. The Goncourts' critique of the French Academy, which they saw as an empty pastiche of the styles of past masters, reflected the growing dissatisfaction with this influential institution. To the painting of Delacroix and Ingres, the Goncourts preferred the art of their friend Gavarni, a chronicler of life in modern Paris whose drawings maintained a spirit and verve, and Decamps, whose Orientalist paintings concentrate on the material representation of North African subjects without an apparent social or political agenda.

Their dissatisfaction with the practices of most modern artists were

first revealed publicly in *Le Salon de 1852* and *La Peinture à l'Exposition Universelle de 1855*. The earlier *Salon* lacks the type of overarching argument that marked their more decisive study of the 1855 exhibition. Certain themes, however, already animated their commentary, including their distaste for 'popular art'. With one sentence, 'Art is aristocratic in its essence', they unleashed a life-long tirade against the vulgarization of beauty, arguing that it was not accessible to *le peuple* who had neither the time nor the proper environment to appreciate it. A second theme advanced in the *Salon* is their refusal to link the modern realist school of writers with that of painters. 'We are partisans of realism in painting', they wrote, 'but not realism sought exclusively in the ugly'. Directed at Gustave Courbet, the Goncourts' attack on what they saw as an unfortunate pictorial trend also accused photography for generating taste for 'nature as it is'.

La Peinture à l'Exposition Universelle de 1855 extended and refined the themes established in his *Salon de 1852*. Still adamant in their refusal to accept a facile juxtaposition of writing and painting, the Goncourts opened their second essay with a defence of painting as 'the material animation of a fact' that should not attempt more than 'the recreation of the optical nerve'. The dominant schools of Romanticism and Academic Idealism fell into the trap of wanting to express a thought through their works, aiming at the viewer's mind rather than eyes. Thus, Ingres and Delacroix and their followers struck the Goncourts as *démodé*, tied as they were to this spiritualist concept of the image, even as their stylistic tendencies opposed one another.

Having felled the 'grandes écoles', the Goncourts quickly dismissed religious and history painting to proclaim the landscape 'the victory of modern art'. They placed their hopes in a new generation of landscape painters known collectively as the Barbizon school. Praising their observation and understanding of nature, the Goncourts cited Troyon, Dupré, Rousseau, and Diaz as artists who best knew how to represent nature by choosing but *not correcting* from its components. The idea of nature 'uncorrected' distinguished the Goncourts' theory from an Academic Idealist vision of nature, which both chooses *and* corrects to arrive at a more perfect form than in fact exists in reality. The maintenance, however, of a concept of choice, no matter how minimal, prevented artists from sinking into the representation of the 'ugly' and 'nature as it is' that the Goncourts felt so marred photography and realist painting.

The Goncourts' aristocratic sense of art may have sprung from their life-long love affair with the French eighteenth century. Their twelve essays on eighteenth-century artists first appeared in periodicals such as

the *Gazette des Beaux-Arts*, *L'Artiste*, and *La Revue Européenne* between 1855 and 1875. Later published collectively as *L'Art du dix-huitième siècle*, the essays transformed their commitment to the 'stuff' of the image into poetic elegies on their favourite images by Watteau, Boucher, Chardin, Fragonard, and others. The Goncourts' *écriture artiste* transcribed the sensual, visual experience of a picture, surpassing mere description to communicate a meditative reverie marked by lengthy accumulations of flowery, breathless phrases. Rather than a dry account of the colours, composition, and subject of a work, the Goncourts offered an engaged, committed experience of an image.

A perhaps uneasy bedfellow of *écriture artiste* shares the pages of *L'Art du dix-huitième siècle*: the Goncourts' concern for the unedited archival details that help establish a scholarly biography and catalogue for the artists they discussed. All of the Goncourts' historical texts celebrated this cult of the document, and the brothers' reputation as researchers has perhaps been overwhelmed by other aspects of their personalities. From unpublished letters to long-lost reports of sessions at the French Academy, the Goncourts sought to track any new bits of information they could find, and so *L'Art du dix-huitième siècle* also acts as a source book for documents such as the Comte de Caylus's biography of Watteau, Greuze's birth certificate, or sales figures from auction catalogues.

The Goncourts' interest in history and documents takes an interesting turn in their works of history *tout court*. In these books, of which *La Femme au dix-huitième siècle* is an excellent example, works of art come to serve the documentary needs of the historian. No longer the highly precious and aestheticized objects of *L'Art du dix-huitième siècle*, images here act as 'witnesses for memory', replacing the more traditional textual sources sought by historians. The conception of the art work as a document that records the world owed a great deal to the invention of photography, even if the Goncourts themselves never stated the connection. It allowed them to proceed using a method of analysis that has now become familiar to us as social or contextual art history.

This broader interest in the society that surrounded and created images informed one of the Goncourts' most famous novels, *Manette Salomon*, published in 1867. Here, they returned to the world of contemporary art, focusing their narrative on a painter, Coriolis, and his model Manette. Mixing fiction and reality, the novel showcased many of the various pictorial trends of the century. Certain scholars have matched the characters to types, such as the student of the École des Beaux-Arts, the Barbizon school landscapist, or the Old Master. The conversations and practices of the characters aped major aesthetic

debates of the mid-nineteenth century, from *plein air* painting to the teaching methods of the Academy, and from the vagaries of the Salon system to daily life in the studios.

Moreover, the novel reinforced another favourite theme of the Goncourts: that of the destructive role of women on an artist's creativity. Coriolis, who had some success with a painting of Manette, continued to use her as a model. As their relationship grew more intimate, she demanded marriage and Coriolis's painting suffered as he ceded control to Manette. With Balzac's fictions *Le Chef-d'oeuvre inconnu* (1831) and Zola's *L'Oeuvre* (1886), the Goncourts' *Manette Salomon* formed a trio of 'behind the scenes' glimpses into the lives of nineteenth-century artists. Not free from their authors' prejudices, however, these books should be taken not as a snapshot of this life, but rather as interpretations that are open to debate.

In 1870, not long after the publication of *Manette Salomon*, the Goncourts' partnership was tragically shattered by the early death of Jules. Bereft at the loss, Edmond turned his attention to honouring his dead sibling by re-editing their volume on eighteenth-century artists and publishing a volume of Jules's own prints (*Les Eaux-fortes de Jules de Goncourt*, 1876), many of which were copies of works in their own collection that they had recently installed in a house outside Paris. Amateurs, artists, and writers gathered at Auteuil to admire the Beauvais tapestries, the Boulle furniture, the print and drawing portfolios, and the Far Eastern art objects.

Still in the spirit of homage to his dead brother, Edmond wrote *La Maison d'un artiste* (1881). This text, which describes the house in all of its eclectic glory, and the house itself were important sources for the *art nouveau* movement and can be placed in context with Joris-Karl Huysmans's novel *A Rebours* (1884). Both represent highly refined collectors surrounded by the objects of their delectation in a claustrophobic atmosphere where the only things that mattered were the richness of a particular tone or the elegance of a trace of sanguine on heavy drawing paper.

Edmond's collection of Japanese art received particular attention in *La Maison d'un artiste*. Among the first generation of *japonisants* in Paris, the Goncourt brothers admired the planar approach to space, the flat juxtaposition of colours, and the concentration of *geisha* in works by Hiroshige, Hokusai, and Utamaro that began to flood Parisian markets in the 1860s. From early collector and enthusiast, Edmond moved to scholar late in his life with two monographs on Utamaro (1891) and Hokusai (1895). Although much of the factual information in these books has since been corrected by later scholarship, the flavour

of their enthusiasm remains an eloquent testament of an on-going European fascination with Japanese art.

With these and other texts, the Goncourts carved out a complex aesthetic programme. Firmly advocating for a modern school and the irrelevance of academic traditions to contemporary art, the Goncourts nevertheless insisted on maintaining a degree of beauty and an elevated concept of 'Art' that ran contrary to the most avant-garde schools of painting. The rich tapestry of their ideas and engagements provides a variety of approaches to art, from the sensual, heady, and ethereal world of *écriture artiste* to the scholarly monograph. The co-existence of these at times contradictory modes in the writing of Edmond and Jules de Goncourt may be the mark of the period in which they lived, which so shaped the formation of art history and art in the early twentieth century.

Biographies

Edmond Huot de Goncourt was born on 26 May 1822 in Nancy and **Jules Huot de Goncourt** on 17 December 1830 in Paris. The sons of an army officer in the Napoleonic Empire, they were educated at the Pension Gobaux, the Lycée Henri IV, and the Collège Bourbon. Edmond entered law school and later worked at the Caisse du Trésor, from 1841–8. In 1848, they embarked on a drawing tour of France and Algeria. With their cousin Charles de Villedeuil, they co-founded two periodicals, *L'Eclair* and *Paris*, from 1851–3. They subsequently published books on eighteenth-century history and society in the 1850s. They undertook a drawing tour of Italy from 1855–6. In the 1860s they turned their attention to novels, including *Renée Mauperin* (1863), *Manette Salomon* (1867), and *Madame Gervaisais* (1869). Jules died in Paris on 20 June 1870. Edmond continued writing, and published *La Fille Elisa* (1877), and *Chérie* (1884). He died in Champrosay on 16 July 1896.

Bibliography

Main texts

Le Salon de 1852 and *La Peinture à l'Exposition Universelle de 1855,* in *Etudes d'art,* Roger Marx (ed.), Paris, Librairie des Bibliophiles, 1893.
Manette Salomon, Paris, 1867.
Gavarni, l'homme et l'oeuvre, Paris, 1873.
Catalogue raisonné de l'œuvre peint, dessiné et gravé de P.P. Prud'hon, Paris, 1876.
French Eighteenth-Century Painters (*L'Art du dix-huitième siècle,* 1880–82), trans. (excerpts) Robin Ironside, London, Phaidon, 1948.

La Maison d'un Artiste, 2 vols, Paris, 1881.

Outamaro, peintre des maisons vertes, Paris, 1891.

Hokusai: L'Art japonais du XVIIIe siècle, Paris, 1895 (significant portions of this appear in Forrer, Matthei, *Hokusai,* New York, Rizzoli, 1988).

Journal, mémoire de la vie littéraire, Robert Ricatte (ed.), Paris, Robert Laffont, 1989. For the Goncourts' journals, see *Pages from the Goncourt Journal,* trans. Robert Baldick, Oxford, Oxford University Press, 1962; and *Paris and the Arts, 1851–1896. From the Goncourt Journal,* trans. George J. Becker and Edith Philips, Ithaca, Cornell University Press, 1971.

Secondary literature

Beurdeley, Michel and Maubeuge, Michèle, *Edmond de Goncourt chez lui,* Nancy, Presses Universitaires de Nancy, 1991.

Brookner, Anita, *Genius of the Future: Studies in French Art Criticism,* New York, Phaidon, 1971.

—— *Romanticism and its Discontents,* New York, Farrar, Strauss, and Giroux, 2000.

Cabanès, Jean-Louis, *Les frères Goncourt: art et écriture,* Bordeaux, Presses Universitaires de Bordeaux, 1997.

Champeau, Stephanie, *La notion de l'artiste chez les Goncourt, 1852–1870,* Paris, Champion, 2000.

Dolan-Stamm, Therese, *Gavarni and the Critics,* Ann Arbor, UMI Research Press, 1981.

Johnson, Deborah, 'Reconsidering Japonisme: the Goncourts' contribution', *Mosaic,* 24/2, Spring 1991, pp. 59–71.

Launay, Elisabeth, *Les frères Goncourt, collectionneurs des dessins,* Paris, Arthena, 1991.

Silverman, Debora, *Art Nouveau in Fin-de-Siècle France,* Berkeley, University of California Press, 1989.

Special issues:

Magazine Littéraire (September 1989).

Revue des Sciences Humaines 259/3 (2000), ed. Jean-Louis Cabanès.

Society journal:

Cahiers Edmond et Jules de Goncourt, Société des Amis des Frères Goncourt (published annually since 1992).

PAMELA WARNER

HIPPOLYTE TAINE (1828–93)

FRENCH HISTORIAN

When Hippolyte Taine gave his first lecture as Professor of Art and Aesthetics at the École des Beaux-Arts in Paris, in 1864, cheering students followed him home through the pouring rain. He had been at loggerheads with the academic authorities since his university days, but it now suited them to exploit his notoriety as a radical thinker and outspoken opponent of Establishment philosophy to quell rumblings

of rebellion in the university. This political appointment, in the place of the conservative Viollet-le-Duc, was quite as instrumental in his success as was his innovative and controversial critical method.

Taine's method provides a paradigm of 'la critique' in nineteenth-century France, which moved away from emotional, judgemental engagement with a work and aimed instead at rational analysis. Criticism now became an exercise in understanding and explanation, encompassing both the ideas of an author or artist and his context. Taine went further, arguing in his doctoral thesis on the poet La Fontaine (1853), when he was only 21, that 'criticism can be turned into philosophical research'. He includes in his criticism a psychological dimension which informs all areas of his thinking, not only on art, but on history, literature and philosophy. Its basis is elaborated in the greatest detail in *De l'Intelligence* (On Intelligence) (1870), a psychological treatise which he valued above all his works. Here he defines a *faculté maîtresse*, or controlling faculty, underlying all thought, which exists as a potential in the human mind and is activated, not by the individual will, but by the combined influence of race (*la race*), environment (*le milieu*), and the historical moment (*le moment*).

The fierce determinism of Taine's argument contrasts with the private man, whose natural sensitivity to the beauty and feeling of the individual works he describes, and to the natural world, more than justifies Zola's intuition that his was 'an essentially artistic nature'. His writing too is often marked by 'word painting' and a style which might be compared to the *écriture artiste* vaunted by the **Goncourt** brothers. Indeed, as a young undergraduate he had aspired to be an academic philosopher and had composed a draft (now lost) of a proposed aesthetics, a hint of whose metaphysical flavour can be detected in the thesis on La Fontaine, where he praises the capacity of poetry to effect a sympathy between primitive and sophisticated forms of knowledge. In a clear concession to some kind of pre-existing, artistic and creative self, he examines the causes of poetry's 'spontaneous', 'involuntary' organization of the natural world and concludes that they lie in an 'obscure' and 'internal' unconscious reasoning that resides in the poet's 'genius'.

Soon though Taine was claiming that the 'scientific' aspect of his determinist critical theory made it possible to establish laws defining the nature, causes and merit of any work of art, and this framework left no room for any non-determined artistic inspiration. His position marks the transition from a Romantic aesthetic to the scientific analysis of art. His apparent denial of the operation of free will or a creative instinct ensured Taine a stormy start to his career and earned

him an uncomfortable notoriety in the eyes of the Establishment during the early, repressive years of the Second Empire. The dogmatic and at times mechanical application of his theory has also been largely responsible for the neglect to which his thinking has, latterly, been exposed.

By the time he took up his appointment at the École des Beaux-Arts all public expression of an innate and undetermined artistic influence had been expunged from his books and from his lectures and would only re-emerge, heavily disguised, in *De l'Intelligence*. His new approach to aesthetics is purely analytical and scientific, and depends on the establishment of facts and on the recognition that a work of art does not exist independently of its context. An artist, he tells his students, is concerned with distilling the essence of things from their context. His work is inextricably dependent on certain fixed associations which lie in the climate, in the artist's physical surroundings, in the man himself and his work, and in the society in which he lives.

Taine's lectures, delivered over almost 20 years at the École des Beaux-Arts, were published successively between 1865 and 1869, and eventually in two volumes, as *Philosophie de l'art* (The Philosophy of Art), in 1880. The separate sections deal with the philosophy of art in itself and in Italy, with painting in The Netherlands and with sculpture in Ancient Greece. In his introduction he re-asserts that, although art would appear to be the most arbitrary and spontaneous of human creations, nevertheless, 'just like the wind that blows', it is subject to precise conditions and fixed laws. In a rapid overview, he applies his theory rigidly, suggesting rather airily that the Renaissance began in Italy because that country's civilization was the first to evolve from a brutal way of seeing the world to a more contemplative one; that the art of Germany, home of metaphysics and systems, is characterized by philosophers who have somehow strayed into painting; that in English art the lack of taste and crude colours are the result of its subordination to commercial priorities; and that in France, art is more akin to literature, with a certain 'archaeological' mentality exploiting the poetic, the historical and the dramatic in subjects, in order to interest and excite the public, rather than pursuing any high aesthetic ideal. The tone is addressed to young students but the message is serious.

Under this formulaic treatment, the work of Benvenuto Cellini is first explained psychologically by means of a brief biographical sketch to account for a nature hardened by brutal experience, after which his Renaissance visionary talent is contrasted with the rationalist one of modern man. In a separate essay on **Leonardo da Vinci** (1865),

which is not included in the final two-volume *Philosophie de l'art* (1880; The philosophy of art), Taine again underlines the inescapability of past and present influences on a work of art, drawing attention to the scientific research and fascination with antiquity that prevailed during Leonardo's lifetime and to their reflection in his work. In the same essay, however, he betrays a contrasting sensibility, as he meditates interestingly on a comparison between the effect in Leonardo's work of chiaroscuro and the one achieved with the use of crescendo and diminuendo in great works of music.

While Mediterranean Renaissance Italy tends, in Taine's view, towards a certain paganism; the northern climate and Germanic influence affecting The Netherlands account, in the same period, for a very different inclination towards Protestantism. Artists there, he claims, are more sympathetic to religious faith than those in Italy at this time, and their painting reflects a deep love of nature. He supports his argument with an analysis of paintings by Memlinck and Jan and Hubert van Eyck, concentrating on their attention to minute and accurate detail and colour. Taine goes on to describe how the mood and attitude in The Netherlands altered with the Wars of Independence, at the end of the sixteenth century: there followed the high point of Flemish art with Rubens and then Rembrandt, whose use of chiaroscuro was the 'last of the great artistic inventions'. In his *Voyage en Italie* (Voyage to Italy) (1866), Taine reverses this argument, contrasting the passion of Rembrandt's etching, *The Annunciation to the Shepherds*, with what he considers the neglect of emotion, in favour of realism, in Raphael's *Transfiguration*.

When it comes to contemporary art, Taine's response is different: the emphasis on the dependency of art on the influence of race, environment and history gives way to an assessment of the *quality* of paintings. Factors accounting for his softened perspective may have been several short holidays in the Forest of Fontainebleau, where he had frequented the artists of the Barbizon school, and his marriage to the daughter of the fresco-painter Alexandre Denuelle. Taine was an amateur collector in a modest way, regularly attending the annual Paris Salons, and he had clear preferences. As a young man his opinions were trenchant: Meissonier, for example, is described, after a visit to the Salon of 1853, as inclining ever more towards 'micrography'; while Courbet is deemed to be 'making meat worthy of the Poissy market'; and Delacroix is caricatured as a perennial art student, full of optimism. Taine subsequently visited Delacroix in his studio on several occasions and recorded his 'constant touching up'. In some unpublished notes of 1863 he describes Delacroix as 'a lion with some cat-like timidity' – a

lion in his features; a cat in the cautiousness of his comments. As Delacroix's strong points, he singles out 'his conceptualization, his landscape and his effect of volume'; as his weaknesses, a lack of finish and a sense of incomplete ideas (Delacroix, for his part, regarded Taine as 'an out and out pedant'). At the same time he writes appreciatively of Cabanel, Castan, Caillou and Daubigny, while regretting that Corot's paintings are becoming routine and mannered. It is remarkable that he makes no comment on the work of Manet, whose relegation to the Salon des Refusés coincided exactly with the controversial publication of Taine's *Les Philosophes classiques du XIXe siècle en France* (French philosophers of the nineteenth century) (1857) and who might have been expected to have inspired some sympathy in a fellow suspect of the Establishment. He may be included among those unnamed fashionable 'new' artists referred to in an essay of 1867, who 'swing between various influences' and whose work is no more than 'an incomplete offshoot' with 'neither strength nor substance'.

Taine's relentless insistence on the determined nature of creativity increasingly incurred the disapproval of his intellectual contemporaries. In 1867 Zola used a pithy quotation from Taine's *Histoire de la littérature anglaise* (History of English literature) (1863–4) to the effect that vice and virtue were as much products as vitriol and sugar, as the epigraph to his first novel, *Thérèse Raquin*, and hailed Taine as the leader of the Naturalist school of writing. But in an article of 1866, while praising Taine's philosophical detachment, he had warned that his deterministic viewpoint was progressively reducing the individuality of man to a mechanical equation.

The attacks of Monseigneur Dupanloup (1863) and of intellectuals like the religious revivalist Paul Bourget (1889) and the nationalist Maurice Barrès (1892) were less forgiving. They described the widespread influence of Taine's ideas as pernicious and irresponsible, encouraging a view that man was a machine with no freedom to espouse either a religious faith or a political opinion. He was a dangerous disseminator of pessimistic and disempowering determinism. Henri Bergson (1888) attacked the mechanism of his language and its inability to encompass insubstantial phenomena such as the self. The novelist and critic Joris-Karl Huysmans, in his notes on contemporary artists in *Certains* (1889), dismissed Taine's method witheringly as adapted only to inferior minds.

Others though held him in greater esteem and his influence in areas beyond the world of art has been detected in the work of Freud, who incorporated aspects of his psychological treatise into his own work, the sociologist Émile Durkheim, who considered him to be the

father of rationalist empiricism, and the linguist Ferdinand de Saussure who saw him as a proto-stucturalist. He was admired by **Nietzsche** as the great proponent of a new history.

Taine's approach to works of art is in many respects the one still widely adopted: biography is almost a *sine qua non* of modern criticism and the national and cultural influences on an artist are automatically taken into account. It may be argued that Taine was instrumental in introducing the now familiar hermeneutic approach to works of art, concerned more with interpretation than with cataloguing, and for inspiring a modern psychological analysis of the artist half a century before Freud appeared on the scene.

It is difficult today to conceive that any group of art students would willingly have contemplated such a mechanistic framework for art appreciation, and it is important to remember that the generation he was teaching was living in the aftermath of 60 years of political turmoil and may have been more prepared, even desperate to accept a structure of reliable laws for almost any area of research. Taine's own personal evolution was dogged by harassment and suspicion on the part of the university authorities and shows symptoms of a similar yearning for order and authority in the development of his writing and thinking, to the point where, after the Paris Commune (1871), he displays a disconcerting conservatism in parts of his *Origines de la France contemporaine* (Origins of contemporary France). A question remains however over whether this was merely tactical, and whether in less politically repressive times his earlier exploration of a more transcendent dimension to artistic genius might not have been pursued.

Biography

Hippolyte-Adolphe Taine was born on 21 May 1828 at Vouziers, Ardennes, the son of a small town notary. He was educated at the Lycée Bourbon and École Normale Supérieure from 1848–51. From 1851–2 he taught in Nevers and Poitiers, and 1853–68 in Paris where he gave private lessons and wrote articles for literary journals: these are collected in *Les Philosophes classiques du XIXe siècle en France, Essais de critique et d'histoire* and *Histoire de la littérature anglaise*. He was appointed Professor of Art and Aesthetics at the École des Beaux-Arts in 1864. His first volume of *Philosophie de l'art* was pubished in 1865. He travelled in Belgium and Holland in 1867, and in Germany, Austria and Italy in 1869. *De l'Intelligence* was finished in 1870. In 1878 he was elected to the Académie Française. He died on 5 March 1893 in Paris.

Bibliography

Main texts

Nouveaux essais de critique et d'histoire (for the essay 'Léonard de Vinci'), Paris, 1865.
Philosophie de l'art en Italie, Paris, 1866.
De l'idéal dans l'art, Paris, 1867.
Philosophie de l'art dans les Pays-Bas, Paris, 1868.
Philosophie de l'art en Grèce, Paris, 1869.
De L'Intelligence, Paris, 1870.
Philosophie de l'art, 2 vols, Paris, 1880.
Life and letters of H. Taine, Westminster, A. Constable, 1902–08.

Secondary literature

Charlton, D.G., *Positivist Thought in France During the Second Empire, 1852–70*, Oxford, Clarendon Press, 1959.
Evans, Colin, *Taine, Essai de biographie intérieure*, Paris, Nizet, 1975.
—— 'Taine and his fate', *Nineteenth Century Studies*, vol. VI (1977–8), pp. 1–2.
Kahn, Shalom, J., *Science and Aesthetic Judgement: A Study in Taine's Critical Method*, New York, Columbia University Press, 1953.
Léger, François, *Monsieur Taine*, Paris, Critérion, 1993.
Nias, Hilary, *The Artificial Self*, Oxford, Legenda, 1999.
Nordmann, Jean-Thomas, *Taine et la critique scientifique*, Paris, Presse Universitaires de France, 1992.
Weinstein, Leo, *Hippolyte Taine*, New York, Twayne, 1972.

HILARY NIAS

LEO TOLSTOY (1828–1910)

RUSSIAN WRITER AND REFORMER

'Art is not a pleasure, a solace, or an amusement; art is a great matter', wrote Leo Tolstoy in the concluding chapter of his treatise *What is Art?* It was a work that railed against the concept of 'art for art's sake' and the aestheticism fashionable in the Europe of his day. The primacy of art's capacity for moral communication was the message that he wished, above all, to impart in a work which had occupied his powerful mind for 15 years before it was eventually published in 1897. But the question of the artist's role and the purpose of art had dogged Tolstoy's thoughts throughout his creative life and often surfaced in his novels and short stories. An example is the portrayal in *Anna Karenina* of Mikhaylov, a Russian artist, who is visited in his studio in Rome by Anna and her lover Vronksy who had moved to Italy to escape the censuring of their illicit relationship

by Russian society. Mikhaylov is presented as a poorly educated but intuitive artist who, in the picture standing on his easel, *Pilate's Admonition*, 'knew that what he wanted to express in that picture had never yet been expressed by anyone' but who was at the same time anxious at the reactions of others to it. When Anna expresses her wonder at Christ's expression in the picture, Mikhaylov's face 'shone with ecstasy', but an angry frown was his response to Vronsky's admiration solely for the technical mastery demonstrated in the painting. Mikhaylov regrets and condemns the fashion for contrasting technique with inner quality 'as if it were possible to paint well something that was bad'. Obvious technique was an obtrusive wrapping obscuring the essential idea. And the artist's vision should not be veiled by any 'wrapping' so that it could be accessible 'to a little child, or to his cook'.

The musings of Mikhaylov, whose attitude to art were close to those of his creator, are a foretaste of Tolstoy's answers to his question *What is Art?* First, he wished to demonstrate what art was not. Certainly art was not to be defined by refinement of technique. If subject matter were disregarded in favour of a concentration on technical mastery, then the result was a false, counterfeit art. Four methods for producing counterfeit art are listed by Tolstoy. The first formula is borrowing hackneyed subjects from works generally accepted as being artistic models and giving them a veneer of novelty. The second it what Tolstoy calls 'imitation', by which he means the accumulation of realistic detail; this reduces painting to the state of mere photography. 'Being striking' is the third method, a contrived assault on the senses; the manipulation of light and the depiction of the horrible being considered the most effective means of 'being striking' in painting. Finally, there is the method of being 'interesting'; pictures, plays and music are deliberately constructed so that their method of expression is their main interest and they 'must be guessed like riddles'.

It was these considerations of what should be excluded from true art that explain Tolstoy's ire directed against the three exhibitions mounted in Paris in 1894: those of the Symbolists, the Impressionists, and the Neo-Impressionists. In *What is Art?*, he relied on the reports of his daughter Tatyana, a gifted artist, who shared her father's general views. The indefiniteness, the lack of subject, the apparent striving for effect in brush technique and palette, the Symbolists' incomprehensibility were all repellent. So Manet, Monet, Renoir and Sisley were all rejected as true artists.

For Tolstoy, the visual arts were particularly susceptible to the temptation of the counterfeit. Technical training was readily available

and the would-be artist has a wealth of subjects – 'mythological, or religious, or fantastic, or symbolic' – as well as topical events from which to borrow. Or, added Tolstoy sarcastically, he could just copy anything thought to be beautiful, 'from naked women to copper basins'.

Counterfeit art was the result of the professionalizing of art, whereby the need to earn a living destroyed the disinterested sincerity that was art's most precious quality. The development of specialized art criticism also led to the high regard in which sophisticated technique, and consequently false art, was held. Above all, it was the professional training imparted in art schools that was injurious. For their instruction consisted in teaching pupils to imitate copies and models, to reproduce the themes treated by celebrated masters and to follow their technical procedures.

Much of *What is Art?* is devoted to demolishing with vitriolic relish what Tolstoy saw as false, counterfeit art. What he saw as 'the great matter' of real art was the obverse of this negative. Art could not be justified by considering its productions objectively, merely for the sake of art. The true measure was not to calculate its pleasurable effect, but to judge 'the purpose it may serve in the life of man and humanity'. It was one of the essential conditions of human life, a means of intercourse between man and man. Art should be viewed not as simply an artefact but an activity whereby the artist strove to express his emotional experiences and other people demonstrated their capacity for experiencing the emotion that the artist has expressed. In contemplating a work of art, the spectator or recipient must enter into a special relationship with its producer. That is why in the portrayal of the artist Mikhaylov at work in his studio, Tolstoy had shown that the reactions of Anna Karenina, her lover Vronsky and their friend Golenshchikov to Mikhaylov's paintings were as important as the attitude of the artist himself to his work.

The key word that Tolstoy used in *What is Art?* to describe the special relationship between the true artist and his recipient was 'infection'. The degree of infectiousness was to be measured by the artist's individuality, the clarity of his expression, and his sincerity. The word is repeated with great rhetorical effect climaxing in one of his main propositions: 'If only the spectators or auditors are infected by the feelings which the author has felt, it is art'. It was this process of 'infection' that was the essential of art, and Tolstoy underlined his pivotal tenet:

> To evoke in oneself a feeling one has experienced, and having
> evoked it in oneself, then by means of movement, lines,

colours, sounds, or form expressed in words so to transmit that feeling that others experience the same feeling – that is the activity of art. Art is a human activity consisting in this, that one man consciously, by means of certain external signs, hands on to others feelings he has lived through, and that others are infected by these feelings and also experience them.

Who would be most open, in this artistic activity, to benign infection? Certainly not the sophisticated, upper-class members of society who were inoculated against it by their over-refined education. Mikhaylov in *Anna Karenina* is deliberately presented as uncouth, although endowed with a natural talent. And he aims to make his work accessible not to the sophisticated but 'to a little child, or to his cook'. In *What is Art?* this class differentiation is heavily underscored. The upper-classes are charged with presenting art as elitist and exclusive, by making it costly and esoteric; their art was not available to the masses. Tolstoy, on the contrary, insisted that the true appreciation of art was an instinctive capacity in the common man. 'For a country peasant of unperverted taste', he wrote 'this is as easy as it is for an animal of unspoilt scent to follow the trace he needs among a thousand others in a wood or forest.'

If appreciating art was a universal human potential, so was the peasant everyman's capacity for religious feeling. Therefore, in its subject matter, art should be inspired by a religious perception. All ages had a distinct religious insight that was reflected in the art they produced. For Tolstoy, the religious perception of his contemporary world was 'the consciousness that our well-being, both material and spiritual, individual and collective, temporal and eternal, lies in the growth of brotherhood among men – in their loving harmony with one another'. His age, therefore, should produce true Christian art that expressed feelings of love of God and one's neighbour. Regrettably, Tolstoy found few examples of this kind of art in modern painting, especially among celebrated artists.

When Tolstoy applied his definition to modern works, the examples he chose to illustrate 'the highest art' were oddly naïve. His choice had been anticipated by two paintings by his fictitious artist Mikhaylov in *Anna Karenina*: the sincere Gospel subject of *Pilate's Condemnation* and a genre picture of two boys angling with its expression of innocence, companionship and wonder. *Anna Karenina* itself was now renounced by its author as an example of sophisticated, counterfeit literary art, in favour of such exemplary novels as *A*

Christmas Carol and *Uncle Tom's Cabin*. The same moralizing purpose determined his choice of paintings. Among the few singled out for praise were a genre picture, *The Poor Boy* by Walter Langley (1852–1922) showing a seven-year-old girl watching a hungry boy and 'evidently understanding for the first time what poverty is and what inequality among people is'; *In the Storm* by the French marine artist Antony Morlon (1868–1905) with a lifeboat going to the aid of a stricken steamer; and the *Man with a Hoe* by Jean-François Millet (1814–75). **Hogarth**, who had been included in the draft manuscript of *What is Art?*, was removed from the final version.

Tolstoy's international standing as a great novelist and modern prophet ensured that his views on art, however iconoclastic and whimsical they might appear, had to be heeded. They were a challenge to the fashionable aestheticism of the time. Some of Tolstoy's tenets seemed to have been embodied in the later Soviet doctrine of Socialist Realism: the rejection of elitism in favour of mass accessibility and the insistence that all art had to have a social purpose. However, there was a chasm between Tolstoy's religious conception of the brotherhood of man and the Soviet socialist ideal; there was no direct bridge across that divide. Outside Russia, too, *What is Art?* did not lead to any new movement in aesthetics. Its argument seemed to lack any philosophical system capable of being addressed by conventional criticism, or adopted. Yet, what it lacked in the clarity of its definition, was more than compensated by the power and resonance of its stimulation.

Biography

Leo Tolstoy (Lev Nikolaevich Tolstoi) was born on 9 September 1828 at Yasnaya Polyana near Tula, the son of a noble landowner. From 1844–7 he studied eastern languages and law at Kazan University. He became an officer in the Russian Army (1852–6) and was on active service in the Caucasus and Sebastopol during the Crimean War. After the war he retired to the family estate at Yasnaya Polyana and established a school on the estate for serf children (1859–60). From 1863–9 he wrote *War and Peace*. He published a complete elementary education course and from 1873–8 wrote *Anna Karenina*. In 1885 he founded the popular press *Posrednik* (Intermediary). In 1899 he campaigned in favour of dissident Dukhobors and was excommunicated from the Russian Orthodox Church in 1901. He died at Astapovo railway station on 7 November 1910.

Bibliography

Main texts

Anna Karénina, trans. Louise and Aylmer Maude, with introduction and notes by W. Gareth Jones, Oxford, Oxford University Press, 1995 (part 5, chaps 9–13, pp. 464–77).

What is Art?, trans. A. Maude, (ed.) with introduction and notes by W. Gareth Jones, London, Bristol Classical Press, 1994.

Secondary literature

Bayley, John, *Tolstoy and the Novel*, London, Chatto & Windus, 1966.

Christian, R.F., *Tolstoy: A Critical Introduction*, Cambridge, Cambridge University Press, 1969.

Diffey, T.J., *Tolstoy's What is Art?*, London, Croom Helm, 1985.

Gifford, Henry, *Tolstoy*, Oxford, Toronto and Melbourne, Oxford University Press, 1982.

Hare, R., 'Did Tolstoy correctly diagnose the disease of "Modern" art?', *Slavonic and East European Review*, xxxvi 86 (1957), pp. 181–9.

Read, Herbert, 'Tolstoy's theory of art', *Adam International Review*, cclxxiv–ccxcvi, 8–16 (1960), pp. 1–73.

Šilbajoris, Rimvydas, *Tolstoy's Aesthetics and His Art*, Columbus, Ohio, Slavica, 1991.

Simmons, Ernest J., *Introduction to Tolstoy's Writings*, Chicago and London, University of Chicago Press, 1968.

Tomas, V., 'Kandinsky's theory of painting', *British Journal of Aesthetics*, ix (1969), pp. 19–38 (the influence of Tolstoy on Kandinsky).

W. GARETH JONES

WILLIAM MORRIS (1834–96)

ENGLISH WRITER, DESIGNER AND CAMPAIGNER

Art in nineteenth-century England had no more important defender and philosopher than William Morris. Art, as he defined it, would help bring about a violent socio-political revolution that would destroy the industrial, capitalist system under which art had been degraded, and usher in an age in which all workers were artists. This age would be founded on the worth and dignity of each individual's contribution to the beauty of life. During the last half of the century, Morris distilled his theories of art, steadily increasing his emphasis on the connection between art and the social system that feeds it. Ultimately, his far-reaching views significantly contributed to the birth and life of the Arts and Crafts Movement throughout Europe, Canada,

and the United States of America. His direct influence can be seen in the works of William de Morgan, Walter Crane, Elbert Hubbard, Gustav Stickley, and Frank Lloyd Wright.

Architecture, painting, sculpture, music and literature were the Fine Arts according to Morris, but he argued that only the elite could understand the Fine Arts and afford to collect such art. Morris thought that until the Italian Renaissance began to fade, the Fine Arts and Decorative Arts (he called them the 'Lesser Arts') had been closely related and of equal value, but the corruption brought about by industrialization had severed them and relegated the makers of Decorative Arts to menial work that had neither beauty nor use. In addition, this severance had removed art further from the influence of nature. Only when art was made in tune with nature could it be truly beautiful. Nevertheless, Morris condoned not the imitation of nature but the use of nature as a guide into the complexities of form and decoration.

Morris defined 'art' in its largest sense as 'the beauty of life', and 'decorative art' as the 'expression of man's pleasure in successful labour'. The craftsperson's love for the work and expression of his or her own joy in it would elevate decorative art to the status of the so-called 'fine arts'. In his essays and speeches, Morris urged his contemporaries to: 'Have nothing in your houses which you do not know to be useful or believe to be beautiful'. He also argued that: 'Nothing should be made by man's labour which is not worth making, or which must be made by labour degrading to the makers'.

With such an emphasis on the handwork of the individual, Morris might have been expected to rail against the use of machinery in the production of decorative goods. However, Morris not only accepted the use of machinery but welcomed it, when it could reduce the tedium of production from the worker's standpoint as well as maintain high quality. For example, some Wilton carpets designed by Morris were machine-woven. However, machines were not to be part of an assembly-line process: he always argued against any division between the work and the worker. Morris foresaw a world in which everyone was an artist and with varied enough skills so that he or she could work in any of several areas, choosing whatever seemed most compatible with individual enjoyment at a given time and contribut-ing to the welfare of the total community by undertaking in turn the less artistic and more physically demanding jobs like farming and laundry. These multi-talented workers would also have the ability to incorporate machines into their art as they saw fit. Furthermore,

judiciously used machines would give workers the necessary leisure to make pieces of art.

Morris longed for the revolution that would transform society into a community whose members saw art as being as essential for life as food and air. Ironically, Morris, who was brought up in a well-off family, became one of the leading socialist voices in Europe. Morris believed that the Decorative Arts should be referred to as the 'Popular Arts' because they were integral to daily life and should be made by all people. To transform the drudges of industry into people who understood the importance of art would require several approaches. He said that the lower classes, like their betters, should have access to museums, to learn about the ornamentation of household objects through the centuries. Except for paintings and sculptures, most objects in museums, were, in fact, common household objects that revealed the true history of a people, Morris said. Menial workers could also be led to appreciate the Decorative Arts through the careful study of churches and other old buildings that had not undergone restoration. A third method of educating the population about Decorative Arts was to insist that everyone learn to draw. The subject matter of these lessons should be the human figure, he said, because human forms have the complexity to challenge and are the quickest way for teachers of drawing to single out and immediately help those whose drawing has gone astray. Ironically, Morris himself had difficulty painting the human figure, one of the reasons he gave up becoming a painter.

What he could draw well were repeating patterns and ornaments. His firm, eventually named Morris & Co., used his designs as well as those of Edward Burne-Jones, Philip Webb, and William de Morgan in manufacturing most of the furniture, tiles, stained glass, metalware (including jewellery), rugs, tapestries, embroidery, wallpaper, and fabrics the firm sold. Morris based many of these designs on those in medieval illuminated manuscripts, paintings, furnishings, and architecture, especially those seen on two early trips to France; he drew his inspiration for many other designs from his keen observation of and delight in nature and his intricate study of European and Eastern furnishings as well as early texts about the arts.

Morris considered the building and the furnishing of houses among the most important arts. He thought the ideal house needed these furnishings: a bookcase with books, a table for work, several movable chairs, a bench, a cupboard with drawers, flower vases, and a small rug if the flooring were in poor condition. In this ideal home, either the walls would be ornamented in a 'beautiful and restful pattern' or they

would have pictures or engravings and other ornamentation. This world – the one largely reflected in Morris's utopian novel *News from Nowhere* (1890) – could come about only when the capitalism of his own society had been thrown off.

Some of Morris's theories about furnishings are embodied in the more than 600 patterns he designed for wallpaper and textiles. Typical names for these patterns reveal Morris's close observation of nature: *Willow, Trellis, Vine, Brother Rabbit, Strawberry Thief, Sunflower, Tulip, Tulip and Rose*, and *Peacock and Dragon*, for example. His enthusiasm for weaving high-warp tapestry led him to experiment with vegetable dyes used centuries before and to revive medieval methods of dying yarns and fabric, especially the indigo discharge method.

Morris believed that all art was narrative: it told the story of a culture as well as the story of its maker. Central to Morris's philosophy of art was the sense of the organic whole, and for him the ultimate image was the mythological tree Branstock, from an Icelandic saga, which signified the eternal life fed by the creative spirit of the storyteller, who, in Morris's philosophy, represented any artist. Morris thought that stories impose meaning on an otherwise incoherent world – in the same way that patterns in wallpaper, fabric, and furniture design do.

Morris's ideas about art arose not from escapism into the medieval world, but from his attempt to rekindle the dignity, courage, and beauty that he saw in medieval society. By doing so, he believed that society could be freed from the chains of industrialization and capitalism, which had degraded both the individual labourer and the community as a whole. He saw modern commerce as the greatest threat to all art, and he believed that the death of any one art from commerce meant the death of all art. Morris believed that art alone could recreate a meaningful, beautiful society, and he found in medieval Icelandic literature especially a model of consummate art, a nearly ideal integration of 'art' and 'craft'. His reading of **Ruskin** had led him to believe that 'craft', looked down upon by many as a kind of rote, uninspired, infinitely reproducible 'product', was indeed art.

Like many writers and other artists in the nineteenth century, Morris looked to the medieval past to find solutions for the problems he foresaw as threats to the future – especially the workers' hatred of tedious, degrading work, society's utter preoccupation with commercialism, and humankind's destruction of the beauty found in nature. Indeed, Morris's aesthetic theories led him to be an early environmentalist.

Among the major influences on his aesthetic philosophy were his passionate reading of medieval sagas and romances; his enthusiasm for the ideas of Thomas Carlyle and John Ruskin; his early employment by the Gothic architect G.E. Street; and his prominent role among the Pre-Raphaelite writers and painters, including intense friendships with Dante Gabriel Rossetti and Edward Burne-Jones. Works by Walter Scott brought the medieval period to life for him, and Charles Dickens's novels, which Morris greatly admired, reinforced his sense of the importance of community. In the early 1870s two lengthy trips to Iceland, where he visited the sites mentioned in the Norse sagas he had begun to translate, forged a more unified, more passionate aesthetic vision of these disparate, somewhat amorphous earlier influences. A late, but important influence, was Karl **Marx**'s *Das Kapital*, which Morris read first in 1882.

Morris's philosophy grew from a richly varied soil. Its elements included the revival of interest in Gothic architecture, the Oxford Movement's renewal of interest in the medieval church, and the growth of such political and economic forces as guilds and the crafts movement. Morris's early vision of medievalism was dualistic. On one hand, he saw a world of pageantry and heroism that was overlaid with a dreamy romanticism. Morris and Edward Burne-Jones built massive settles and cabinets in the heavy medieval style and painted them with scenes from medieval romances. On the other hand, he knew the tough language of Carlyle and Ruskin, who, though also romantic, also communicated much hard truth of medieval life and art. Morris has been called naïve about the realities of medieval Europe, but he knew the suffering, poverty, and barbarism of the medieval world. He was not escaping his own age, but trying to find a way to reform it.

One of his important and controversial artistic theories resulted from his early pursuit of architecture as a career. As an apprentice in the offices of G.E. Street, a well-known architect whose Gothic designs were becoming increasingly popular, especially his designs of churches, Morris admired Street's recognition that building materials themselves contribute importantly to the texture of a building and its impact. In his emphasis on the need for careful handcraft in building, Street shared some views set forth by Ruskin in *The Stones of Venice* (1851–3). However, Morris's own passionate following of Ruskin ultimately led him to disagree publicly with Street over the issue of church restoration, a practice that meant scraping away damaged ornamentation and replacing it with new faux-period details. Such restoration also enforced an ideal unity onto buildings that had been

added on to or otherwise altered over the years, destroying the parts that did not fit the nineteenth century's interpretation of a building's dominant style or period. Morris's absolute loathing for this kind of 'restoration' led him in 1877 to found The Society for the Protection of Ancient Buildings (SPAB). Morris believed that old buildings – and the handwork that formed part of the texture and meaning of the architecture – must be carefully repaired but they never should be even partially destroyed to make room for the age's interpretation of the building's original design.

Ultimately Morris made the connection between art – everything from weaving to illuminating manuscripts, making books, and designing wallpaper – and politics, becoming one of Europe's leading socialists. Neither the Fine Arts nor the Decorative Arts could flourish, and become one again, unless society underwent a violent revolution that overthrew the government and all institutions that divided those who owned the wealth and those who labored for them. Society – and Art – could exist only when people formed a true community based on artistic expression and not money and other property, a society in which each person's craft was appreciated as integral to society and an expression of individual dignity and self-worth.

Although Morris's dream of the ideal society has not been realized, Morris's influence among the arts lives on at the beginning of the twenty-first century. Beyond his own designs, writing, and lectures, Morris influenced the Arts and Crafts Movement in England as well as in other European countries and in America. Although many of the arts and crafts groups did not favour the use of machinery, Morris's view of the reciprocal roles of art and community nevertheless made him the leading voice of this movement, and a key influence on twentieth-century art and design.

Biography

William Morris was born on 24 March 1834 in Walthamstow, near London, the son of a financier. He studied at Exeter College, Oxford. In 1856 he became apprentice to Gothic architect G.S. Street. In 1861 he founded Morris, Marshall, Faulkner and Co. He learned Icelandic in the 1860s, translated sagas, and visited Iceland in 1871 and 1873. In 1875 he bought out his partners' shares and renamed the firm Morris & Co. In 1877 he founded The Society for the Protection of Ancient Buildings. He joined the Social Democrat Federation in 1883, and was a founding member of the Socialist League in 1884. He edited *The*

Commonweal from 1885–90. In 1890 he founded the Hammersmith Socialist Society and in 1891 the Kelmscott Press. He died on 3 October 1896 at Kelmscott House, Hammersmith, London.

Bibliography

Main texts

Hopes and Fears for Art. Five Lectures Delivered in Birmingham, London and Nottingham, 1878–1881, London. Reeves & Turner, 1882.

News from Nowhere, London, Reeves & Turner, 1891.

Socialism: Its Growth and Outcome (with E. Belfort Bax), London, Swan Sonnenschein, 1893.

Collected works:

The Collected Works, May Morris (ed.), 24 vols, London, Longman Green, 1910–15; repr. New York, Russell & Russell, 1966.

Selected works:

William Morris: Artist Writer Socialist, May Morris (ed.), Oxford, Blackwell, 1936; repr. New York, Russell and Russell, 1966.

The Ideal Book: Essays and Lectures on the Arts of the Book, William S. Peterson (ed.), Berkeley, CA, University of California Press, 1982.

William Morris by Himself: Designs and Writings, Gillian Naylor (ed.), Edison, NJ, Chartwell Books, 1996.

Correspondence:

The Unpublished Lectures of William Morris, Eugene D. LeMire (ed.), Detroit, Wayne State University Press, 1969.

The Collected Letters of William Morris, 4 vols, Norman Kelvin (ed.), Princeton University Press, 1984–96.

Secondary literature

Cumming, Elizabeth, and Kaplan, Wendy, *The Arts and Crafts Movement*, London, Thames and Hudson, 1991.

Fiell, Charlotte and Peter, *William Morris (1834–1896)*, London, Taschen, 1999.

Harvey, Charles, and Press, Jon, *William Morris: Design and Enterprise in Victorian Britain*, Manchester, Manchester University Press, 1991.

McCarthy, Fiona, *William Morris: A Life for Our Time*, London, Faber & Faber, 1994.

Parry, Linda, *William Morris and the Arts and Crafts Movement: A Source Book*, New York, Portland House, 1989.

—— (ed.), *William Morris, Art & Kelmscott*, Boydell & Brewer, Woodbridge, 1996.

Stansky, Peter, *Redesigning the World: William Morris, the 1880s, and the Arts and Crafts*, Princeton, Princeton University Press, 1985.

Wilhide, Elizabeth, *William Morris: Décor and Design*, New York, Harry N. Abrams, 1991.

LINDA A. JULIAN

WALTER PATER (1839–94)

ENGLISH WRITER AND CRITIC

Walter Pater was a periodical writer and critic, an author of fiction, and university lecturer in Classics. He is best known for his contribution to the theorizing of what he called 'aesthetic criticism', a book on the Renaissance, and for his prose style, the most famous example of which is a prose portrait of Leonardo's *Mona Lisa*. Historically, his defence of 'art for art's sake' is best seen as a dissenting response to the positions of two critics of the previous generation: Matthew Arnold and John **Ruskin**, both of whom in different ways tied the value of art to morality and contemporary politics. As an early reader of Ruskin and a student of his tutelage of the eye, all of Walter Pater's diverse work – from critical prose to 'imaginary portrait' – is suffused with a consciousness of visual art in all its forms – architecture, painting, sculpture, relief, archaeological artefacts, and ceramics. So, while a plethora of articles and books by Pater announce their subject as fine art, art also permeates the prose apparently on other subjects, such as the landscapes of his fiction which are strewn with allusions to buildings and art objects.

Pater's earliest writing took the form of anonymous book reviews in the periodical press from the mid 1860s. In the safety that anonymity and 'reviewing' afforded, and in a radical journal (*Westminster Review*), Pater wrote two of his boldest and lengthy articles on his contemporary William **Morris**, the Pre-Raphaelite poet and artist, and on his gay eighteenth-century predecessor **Winckelmann**, the German neo-classical art historian. Thus, Pater immediately trespassed on Ruskin's and Arnold's patches, Pre-Raphaelitism and classicism respectively. Aestheticizing the former and gendering the latter, he transformed them both by overwriting the versions of his predecessors with his own. By 1873, in the Preface to *Studies in the History of the Renaissance*, Pater's rewriting of Arnold's famous dictum: 'To see the object as in itself it really is' was explicit – the primacy of the subjective impression of the object displaces that of the external object 'itself'. So, between 1866 and 1873 Pater was effecting a turn from the absolutes of religion and ideology to the relativism, flux, impressionism, and empiricism that underpinned the science-orientated discourses of Flaubert's realism *and* French Impressionism. 'What is this song or picture to *me*?' he insists early in the Preface. Pater's identification of form and beauty as the defining characteristics of art, rather than the subject or morality of the

contents, is also clear in *Studies*. That it is art for *no* purposes other than artistic, i.e. perfection of form and beauty, and the pleasure they afford the spectator, is the argument of the celebrated Conclusion to *Studies*, which provoked immediate denunciation in pulpits in Oxford as potentially misleading for youth. Ruskin's socialist notion of art as the product of Christian labour and Arnold's location of national salvation in ancient Greek art and culture were obviated in the Conclusion, which Pater had lifted verbatim from his 1868 anonymous review of Morris's hedonistic and world-weary poetry.

However, by defending the Renaissance, the period which Ruskin singles out as artistically corrupt, *Studies* is both a retort to Ruskin and part of a wider interest in the Renaissance at the time. This may be gauged by the appearance of books on the Renaissance throughout the century as well as Ruskin's animadversions in *Modern Painters* (1834–56) and *The Stones of Venice* (1851–3). Pater's argument about the period is innovatory. On the one hand he *is* interested in periodization, in so far as he wishes to stretch the period backward into the fourteenth century and forward into the eighteenth century. He also emphasizes its wider continental manifestations, including France and Germany as well as Italy. But he is likewise touting a trans-historical notion of the *idea* of the Renaissance as a reawakening of the classical, which is evident in Winckelmann and Goethe, and remains an option in Victorian England. Pater rehearses this argument later, from a different tack, in an article on 'Romanticism' (1876) that he includes in *Appreciations* (1889) as its Postscript.

Pater's definitions of what constitutes 'art' are also inclusive, a catholicity which corresponds to our idea of multi-media. In addition to the painting of Botticelli and **Leonardo**, he treats the reliefs of Della Robbia, the poetry of Du Bellay and **Michelangelo**, and Winckelmann's art criticism. He expands the identification of the Renaissance with visual art to include Provençal chansons and prose, Pico's Neoplatonist theology, and (covertly) the poems of William Morris. In a period before the introduction of art history into academic syllabuses, the category of culture was still largely general, embracing what are now specialized disciplines. Pater's conception of his hybrid book marries well with our contemporary notion of 'area' studies, in which diverse aspects of a period (or language and culture) from different 'disciplines' comprise the subject. While a proportion of Pater's subject was visual art, the 1873 edition was not illustrated, unlike Ruskin's works. Rather than specialist art history, academic history, literary essays, and/or a guidebook to Italy, generically *Studies* most resembled Matthew Arnold's recently revived category of 'criticism'.

As for individual artists, Pater was one of the earliest in Britain to note (and champion) Botticelli in an 1870 article, before Ruskin; his prose picture of Leonardo's *Mona Lisa* as a *femme fatale*, which Yeats published as a poem in his 1936 edition of *The Oxford Book of Modern Verse*, has become the passage by which Pater's writing is best known; and in an 1877 essay provocatively titled 'The School of Giorgione' and later added to *Studies*, Pater's dismissal of anxieties about originality and attribution in a celebration of the Giorgionesque seems a direct confutation of commercial, connoisseur and, to an extent, Ruskinian values. The decision by Pater to include his outspoken and hitherto anonymous 'Winckelmann' article in *Studies* unmistakeably identified Pater with its sympathy for Winckelmann's (homo)sexual orientation. For readers then and now who understand the discourse, the rest of *Studies* can be seen to include similar themes in, for example, its Provençal tale of two friends, its account of Leonardo's favourite, its interest in androgyny, its treatment of Michelangelo's poetry, and aspects of the Conclusion. Likewise, Ruskin's obsession with seeing and looking at art, his seriousness about visual art as a subject, and his evident pleasure from it are echoed throughout *Studies* by Pater's similar excitement about palpable, material pieces of art which are reproduced for us through *ekphrasis* or 'prose pictures'.

However, Pater's pleasure and excitement in *Studies* are not occasioned by art objects alone. In parallel with his announced subject of the Renaissance is his evident interest in the form of his own work, the possibilities of prose as an art form, and the literary conventions in which he is working (the article, the review, the essay, the chapter, the book). In this respect, *Studies* reads like a series of *biographies*, reminiscent of **Vasari**'s lives of the artists; and as in conventional biography, the overall narrative of the life, the build-up of *character*, the *plot*, the *story* and the *setting* (here historical) all impel these articles/chapters toward the borders of fiction. They are clear antecedents of Pater's genre of 'imaginary portraits', which invoke only to displace the notions of the true or historical likeness by the 'imaginary', and visual portraiture by the *ekphrasis* of prose. Even Pater's two novels may be read as extended imaginary portraits, which allows for his Pre-Raphaelite attention to the detail of landscape and 'background' to an extent that is rare even in historical fiction.

Pater pursued his interest in Greek sculpture in 'Winckelmann', in subsequent writing on classical art and artefacts, some of which had been found by archaeologists in recent digs, and in 1885 allusions to ancient Roman remains filled the pages of his novel, *Marius the Epicurean*. In the 1870s he published two articles on Greek sculpture

and ancient Greek artefacts. Greek art was a subject introduced by Pater into classics lectures at Oxford from 1878, much as Ruskin as Slade Professor from 1869 had pedagogical ambitions to imbricate the study of modern art and aesthetics in the Oxford education of under-graduates. Despite his early apostasy from Ruskin's coupling of art with morality, Pater's debt to Ruskin was crucial to the younger critic's work: like his contemporaries, Pater benefited from Ruskin's succession of volumes over 20 years, which established art criticism as a public discourse and visual art as an important modern subject. Pater's articles on Raphael and on church architecture in the 1890s, not long before he died, attest to his lifelong interest in visual art, as do his curatorship of the University collections and (unsuccessful) candidature (as Ruskin's successor) for the Slade Professorship of Art in 1885.

Pater went up to Oxford in 1858 soon after William Morris had decorated the Oxford Union, and as a young man he had contact with contemporary Pre-Raphaelite painters such as Morris, D.G. Rossetti, W.H. Hunt, E. Burne-Jones and above all, Simeon Solomon. His portrait of Pater in 1872, preceded the notoriety of them both in 1873, which followed Pater's signed publication of *Studies* in February and Solomon's arrest for public indecency soon afterward in the same month. Pater's early style of prose criticism was influenced by Swinburne, whose articles in the *Fortnightly Review* from July 1868 and book on William Blake (1868) appeared during the formation of Pater's style. Thus, Swinburne's apparently provisional but actually elaborate and libertine 'Notes on Designs of the Old Masters at Florence' is followed by Pater's 'notes' on Leonardo (1869) and 'fragment' on Botticelli (1869), both in the *Fortnightly*, the 'studies' of 1873, and his 'art notes' in northern Italy (1890). Other friends of Pater's from art if not artist circles included Arthur Symons, and Oscar Wilde, who came up to Oxford as an undergraduate of 20 in 1876. As the means of introducing himself to the object of his admiration, Wilde took Pater at his word, as an *art* critic, and posted Pater his review of a Grosvenor Gallery opening.

Although it is true that Pater took as his first subject the fine art of Renaissance Europe, and although he continued to include visual art in the array of his subjects, he cannot be said primarily to be an art critic or an art historian. If he alluded to Solomon's work approvingly in *Studies*, he never wrote sustained pieces on contemporary British or European art like bread-and-butter art critics. Nor did he ever seek to be an art historian after the half-hearted claim in the title of *Studies in the History of the Renaissance*, although he let scholarship inform his work. Rather, Pater was primarily interested in aesthetic criticism and writing, and in form more generally, rather than any specific *subject* or

medium or genre, although he makes a strong case for imaginative (including non-fictional) prose in his essay 'Style' (1888).

It is in 'Style' that Pater's primary emphases on aesthetic criticism in the 1880s may be seen clearly. Here he draws on Flaubert's model of composition for his 'architecture' of form – its exclusions, its singleminded shapeliness, the precision of what is included, and its overall perfection achieved by an unfailing austerity. Pater goes some way in 'Style' to accommodate the contemporary emphasis on the moral qualities of content in evaluating art, but instead of readily adopting prescription for all categories of art, most art – 'good art' – is left untrammelled. Only great art depends on 'the quality of the matter it informs' rather than exclusively on its form. But Pater carefully adumbrates the other requirements of 'great art', some of which – 'compass' and 'variety' – seem closely related to form, whereas other desiderata are wider than a narrowly defined morality would allow. These include the depth of *revolt*, the largeness of *hope*, the alliance to great ends, the increase of *happiness*, the redemption of the oppressed, and the enlargement of human sympathies. While this list pertains to literature, style in art more generally is always on the agenda here, particularly because form figures so centrally. If Pater goes on to link his literature-based argument in 'Style' with music rather than visual art, informed readers, familiar with Impressionism and post-Impressionism, could readily supply the parallels with schools of contemporary art, in which the 'subject' is absorbed by form and light, as in the arrangements, harmonies and nocturnes of colour by Pater's contemporary, James McNeill Whistler.

From the outset of Pater's career as a writer, when Frances Pattison challenged the claim of *Studies* to be a work of (art) history as its title claimed, Pater's relation to the field of the visual arts has been problematic. This stems from both the breadth of his interests – in literature and a range of the arts, and the breadth of his writing, including as it does journalism, criticism, lectures, fiction, and history. Hybridity at every level is the primary characteristic of Pater's work. One result is a series of texts, rich in potential for a variety of discourses, among them art history and aesthetics.

Biography

Walter Horatio Pater was born on 4 August 1839 in Stepney, London, the third child of a surgeon. He was taught at home, and at a cathedral grammar school and went on to read Classics at Oxford. Here he was a (Resident) Fellow and Tutor of Brasenose College,

Oxford, and a University Lecturer from 1863–94. During his lifetime he published three books of collected articles and lectures, and three works of fiction. Among the articles/lectures are: *Studies in the History of the Renaissance*, 1873; *Appreciations*, 1889 (primarily English literature); *Plato and Platonism*, 1893 (university lectures in classics). His works of fiction are *Marius the Epicurean*, 1885, *Gaston de Latour*, 1888–89, and a collection of short stories, *Imaginary Portraits*, 1887. He died on 30 July 1894 in Oxford.

Bibliography

Main texts

Studies in the History of the Renaissance, 1873; 1893; Donald Hill (ed.), Ann Arbor, University of Michigan, 1980; Adam Phillips (ed.), Oxford and New York, 1986.
Imaginary Portraits, London, 1887.
Appreciations, London, 1889.
Plato and Platonism, London, 1893.
Greek Studies, London, 1895.
Miscellaneous Studies, London, 1895.
Selections:
Essays on Literature and Art, Jennifer Uglow (ed.), London, J.M. Dent & Sons, 1973; London, Everyman, 1990.

Secondary literature

Brake, Laurel, 'The politics of illustration: Ruskin, Pater, and the Victorian Art Press', in *Print in Transition 1850–1910*, Basingstoke and New York, Palgrave, 2001.
—— 'Degrees of darkness: Ruskin, Pater, and Modernism', in *Ruskin and Modernism*, Peter Nicholls and G. Cianci (eds), Basingstoke and New York, Palgrave, 2000.
Bullen, Barry, 'Walter Pater's "Renaissance" and Leonardo da Vinci's reputation in the nineteenth century', *Modern Language Review* 74 (1979), pp. 268–80.
—— 'Pater and Ruskin on Michelangelo', in *Walter Pater. An Imaginative Sense of Fact*, Philip Dodd (ed.), London, Cass, 1981.
—— 'The Renaissance as enactment: Walter Pater', in *The Myth of the Renaissance in Nineteenth-Century Writing*, Oxford and New York, Oxford University Press, 1994.
Dellamora, Richard, *Masculine Desire: the Sexual Politics of Victorian Aestheticism*, Chapel Hill, NY, and London, University of North Carolina Press, 1990.
Dowling, Linda, 'The aristocracy of the aesthetic', in *The Vulgarisation of Art*, Charlottesville and London, University Press of Virginia, 1996.
Potts, Alex, 'Pungent prophecies of art: Symonds, Pater, and Michelangelo', *J.A. Symonds: Culture and the Demon Desire*, John Pemble (ed.), Basingstoke, Macmillan, 2000.
Siegel, Jonah, 'Modernity as resurrection in Pater and Wilde', in *Desire and Excess:*

The Nineteenth-Century Culture of Art, Princeton and Oxford, Princeton University Press, 2000.

Stein, Richard, 'Walter Pater', in *The Ritual of Interpretation: the Fine Arts as Literature in Ruskin, Rossetti, and Pater*, Cambridge, MA, Harvard University Press, 1975.

Wollheim, Richard, 'Walter Pater as a critic of the Arts', in *On Art and Mind*, Cambridge, MA, Harvard University Press, 1974.

LAUREL BRAKE

FRIEDRICH NIETZSCHE (1844–1900)

GERMAN PHILOSOPHER

Friedrich Nietzsche's fundamental aesthetic position is encapsulated in the thought that art is intimately bound up with life. This thought constitutes the elusive core of his diverse reflections on art in each of his philosophical periods, and is given its most well-known expression in his first book, *Die Geburt der Tragödie* (*The Birth of Tragedy*) (1872). As Nietzsche himself observes, *The Birth of Tragedy* was written under the aegis of **Schopenhauer's** metaphysics, and thus belongs to the post-Kantian tradition in philosophical aesthetics. In his mature writings (1886–8), however, Nietzsche attempts to extricate himself from this tradition, and is thereby able to give more idiosyncratic voice to his enduring aesthetic vision. It is Nietzsche's later aesthetics, then, that will provide the focus for the present discussion.

Nietzsche's general view of art – and, indeed, his mature thought as a whole – is underpinned by a form of vitalism, which is a normative doctrine that employs 'life' as a criterion of worth. It is adopted by Nietzsche as a bulwark against the lures of metaphysical transcendence; and he employs it to assess the relative value of a variety of cultural phenomena, as well as cultures themselves. Nietzsche's interpretative commitment, then, '*to look at art through the prism of life*' – as he puts it in the 1886 Preface to *The Birth of Tragedy* – sets the context for his entire aesthetics.

It is in *Götzen-Dämmerung* (*Twilight of the Idols*) that Nietzsche advances, in most concise form, his view of art's vitalistic credentials: the 'meaning of art', he states, is 'life'. Two thoughts underlie this statement. First, Nietzsche construes art as the manifestation of life in the form of the artist's inward life. The '*compulsion* to transform into the perfect is – art' (IX. §9), he writes. Art, then, is to be understood as the manifestation of the compulsions and needs – that is, the needful life –

of the artist. Second, Nietzsche identifies art's role as an agent in the life of an individual or a culture – he points, in other words, to art's capacity for acting upon, or affecting, life. This idea supplies the motivation for the following claim: 'Art is the great stimulus to life' (IX.§24). For Nietzsche, then, art both manifests and acts upon life. His claims for art, however, are stronger than that. He thinks, as we have seen, that life is art's meaning; and in *Der Fall Wagner* (*The Case of Wagner*) he writes that art and life are 'tied indissolubly'. Nietzsche's stronger claim is that art's capacity to manifest and move life is a capacity that other human practices do not – or perhaps cannot – possess.

It is thus the vitalistic efficacy of art that ensures that – in Nietzsche's 'order of rank' – it is placed above all other cultural phenomena, including, to take the most prominent example, morality, which in its present form Nietzsche regards as particularly detrimental to life. Nietzsche's vitalism, however, is qualified by a critical dichotomy that enables him to perform discriminations within the aesthetic sphere itself. It is the dichotomy between 'impoverished life' and 'abundant life', and is presented in *Die fröhliche Wissenschaft* (*The Gay Science*):

> Regarding all aesthetic values I now avail myself of this main distinction: I ask in every instance, 'is it hunger or super-abundance that has here become creative?'
>
> (§370)

Nietzsche draws the distinction between a creativity of 'hunger' and one of 'superabundance', and bases his aesthetic evaluations upon these psychological categories. This critical dichotomy emerges from Nietzsche's claim – made earlier in the same section – that every 'art . . . may be viewed as a remedy and an aid in the service of growing and declining life' (§370). Thus, art that is created from hunger aids declining life, or the '*impoverishment of life*', whilst art that springs from superabundance is in the service of growing life or the '*over-fullness of life*'.

In accordance, then, with Nietzsche's vitalistic precept, art that is symptomatic of impoverished life is ranked below art that is created from the abundance of life. The dichotomy of impoverished/abundant life, however, does not only apply to the artist's psychology and its embodiment in art, but also to the spectator of art. Those who are drawn to impoverished art – to art that contains, as Nietzsche writes in *The Case of Wagner*, the '*stimulantia* of the exhausted' (§5) – betray their own impoverishment, 'exhaustion', or 'sickness'. Moreover, impoverished art – in its capacity as an agent of life, of sickly life – will

stimulate and so exacerbate the spectator's impoverishment. Super-abundant art, conversely, will attract those individuals who see their own fullness of life (or 'health', 'strength') mirrored in such art, and it will affect the consolidation of the individual's own abundance.

The force of Nietzsche's opposition of impoverished/abundant life can be grasped in two ways. It may be understood, first of all, in historical terms. Nietzsche, in *The Gay Science*, is concerned to denounce nineteenth-century 'romanticism in art and insight' by placing into the category of impoverished creation the work of the 'two most famous and pronounced romantics' (§370), that is, Schopenhauer and Wagner – his former mentors. At the same time, Nietzsche appraises the art of Greek antiquity – 'Dionysian art' – as the paradigm of superabundant creation. Secondly, Nietzsche's critical opposition can be understood as functioning at a more profound level: the psychological sphere of human need and instinct. At this level, Nietzsche is making an incisive claim about the deep motivations of individuals and cultures in general. In the final analysis, Nietzsche believes that value can be ascertained only with reference to the prickly realm of human frailty and strength. It is the realm of, as he puts it in the preface to *Zur Genealogie der Moral* (*On the Genealogy of Morals*), 'subterranean seriousness' (§7) where life-negating (impoverished) or life-affirming (abundant) impulses can be grasped in their nakedness.

Nietzsche's critical methodology – and part of his basic claim that art and life are indissolubly tied – rests on the assumption that there is a continuity between artist and art. If there were not such continuity, Nietzsche would be unable to evaluate aesthetic value by means of the nature of the artist's creative impulse. As we have already seen, Nietzsche thinks that art is the manifestation of the artist's inward life. He can be interpreted, then, as embracing a form of 'expressionism' – one, indeed, that could quite easily have emanated from the romantic tradition against which he inveighs. However, as the following passage from *On the Genealogy of Morals* reveals, Nietzsche's thoughts on the matter are more subtle. In the determination of the relation between artist and art, he advises that one should

> guard against confusion through psychological *contiguity* . . . a confusion to which an artist himself is only too prone; as if he himself were what he is able to represent, conceive, and express. The fact is that *if* he were it, he would not represent, conceive, and express it.
>
> (III.§4)

Nietzsche distinguishes between what an artist *is* and what he is able to create, and then makes the stronger claim that the fact that the artist *does* create a certain thing is a sure sign that the artist *is* not that thing. The artwork, then, is not an expression of the artist, rather, it is a symptom of precisely that which the artist lacks. The artist is 'disguised by his creations' (§269), writes Nietzsche in *Jenseits von Gut und Böse* (*Beyond Good and Evil*), thus there is no 'psychological contiguity' between artist and art.

Despite the air of contradiction – Nietzsche seems to be affirming both the continuity and discontinuity of artist and art – he is actually advancing two different and compatible views. Nietzsche rejects the romantic claim that the artist *is* what he is able to express; but at the same time he is committed to the view that art is highly symptomatic of the artist's fundamental needs. In short, art is symptom, not expression. And it is in this sense that art and artist are intimately connected.

For Nietzsche, then, the work of art is a complex agglomeration of symptoms – indeed, a 'sign-language' (*Twilight of the Idols*) – of the artist's equally complex inner world of conflicting drives; a world that the critic – who is also a cultural psychologist – must excavate so as to determine the vitalistic value of the work. In *The Gay Science*, Nietzsche illustrates one of the many possible paths that the critic might follow. He identifies two antithetical qualities, '*being*' and '*becoming*' (§370), that he regards, in light of his own critical excavations, as highly symptomatic. When faced with works of art that are dominated by, for example, the desire for becoming – 'the desire for destruction, for change' – Nietzsche asks: what manner of life lies at the root of such a desire? The answer he provides gives an indication of the labyrinthine nature of his approach.

The desire for becoming, Nietzsche writes, 'requires a dual interpretation'. It can be symptomatic of

> an excess of procreating, fertilizing energies ... pregnant with future (my term for this is ... 'Dionysian'); but it can also be the hatred of the ill-constituted ... who destroy, *must* destroy, because what exists, indeed all existence ... outrages and provokes them.
>
> (§370)

The impulse to destroy, then, can emerge from an overabundant or well-constituted life, whose act of destruction is at the same time a mode of fertilization that heralds the future. Or it can be the

manifestation of the hatred of life, in which case the act of destruction is revenge on life itself – on that which is interpreted to be the cause of ill-constitutedness. According to Nietzsche, the former impulse is life-affirming and constitutive of authentic tragic art, while the latter is life-negating and represents the corruption of tragedy.

In *Beyond Good and Evil*, Nietzsche calls himself 'a born ... psychologist and unriddler of souls' (§269) and refers, in the Preface to *The Case of Wagner*, to his 'keen eye for ... symptoms'. While we should not unhesitatingly endorse such self-assessments, indeed, we should question them strenuously; it is the case, none the less, that such qualities as Nietzsche describes are essential prerequisites for the profitable application of his style of criticism.

In a passage from *Twilight of the Idols*, Nietzsche expands upon his conception of the psychologist-critic. The 'born psychologist' is, for Nietzsche, a close relative of the 'born painter' who

> never works 'from nature' – he leaves it to his instinct, his *camera obscura*, to sift and strain 'nature', the 'case', the 'experience' ... He is conscious only of the *universal*, the conclusion, the outcome: he knows nothing of that arbitrary abstraction from the individual case.
>
> (IX. §7)

The born painter does not consciously select from experience; such a selection, on Nietzsche's account, would be 'arbitrary' – that is, not responsive to his fundamental impulses. His sifting and straining of experience, rather, is instinctive and rises to consciousness only during the act of creation in the form of the 'universal'. In other words, painting, according to Nietzsche, is simultaneously the instinctive abstraction from particularity *and* the conscious giving form to the resultant generality. It is in this sense, then, that the *'psychologist's* eye' and the painter's eye are of a piece. And it is also in this sense, perhaps, that we can best contextualize Nietzsche's own incisive accounts of the creative impulse: they are 'audacious frescoes' (*The Gay Science*, §87) of life at its most vital and consumptive.

Nietzsche's aesthetics are an attempt to understand art in the broadest perspective, life, and to draw from this understanding a basis for the discrimination of aesthetic value. He upsets many of our assumptions with respect to artists, works of art, audiences and their value. But that, it seems, is part of his point. Indeed, if we take seriously Nietzsche's philosophy of art, we will not only be led to scrutinize our aesthetic beliefs, but also our beliefs about life itself.

Biography

Friedrich Wilhelm Nietzsche was born on 15 October 1844 in Röcken, Saxony, the son of a Lutheran clergyman. He attended Schulpforta from 1858–64, and studied classical philology at the University of Leipzig from 1865–8. In 1869, he was appointed to the chair of classical philology at the University of Basel. In 1872 he wrote *The Birth of Tragedy*. He resigned in 1879 due to ill health and, supported by a university pension, lived in France, Italy and Switzerland. He wrote *Beyond Good and Evil* in 1886 and *Twilight of the Idols* in 1888. He collapsed insane in 1889, and spent his remaining years as an invalid in Jena, Naumburg and Weimar. He died on 25 August 1900 in Weimar.

Bibliography

Main texts

Die Geburt der Tragödie, 1872, trans. Ronald Speirs, *The Birth of Tragedy*, Cambridge, Cambridge University Press, 1999.

Unzeitgemässe Betrachtungen, 1873–76, trans. R.J. Hollingdale, *Untimely Meditations*, Cambridge, Cambridge University Press, 1983.

Menschliches, Allzumenschliches, 1878, trans. R.J. Hollingdale, *Human, All Too Human*, Cambridge, Cambridge University Press, 1986.

Die fröhliche Wissenschaft, 1882–1887, trans. Walter Kaufmann, *The Gay Science*, New York, Vintage, 1974.

Jenseits von Gut und Böse, 1886, trans. Walter Kaufmann, *Beyond Good and Evil*, trans. New York, Vintage, 1989.

Zur Genealogie der Moral, 1887, trans. Walter Kaufmann, *On the Genealogy of Morals* in *Basic Writings of Nietzsche*, New York, Random House, 1968.

Der Fall Wagner, 1888, trans. Walter Kaufmann, *The Case of Wagner*, New York, Vintage, 1967.

Götzen-Dämmerung, 1888, trans. R.J. Hollingdale, *Twilight of the Idols*, London, Penguin, 1990.

Der Wille zur Macht, notes from the 1880s, trans. Walter Kaufmann and R.J. Hollingdale, *The Will to Power*, New York, Vintage, 1968.

Selected writings:

Basic Writings of Nietzsche, trans. Walter Kaufmann, New York, Random House, 1968.

Secondary literature

Heidegger, Martin, *Nietzsche: der Wille zur Macht als Kunst*, 1985, trans. David Farrell Krell, *Nietzsche, Volume I: The Will to Power as Art*, San Francisco, HarperCollins, 1991.

Heller, Erich, *The Importance of Nietzsche: Ten Essays*, Chicago, University of Chicago Press, 1988.

Nehamas, Alexander, *Nietzsche: Life as Literature*, Cambridge, MA, Harvard University Press, 1985.

Rampley, Matthew, *Nietzsche, Aesthetics and Modernity*, Cambridge, Cambridge University Press, 2000.

Ridley, Aaron, 'What is the meaning of aesthetic ideals?' in *Nietzsche, Philosophy and the Arts*, S. Kemal, I. Gaskell, D.W. Conway (eds), Cambridge, Cambridge University Press, 1998.

Silk, M.S. and Stern, J.P., *Nietzsche on Tragedy*, Cambridge, Cambridge University Press, 1981.

Staten, Henry, '*The Birth of Tragedy* Reconstructed' in *Nietzsche's Voice*, Ithaca, Cornell University Press, 1990.

Tanner, Michael, Introduction to *The Birth of Tragedy*, trans. Shaun Whiteside, London, Penguin, 1992.

Young, Julian, *Nietzsche's Philosophy of Art*, Cambridge, Cambridge University Press, 1992.

RUBEN BERRIOS

ALOIS RIEGL (1858–1905)

AUSTRIAN ART HISTORIAN

Alois Riegl is regarded, along with Wölfflin and Panofsky, as one of the founders of art history as a discipline. All three were steeped in the tradition of German Idealist philosophy stemming from **Kant** and **Hegel**. This is perhaps especially true of Riegl, whose mission, as he saw it, was to counter an increasingly influential materialist conception of art. He associated this tendency with the name of Gottfried Semper, a writer on art theory and a prominent architect whose buildings adorn the centre of Vienna. Riegl accused the 'Semperians' of holding the view that style is the product of a conjunction of certain materials and techniques. Riegl countered this idea by introducing what he called the *Kunstwollen* – a will to make art in a particular style that transcends any necessities imposed by practical utility, available materials, or technologies.

Interestingly, the notoriously abstract concept of the *Kunstwollen* was first formulated in the context of the 'decorative' arts, in particular, debates concerning the genesis of ornamental motifs that Riegl engaged in his first book *Stilfragen: Grundlegen zu einer Geschichte der Ornamentik* (*Problems of Style: Foundations for a History of Ornament*) (1893). He argued that the origin of the zigzag pattern, for example, is not to be traced back to a happy accident that occurred when different coloured grasses were woven together. On the contrary, the geometric

pattern tells us a great deal about the aesthetic feeling of the people who made it and, more generally, about how they framed their relationship to the world. On the same grounds, Riegl argued against the view that the imitation of nature had much to do with the appearance of new motifs; he showed how the ubiquitous acanthus leaf pattern was really a simple lotus motif elaborately evolved over generations. Ornament was thus provided with an autonomous history based on principles of design. The implications of this debate can be clearly seen in the case of architecture: if, as was claimed by some contemporary theorists of architecture, form is dictated by technology and function, then architectural forms lack all meaning. Materialist approaches to style give it a casual explanation, rather than an interpretation in terms that would link it to peoples' most fundamental attitudes.

The idea of the *Kunstwollen* is fully elaborated in Riegl's *Die spätrömische Kunstindustrie nach den Funden in Österreich-Ungarn* (1901; *Late Roman Art Industry*). Here the concept has another resonance, for the art of the Hellentistic, late Roman and early Christian periods was regarded as symptomatic of the cultural decadence of the Empire brought about by barbarian invasions. Yet if the art of each period of art's history has a distinctive *Kunstwollen*, the notion of decadence can have no place. Instead of contrasting late Roman art unfavorably with classical antiquity, Riegl searched for an immanent aesthetic governing the style. He also secured for the period a necessary place in the history of art. Its particular anti-classical tendency was a necessary step paving the way from antique to modern forms of representation. Since Riegl thought that architecture, sculpture, painting and crafts were all subject to the same aesthetic intention, the *Kunstwollen* of a period style had to be defined in highly abstract terms: 'the appearance of objects as form and colour in the plane or in space'. Riegl held that transformations of these highly formal characteristics of art could be attributed to shifts in peoples' sensibility or their worldview. Riegl's formalism was partly dictated by the fact that iconographical motifs have only a marginal place in architecture and craft and so cannot be considered fundamental or essential to the visual arts in general. Also, consistent with his German Idealist background, he was more interested in *how* something is represented rather than with what it is represented. The contours of the mind's relation to the world and their transformations are best indicated by the way motifs are taken up and treated. Accordingly, Riegl's book on late Roman art begins with a long chapter on architecture, which, along with craft, reveals the *Kunstwollen* in its purity.

Riegl's great contribution to the history of art, advanced in *Late Roman Art Industry*, is the distinction between the 'haptic' (or tactile) and the 'optical' modes of representation. His highly speculative history of art is one that plots a continuous historical evolution from one pole of this opposition to the other. In the early stages of art's history, he proposes, people have a defensive relationship to a hostile nature and so their way of framing their ideal perceptual relation to the world in art is to keep objects tightly controlled within boundaries. Riegl regards the *Kunstwollen* determining ancient Egyptian pyramids, and art of the period generally, to be 'the creation of self-contained objects surrounded by space conceived as a void'. To put it another way, this artistic will aimed to represent something like Kant's 'thing-in-itself' prior to the dissolving effects of visual perception. Since a substantive conception of space would blur the boundary between objects and their surrounding space and thus compromise the absolute self-containedness of objects, depth had to be reduced to a minimum. This ideal object is one kept, as it were, at arm's length and is likened to the conception we gain of objects via the sense of touch. It is termed the haptic ideal so as to avoid connotations of literal touching. However, the perception of even flat, circumscribed things requires some subjective synthesis to bring the separate, haptic points of perception together to form a plane. Thought processes, even at this early stage, inevitably find their way into the object of perception and compromise its absolute integrity and objectivity. Our mental framework gradually becomes more and more entangled with the object perceived and, more importantly, this fusion is increasingly tolerated. According to Riegl's history, classical Greek art and the columned portico of the temple acknowledges to a greater extent the mind-constituted nature of the world. Relief sculpture, so typical of the period, includes some projections, soft shadows and gentle foreshortenings, but figures are still made to adhere firmly to the ground plane. This ideal contrasts with relief sculpture typical of the late Roman Empire where deep undercutting fragments and disperses the tactile plane. Instead, we perceive an optical-coloured plane. Late Roman art is thus aligned with contemporary Impressionist painting except that, in contemporary art, the object in perception finally loses all trace of its self-contained exteriority.

The *Kunstwollen* of late Roman art turns out to be the negation of tactile coherence, the opening up of the object into a surrounding space, which makes possible the Renaissance's conception of fully three-dimensional, infinite space. There are, of course, echoes of Hegel's great systematic philosophy of art in Riegl's ambitious history.

The morphology of Riegl's three phases coincides, more or less, with Hegel's Symbolic, Classical and Romantic phases of art's history. But for Hegel, the purpose of art is to enable human beings to come to the gradual realization that their highest thoughts and ideals (such as God) cannot be properly represented in any of the materials of art. Art is finally absorbed in and transcended by religion and philosophy. Hegel's system obviously implies a hierarchy of value since later forms of art are closer to art history's ultimate, self-cancelling destination. Riegl wanted to adopt Hegel's rich multiple morphology of stylistic types as well as his idea of a history of art couched in terms of increasingly subjectivized models of the mind's relation to the world, but without importing the notion of progressive development. In fact, Riegl had misgivings about modern art's obliteration of any sense of a world independent of our mind-constituted conceptions and thought he detected a return to a haptic ideal in the work of some Secession artists. He seemed to be most at home with seventeenth-century Dutch art, the subject of his next book.

Das Holländische Grüppenporträt (*The Group Portraiture of Holland*) (1902) carries forward many of the ideas elaborated in the book on late Roman art, but does so in a context focused on a particular genre and restricted to a narrower geographical and historical purview. It also abandons the strict formalism of the earlier book and replaces its distinction between haptic and optic styles with the terms objective and subjective. This book's major contribution to the history of art is Riegl's characterization of a type of composition whose coherence is dependent on the presence of the beholding subject. A compositional problem arises for group portraiture because it must somehow combine a number of figures in a group without involving them in any distracting and distorting action. In order for a group portrait to cohere, the figures must be shown in attentive attitudes, listening to, or looking at, one another. This would result in a weaker form of coherence, if the artist did not compensate by eliciting a heightened attentiveness on the part of the beholder: we are solicited, often by the outward gaze of depicted figures, to join and close their circle. Riegl gave the name 'external coherence' to this type of composition that makes the world of the painting imaginatively continuous with our own and contrasts it with the Italian paradigm of 'internal coherence', which is achieved through action and subordination. In Rembrandt's *The Syndics of the Cloth Draper's Guild*, for example, the figures are immersed in a shallow circumambient space registered by the blurring effects of loose, painterly handling and their psychical relation to one another is carried by the suggestion of aural attention paid to the

central figure. The spectator is called on to attend and to complete the scene by imagining a person to his or her left who is addressed by their steady gazes. The concept of attention describes both the viewer's and depicted figures' activity and is the solution to the problem of coherence in group portraiture.

Riegl sums up the meaning of the term as follows: 'Attention is passive, as it permits itself to be impressed by external objects and does not try to subdue them; at the same time it is active as it searches for the objects without intending to make them sub-servient to selfish desire'. An ethics of beholding is implied that values a kind of perception free of willful designs or emotional charge – a spiritual peace. **Schopenhauer**'s hymn of praise to Dutch still-life painters seems to me a likely inspiration for Riegl's formulation of this attitude: they depict simple objects with great care and 'the aesthetic beholder does not contemplate this without emotion, for it graphically describes to him the calm, tranquil, will-free frame of mind which was necessary for contemplating such insignificant things so objectively, considering them so attentively, and repeating this attention with such thought'. This is, as it were, the 'objective' side of attention and portraiture obviously partici-pates in this attitude when depicting individual physiognomies. But what characterizes Dutch portraiture is the depiction of attentive attitudes to the world; it depicts the subjects of attention rather than the objects.

Although Riegl tried to elaborate a history of art without aesthetic norms where every style would have an immanent aesthetic ideal and a place in the history of art, the subjects he chose and his treatment of them imply a certain ethical standpoint. In both his major books, Riegl celebrated a kind of aesthetic ideal that breaks down the self-contained separateness of objects and persons. This is achieved in early Christian art by formal means: the shallow circumambient space binds figures together. For Riegl, 'it is significant that this physical bridge between figures was built at the same time as that between persons, which we call attentiveness in the Christian sense'. While both moments in art's history make space embrace disparate elements, Dutch art of the seventeenth century perfects the representation of psychological bonds and elicits a performative attentiveness from the spectator. While the attentive person does not give up his or her identity, the attitude does imply the partial dissolution of a self-contained ego necessary for sympathy and community without coercion.

Biography

Alois Riegl was born on 14 January 1858 in Linz . He studied law, then philosophy and history, and finally art history at the University of Vienna, where he was a student of Robert Zimmermann. He was appointed Keeper of Textiles at the Österreichisches Museum für Angewandte Kunst, Vienna in 1887 and Lecturer in Art History at the University of Vienna in 1889. He wrote *Stilfragen: Grundlegen zu einer Geschichte der Ornamentik* (*Problems of Style: Foundations for a History of Ornament*) in 1893. He was made full professor in 1897 and appointed head of the Art Conservation Commission in 1901. He wrote *Late Roman Art Industry* in 1901, *The Group Portraiture of Holland* in 1902, and *Der moderne Denkmalkultus, sein Wesen, seine Entstehung* (*The Modern Cult of Monuments: Its Origins and Character*) in 1903. He died on 17 January 1905 in Vienna.

Bibliography

Main texts

Stilfragen: Grundlegen zu einer Geschichte der Ornamentik, 1893, trans. Evelyn Kain, *Problems of Style: Foundations for a History of Ornament*, with notes and introduction by David Castriota, preface by Henri Zerner, Princeton, NJ, Princeton University Press, 1992.

Die spätrömische Kunstindustrie nach den Funden in Österreich-Ungarn, 1901, translated by Rolf Winkes, Rome, G. Bretschneider, 1985.

Das Holländische Grüppenporträt, 1902, trans. Evelyn M. Kain, *The Group Portraiture of Holland* with introduction by Wolfgang Kemp, Los Angeles, Getty Research Institute for the History of Art and the Humanities, 1999. (Contains complete Riegl bibliography.)

Der moderne Denkmalkultus, sein Wesen, seine Entstehung, 1903, trans. Kurt Foster and Diane Ghirardo as 'The modern cult of monuments: its origins and character', in *Oppositions*, no.25 (1982), pp.21–50.

Collected works:

Gesammelte Aufsätze, K.M. Swoboda and O. Pächt (eds), Graz, 1929.

Secondary literature

Binstock, Benjamin, 'Alois Riegl in the presence of *The Nightwatch*', *October*, 74 (Fall 1995), pp. 36–44.

Dvorák, Max, 'Alois Riegl' (1905), *Gesammelte Aufsätze zur Kunstgeschichte*, Johannes Wilde and Karl M. Swoboda (eds), Munich, 1929.

Foster, Kurt, 'Monument/memory and the morality of architecture', *Oppositions*, 25 (Fall 1982), pp. 5–16.

Iversen, Margaret, *Alois Riegl: Art History and Theory*, Cambridge, MA, and London, MIT Press, 1993.

Kemp, Wolfgang, 'Introduction', *The Group Portraiture of Holland*, trans. Evelyn M.

Kain, Los Angeles, Getty Research Institute for the History of Art and the Humanities, 1999.

Olin, Margaret, *Forms of Representation in Alois Riegl's Theory of Art*, University Park, Pennsylvania, Pennsylvania University Press, 1992.

Pächt, Otto, 'Art historians and critics, IV: Alois Riegl', *Burlington Magazine*, 105 (May 1963), pp. 183–8.

Podro, Michael, *The Critical Historians of Art*, New Haven and London, Yale University Press, 1982.

Woodfield, Richard (ed.), *Framing Formalism: Riegl's Work*, London, Routledge, 2001.

Zerner, Henri, 'Alois Riegl: art value and historicism', *Daedelus* 105 (Winter, 1976), pp. 177–88.

MARGARET IVERSEN

INDEX